VINTAGE T SHIRTS

CAUTION: CONTENTS OF THIS SHIRT MAY BE HABIT FORMING

Patrick & Marc Guetta
of vintagetshirt.com

Text by Alison A. Nieder

TASCHEN

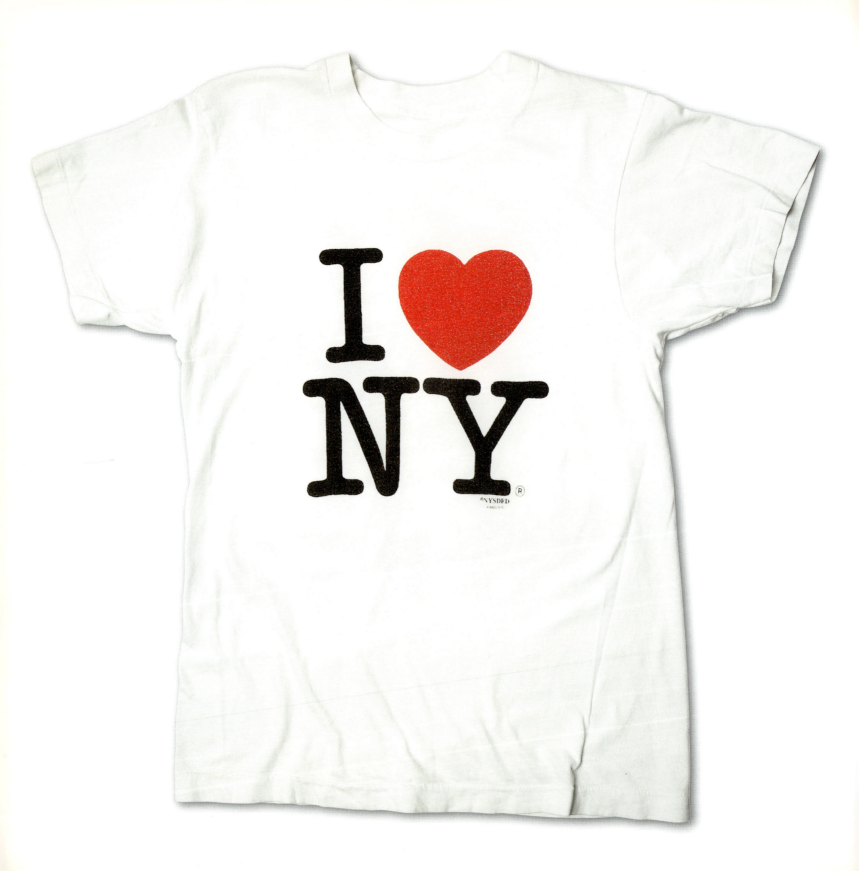

Foreword	7	**Vorwort**	19	**Avant-propos**	31		
American Classic	9	**Amerikanische Klassiker**	21	**Un classique américain**	33		
T-Shirts by Theme	42	**T-Shirts nach Themen**	42	**T-shirts par thèmes**	42		
Sports & Recreation	44	Sport	44	Sports et loisirs	44		
Food & Beverage	64	Essen & Trinken	64	Aliments et boissons	64		
Construction	72	Handwerk	72	Outillage et bâtiment	72		
Electronics	74	Elektronik	74	Electronique	74		
Music	76	Rock & Pop	76	Musique	76		
Apparel	178	Marken	178	Habillement	178		
Anatomy	186	Anatomie	186	Anatomie	186		
Automotive	188	Motorsport	188	Bolides	188		
Aeronautics	198	Raumfahrt	198	Conquête de l'espace	198		
Surf & Sun	200	Surfen	200	Surf et plage	200		
Guns & Ammo	206	Waffen	206	Armes	206		
Military	208	Army	208	Armée	208		
Slogans	212	Slogans	212	Slogans	212		
Sexy	238	Sex	238	Sexy	238		
Alcohol & Drugs	253	Alkohol & Drogen	253	Drogue et alcool	253		
Tourism	262	Fremdenverkehr	262	Tourisme	262		
Entertainment	287	Film & Fernsehen	287	Industrie du spectacle	287		
Politics & Activism	340	Politik	340	Politique et militantisme	340		
Characters	354	Comicfiguren	354	Personnages de BD	354		
Index	387	**Index**	387	**Index**	387		
Acknowledgments	391	**Danksagungen**	391	**Remerciements**	391		

←← "Caution," ca. 1979

← "I Love NY," Milton Glaser, 1980s

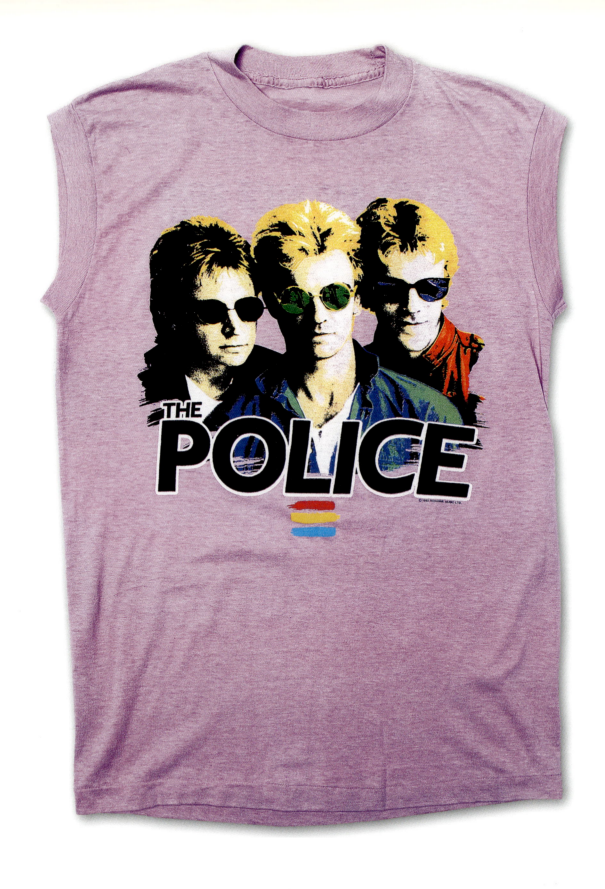

FOREWORD
Patrick Guetta

I am often asked if I remember my favorite T-shirt from childhood. Actually, I don't. I had been selling them since I was a teenager, but it wasn't until I got into the vintage end of the business that I said, "We can't sell this T-shirt! It's the Police! The Police!!!" (It was from the 1983 North American tour, to be precise.) I grew up on the Police. I had imagined myself singing and playing guitar in front of 20,000 people as a member of the band. We couldn't sell this shirt. It was part my youth, part my life.

Born and raised in France, I moved to Los Angeles with my family in 1982 and immediately embraced American pop culture. My brothers Marc (aka "Tony"), Thierry (aka Mr. Brainwash), and I started an apparel company in 1987 called Too Cute!, which manufactured high-end embroidered T-shirts, licensing characters from Disney and Warner Bros. to the Beatles and Betty Boop. Along the way, we worked with animation legends like Mel Blanc, Charles "Sparky" Schultz, and Bob Kane and Hollywood legends such as Steven Spielberg, Michael Jackson, Jeffrey Katzenberg, and Michael Eisner. We also developed our own characters, the "Junglenuts," which we hope will one day be "at a theater near you."

In 2000, Tony, who had always been a collector, told me he had a vision of opening a vintage T-shirt store, and asked if I wanted to go into business with him. I agreed, but on one condition: We had to have a washer and dryer and wash all the T-shirts thoroughly—with a lot of soap and Bounce. I cannot stand the smell of old clothes!

Back then, I was only an assistant. I knew nothing. Tony bought the tees, we would wash them, and he would price them. But one day, I saw the Police T-shirt. And then the Bee Gees and Pat Benatar and many more. I grew to see T-shirts as a personal billboard, and I became passionate about them, too. We collected concert, surf, movie, army, Harley, sports, slogan tees, and more. Then we thought it would be great to immortalize this massive collection in a book, as a snapshot of American culture.

Over the years, I've learned a couple of tricks for recognizing a good vintage T-shirt. (These are basically trade secrets, but I'm willing to share them with fellow collectors and fans.) First, the quality: Hold the T-shirt and feel how soft it is on your skin and how heavy it is. Second, the design: Is it cool? Does it look vintage? Third, the sentimental value: Does it bring back memories of good moments, a good friend, or events that touched your life? Fourth... (Sorry, that really *is* a trade secret. I can't give away *all* the tricks!)

It is with great pride that we invite you to travel into our world of vintage T-shirts. Enjoy!

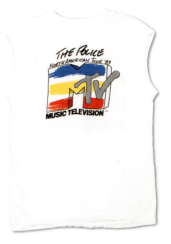

←↑ *Synchronicity* North America Tour, The Police, 1983

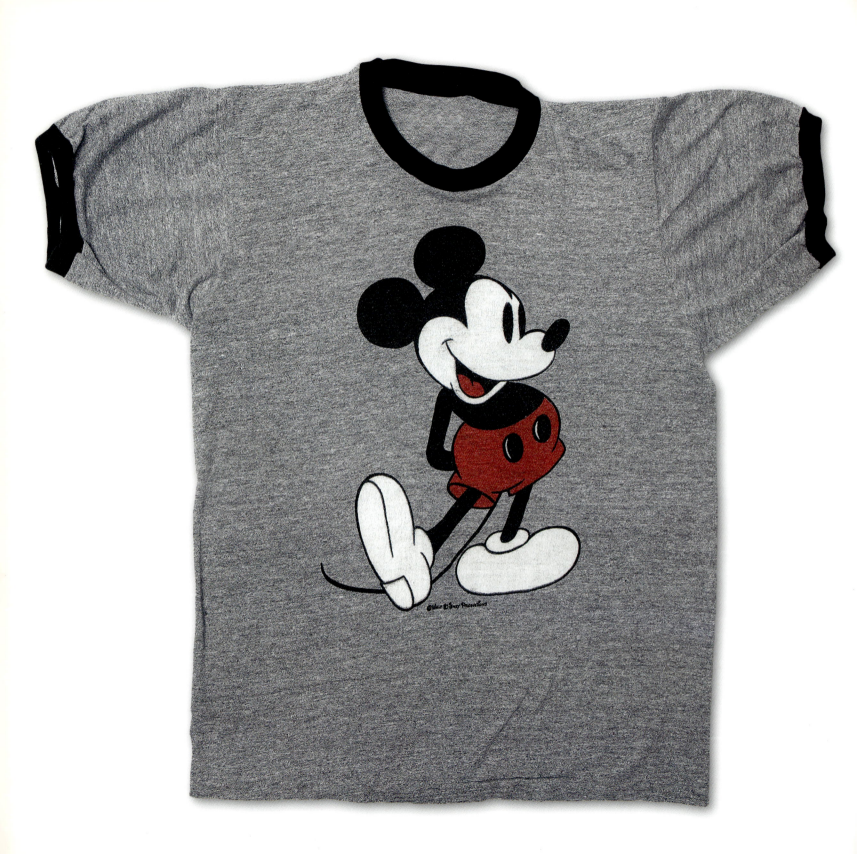

AMERICAN CLASSIC
Alison A. Nieder

James Dean wore one under a red jacket in *Rebel Without a Cause*. Marlon Brando wore his under a leather jacket in *The Wild One* and tore it off in *A Streetcar Named Desire*. Coco Chanel's T-shirt made nautical stripes chic and Pablo Picasso made them an artist's uniform. With help from Vivienne Westwood, Sid Vicious wore his slashed and safety-pinned. Post-Beatles John Lennon seemed the quintessential Manhattanite in his "New York City" ringer with the sleeves cut off. Giorgio Armani wears his tees with a tan and Patti Smith wears hers without. Fashion plate Factory girl Edie Sedgwick dressed up her dime-store tees with tights, big earrings, and a mink. And, in 1996, actress Sharon Stone, in what was possibly her second most memorable outfit, paired a Gap tee with a Valentino ball skirt for the Academy Awards. The list of icons associated with the T-shirt is endless.

During the height of the Gap's popularity, then-CEO Mickey Drexler likened the expansion of the denim and basics retail chain to grocery stores. "Think about it," he told *Fortune* magazine in 1998. "If you go into a supermarket, you would expect to find some fundamental items. You would expect to find milk: nonfat, 1%, 2%, whole milk. You'd expect the dates to be fresh. You want butter. You want certain types of bread. You have your list. I don't know why apparel stores should be any different." Drexler's vision of clothing as commodity put a Gap in every mall in America. T-shirts, which are half the equation for success at Gap, are, at first glance, the quintessential commodity product. Inexpensive and easy to produce in large volumes, about 1.5 billion T-shirts are imported into the United States each year.

Despite the price, simplicity, and volume, not all T-shirts fall under the commodity label. When Dov Charney, founder of T-shirt giant American Apparel, first launched his company in 1997 in Los Angeles, he wanted to make over the typical "blank," the name for a T-shirt destined to be printed, embroidered, or otherwise embellished before it is sold to the consumer. The blanks business had, until then, been dominated by huge T-shirt makers such as Hanes and Fruit of the Loom. Blanks were heavy and boxy and available in few styles: short-sleeve, long-sleeve, V-neck, and crew neck. Charney envisioned imprintable tees in a wider range of styles, in lighter weights, and with more body-hugging silhouettes—and ushered in the tee's latest incarnation: the "fashion blank."

The Technology of Tees

Over the course of its 100-plus-year history, the T-shirt has been defined as underwear, sportswear, workwear, and fashion. Its birth is tied to the industrial revolution and the invention of the industrial knitting machine. The early knitting mills used their machines to produce a tube of knitted fabric, which was made into stockings and hosiery. Soon, knitting mills turned to making men's underwear in the popular one-piece union-suit style. Hanes' predecessors, P. H. Hanes Knitting Company and Shamrock Mills, introduced a two-piece version of the union suit, creating a prototype for the tank top. Russell Manufacturing Company knit fabric for two decades before setting its sights on the athletic market in the 1920s.

For much of the first half of the century, the T-shirt was viewed as something that could get dirty, be laundered frequently, and was rarely seen except in specific circumstances, such as workwear to be worn for heavy manual labor. Then Coco Chanel, the Paris couturier who redefined the look of women's wear in the 1920s, helped changed that. The image

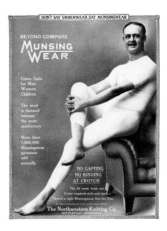

← Mickey Mouse, ca. 1983
↑ Munsingwear underwear advertisement, 1913

"The thing I hate most about rock and roll is the tie-dyed T-shirts, unless they're dyed with the blood and urine of Phil Collins."
—Kurt Cobain

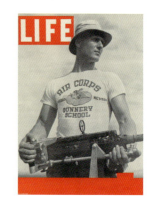

↗ *Life* magazine cover, July 13, 1942
↓ Sailors aboard USS *California*, 1923
→ Knit shirt, ca. 1940

of the whip-thin designer in a striped mariner T-shirt is a familiar one (thirty years later, her much curvier countrywoman Brigitte Bardot would adopt a similar look). During the first World War, when many fabrics were in short supply, Chanel began looking for a machine-made knit and found it in 1916 at Paris-based company Rodier. Knitted jersey, which had previously been used for men's underwear, soon had a central place in Chanel collections.

Although the white short-sleeve crew neck T-shirt had been part of the U.S. Navy's official uniform since 1913, it remained hidden as an undershirt until the second World War, when photojournalists and newsreel photographers captured images of servicemen out of uniform and in their tees. By the 1950s, the T-shirt was already becoming a symbol of rebellion (Brando in *The Wild One*, Dean in *Rebel Without a Cause*), of overt masculinity (Brando, again, in *A Streetcar Named Desire*), and of overt femininity (Bardot in *Babette Goes to War*). In *Jailhouse Rock* (1957), Elvis Presley wears a black-and-white striped tee for the film's centerpiece musical number.

With the exception of athletic apparel, most tees remained plain and unadorned until the midcentury. The advent of several key developments in printing technology shifted the T-shirt from being behind the scenes to representing a blank canvas. The art of screen-printing had been around for centuries, with roots in Japanese stenciling. Screen-printing gained popularity during World War I for posters and advertisements. The technique was used for apparel, but it was in the late 1950s that a new ink called plastisol changed the quality of screen-printing, making the graphics more durable and more flexible than those made with traditional pigments. By 1960, the process became mechanized with the invention of the rotary, multicolor garment screen-printing machine.

Next came the development of heat-transfer technology, which allows an artist to transfer an image to a garment using special heat-transfer paper and inks. The following decade T-shirt printing machines appeared in drugstores, sporting goods shops, and specialty T-shirt stores, which carried a supply of blank tees, iron-on letters, and a selection of heat-transfer graphics—consumers could easily customize their own tees. Heat-transfer graphics made photo-realistic imagery on T-shirts possible. Popular graphics in the 1970s included movie logos and film stills, which allowed movie fans to pay homage to their favorite movies—and helped the film studios realize the profitability of the T-shirt tie-ins with the marketing of blockbusters such as *Jaws*, *Star Wars*, and *E.T.*

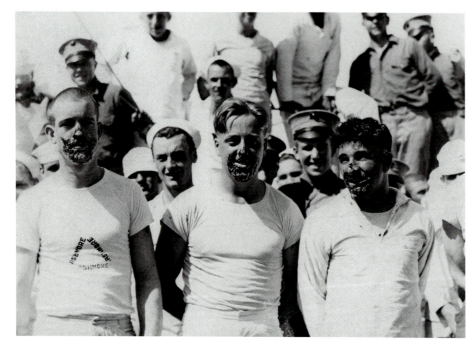

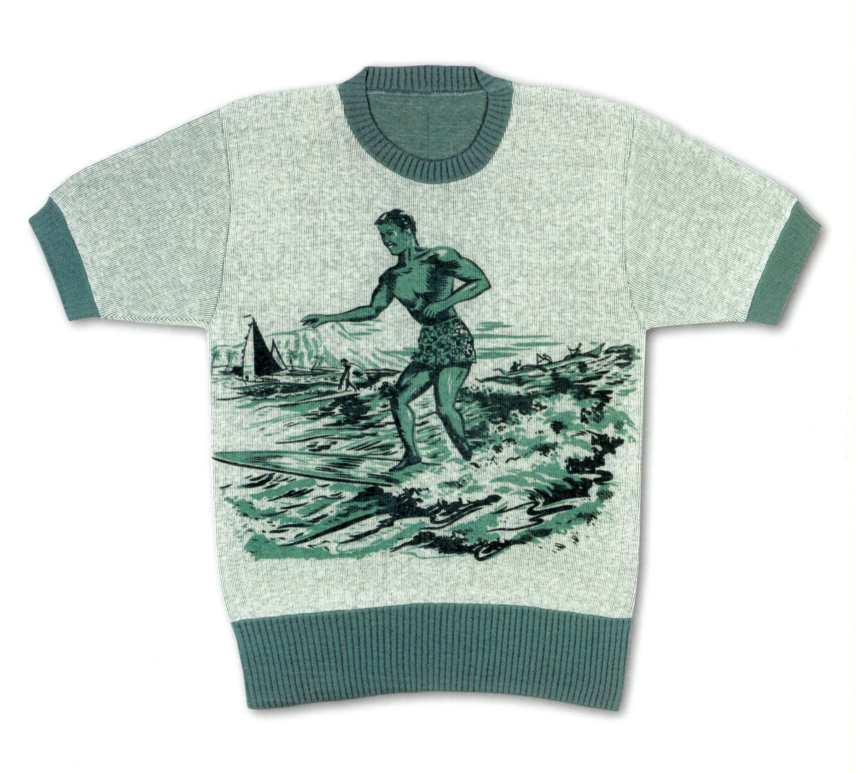

AMERICAN CLASSIC 11

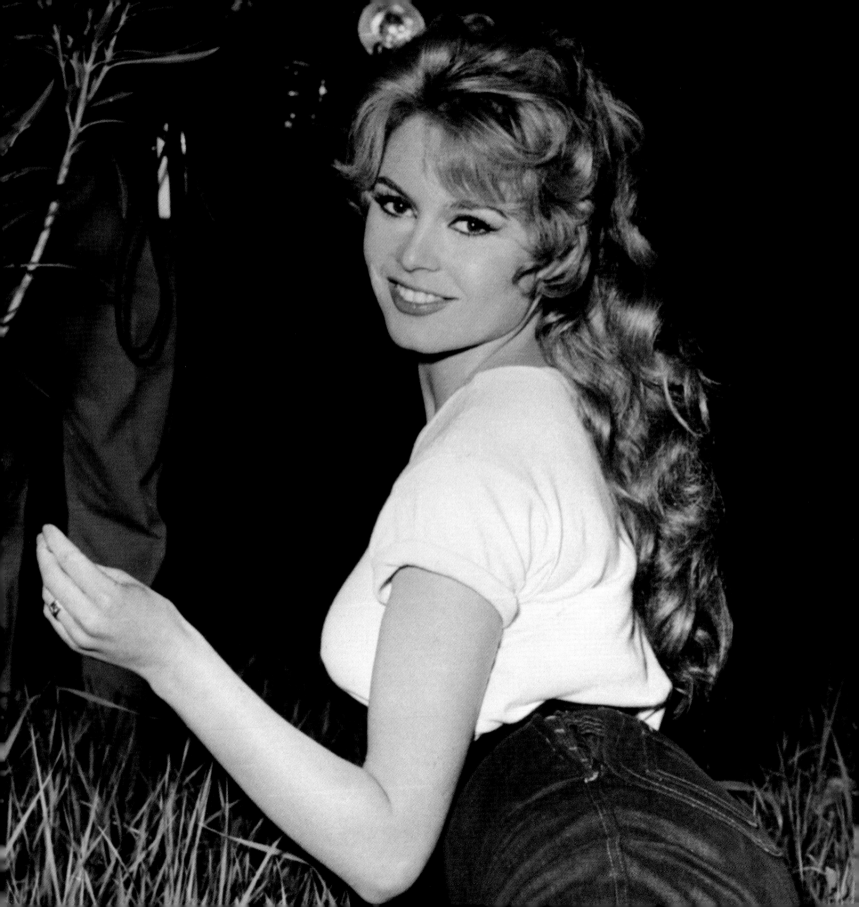

> "I would like to see the pope wearing my T-shirt."
> —Madonna

The Medium and the Message

One of the first applications for printed tees was the souvenir shirt, typically sold at resorts and other vacation destinations, which allowed the returning visitor to bringvf paradise home and broadcast his or her status as a world traveler to neighbors. The popularity of the souvenir tee has never waned and, in a few notable instances—the "Virginia is for Lovers" tee, which was created as part of a 1969 campaign of the same name by the Virginia State Travel Service, and the "I Love NY" shirt, featuring the logo created by artist Milton Glaser in the late '70s—the T-shirt slogan and the location become intrinsically linked.

If the souvenir shirt acts as a virtual passport, the surf tee serves as a sign of membership in an elite tribe. The *Encyclopedia of Surfing* credits San Diego surfboard maker Floyd Smith with the invention of the surf tee in 1961. Legend has it that Smith taught himself to silk-screen and then offered to print the logo of his company, Gordon & Smith Surfboards, for free on the T-shirts that customers brought into their store. By the end of the year, other brands such as O'Neill dove into the tee business as well.

Baby boomers embraced the idea that a printed T-shirt could tell you something about the wearer—from political affiliation to musical preference. (Though the oldest-known political tee, "Dew it with

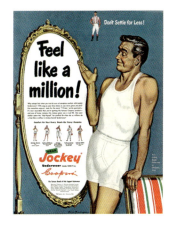

← Brigitte Bardot, Paris, France, 1958

↑ Jockey advertisement, 1950

↙ Marlon Brando, *A Streetcar Named Desire*, 1951

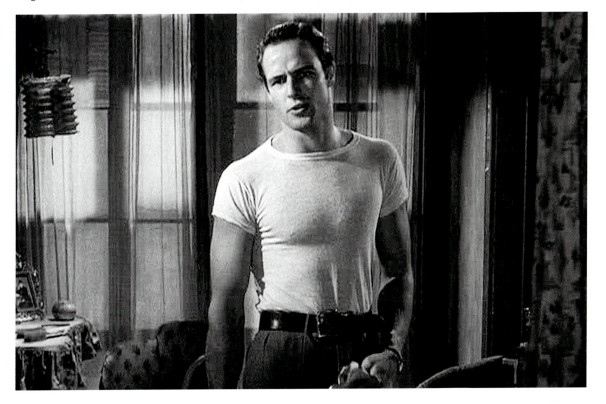

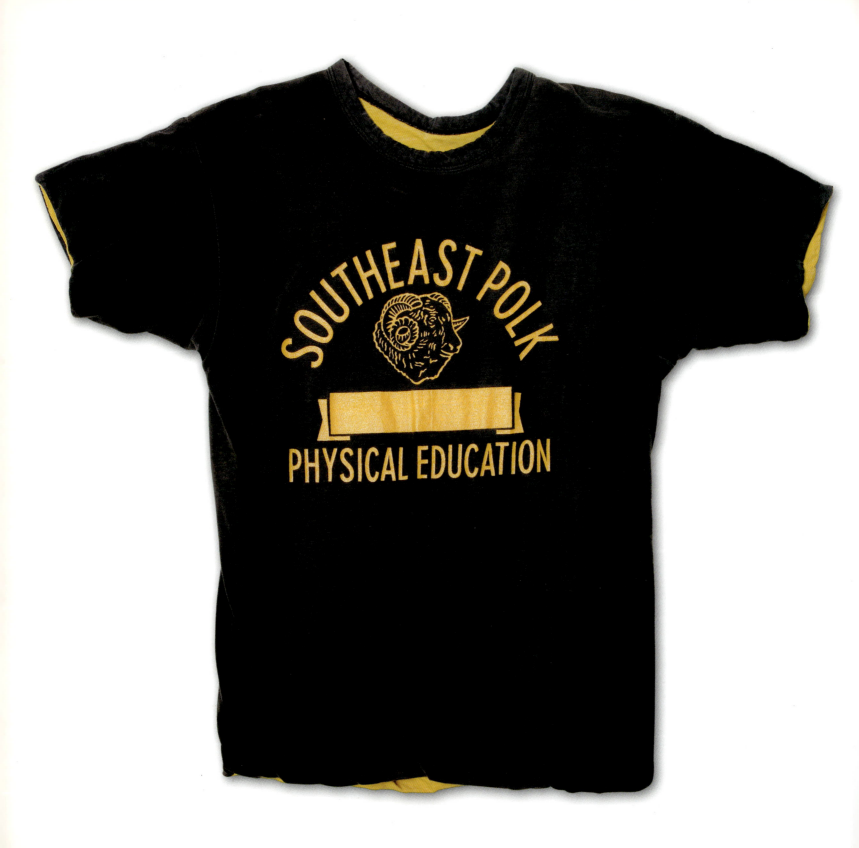

> "I always said punk was an attitude. It was never about having a Mohican haircut or wearing a ripped T-shirt. It was all about destruction, and the creative potential within that."
> —Malcolm McLaren

Dewey"—which currently resides at the Smithsonian Institution in Washington, D.C.—was used in 1948 for Thomas E. Dewey's political campaign. And T-shirts were among the long list of licensed "Elvis" merchandise launched for Elvis Presley's 1956 tour).

Throughout the '60s the T-shirt reigned supreme as a symbol of the counterculture, second only to blue jeans. T-shirts provided the perfect platform for self-expression—either through the printed word or image, with concert tees and political messages—or as a blank canvas for a DIY movement, which resurrected African tie-dye and Eastern batik to transform T-shirts into psychedelic personal statements. Followers of the Grateful Dead took the DIY aesthetic to heart, tie-dyeing and silk-screening their own graphics on T-shirts, which were sold at the band's shows.

Over the years, concert merchandise grew from a cottage industry to big business. Winterland Productions was founded in 1973 as an offshoot of Bill Graham Presents, the legendary concert promoter's company. Winterland had the rights to produce concert merchandise for artists such as Eric Clapton and Bruce Springsteen. A flurry of acquisitions eventually brought many of the concert merchandise companies under one nameplate: Live Nation Merchandise, which today holds the licenses for more than 150 musicians and bands.

Just as concert tees paid homage to favorite musical groups, T-shirts also chronicled current events such as the Olympic games, the launch—and landing—of the Space Shuttle, or fads of the day ("Keep on Streaking") or new sports (Ultimate Frisbee). And with the ubiquity of T-shirt graphics came the sardonic tee, which featured tongue-in-cheek phrases ranging from the sarcastic ("My Mom Went to Ft. Lauderdale and All I Got Was This Lousy T-shirt") to sophomoric ("Bankers Do It With Interest").

In the 1980s, the fashion industry began to infiltrate the music scene, turning Frankie Goes to Hollywood's "Frankie Says Relax" tees into as big a hit as the band's 1984 song "Relax." That same year George Michael and Andrew Ridgeley of British pop group Wham! wore British designer Katharine Hamnett's "Choose Life" shirts in their "Wake Me Up Before You Go-Go" video—shining a spotlight on Hamnett's use of her tees to protest issues of the day ("Choose Life" was meant to decry suicide and drug use).

Brand Management

In 1971, seven-year-old Blue Ribbon Sports changed its name to Nike and introduced its swoosh logo. The Nike name and its now unmistakable swoosh soon migrated from running shoes to tees. Similarly,

← "Southeast Polk Physical Education," ca. 1979
↖ Arizona State University, ca. 1973
↓ Emilio Estevez and C. Thomas Howell, *The Outsiders*, 1983

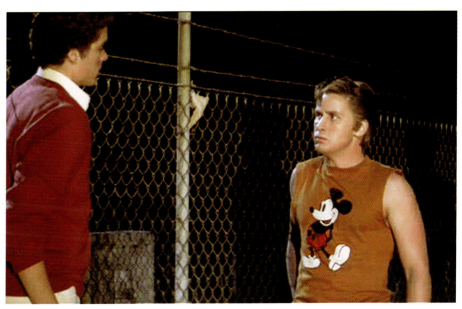

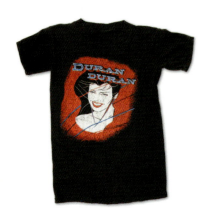

↑ Duran Duran, 1982
→ "I Left My Heart," San Francisco, ca. 1983

the *Playboy* rabbit head logo, created in 1954 by *Playboy* art director Art Paul, made the leap from the magazine to the T-shirt—and just about every other conceivable consumer product.

Once an ad slogan reached a level of notoriety, it served as a stand-in for the logo on a tee. That was the case with Nike's 1988 slogan "Just Do It" (Porky Pig's "J-j-just Do It") and Moosehead Canadian Lager's "Moose Is Loose" slogan. And after several years of slogans based on the Swedish spelling of its brand name, Absolut Vodka turned the shape of its bottle into a stand-in for its logo in its ads—and on T-shirts. Perhaps no brand name and logo is more widely recognized—or more widely copied—than the swirly script of the Coca-Cola logo. The brand name is as likely to turn up on a tee as are the seemingly endless permutations of its logo, ranging from place names ("Cape Cod") to drug references ("Cocaine").

If the Coca-Cola logo is the best recognized name in the world of branding, Mickey Mouse is likely the best recognized icon. He serves as the ambassador for the Walt Disney Company, which operates a sophisticated licensing department that oversees the placement of all its characters, including Mickey, on everything from toys to tees. The cartoon mouse typically serves as a wholesome reminder of American innocence, but its image can carry other meanings. Emilio Estevez wore a Mickey Mouse ringer tee with cut-off sleeves to play Two-Bit Matthews— an early '60s gang member in the film *The Outsiders* (1983). And, according to Mike Wallace's *Mickey Mouse History and Other Essays on American Memory*, in 1984 1,900 Disneyland employees donned "No Mickey" tees to protest a 16% pay cut.

From Lowbrow to High End

The T-shirt's longstanding association with the workingman make it an ideal platform for mainstream art. Alongside airbrushed graphics of muscle cars and sunset scenes, cartoon characters have long been a T-shirt favorite. Cartoonists Gary Patterson, Tom Wilson ("Ziggy"), and Jim Davis ("Garfield") tapped a rich vein when they began reproducing their works on T-shirts. Similarly, sci-fi illustrator Boris Vallejo found a new venue for his art on tees.

Even as cartoonists were finding a new market in T-shirts, other artists were, as well. Patrick Nagel, whose '80s pinups appeared in *Playboy* and on the cover of Duran Duran's 1982 *Rio* album, also found a new canvas in the printed T-shirt. And at the height of artist Keith Haring's fame, his work was as likely to be seen in a gallery as it was on a T-shirt.

By the 1990s, the T-shirt made its way to the runway. In 1992, Chanel's collection included a rib-knit tank top—aka a "wife beater" tee—with its double C logo splashed across the front. Two years later, Isaac Mizrahi paired similar knit tanks with candy-colored ball skirts for his fall collection. And in 1996, Oscar nominee Sharon Stone made fashion headlines when she attended the Academy Awards in a Gap tee.

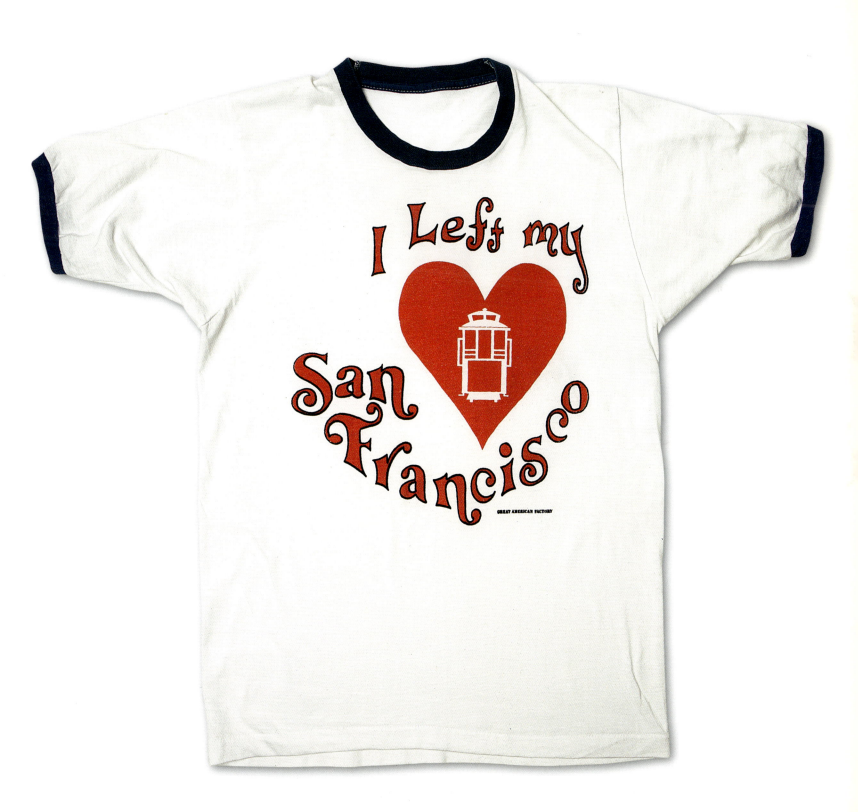

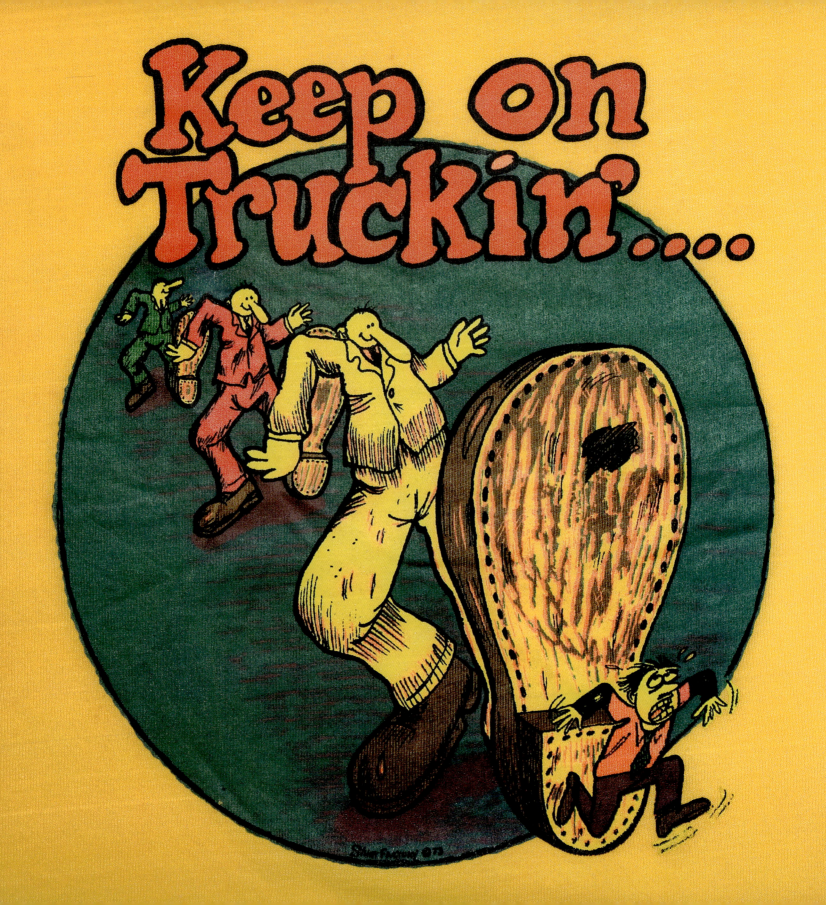

VORWORT
Patrick Guetta

Ich werde oft gefragt, ob ich mich an das liebste T-Shirt meiner Kindheit erinnere. Leider nicht. Seit meiner Teenagerzeit habe ich T-Shirts verkauft, aber erst, als ich ins Geschäft mit gebrauchten T-Shirts eingestiegen war, kam der Augenblick, in dem ich gesagt habe: „Dieses T-Shirt können wir nicht verkaufen! Das ist von Police! The Police!!!" (Genauer gesagt stammte es von der Nordamerikatournee 1983.) Ich bin mit Police aufgewachsen. Ich habe mir oft vorgestellt, wie ich als Mitglied der Band vor 20 000 Zuschauern singen und Gitarre spielen würde. So ein T-Shirt konnte man nicht verkaufen. Das war meine Jugend, das war Teil meines Lebens.

Ich bin in Frankreich geboren und aufgewachsen, bis wir mit unserer Familie 1982 nach Los Angeles zogen, wo ich mich augenblicklich in die amerikanische Popkultur stürzte. Meine Brüder Marc (genannt „Tony"), Thierry (genannt „Mr. Brainwash") und ich gründeten 1987 eine Oberbekleidungsfirma mit dem Namen Too Cute!, die aufwändig bestickte T-Shirts produzierte, mit Disney- und Warner-Brothers-Figuren bis hin zu den Beatles and Betty Boop. Wir arbeiteten mit legendären Zeichnern wie Mel Blanc, Charles „Sparky" Schultz und Bob Kane sowie mit Hollywoodgrößen wie Steven Spielberg, Michael Jackson, Jeffrey Katzenberg und Michael Eisner zusammen. Wir erfanden auch unsere eigenen Figuren, die „Junglenuts", die eines Tages hoffentlich auch in einem Kino in Ihrer Nachbarschaft aufkreuzen werden.

2000 erzählte mir Tony, der immer schon ein begeisterter Sammler gewesen war, von seinem Traum, einen Laden für Vintage-T-Shirts zu eröffnen, und fragte mich, ob ich mit ihm zusammen ins Geschäft einsteigen wolle. Ich sagte zu, unter einer Bedingung: Wir mussten uns eine Waschmaschine und einen Trockner hinstellen und sämtliche T-Shirts ordentlich durchwaschen – mit schön viel Waschmittel und Trocknertüchern. Den Geruch alter Klamotten kann ich nicht ertragen!

Damals war ich nur die Hilfskraft. Ich hatte keine Ahnung. Tony hat die T-Shirts gekauft, dann haben wir sie gewaschen, er hat sie ausgepreist. Bis ich eines Tages das Police-T-Shirt sah. Und dann das von den Bee Gees und Pat Benatar und viele andere. T-Shirts kamen mir immer mehr wie meine persönliche Pinnwand vor, und ich entwickelte eine Leidenschaft für sie. Wir sammelten Shirts von Konzerten, zu den Themen Surfen, Filme, Armee, Harleys, Sport, Slogans etc. Dann dachten wir, es wäre wunderbar, diese riesige Sammlung in einem Buch zu verewigen, als Momentaufnahme der amerikanischen Kultur.

Im Lauf der Jahre habe ich ein paar Tricks gelernt, wie man ein gutes Sammlerstück erkennt. (Das sind grundlegende Branchengeheimnisse, aber ich verrate sie jetzt meinen Mitsammlern und Fans trotzdem.) Das Wichtigste ist die Qualität: Nimm das T-Shirt in die Hand und spüre, wie weich es sich auf der Haut anfühlt und wie schwer es ist. Zweitens das Design: Ist es cool? Sieht es wirklich nach Vintage aus? Drittens der nostalgische Wert: Weckt es wunderbare Erinnerungen an schöne Augenblicke, gute Freunde oder große Ereignisse im eigenen Leben? Viertens … (Tut mir leid, aber das ist nun wirklich ein Insidergeheimnis. Ich kann ja nicht *alle* Tricks der Branche verraten!)

Mit großem Stolz laden wir Sie ein zu einer Reise durch unsere Welt der Vintage-T-Shirts. Viel Spaß!

← "Keep on Truckin'," R. Crumb, 1968
↑ Rat Fink, Ed Roth, ca. 1980

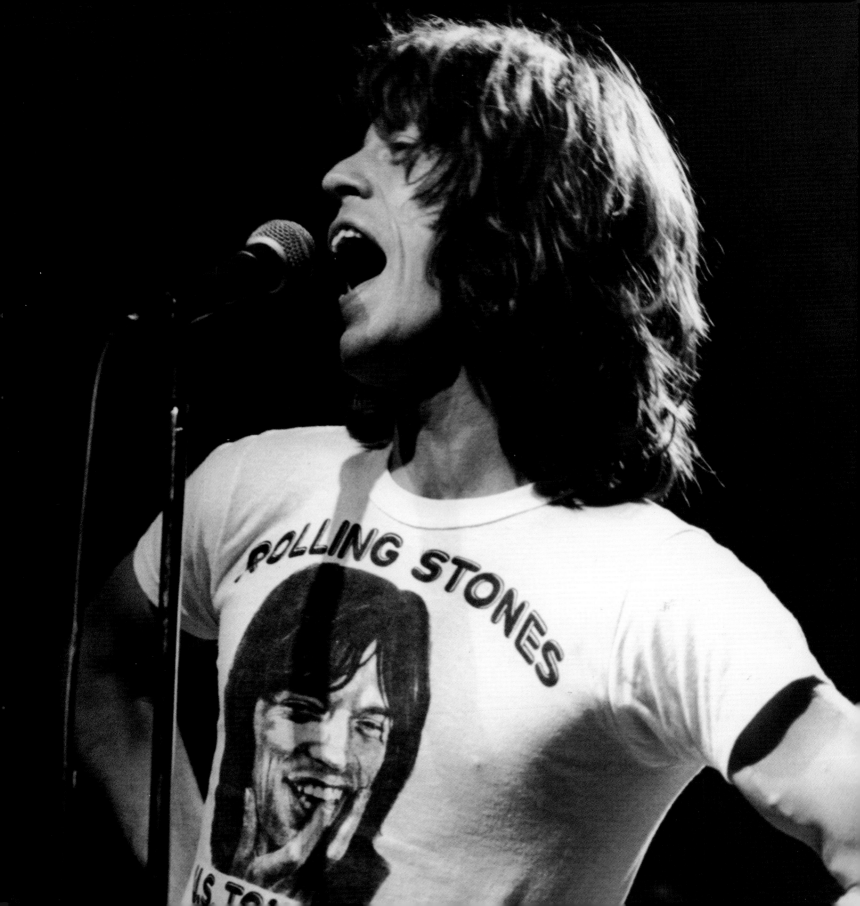

AMERIKANISCHE KLASSIKER

Alison A. Nieder

James Dean trug eins in *... denn sie wissen nicht, was sie tun* unter einer roten Jacke. Marlon Brando trug es in *Der Wilde* unter der Lederjacke und riss es sich in *Endstation Sehnsucht* vom Leib. Coco Chanels Streifenhemdchen machte den Seemannslook schick, Pablo Picasso ließ das Ringelshirt zur Uniform des Künstlers werden. Mit ein bisschen Nachhilfe von Vivienne Westwood trug Sid Vicious seins zerfetzt und mit Sicherheitsnadeln zusammengesteckt. Der John Lennon der Nach-Beatles-Ära wirkte in seinem „New-York-City"-Ringershirt mit den abgeschnittenen Ärmeln wie der ultimative Einwohner Manhattans. Giorgio Armani trägt seine T-Shirts zur Sonnenbräune, Patti Smith hingegen ohne. Das Fashion Model und Warhol-Factory-Girl Edie Sedgwick peppte ihre Billig-T-Shirts mit Strumpfhosen, großen Ohrringen und Nerz auf. Und 1996 kombinierte Schauspielerin Sharon Stone bei der Oscar-Verleihung ein Gap-T-Shirt mit einem Valentino-Ballrock, vermutlich das Outfit von ihr, das am zweitbesten in Erinnerung geblieben ist. Die Liste der Ikonen im Leibhemd ist endlos.

Als die Ladenkette The Gap auf dem Höhepunkt ihrer Beliebtheit angelangt war, verglich der damalige Firmenchef Mickey Drexler die Expansion der Jeans-und-Basics-Kette mit einem Supermarkt: „Denken Sie doch mal drüber nach", sagte er 1998 zur Zeitschrift *Fortune*, „wenn Sie einen Supermarkt betreten, erwarten Sie, dort sämtliche Grundnahrungsmittel vorzufinden. Sie erwarten, dass es Milch gibt: entrahmte, teilentrahmte und Vollfettmilch. Sie gehen davon, dass die Milch frisch ist. Sie wollen Butter, Sie wollen verschiedene Brotsorten. Jeder hat seine Einkaufsliste. Ich sehe nicht ein, warum ein Modegeschäft anders funktionieren sollte." Drexlers Vision von Kleidung als Gebrauchsgegenstand sorgte dafür, dass in jeder Shoppingmall Amerikas ein Gap-Laden zu finden war. T-Shirts, die bei Gap die Hälfte des Erfolgs ausmachten, sind auf den ersten Blick der Gebrauchsgegenstand schlechthin. Sie lassen sich leicht und billig in großer Stückzahl herstellen, jährlich werden ca. 1,5 Milliarden von ihnen in die USA importiert.

Trotz Preis, Schlichtheit und Volumen fallen nicht alle T-Shirts in die Kategorie Gebrauchsgegenstand. Als Dov Charney, Gründer des T-Shirt-Giganten American Apparel, 1997 sein Unternehmen in Los Angeles aus der Taufe hob, wollte er eine grundlegende Neuerfindung des typischen „Blank" – des einfarbigen T-Shirts, das hergestellt wird, um vor dem Verkauf an den Endverbraucher bedruckt, bestickt oder anderweitig verziert zu werden. Das Geschäft mit den Blanks war bis dahin von riesigen T-Shirt-Fabrikanten wie Hanes und Fruit of the Loom dominiert worden. Die Unihemden waren schwer, eckig geschnitten und nur in wenigen Formen erhältlich: mit kurzen oder langen Ärmeln, V-Ausschnitt oder rundem Halsausschnitt. Charney träumte von bedruckbaren Shirts in vielen verschiedenen Schnitten, mit einem geringeren Gewicht und einer stärker körperbetonten Silhouette – und brachte so die neueste Wiedergeburt des T-Shirts in die Welt: das „Fashion Blank."

T-Shirt-Technologie

Im Lauf seiner über 100-jährigen Geschichte war das T-Shirt schon Unterhemd, Sporttrikot, Arbeitshemd und Modeartikel. Seine Geburt hängt direkt mit der industriellen Revolution und der Erfindung der industriellen Strickmaschine zusammen. Die frühen Strickwarenfabriken ließen von ihren Maschinen einen Schlauch aus Trikotware stricken, aus dem dann Strümpfe und Wirkwaren hergestellt wurden.

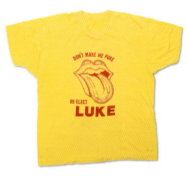

← Mick Jagger, Rolling Stones U.S. tour, 1975

↑ "Re-Elect Luke," ca. 1979

> „Was ich am meisten am Rock 'n' Roll hasse, sind die Batik-T-Shirts, außer sie wären mit dem Blut und dem Urin von Phil Collins gefärbt."
> —Kurt Cobain

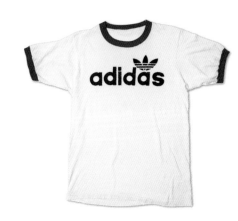

↗ Adidas, ca. 1983
→ John Lennon, New York City, 1974

Bald schon wandten sich die Strickwarenfabriken der Produktion von Herrenunterwäsche zu und stellten die beliebten einteiligen langen Hemdhosen her. Der Hanes-Vorgänger, die P. H. Hanes Knitting Company and Shamrock Mills, führte eine zweiteilige Version der Hemdhose ein, wodurch der Prototyp des Trägerhemds entstand. Die Russell Manufacturing Company strickte zwei Jahrzehnte lang Trikotstoff, bevor sie in den 1920er-Jahren die Sportbekleidung ins Visier nahm.

In der ersten Jahrhunderthälfte war das T-Shirt ein Unterhemd, das schmutzig werden durfte, oft gewaschen werden konnte und nur selten in der Öffentlichkeit zu sehen war, außer als Arbeitskleidung bei schwerer körperlicher Arbeit. Dann kam Coco Chanel, die Pariser Modeschöpferin, die die Damenmode in den 1920er-Jahren von Grund auf neu definierte, und änderte das. Das Bild der gertenschlanken Designerin im maritimen Ringelshirt ist noch heute wohl bekannt (ihre wesentlich kurvenreichere Landsfrau Brigitte Bardot zeigte sich 30 Jahre später in einem ähnlichen Look). Während des Ersten Weltkriegs, als viele Stoffe nur schwer zu haben waren, begann Coco Chanel mit der Suche nach einem maschinellen Strickgewebe, das sie 1916 bei der Pariser Firma Rodier fand. Gestrickter Jersey, der bis dahin für Männerunterwäsche benutzt wurde, nahm schon bald einen zentralen Platz in den Chanel-Kollektionen ein.

Auch wenn das weiße, kurzärmelige T-Shirt mit rundem Halsausschnitt bereits seit 1913 ein Teil der offiziellen Uniform der U. S. Navy war, blieb es in seiner Eigenschaft als Unterhemd bis zum Zweiten Weltkrieg unsichtbar, bis Fotojournalisten und Dokumentarfilmer Bilder von Soldaten ohne Uniform, nur im T-Shirt, verbreiteten. In den 1950er-Jahren wurde das T-Shirt zum Symbol der Rebellion (Brando in *Der Wilde*, Dean in *… denn sie wissen nicht, was sie tun*,), offen zur Schau getragener Männlichkeit (nochmals Brando in *Endstation Sehnsucht*) und ebenso offen zur Schau getragener Weiblichkeit (Bardot in *Babette zieht in den Krieg*). In *Jailhouse Rock – Rhythmus hinter Gittern* (1957) trägt Elvis Presley beim wichtigsten Musikstück des Films ein schwarz-weiß gestreiftes T-Shirt.

Mit der Ausnahme von Sporttrikots blieben die T-Shirts bis Mitte des letzten Jahrhunderts einfarbig und unverziert. Doch die Einführung mehrerer wesentlicher Neuerungen in der Drucktechnik ließ das T-Shirt hinter den Kulissen hervortreten und verwandelte es in eine zu bedruckende Leinwand. Die Kunst des Siebdrucks gibt es schon seit Jahrhunderten, die Ursprünge gehen auf japanische Schablonentechniken zurück. Während des Ersten Weltkriegs wurde der Siebdruck für Plakate und Werbung sehr beliebt. Die Technik wurde auch auf Kleidungsstücken angewandt, aber erst Ende der 1950er kamen Plastisole auf den Markt, neue Druckfarben, mit denen sich die Qualität des Siebdrucks stark verbesserte. Die Aufdrucke wurden haltbarer und flexibler als die mit herkömmlichen Pigmenten gemachten. 1960 wurde das Siebdruckverfahren auf Kleidungsstücken dann durch die Erfindung der Mehrfarben-Rotationsdruckmaschine mechanisiert.

Als Nächstes kam die Entwicklung der Thermodrucktechnik, mit der man ein Bild mittels Thermosublimations-Farbbändern auf ein Kleidungsstück übertragen kann. Im darauf folgenden Jahrzehnt tauchten überall T-Shirt-Druckmaschinen auf, in Drugstores, Sportgeschäften und Spezialläden, in denen stapelweise Unihemden, aufbügelbare Buchstaben und Grafiken für den Thermodruck zu finden waren – die Käufer konnten sich ihre T-Shirts ganz leicht selbst gestalten. Mit dem Thermodruckverfah-

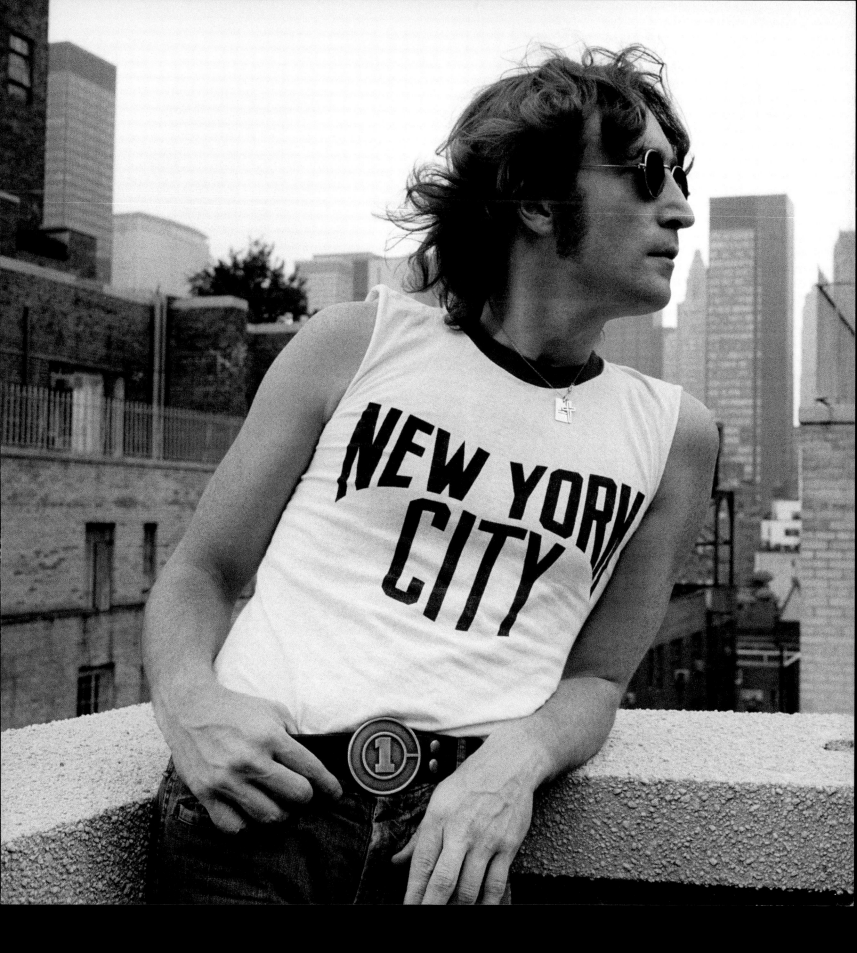

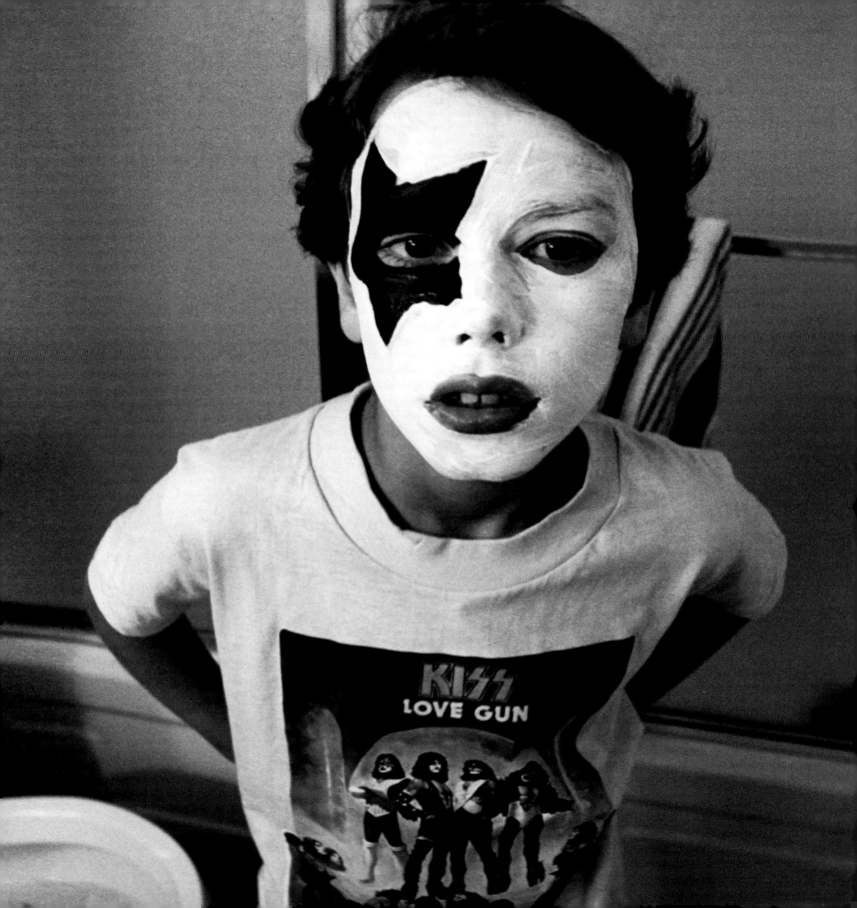

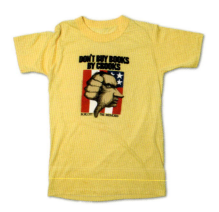

„Ich würde gerne sehen, wie der Papst mein T-Shirt trägt."
—Madonna

ren wurden auch fotorealistische Abbildungen auf T-Shirts möglich. In den 1970er-Jahren waren besonders Logos und Standbilder aus Filmen beliebt, mit denen die Fans ihren Lieblingsfilmen Tribut zollen konnten – für die Filmstudios entwickelte sich die Vermarktung von T-Shirts zu Filmhits wie *Der weiße Hai*, *Der Krieg der Sterne* und *E. T. – der Außerirdische* zur lukrativen Einnahmequelle.

Das Medium und die Botschaft

Eines der ersten Einsatzgebiete für den T-Shirt-Druck war das Souvenirshirt, das meist an Urlaubsorten und anderen Touristenhochburgen verhökert wurde; der heimkehrende Besucher konnte sich ein Stückchen Paradies mit nach Hause nehmen und den Nachbarn so seinen Status als Weltreisender kundtun. Die Popularität des Souvenirshirts hat nie nachgelassen und in einigen bemerkenswerten Fällen – wie bei dem T-Shirt „Virginia is for Lovers", das 1969 im Rahmen einer Werbekampagne vom Reisebüro des Bundesstaats Virginia entwickelt wurde, und dem Shirt „I Love NY" mit dem von dem Künstler Milton Glaser Ende der 1970er-Jahre entworfenen Logo – gingen T-Shirt-Slogan und Ort eine untrennbare Verbindung miteinander ein.

Wirkt das Souvenirhemd wie eine Art Reisepass, so ist das Surfershirt Ausdruck der Mitgliedschaft in einem Eliteklub. Die *Encyclopedia of Surfing* nennt den Surfbrettbauer Floyd Smith aus San Diego 1961 als Erfinder des Surfershirts. Der Legende zufolge brachte Smith sich das Siebdruckverfahren selbst bei und bot seinen Kunden an, das Logo seines Unternehmens, Gordon & Smith Surfboards, kostenlos auf die T-Shirts zu drucken, die ihm die Kunden in den Laden brachten. Zum Ende des Jahres stürzten sich auch andere Läden wie O'Neill ins Shirt-Geschäft.

Die Babyboomer-Generation gewöhnte sich an die Idee, dass ein bedrucktes T-Shirt etwas über dessen Träger mitteilen konnte – von politischer Überzeugung bis hin zum Musikgeschmack. (Das älteste bekannte politische T-Shirt, „Dew it with Dewey" – das in der Smithsonian Institution in Washington, D.C., zu finden ist – wurde allerdings schon 1948 für den Wahlkampf von Thomas E. Dewey hergestellt. Und zu der langen Liste offizieller „Elvis"-Produkte, die im Rahmen der Elvis-Presley-Tournee 1956 auf den Markt geworfen wurden, gehörte ebenfalls ein T-Shirt).

Die gesamten 1960er-Jahre hindurch rangierte das T-Shirt direkt hinter den Blue Jeans als unangefochtenes Symbol der Alternativkultur. T-Shirts boten der Selbstdarstellung die ideale Plattform – entweder durch aufgedruckte Worte oder Abbildungen, Konzertsouvenirs oder politische Aussagen, oder als Leinwand zum Selbstgestalten, bei dem afrikanische und asiatische Batiktechniken wiederentdeckt wurden, um T-Shirts in persönliche psychedelische Statements zu verwandeln. Die Anhänger der Kultband The Grateful Dead nahmen sich die Do-it-yourself-Ästhetik besonders zu Herzen und produzierten T-Shirts in Abbindebatik und Siebdruck mit eigenen Grafiken, die dann bei den Konzerten der Band verkauft wurden.

Über die Jahre hinweg entwickelte sich das Konzertmerchandising dann von der Handarbeit zur Großindustrie. 1973 wurde Winterland Productions als Ableger von Bill Graham Presents gegründet, der legendären Konzertveranstaltungsfirma. Winterland bekam die Rechte, Merchandisingprodukte für Sänger wie Eric Clapton und Bruce Springsteen zu produzieren. Durch eine Vielzahl von Firmenübernahmen gerieten schließlich viele der Konzertmerchandisingfirmen unter das Dach der Live Nation

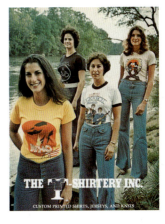

← Kiss fan, Fresno, California, 1977

↖ "Don't Buy Books By Crooks, Boycott the Memoirs," 1979

↑ The T-Shirtery advertisement, 1976

AMERIKANISCHE KLASSIKER

„Ich habe immer gesagt, dass Punk eine Einstellung ist. Es hatte nie was damit zu tun, ob man einen Irokesenschnitt oder ein zerfetztes T-Shirt trägt. Es ging um Zerstörung und das kreative Potenzial, das darin steckt."
—Malcolm McLaren

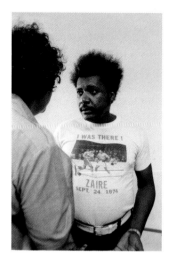

↑ Don King, Zaire, 1974
→ *Never Mind the Bollocks, Here's the Sex Pistols*, 1977

Merchandise, die heute Lizenzinhaberin von über 150 Musikern und Bands ist.

Konzertshirts huldigten den beliebtesten Musikgruppen, andere T-Shirts schrieben eine Chronik der Ereignisse wie die Olympischen Spiele, Start und Landung des ersten Spaceshuttles oder gerade aktuelle Trends („Keep on Streaking") oder neue Sportarten (Ultimate Frisbee). Mit der Allgegenwart bedruckter T-Shirts ließen natürlich auch satirische Shirts nicht lange auf sich warten, mit Inschriften, die vom Sarkastischen („My Mom Went to Ft. Lauderdale and All I Got Was This Lousy T-shirt") bis zum Pubertären reichten („Bankers Do It With Interest").

In den 1980ern begann die Modeindustrie, die Musikszene zu infiltrieren, und die Shirts von Frankie Goes to Hollywood mit der Aufschrift „Frankie Says Relax" waren ein ähnlich großer Hit wie ihr Song „Relax" von 1984. Im selben Jahr trugen George Michael und Andrew Ridgeley von der britischen Popgruppe Wham! in dem Video „Wake Me Up Before You Go-Go" die „Choose-Life"-Shirts der Designerin Katharine Hamnett – womit sie Hamnetts Einsatz von T-Shirts zum Protest gegen aktuell wichtige Themen extrem populär machten („Choose Life" war ein Aufruf gegen Selbstmord und Drogenmissbrauch).

Markenmanagement

1971 benannte sich das sieben Jahre alte Unternehmen Blue Ribbon Sports in Nike um und führte sein Haken-Logo (den Swoosh) ein. Der Name Nike und sein bald unverwechselbarer Swoosh fanden schnell den Weg von Turnschuhen auf T-Shirts. Auch das *Playboy*-Logo mit dem Hasenkopf, 1954 von *Playboy*-Art-Direktor Art Paul erfunden, schaffte den Sprung von der Zeitschrift aufs T-Shirt – und auch sonst auf praktisch jeden anderen vorstellbaren Gebrauchsgegenstand.

Ist ein Werbeslogan erst einmal allseits bekannt, dann wird er auch als Spruch auf einem T-Shirt verwurstet, so z. B. der von 1988 stammende Nike-Slogan „Just Do It" (Schweinchen Dick: „J-j-just Do It") oder der Werbespruch des kanadischen Bierbrauers Moosehead: „Moose Is Loose". Nachdem es in den USA jahrelang eine Werbekampagne für Absolut Vodka basierend auf der schwedischen Schreibweise des Namens gab, wurde schließlich die Form der Flasche an sich zum Logo der Marke, in Anzeigen – und auf T-Shirts. Es gibt vermutlich keinen Markennamen und kein Logo, das auf der ganzen Welt bekannter ist – und häufiger kopiert wird – als der verschnörkelte Coca-Cola-Schriftzug. Der Markenname taucht mit schöner Regelmäßigkeit immer wieder in vielfältigsten Abwandlungen auf T-Shirts auf, von Ortsnamen („Cape Cod") bis hin zu Drogen („Cocaine").

Wenn Coca Cola der bekannteste Name in der Welt der Markenpolitik ist, dann ist Micky Maus mit ziemlicher Wahrscheinlichkeit die bekannteste Figur. Sie fungiert als Botschafter für die Walt Disney Company, die eine hoch entwickelte Lizenzabteilung betreibt, die die Verwendung aller Figuren, einschließlich Micky, überwacht, von Spielzeug bis T-Shirts. Die gezeichnete Maus steht meist für die gesunde Erinnerung an die amerikanische Unschuld, aber ihr Bild kann auch andere Bedeutungen annehmen. 1983 trug Emilio Estevez ein Micky-Maus-Ringershirt mit abgeschnittenen Ärmeln, als er in dem Film *Die Outsider* den „Two-Bit"-Matthews spielte, ein Bandenmitglied aus den 60er-Jahren. Und Mike Wallaces *Mickey Mouse History and Other Essays on American Memory* zufolge trugen 1900 Disneyland-Mitarbeiter T-Shirts mit der Aufschrift „No Mickey", um 1984 gegen eine Lohnkürzung von 16 Prozent zu protestieren.

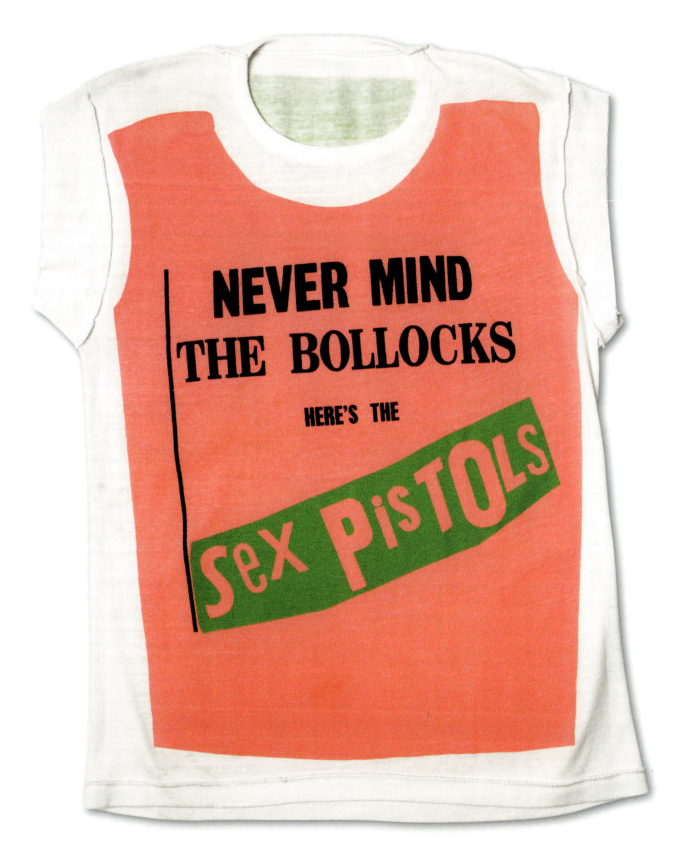

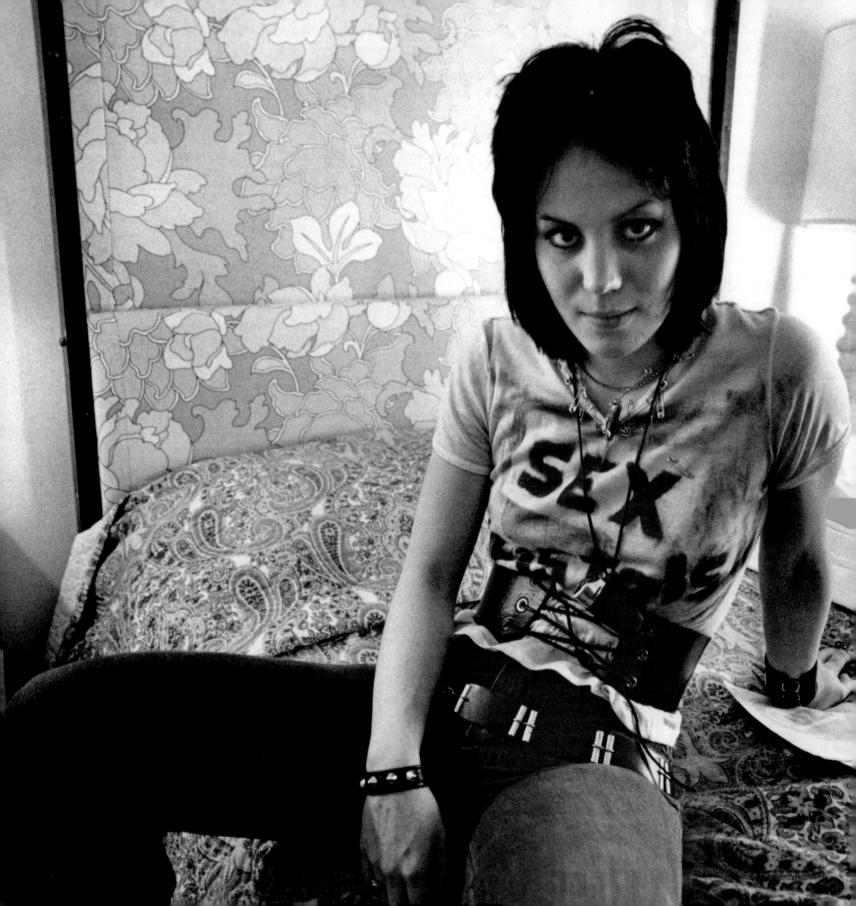

Von billig bis ultraschick

Die ganz bis zu den Anfängen zurückreichende Verbindung des T-Shirts mit der Arbeiterklasse machte es zur idealen Plattform für Kunst für die breite Masse. Neben Airbrush-Grafiken von scharfen Schlitten und Sonnenuntergängen sind Zeichentrickfiguren seit Langem T-Shirt-Lieblinge. Die Zeichner Gary Patterson, Tom Wilson („Ziggy") und Jim Davis („Garfield") stießen auf eine Goldader, als sie anfingen, ihre Werke auf T-Shirts drucken zu lassen. Auch der Science-Fiction-Illustrator Boris Vallejo fand auf T-Shirts eine neue Ausdrucksform für seine Kunst.

Als die Comiczeichner den T-Shirt-Markt eroberten, ließen sich auch andere Künstler nicht lange bitten. Patrick Nagel, dessen Pin-ups in den 1980ern im *Playboy* und auf dem Cover des Albums „Rio" (1982) von Duran Duran zu finden waren, schuf sich mit dem bedruckten T-Shirt ein neues Medium. Und als der Maler Keith Haring auf dem Höhepunkt seines Ruhms angelangt war, traf man seine Männchen mindestens so häufig auf T-Shirts wie in Galerien an.

In den 1990ern war das T-Shirt dann auf dem Laufsteg gelandet. Die Chanel-Kollektion von 1992 zeigte ein gerripptes, ärmelloses Shirt – das berüchtigte Feinripphemd also – mit einem großen Doppel-C-Logo vorne drauf. Zwei Jahre später kombinierte Isaac Mizrahi in seiner Herbstkollektion ähnliche Feinripphemden mit bonbonfarbenen Röcken zu Ballkleidern. Und 1996 schrieb die für einen Oscar nominierte Sharon Stone Modeschlagzeilen, als sie zur Preisverleihung in einem Gap-T-Shirt aufkreuzte.

← Joan Jett, Sunset Marquis Hotel, Los Angeles, 1978

↖ "No Bozos," 1980s

↙ Sean Penn, *Fast Times at Ridgemont High*, 1982

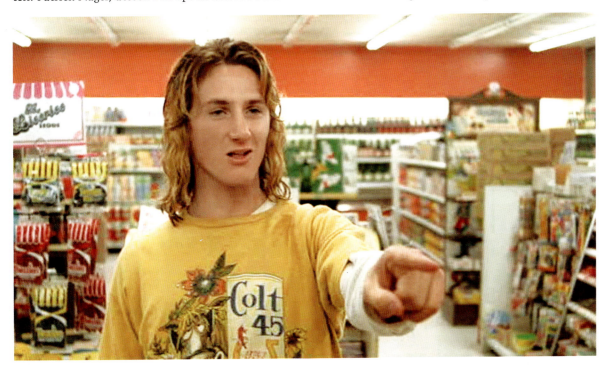

AMERIKANISCHE KLASSIKER

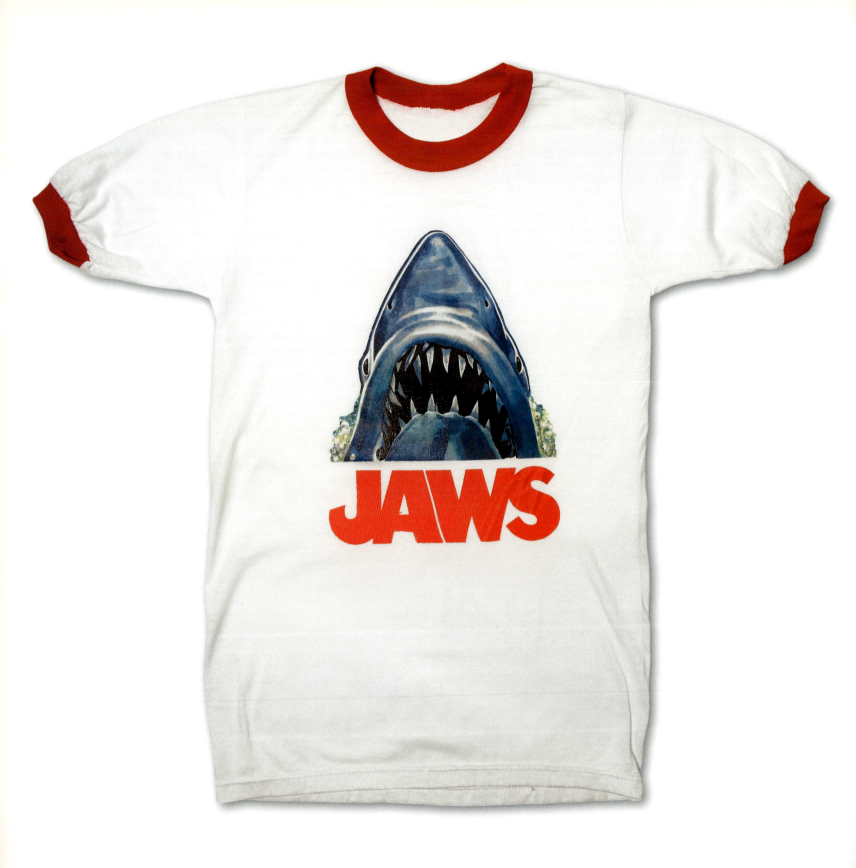

AVANT-PROPOS
Patrick Guetta

On me demande souvent si je me souviens du t-shirt que je préférais quand j'étais petit. En réalité, non. J'en vends depuis mon adolescence, mais ce n'est que lorsque je me suis lancé dans le vintage que je me suis dit : « On ne peut pas laisser partir ce t-shirt ! C'est The Police ! *The Police !* » (Plus précisément, il datait de la tournée du groupe en Amérique du Nord en 1983.) J'ai grandi avec The Police. En portant ce t-shirt, je m'étais imaginé en membre du groupe, chantant et jouant de la guitare devant 20 000 personnes. Je ne pouvais pas le vendre. Il faisait partie de ma jeunesse, de ma vie.

Je suis né et j'ai grandi en France. Quand ma famille a déménagé à Los Angeles en 1982, j'ai été immédiatement happé par la culture pop américaine. En 1987, mes frères Marc (alias « Tony »), Thierry (alias « Mr. Brainwash ») et moi avons monté une société de confection baptisée Too Cute ! (« Trop mignon »). Nous fabriquions des t-shirts de luxe brodés et nous possédions les droits d'exploitation de toutes sortes de personnages, des héros de Disney à ceux de Warner Bros., des Beatles à Betty Boop. Cela nous a permis de rencontrer et de travailler avec des géants de l'animation comme Mel Blanc, Charles « Sparky » Schultz et Bob Kane, ainsi que des figures légendaires d'Hollywood telles que Steven Spielberg, Michael Jackson, Jeffrey Katzenberg et Michael Eisner. Nous avons également créé nos propres personnages, les « Junglenuts », qui, nous l'espérons, seront un jour portés à l'écran.

En 2000, Tony, qui avait toujours été collectionneur, m'a fait part de son envie d'ouvrir une boutique de t-shirts vintage. Il m'a proposé de m'associer avec lui. J'ai accepté à une condition : nous devions avoir une machine à laver, un sèche-linge et ne pas lésiner sur la lessive. Je ne supporte pas l'odeur des vieux vêtements !

À l'époque, je n'étais qu'assistant. Je n'y connaissais rien. Tony achetait les t-shirts, nous les lavions et il fixait les prix. Jusqu'au jour où je suis tombé sur ce fameux t-shirt de The Police. Puis, sur un autre des Bee Gees, de Pat Benatar et ainsi de suite. J'en suis venu à voir ces t-shirts comme des panneaux d'affichage où chacun mettait un message personnel et j'ai développé pour eux une vraie passion. Nous avons collectionné tous ceux ayant trait à des concerts, au surf, au cinéma, à l'armée, aux Harley Davidson, au sport ; ceux qui portaient des slogans et bien d'autres encore. Puis, nous nous sommes dit qu'il serait bien d'immortaliser cette immense collection dans un livre, un instantané de la culture américaine.

Au fil des ans, j'ai appris quelques astuces pour reconnaître un bon t-shirt vintage. (Ce sont essentiellement des secrets professionnels, mais je suis prêt à les partager avec d'autres collectionneurs et les amateurs.) Tout d'abord, la qualité : prenez le t-shirt et soupesez-le ; il doit être doux sur la peau. Ensuite, le design : Est-il cool ? Fait-il vintage ? Puis, la valeur sentimentale : Vous rappelle-t-il de bons souvenirs ? Un ami proche ? Des événements qui ont marqué votre vie ? Enfin... (Non, désolé, ça, c'est vraiment un secret professionnel et je ne vais pas quand même pas dévoiler tous mes trucs !)

C'est avec une grande fierté que nous vous invitons à voyager dans notre univers des t-shirts vintage. J'espère qu'ils vous plairont !

← *Jaws*, 1975
↑ "Joe's," Junglenuts, 1990

UN CLASSIQUE AMÉRICAIN

Alison A. Nieder

James Dean en portait un sous un blouson rouge dans *La Fureur de vivre*. Marlon Brando portait le sien sous un blouson en cuir dans *L'Équipée sauvage* et le déchirait dans *Un Tramway nommé Désir*. Celui de Coco Chanel a rendu chic les rayures de marin, tandis que Pablo Picasso en a fait l'uniforme de l'artiste. Avec l'aide de Vivienne Westwood, Sid Vicious a taillé le sien et l'a orné d'épingles à nourrice. Dans sa période post-Beatles, John Lennon devint un vrai enfant de Manhattan dans son *ringer* (un t-shirt au col et au bord des manches d'une couleur différente) « New York City » aux manches découpées. Giorgio Armani arbore les siens sur une peau bronzée, Patti Smith sur une peau blanche. La diva warholienne Edie Sedgwick rendait plus habillés ceux qu'elle achetait dans les friperies de collants, à l'aide de grandes boucles d'oreilles et d'un manteau de vison. En 1996, l'actrice Sharon Stone est apparue dans la seconde tenue la plus mémorable de sa carrière à la cérémonie des Oscars dans un t-shirt Gap assorti d'une jupe de bal de Valentino. La liste des célébrités associées au t-shirt est interminable.

À l'époque où l'enseigne Gap était au sommet de sa popularité, son patron d'alors, Mickey Drexler, comparait l'expansion des chaînes de boutiques de jeans et de vêtements basiques à celle des épiceries. En 1998, il déclara au magazine *Fortune* : « Réfléchissez. Quand vous vous rendez au supermarché, vous vous attendez à y trouver l'essentiel : du lait sans matière grasse, écrémé, demi-écrémé, entier ; à ce que les dates soient fraîches ; à ce qu'il y ait du beurre, plusieurs types de pain, etc... Vous y allez avec votre liste. Pourquoi en irait-il autrement avec les magasins d'habillement ? » Fort de cette vision de la confection comme un produit de base, il fit fleurir des boutiques Gap dans tous les centres commerciaux américains. Les t-shirts, qui sont en grande partie à l'origine de la réussite de l'enseigne, sont, à première vue, le produit de base par excellence. Peu coûteux et faciles à produire en grandes quantités, on en importe chaque année près d'un milliard et demi aux États-Unis.

Toutefois, malgré leur prix, leur simplicité et leur important débit, tous les t-shirts ne sont pas des articles basiques. Quand Dov Charney, fondateur d'American Apparel, a lancé sa société en 1997 à Los Angeles, il visait le créneau des *blanks*, à savoir les t-shirts neutres destinés à être imprimés, brodés ou embellis d'une manière ou d'une autre avant d'être vendus aux consommateurs. Ce marché était jusque-là dominé par des géants du t-shirt tels que Hanes et Fruit of the Loom. Épais et rectangulaires, les *blanks* n'existaient que dans quelques versions : à manches courtes, à manches longues, avec un col en V ou avec un col rond. Charney voulait en proposer dans une plus grande variété de styles, dans des cotons plus légers et avec des coupes plus moulantes. Il lança alors une nouvelle incarnation du t-shirt : le *blank* branché.

La technologie des t-shirts

Au fil de son histoire plus que séculaire, le t-shirt a été défini comme un sous-vêtement, un vêtement de sport, un vêtement de travail et un accessoire de mode. Il est né avec la révolution industrielle et l'invention de la tricoteuse industrielle. Les premières usines étaient équipées de machines débitant des tubes de tricot destinés à alimenter les ateliers de bas et de bonneterie. Bientôt, elles se tournèrent vers le sous-vêtement masculin, produisant des combinaisons en coton d'une pièce. Les prédécesseurs de Hanes, P. H. Hanes Knitting Company et Shamrock Mills, lancèrent ensuite une version en deux pièces,

← Faux Tuxedo, Athletic Supporter Ltd., 1980

↑ Frankie Goes to Hollywood, 1985

«Ce que je déteste le plus dans le rock n' roll, ce sont les t-shirts noués, liés et teintés, à moins qu'ils n'aient été teintés avec le sang et l'urine de Phil Collins.»
—Kurt Cobain

↗ "Shit Happens!," 1980s
→ Bon Jovi, Farm Aid concert, 1986

un caleçon long surmonté du premier débardeur. La Russell Manufactoring Company produisit du tricot pendant deux décennies avant de se tourner vers le marché de l'athlétisme dans les années 1920.

Durant pratiquement toute la première moitié du 20e siècle, le t-shirt fut considéré comme un vêtement qu'on pouvait salir, laver souvent et qu'on ne voyait que dans des circonstances spécifiques, comme sur un ouvrier effectuant de lourdes tâches manuelles. Cette perception fut en grande partie bouleversée par Coco Chanel, la couturière française qui redéfinit la silhouette de la femme dans les années 1920. Tout le monde a en tête l'image longiligne de la couturière portant un t-shirt de marin à rayures. (Un look qui sera repris trente ans plus tard par Brigitte Bardot, sa compatriote aux courbes plus généreuses.) Pendant la Première Guerre mondiale, bon nombre de types d'étoffes venant à manquer, Chanel se mit en quête d'un tissu tricoté à la machine. Elle le trouva en 1916 chez le fabriquant parisien Rodier. Le jersey, jusque-là utilisé pour les sous-vêtements masculins, occupa bientôt une place centrale dans les collections de Chanel.

Bien que faisant partie de l'uniforme de la marine américaine depuis 1913, le t-shirt blanc à col rond et manches courtes resta caché sous les chemises jusqu'à la Seconde Guerre mondiale, quand les reporters et les films d'actualité montrèrent des soldats au repos. Dans les années 1950, il était déjà un symbole de rébellion (Brando dans *L'Équipée sauvage*, Dean dans *La Fureur de vivre*), de virilité (de nouveau Brando dans *Un Tramway nommé Désir*) ou de féminité exacerbée (Bardot dans *Babette s'en va-t-en guerre*). Dans le numéro musical éponyme du film *Le Rock du bagne* (1957), Elvis Presley porte un t-shirt à rayures noires et blanches.

À l'exception de son utilisation dans le domaine sportif, le t-shirt resta généralement simple et sans ornements jusqu'au milieu du siècle. Plusieurs grandes avancées technologiques dans le domaine de l'impression le sortirent des coulisses pour le placer sur le devant de la scène. L'impression au cadre existait depuis des siècles, puisant ses racines dans l'art du pochoir japonais. Elle fut très utilisée au cours de la Première Guerre mondiale pour imprimer des affiches et des publicités. Cette technique était également employée dans la confection, mais ce ne fut qu'à la fin des années 1950 qu'une nouvelle encre appelée le plastisol améliora la qualité des images, les rendant plus durables et flexibles que celles imprimées avec les pigments traditionnels. En 1960, le procédé devint mécanisé grâce à l'invention de la machine d'impression multicolore rotative.

Ensuite vint la technologie du transfert à chaud, qui permit aux artistes de reproduire des images sur le tissu à l'aide d'encres et de papiers spéciaux. Au cours de la décennie qui suivit, des machines à imprimer sur t-shirt apparurent dans les drugstores, les magasins de sport et les boutiques spécialisées qui proposaient des t-shirts neutres, des lettres thermocollantes et une sélection de graphismes pouvant être transférés à chaud. Les clients pouvaient ainsi customiser leur t-shirt. Grâce aux motifs transférables à chaud, il était désormais possible de transposer sur le vêtement des images d'un réalisme photographique. Dans les années 1970, les plus populaires étaient des titres et des images de films. Les fans pouvaient ainsi rendre hommage à leurs œuvres préférées. L'industrie cinématographique prit rapidement conscience de la rentabilité du t-shirt comme produit dérivé lors du lancement des grosses productions telles que *Les Dents de la mer*, *La Guerre des étoiles* ou *E. T.*

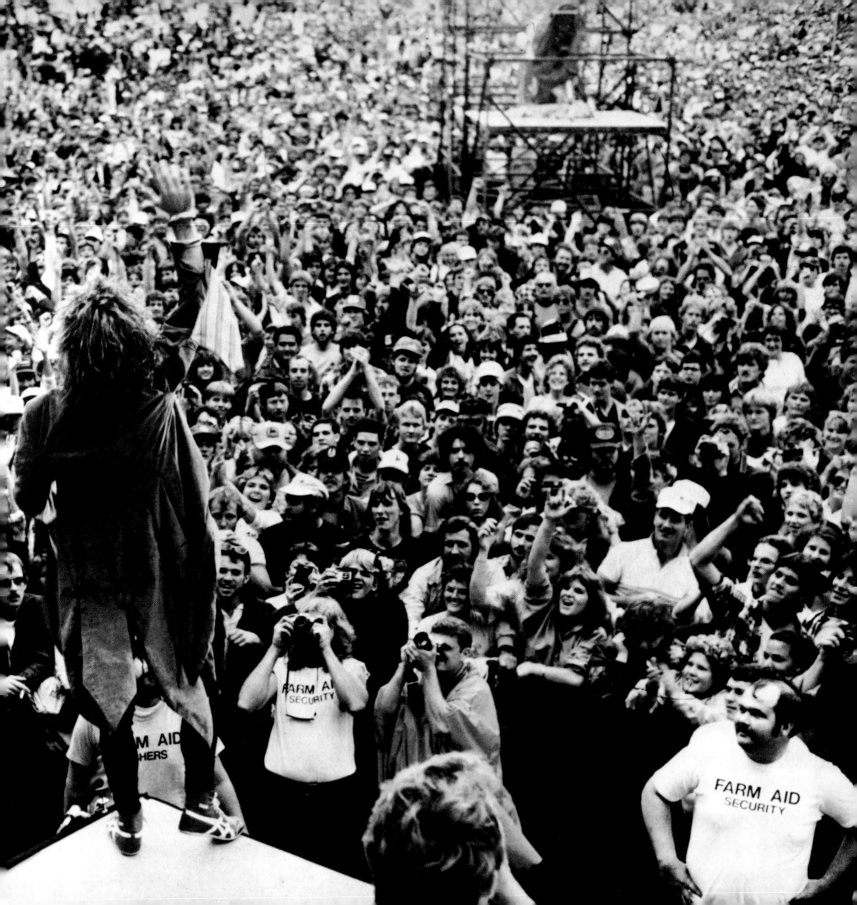

> « J'aimerais voir le pape porter mon t-shirt. »
> —Madonna

Le moyen d'expression et le message

L'une des premières applications du t-shirt imprimé fut le souvenir, généralement vendu dans les stations balnéaires et autres lieux de villégiature. Il permettait au vacancier de rapporter chez lui un petit coin de paradis et d'annoncer son statut de voyageur du monde à ses voisins. La popularité du t-shirt souvenir ne s'est jamais démentie et, dans quelques cas remarquables, le slogan et le lieu sont devenus indissociables, comme le *Virginia is for Lovers*, créé lors de la campagne du même nom en 1969 par l'office du tourisme de Virginie, et le *I Love NY*, dont le logo fut dessiné par l'artiste Milton Glaser à la fin des années 1970.

Si le t-shirt souvenir opère comme un passeport virtuel, le t-shirt de surfeur sert de signe de ralliement à une tribu élitiste. *The Encyclopedia of Surfing* attribue son invention au fabricant de planches de surf Floyd Smith en 1961. Selon la légende, Smith aurait appris seul l'art de la sérigraphie, puis aurait proposé d'imprimer gratuitement le logo de sa société, Gordon & Smith Surfboards, sur les t-shirts que les clients achetaient dans sa boutique. À la fin de la même année, d'autres marques telles qu'O'Neill se lancèrent sur le même marché.

Les baby-boomers furent séduits par l'idée qu'on puisse utiliser son t-shirt afin de révéler quelque chose sur sa propre personnalité, de son affiliation politique à ses goûts musicaux. (Le plus ancien t-shirt politique connu, *Dew it with Dewey*, apparut toutefois en 1948 lors de la campagne du politicien Thomas E. Dewey. Il est aujourd'hui conservé au Smithsonian Institution à Washington. De même, les t-shirts faisaient déjà partie de la longue liste de produits dérivés de la tournée d'Elvis Presley en 1956.)

Tout au long des années 1960, le t-shirt fut érigé en symbole de la contre-culture, juste derrière le blue-jean. Il offrait une tribune idéale pour s'exprimer – qu'on choisisse de le faire avec des mots ou des images, avec un t-shirt de concert, un message politique ou un support expérimental pour une technique artisanale. La redécouverte des teintures africaines et des batiks indiens transforma les t-shirts en messages psychédéliques personnels. Prenant ces techniques à cœur, les adeptes des Grateful Dead teintèrent et reproduirent par sérigraphie leurs propres motifs sur des t-shirts qu'ils vendaient lors des concerts de leurs idoles.

Au fil des ans, le merchandising des concerts passa d'une industrie artisanale au gros business. Winterland Productions fut fondée en 1973 comme une filiale de Bill Graham Presents, la légendaire société de production de concerts. Winterland obtint le droit de commercialiser des produits dérivés de concerts d'artistes tels qu'Eric Clapton et Bruce Springsteen. Suite au déferlement d'entreprises du même genre qui s'ensuivit, bon nombre d'entre elles se regroupèrent sous le nom de Live Nation Merchandise, qui détient aujourd'hui les droits de plus de 150 musiciens et groupes.

Les t-shirts ne servaient pas qu'à rendre hommage aux groupes musicaux en vogue, ils chroniquaient également des événements de l'actualité tels que les Jeux olympiques, le lancement et l'atterrissage de la navette spatiale, les dernières modes (« Courrez nu en public ») ou les nouveaux sports (« le frisbee suprême »). Avec l'omniprésence des graphismes sur les t-shirts vinrent les messages ironiques avec des textes allant du sarcastique (« Ma mère est allée à Fort Lauderdale et tout ce que j'ai eu c'est ce t-shirt pourri ») au plus pédant (« Les banquiers le font avec intérêt »).

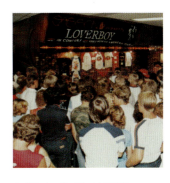

← "We Are the World," 1985
↖ "E.T. Phone Home!," 1983
↑ Merchandise table, Loverboy concert, 1983

UN CLASSIQUE AMÉRICAIN

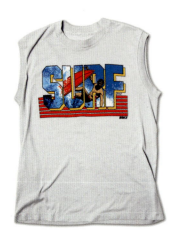

↑ Surf, ca. 1989
↘ Val Surf Boardshop advertisement, 1978
→ "Valley Girl," ca. 1983

Dans les années 1980, l'industrie de la mode commença à infiltrer le milieu de la musique. Le t-shirt *Frankie says Relax* connut un succès aussi colossal que le tube de 1984 du groupe Frankie Goes to Hollywood, *Relax*. La même année, dans leur clip *Wake Me Up Before You Go-Go*, George Michael et Andrew Ridgeley, du groupe anglais Wham!, arboraient les t-shirts *Choose Life* de Katharine Hamnet, attirant les projecteurs sur la styliste britannique qui transformait ses créations en messages de protestation (en l'occurrence, pour s'ériger contre le suicide et la drogue).

Gestion de marque

En 1971, la société Blue Ribbon Sports, alors âgée de sept ans, changea son nom pour Nike et présenta son nouveau logo, le Swoosh. Ce dernier, désormais reconnaissable entre tous, migra rapidement des chaussures aux t-shirts. De même, le lapin de *Playboy*, créé en 1954 par le directeur artistique du magazine Art Paul, bondit du papier glacé sur le coton, ainsi que sur tous les produits dérivés imaginables.

Dès qu'un slogan publicitaire atteignait une certaine notoriété, il se substituait au logo sur les t-shirts. Ce fut le cas pour celui de Nike en 1988, *Just Do It* (inspiré de Porky, le cochon bègue), et de celui de la brasserie canadienne Moosehead Canadian Lager, *Moose Is Loose*. Après avoir utilisé pendant plusieurs années des slogans reposant sur l'orthographe suédoise de son nom, Absolut Vodka les remplaça par la silhouette caractéristique de sa bouteille dans ses publicités… ainsi que sur des t-shirts. Avec son graphisme reconnaissable entre tous, le logo de Coca-Cola est sans doute le plus universellement connu – et copié. On le retrouve aussi souvent sur des t-shirts que ses innombrables détournements, qu'il soit transformé en nom de lieu (« Cape Cod ») ou en référence à la drogue (« Cocaïne »).

Si le logo de Coca-Cola est immédiatement identifiable, Mickey Mouse, icône universelle, sert d'ambassadeur pour la Walt Disney Company. Celle-ci possède un département de franchise sophistiqué qui supervise le placement de tous ses personnages, y compris Mickey, sur tous types de supports, des jouets aux t-shirts. La souris incarne le souvenir d'une Amérique saine et innocente, mais son image peut aussi véhiculer d'autres sens. Emilio Estevez portait un *ringer* Mickey Mouse aux manches coupées pour incarner Two-Bit Matthews, le membre d'un gang du début des années 1960 dans le film *Outsiders* (1983). Selon l'ouvrage de Mike Wallace,

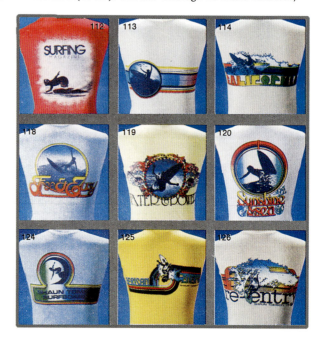

Groddie To The Max

Gag Me With A Spoon

I Am Sure

VALLEY GIRL

Hurt Me

Far Out

So Bitchen

Freaking Out

Totally

For Sure

Tubular

«J'ai toujours soutenu qu'être punk, c'était avant tout une attitude. Porter une coupe à l'iroquoise ou un t-shirt déchiré n'avait rien à voir là-dedans. Il s'agissait d'exploiter le potentiel créatif de la destruction.»
—Malcolm McLaren

→ "Just Do It," Nike, ca. 1989
↘ Alex Winter and Keanu Reeves, *Bill & Ted's Excellent Adventure*, 1989
→→ "You Are Here," 1981

Mickey Mouse History and Other Essays on American Memory, en 1984, 1900 employés de Disneyland enfilèrent des t-shirts «On n'est pas des Mickey» pour protester contre une réduction de salaire de 16%.

Du sans prétention au haut de gamme

Sa longue association avec le monde ouvrier fait du t-shirt un support idéal pour l'art populaire. Avec les images à l'aérographe de bolides customisés et de couchers de soleil, les personnages de bandes dessinées occupent depuis longtemps une place de choix. Les dessinateurs Gary Patterson, Tom Wilson («Ziggy») et Jim Davis («Garfield») découvrirent un riche filon quand ils se mirent à reproduire leurs œuvres sur des t-shirts. De même, l'illustrateur de science-fiction Boris Vallejo trouva là un nouveau débouché pour son art.

Les créateurs de bandes dessinées furent rapidement imités par d'autres artistes. Patrick Nagel, dont les pin-up des années 1980 étaient publiées dans *Playboy* et parurent sur la pochette de l'album *Rio* de Duran Duran en 1982, trouva une nouvelle inspiration avec les t-shirts imprimés. Alors que Keith Haring était au sommet de sa gloire, on pouvait voir ses œuvres dans les galeries et aussi sur des t-shirts.

Dans les années 1990, le t-shirt se fraya un chemin jusque sur les podiums de la mode. En 1992, la collection Chanel incluait des débardeurs en jersey moulant (autrement dit des «marcels») ornés du grand logo aux deux «C». Deux ans plus tard, Isaac Mizrahi mariait des débardeurs similaires avec des jupes de bal aux couleurs acidulées pour sa collection d'automne. Puis, en 1996, Sharon Stone, nominée aux Oscars, fit la une de tous les magazines de mode en se présentant à la cérémonie avec un t-shirt Gap.

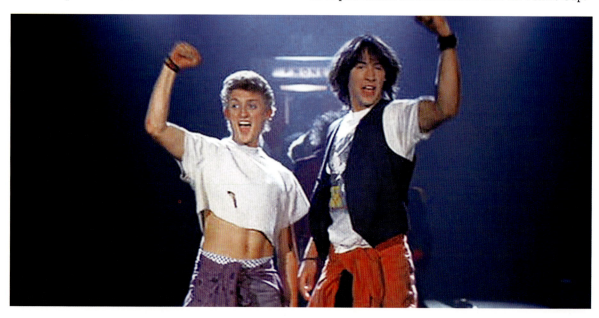

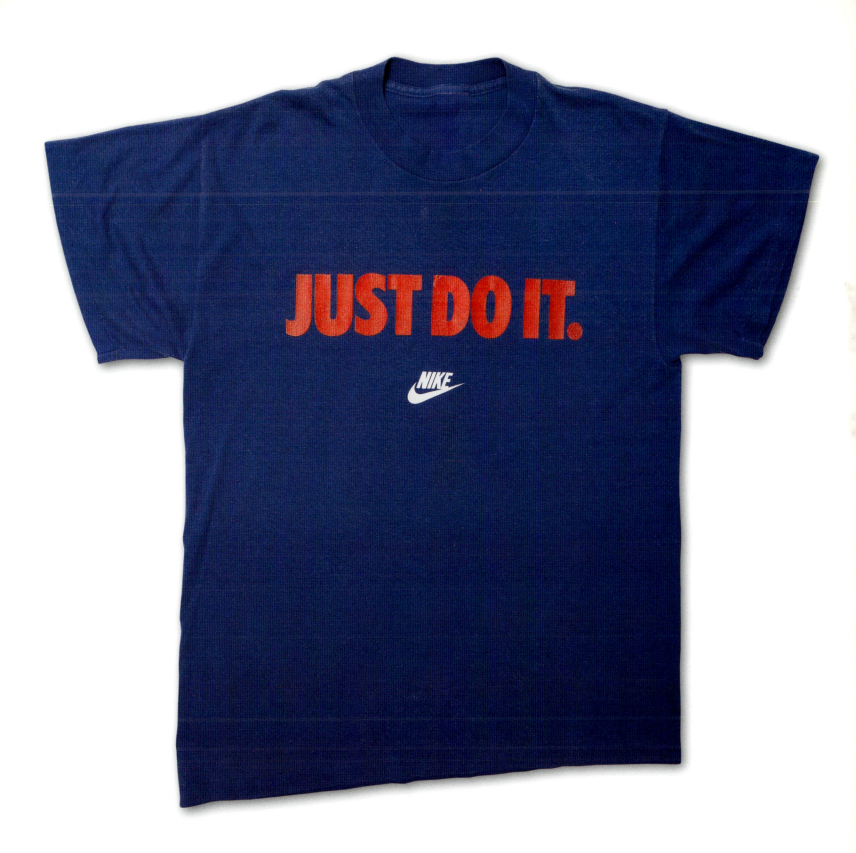

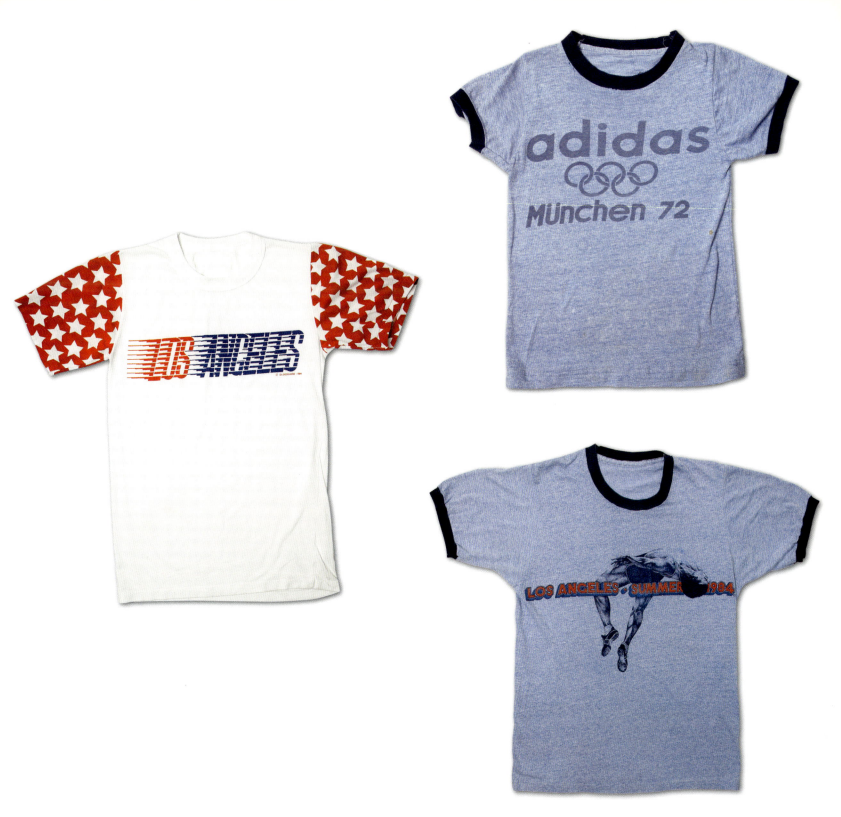

← Munich Olympics, 1972
↑ Munich Olympics, Adidas, 1972; "Los Angeles," Summer Olympics, 1984; "Los Angeles," Summer Olympics, 1984

SPORTS & RECREATION 45

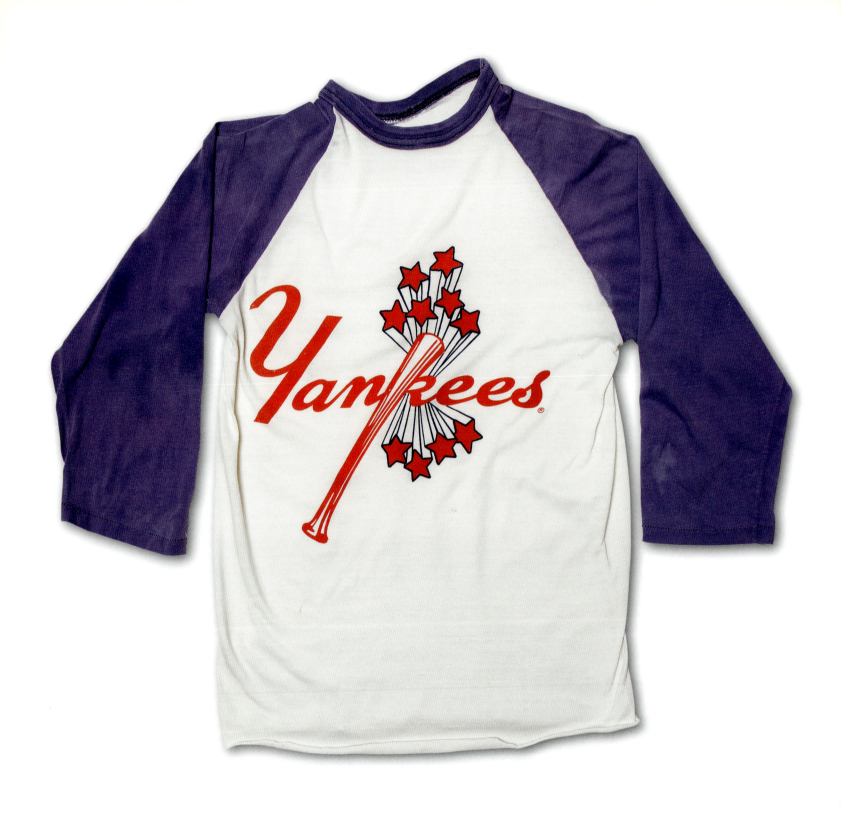

↑ "Yankees," New York Yankees, 1980s

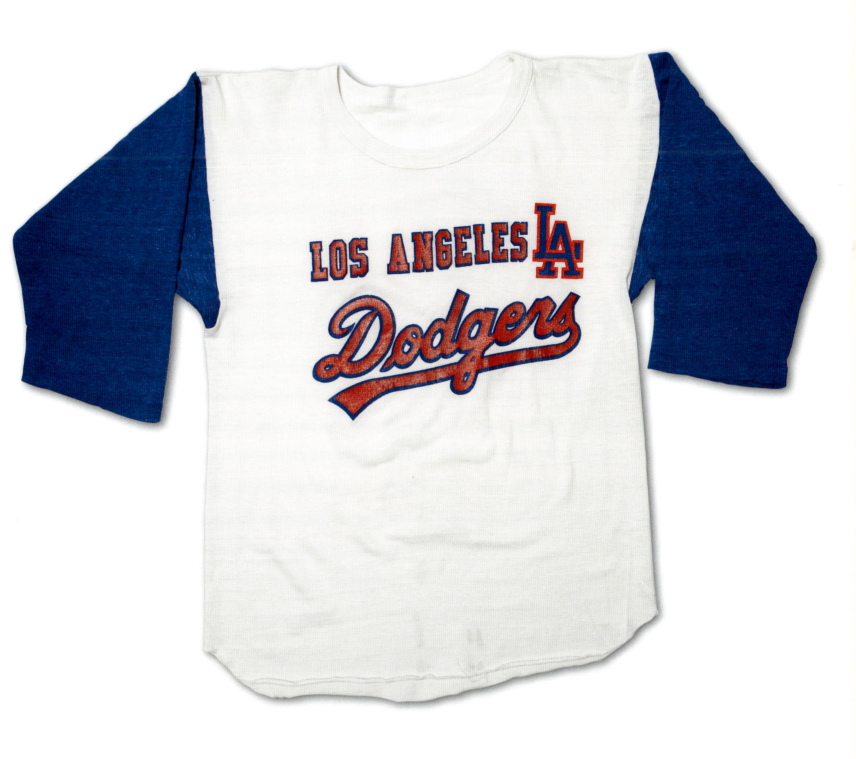
↑ Los Angeles Dodgers, 1980s

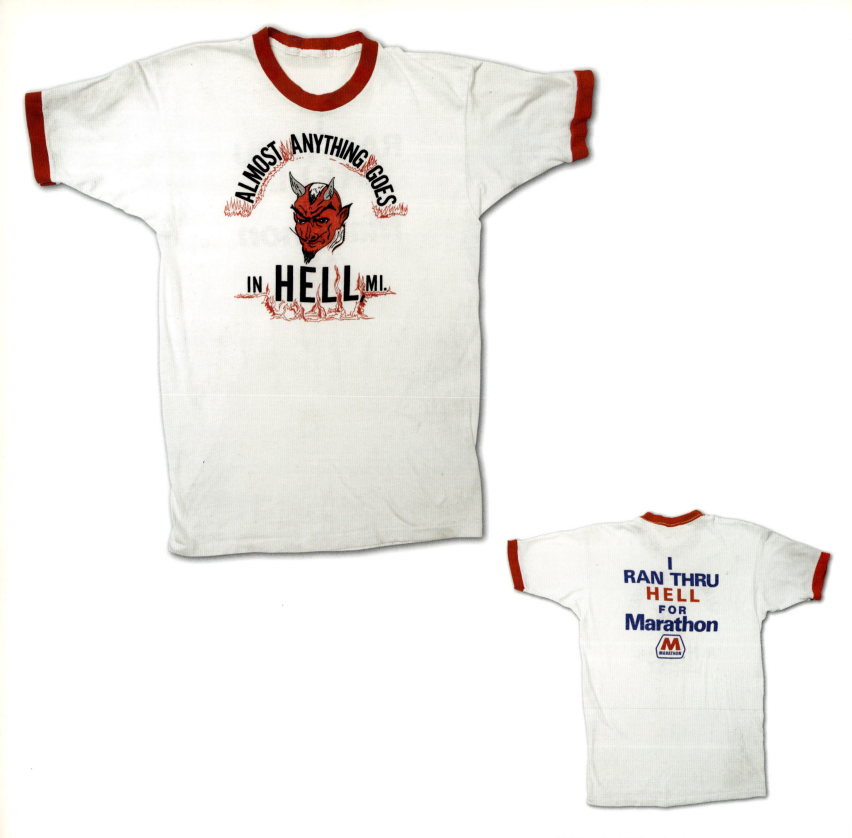

↑ "Hell," Run Thru Hell Marathon, front and back, ca. 1986

48 SPORTS & RECREATION

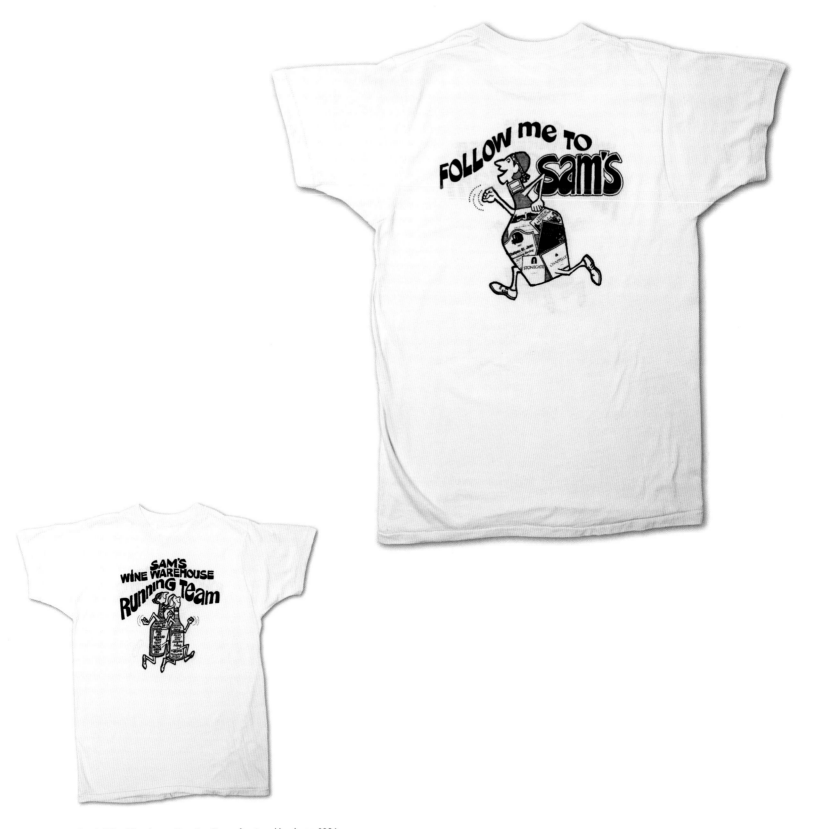

↑ Sam's Wine Warehouse Running Team, front and back, ca. 1986

SPORTS & RECREATION 49

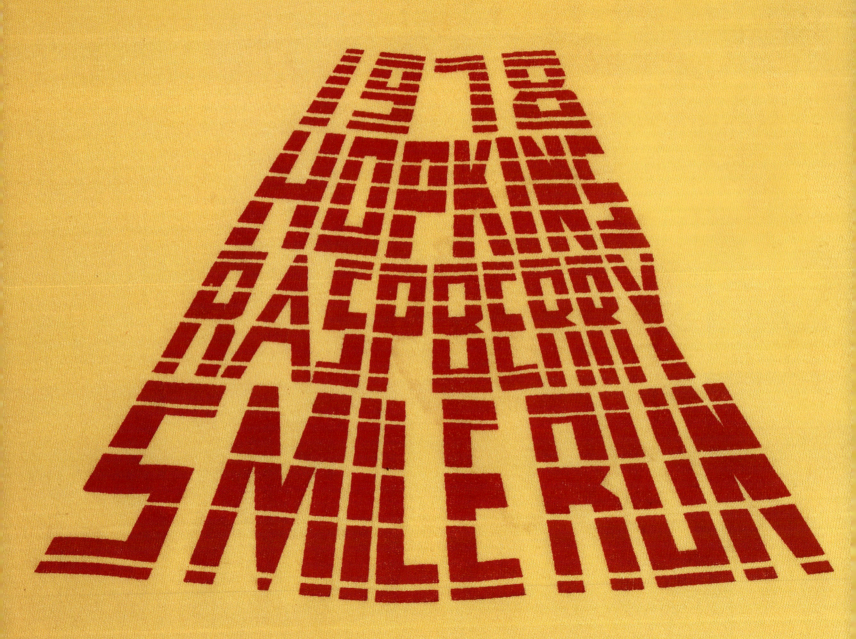

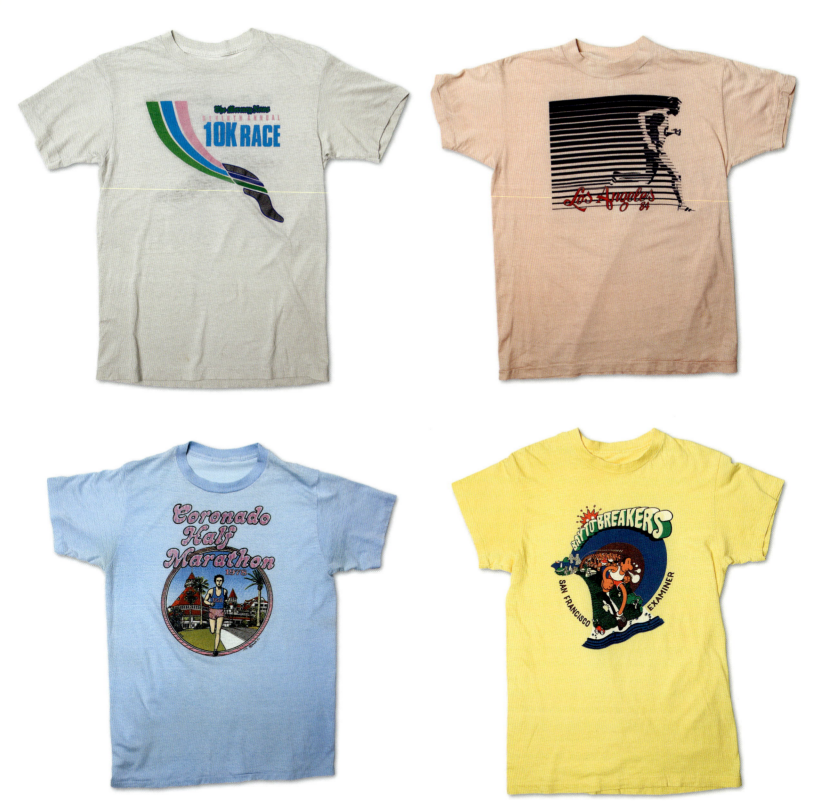

← Hopkins Raspberry Smile Run, 1978
↑ "Seventh Annual 10K Race," *The Mercury News,* 1980s; "Los Angeles," Summer Olympics, 1984; Coronado Half Marathon, 1978; "Bay to Breakers," *San Francisco Examiner,* 1980s

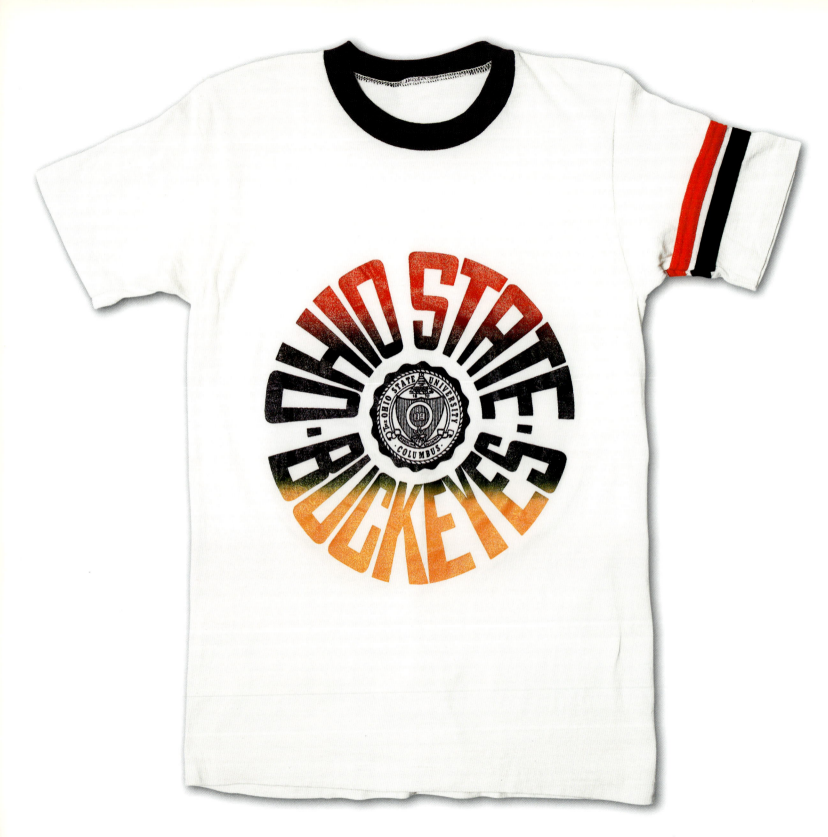

↑ Ohio State University, 1988

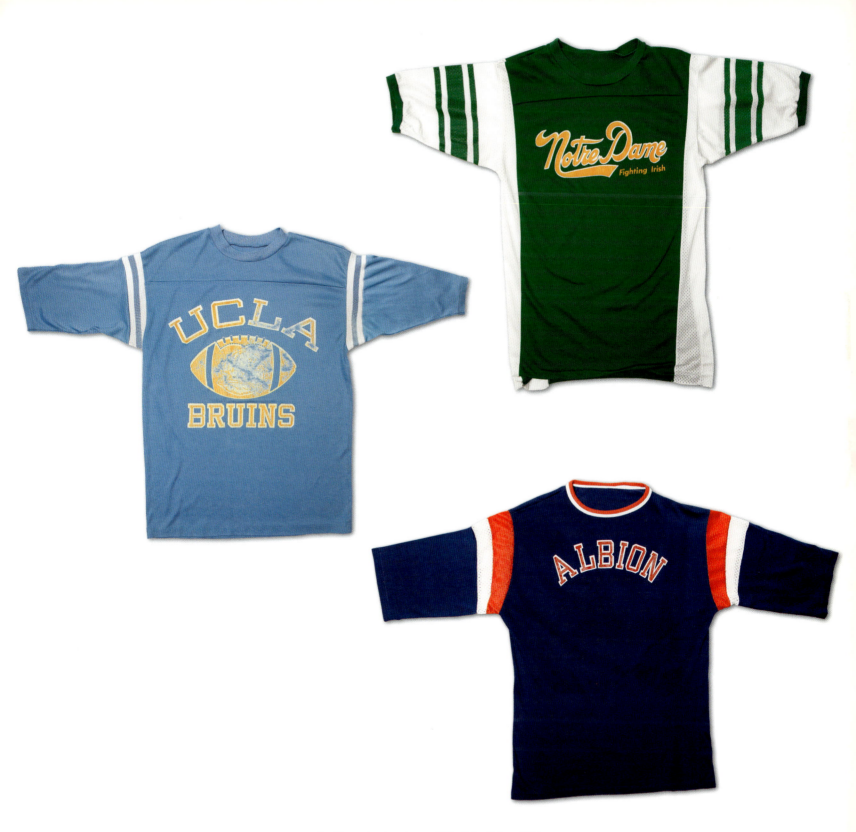

↑ University of Notre Dame, ca. 1983; "Bruins," University of California, Los Angeles, ca. 1979; Albion College, 1970s

↑ Chicago Bears, 1980s; San Francisco 49ers, ca. 1989; New York Giants, 1980s

↑ "The Silver and Black Attack," Oakland Raiders, 1986

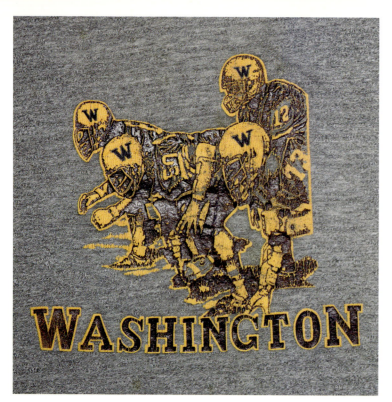

↑ University of Washington, ca. 1983; "Fightin' Irish," University of Notre Dame, ca. 1983; "Score for Maine," University of Maine, ca. 1979; "Hawkeyes," University of Iowa, ca. 1983

→ "Purdue Power," Purdue University, 1980s

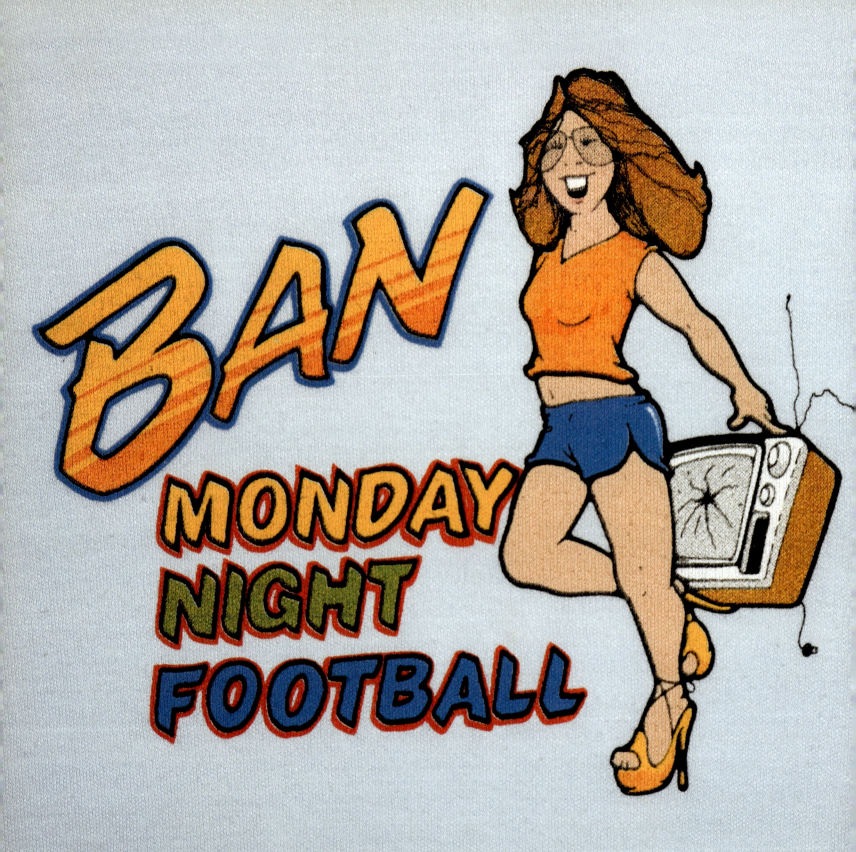

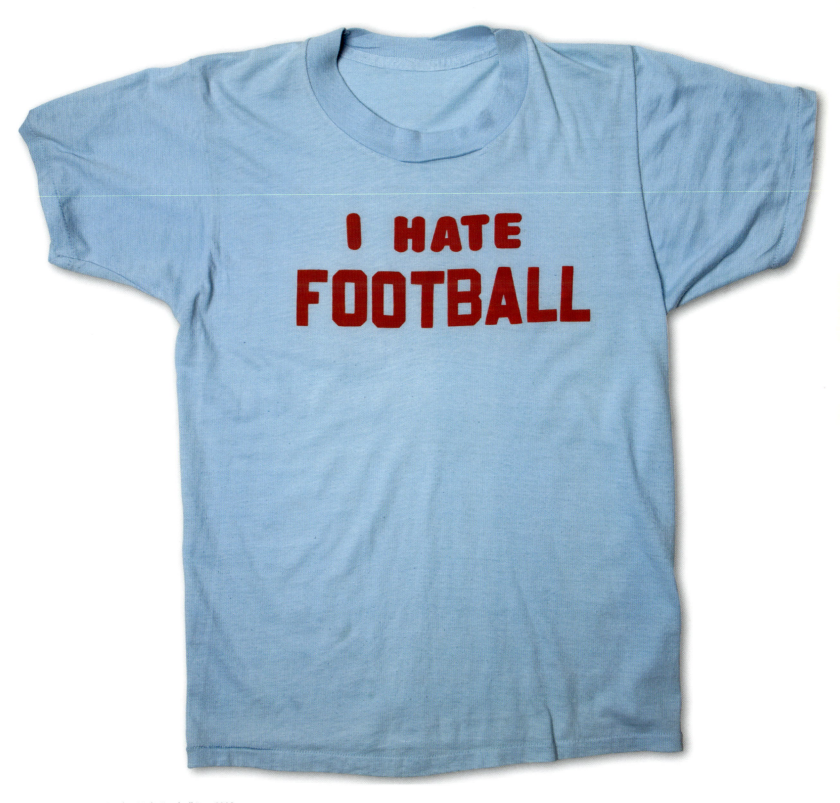

← "Ban Monday Night Football," ca. 1983
↑ "I Hate Football," ca. 1979

↑ "World Champions," Los Angeles Lakers, 1987

↑ "Larry Bird MVP," Boston Celtics, 1986

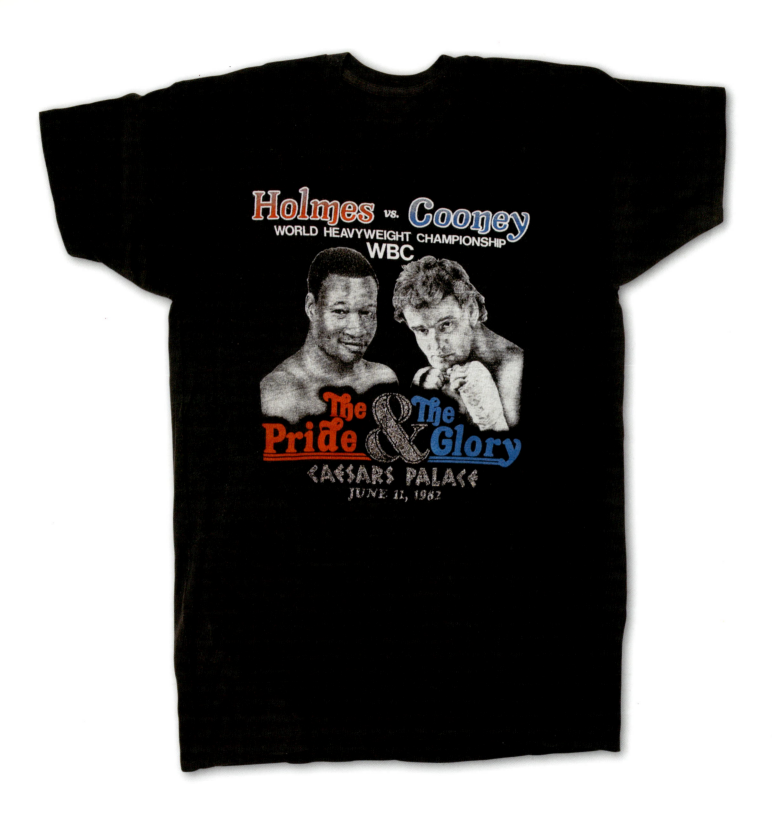

↑ "Holmes vs. Cooney," Caesar's Palace, 1982

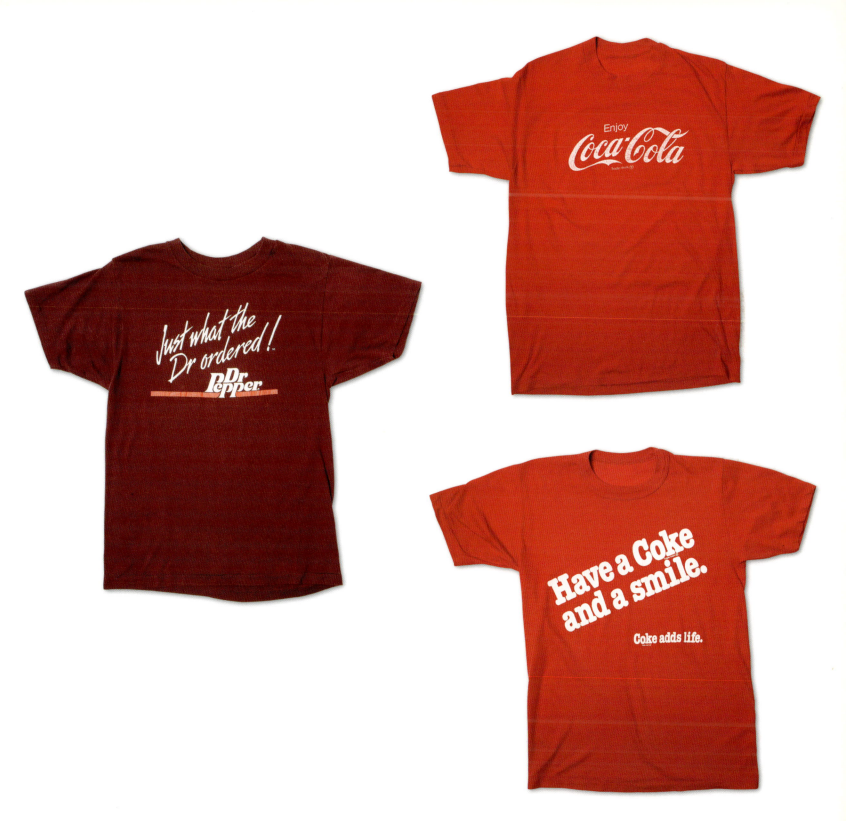

← "Enjoy Coca-Cola," 1980s
↑ "Enjoy Coca-Cola," ca. 1983; "Just What the Dr. Ordered," Dr. Pepper, 1980s; "Have a Coke and a Smile," 1979

FOOD & BEVERAGE

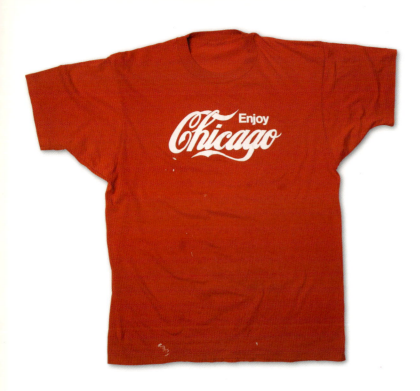
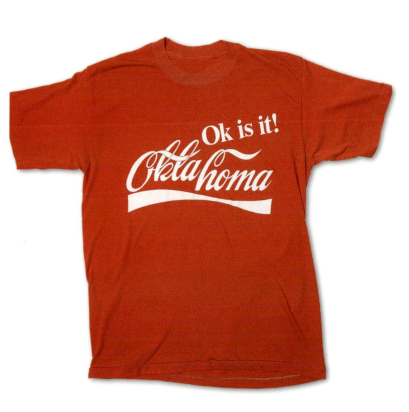
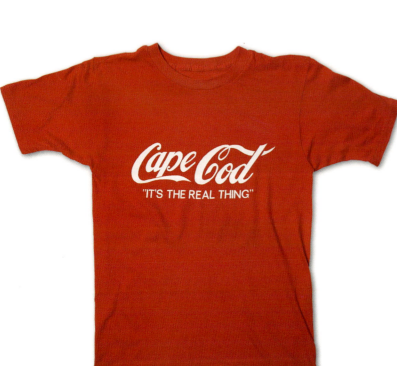

↑ "Enjoy Chicago," 1980s; "Ok Is It!," Oklahoma, 1980s; "It's the Real Thing," Cape Cod, ca. 1983

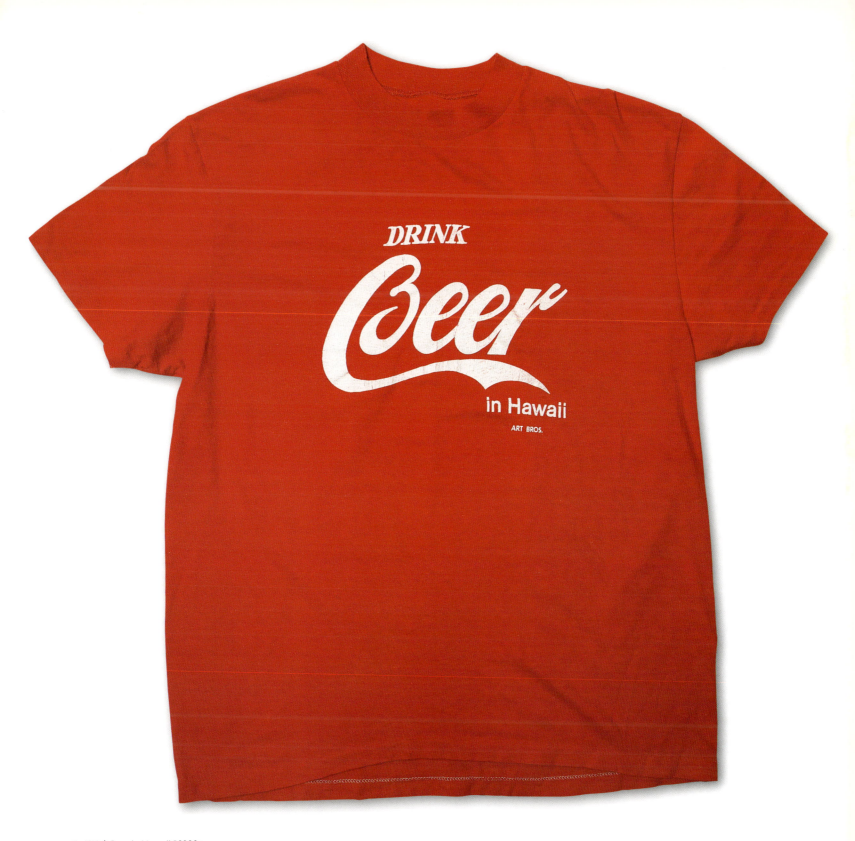
↑ "Drink Beer in Hawaii," 1980s

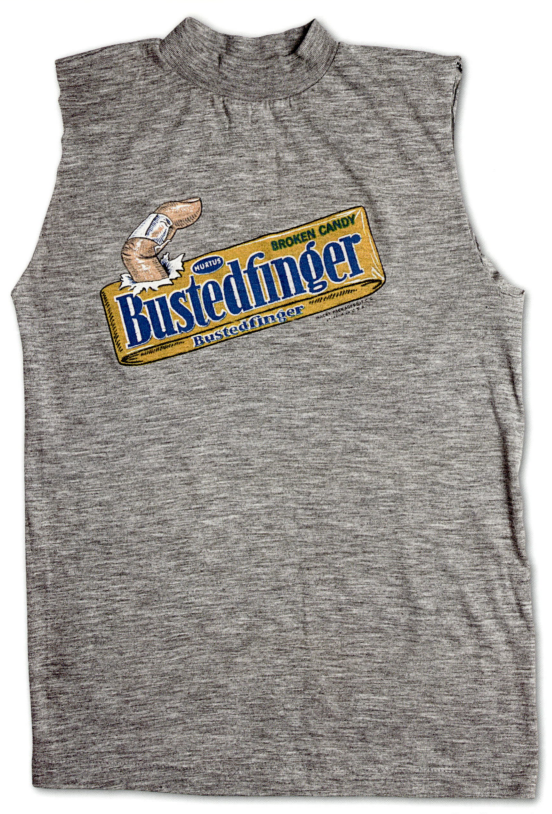

↑ "Bustedfinger," Wacky Packages, ca. 1979
→ Topps collectible cards, Art Spiegelman, ca. 1979

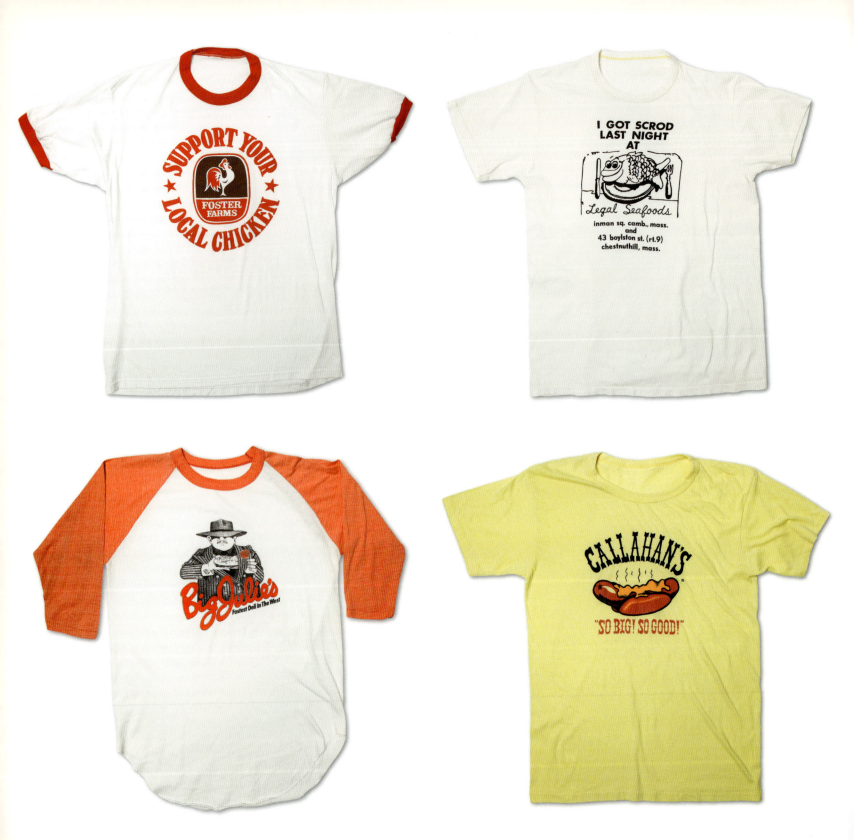

↑ "Support Your Local Chicken," Foster Farms, 1980s; "I Got Scrod Last Night," Legal Seafoods, ca. 1983; Big Julie's Deli, ca. 1979; Callahan's Restaurant, ca. 1979

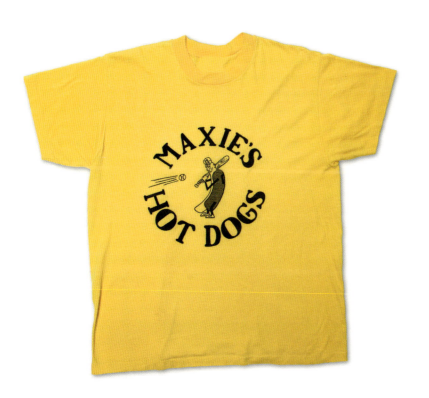
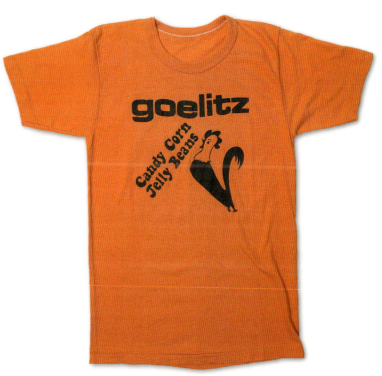

↑ Maxie's Hot Dogs, ca. 1983; Herman Goelitz Candy Co., ca. 1979; "USDA Choice Meat," 1980s; "Two Great Tastes," Reese's Peanut Butter Cups, 1980s

FOOD & BEVERAGE 71

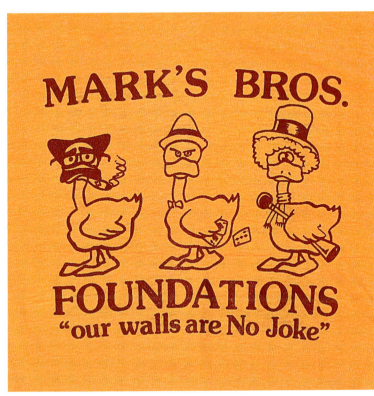
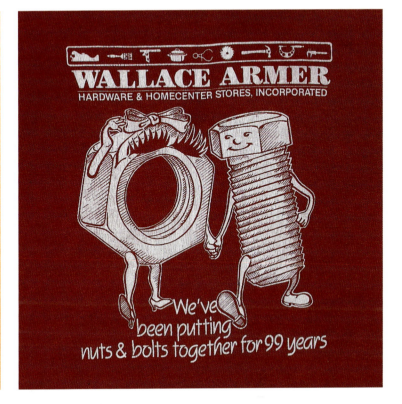

← "His Prices Are Insane!," Crazy Eddie," ca. 1983
↑ Laurel Hardware, 1980s; "The Incredible Bulk," ca. 1979; "Our Walls Are No Joke," Mark's Bros. Foundations, ca. 1989; Wallace Armer, 1980s

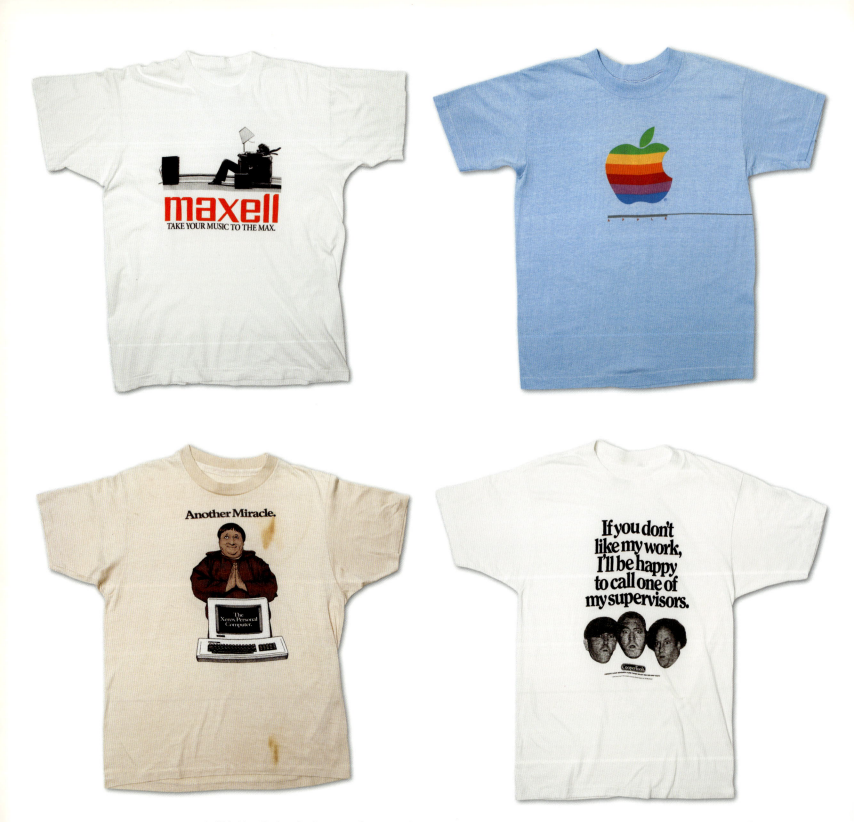

↑ "Take Your Music to the Max," Maxell, 1978; Apple, 1980s; "Another Miracle," Xerox, 1980s; "If You Don't Like My Work," Three Stooges, 1980s
→ "My Components Are Pioneer," ca. 1983

MY COMPONENTS ARE

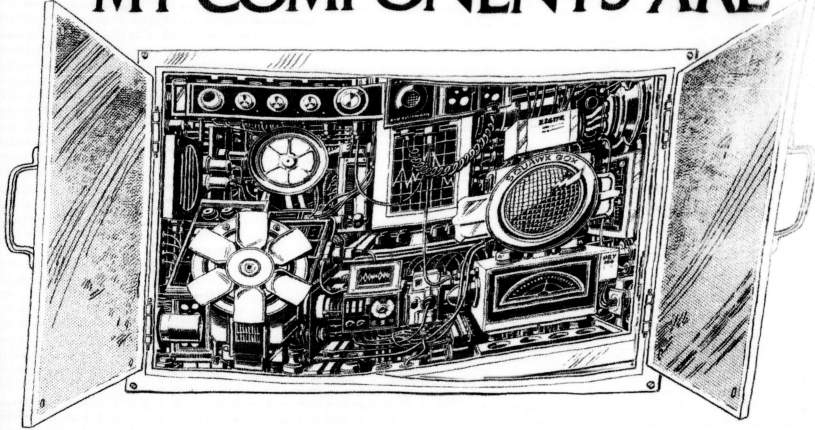

ⓦ PIONEER
HIGH FIDELITY

TITTIES 'N' BEER

Zappa [signature]

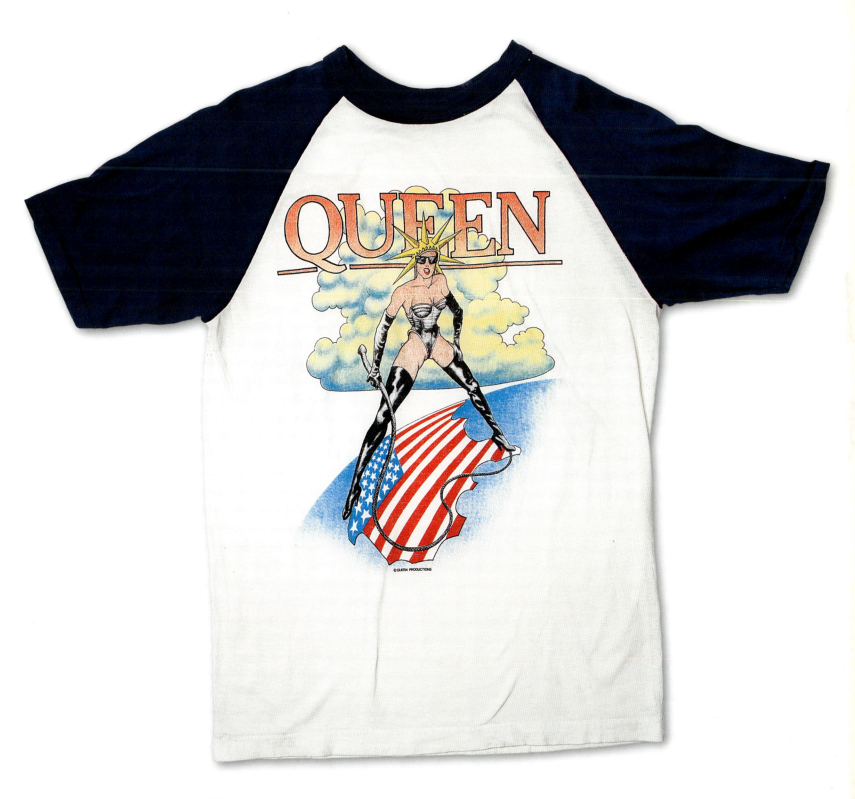

← "Titties 'n' Beer," Frank Zappa, 1983
↑ Queen, ca. 1983

MUSIC 77

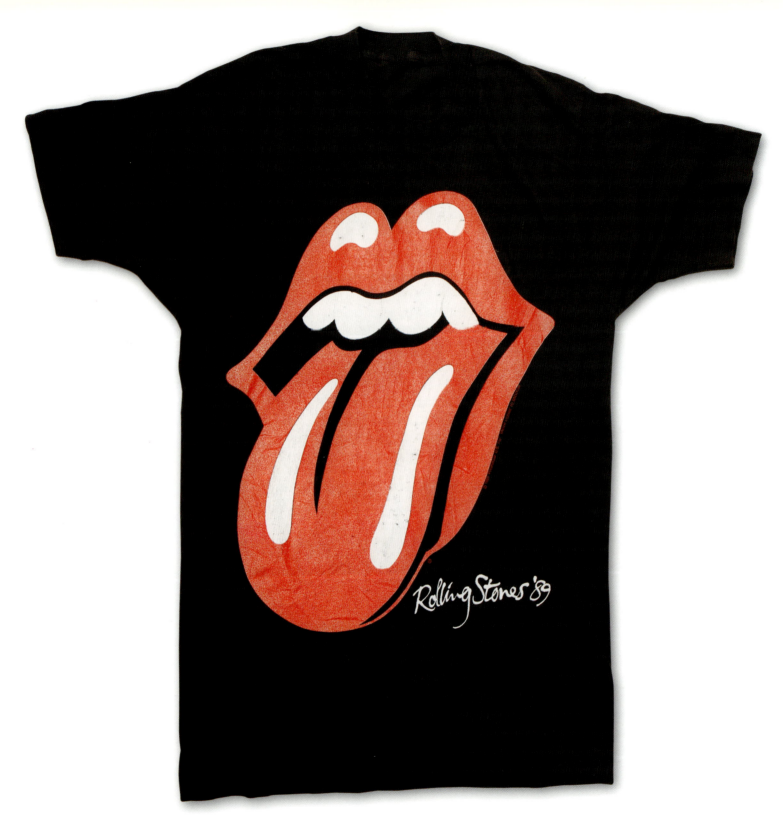

↑ The Rolling Stones, 1989

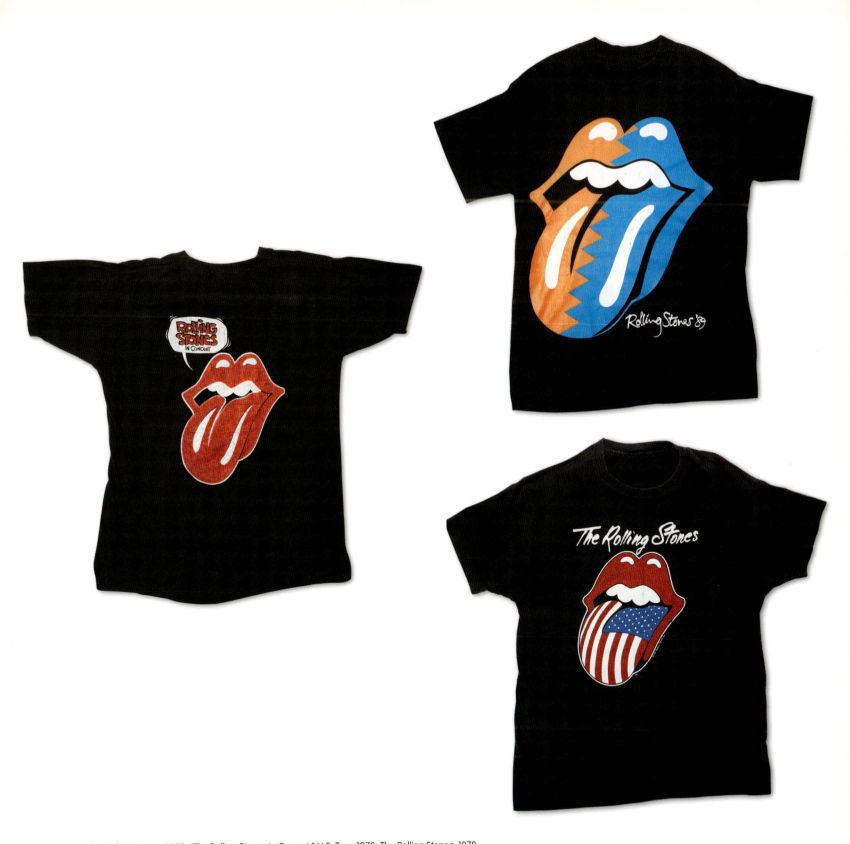

↑ The Rolling Stones, 1989; "The Rolling Stones in Concert," U.S. Tour, 1978; The Rolling Stones, 1979

Elvis®

Still The King

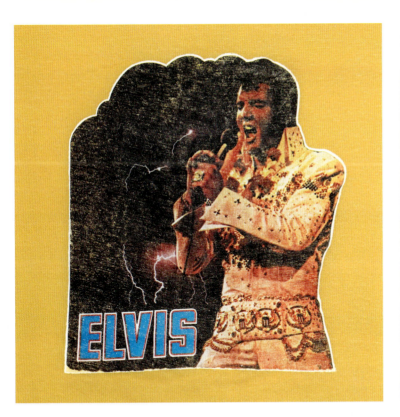

← "Elvis, Still the King," 1980s
↑ Elvis Presley, ca 1979; "Elvis," ca. 1989; Graceland, 1980s; "Love Me Tender," Elvis Presley, ca. 1979

↑ "World Tour '77," Yes, 1977

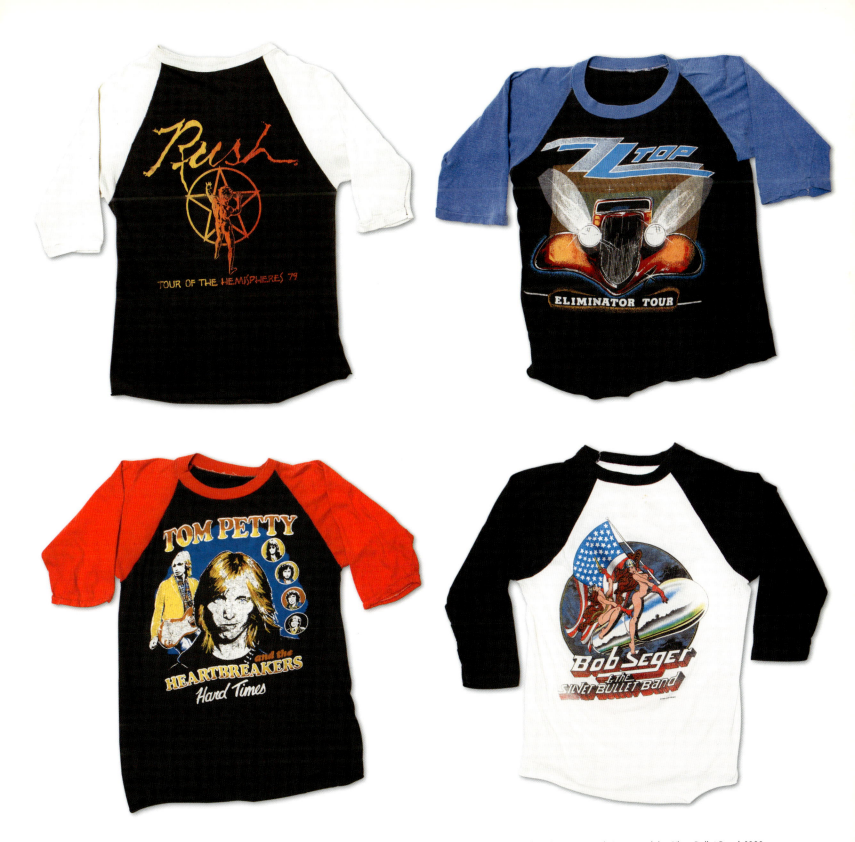

↑ "Tour of the Hemispheres," Rush, 1979; "Eliminator Tour," ZZ Top, 1983; "Hard Times," Tom Petty and the Heartbreakers, 1981; Bob Seger and the Silver Bullet Band, 1983

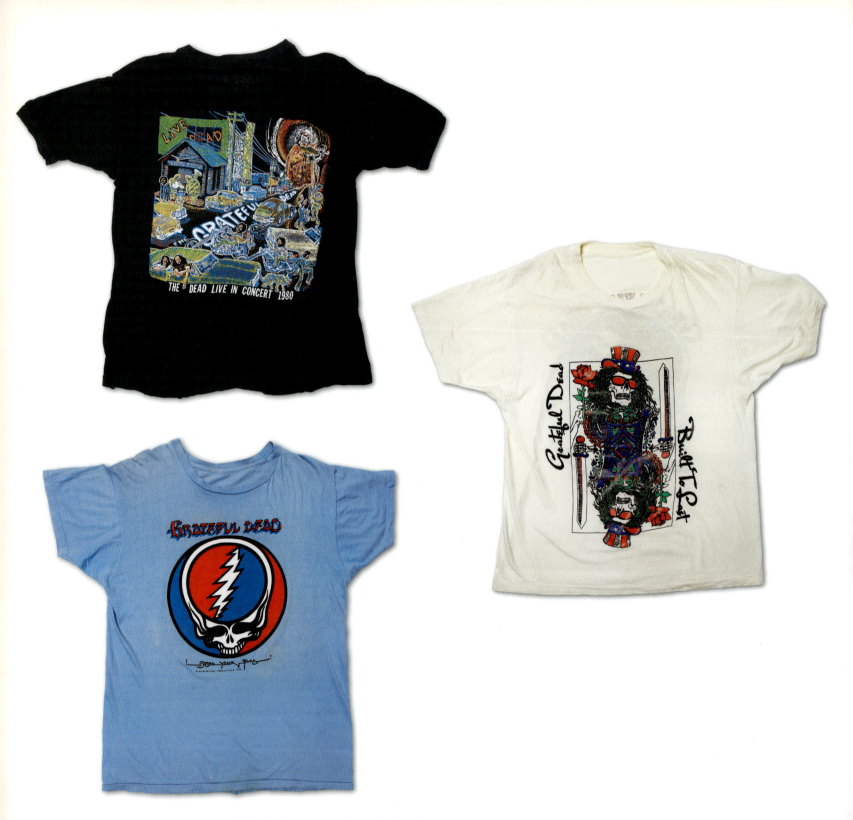

↑ "The Dead Live in Concert 1980," The Grateful Dead, 1980; *Built to Last*, The Grateful Dead, 1989; *Steal Your Face*, Grateful Dead, 1976

→ Grateful Dead, 1979

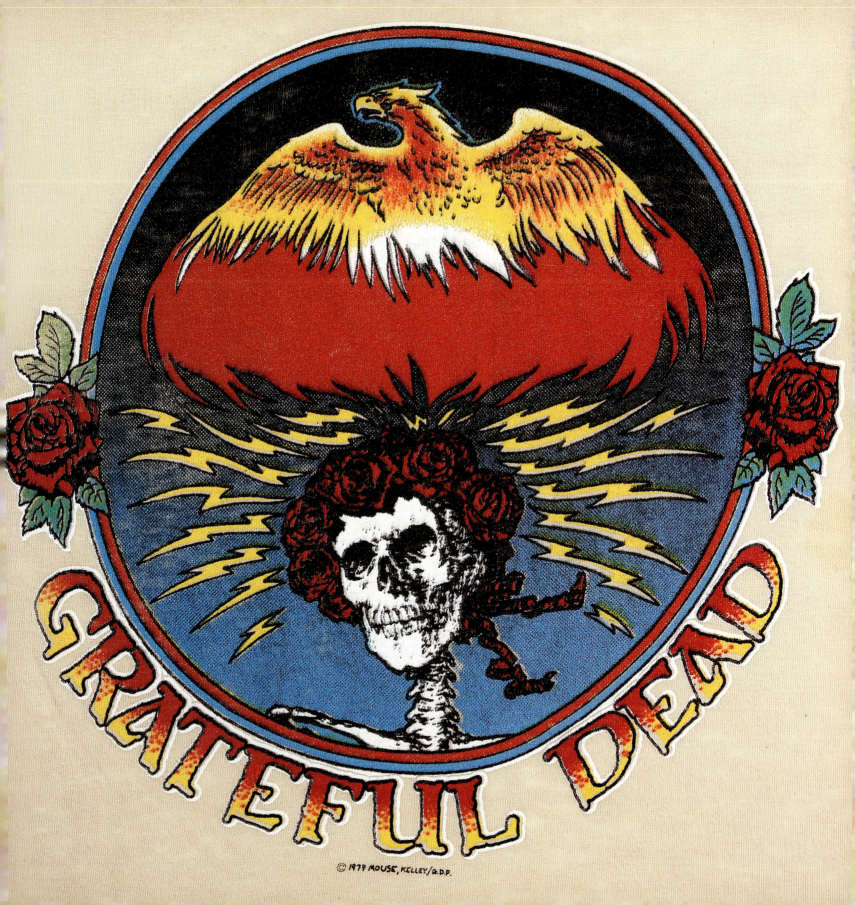

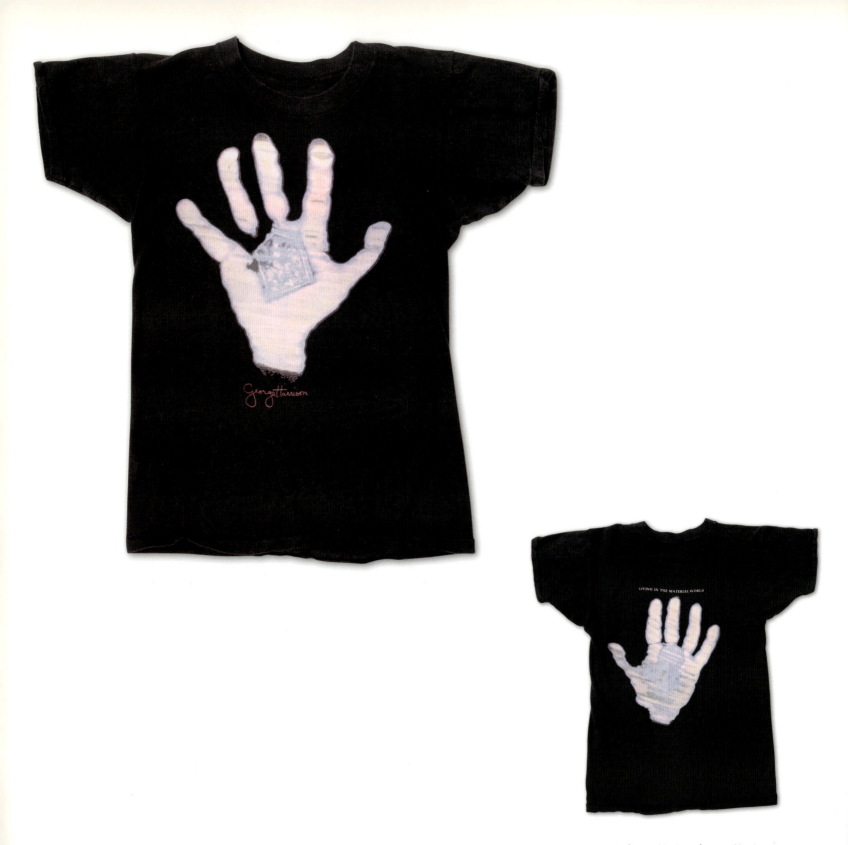

↑ George Harrison, front and back, 1982

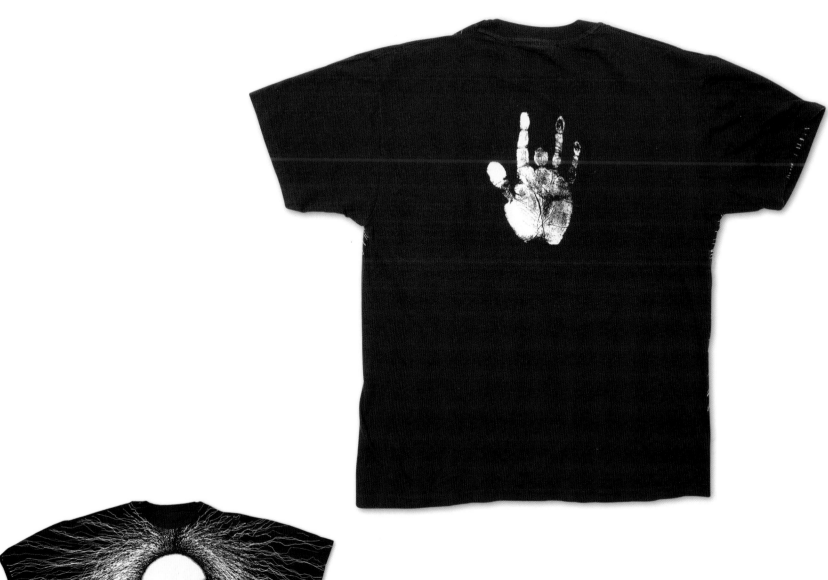
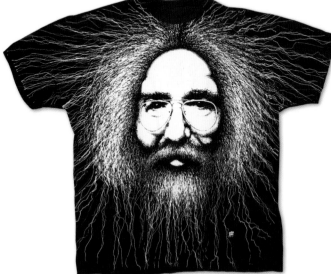

↑ Grateful Dead, front and back, ca. 1989

MUSIC 87

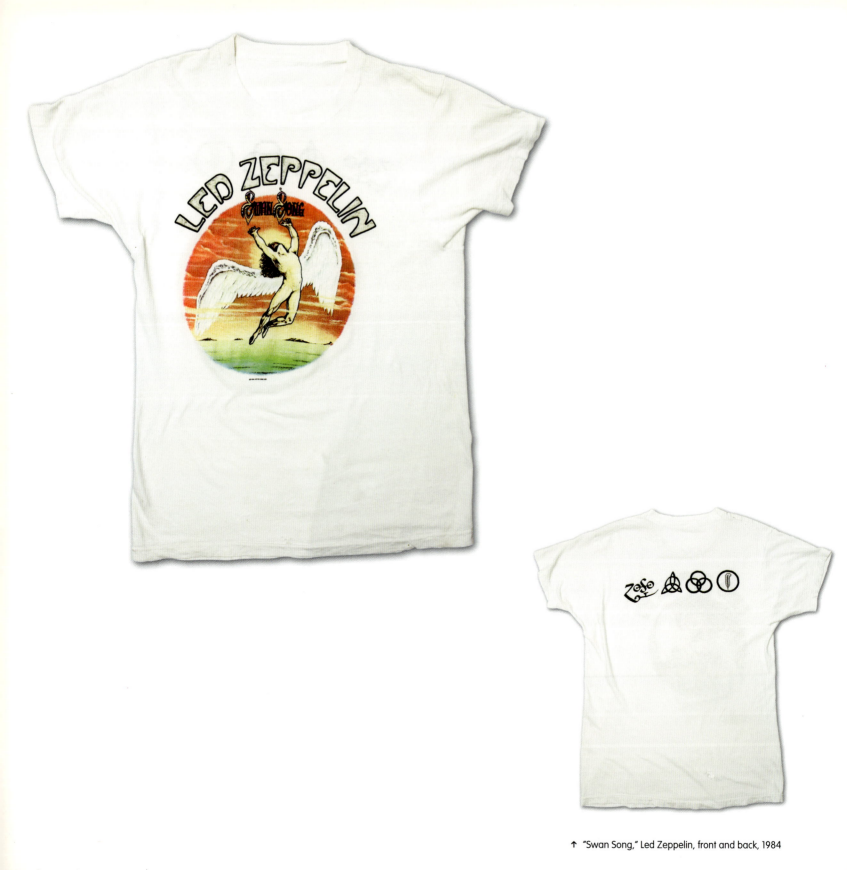

↑ "Swan Song," Led Zeppelin, front and back, 1984

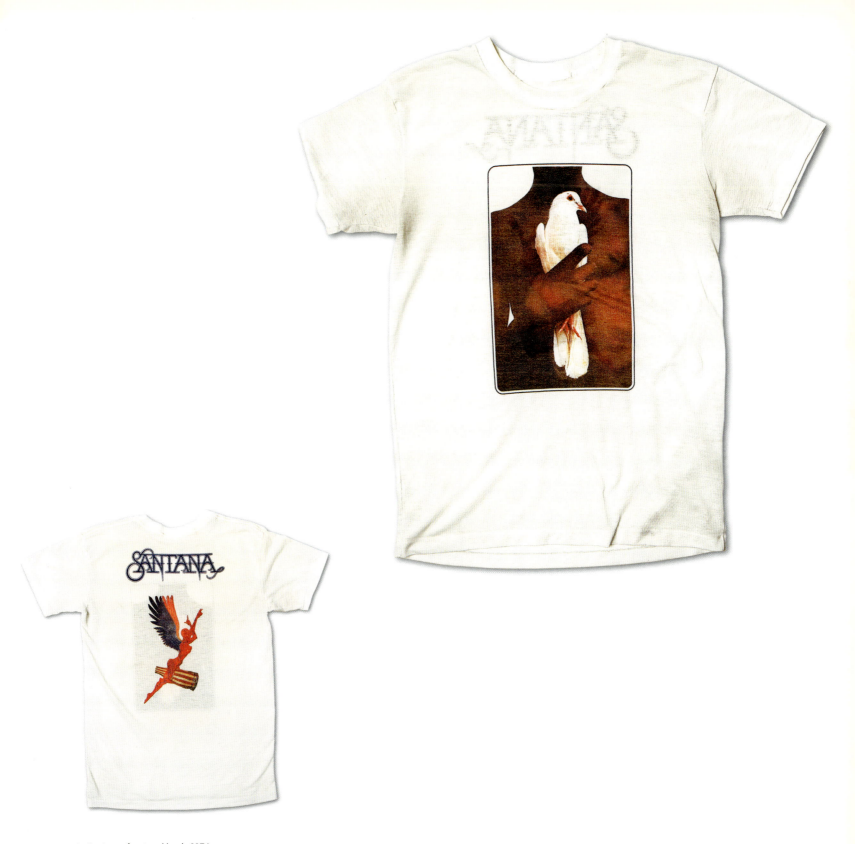

↑ Santana, front and back, 1974

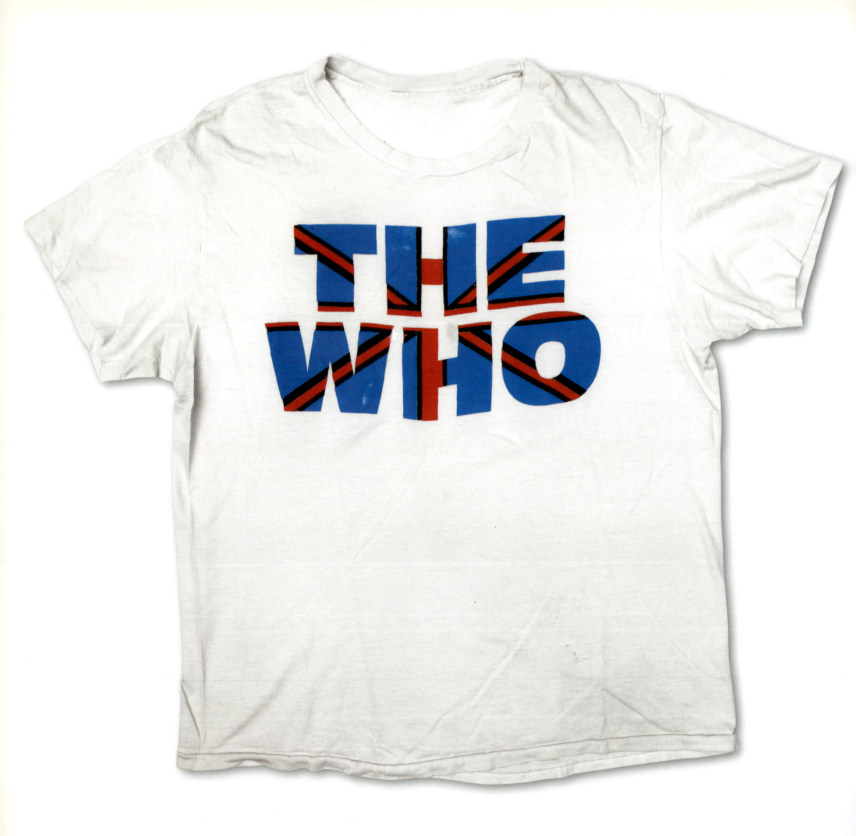

↑ The Who, ca. 1986

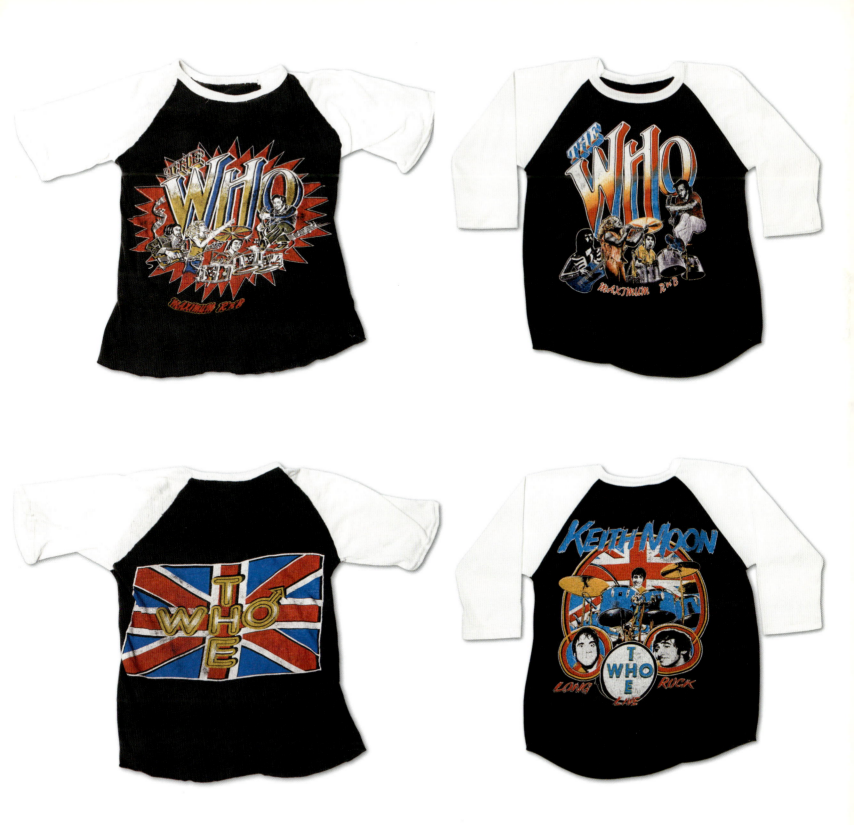

↑ The Who, front, ca. 1973; "Keith Moon," The Who, front, 1973; The Who, back, ca. 1973; "Keith Moon," The Who, back, 1973

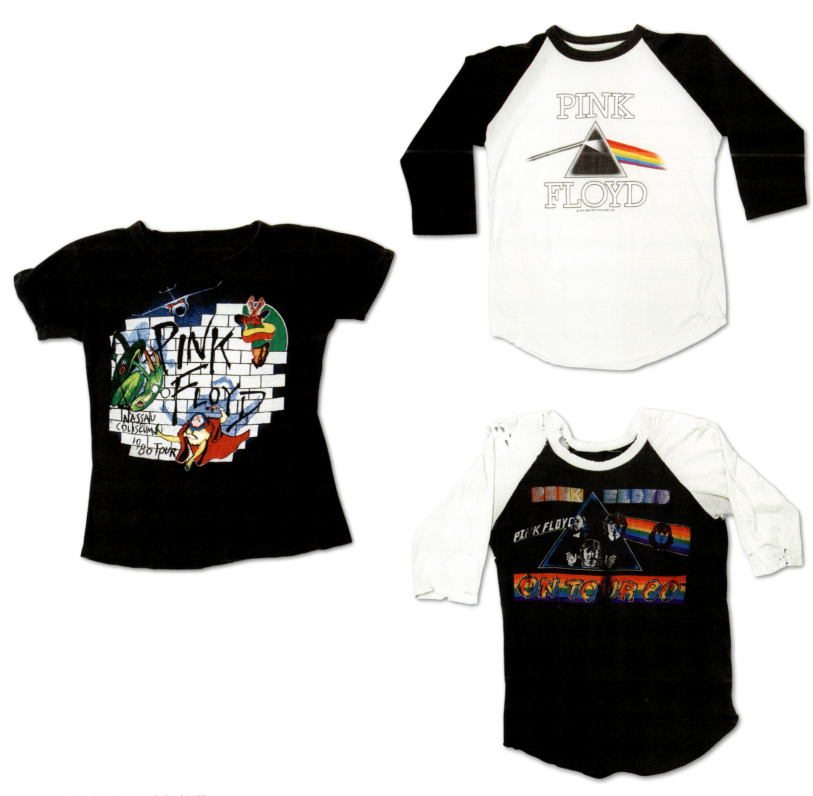

← "Animals Tour '77," Pink Floyd, 1977
↑ Pink Floyd, 1982; "The Wall Tour," Pink Floyd, 1980; "Pink Floyd on Tour," 1980

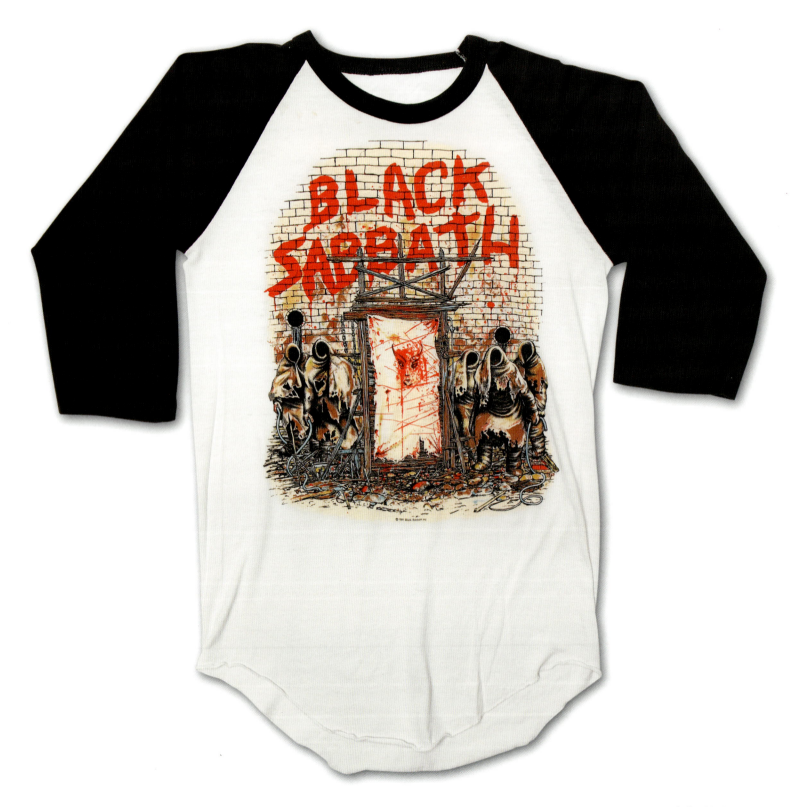

↑ Black Sabbath, 1981

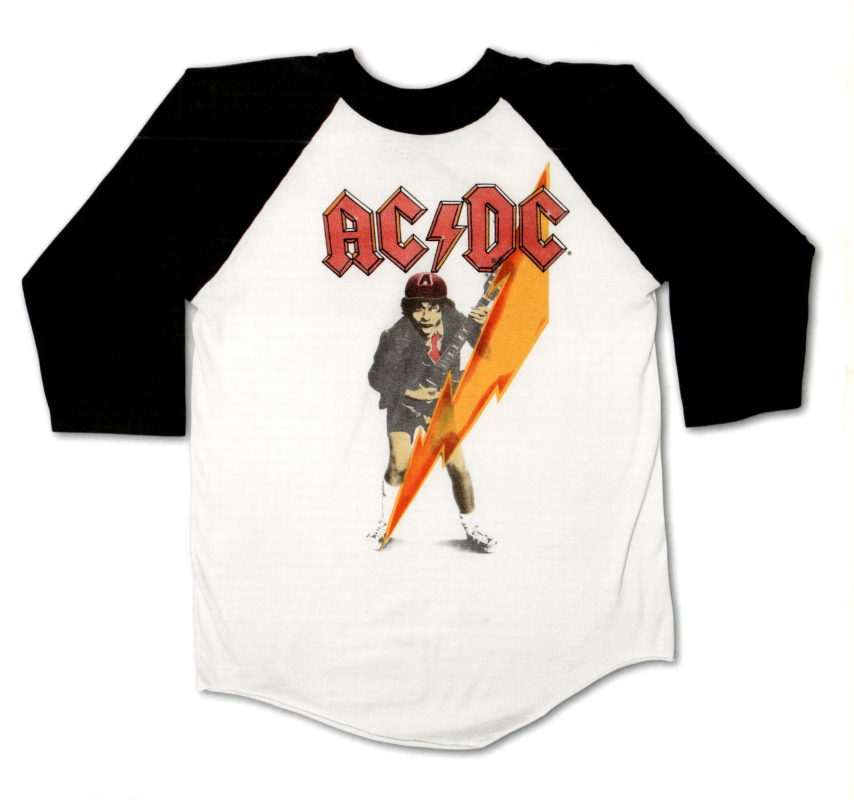

↑ AC/DC, ca. 1989

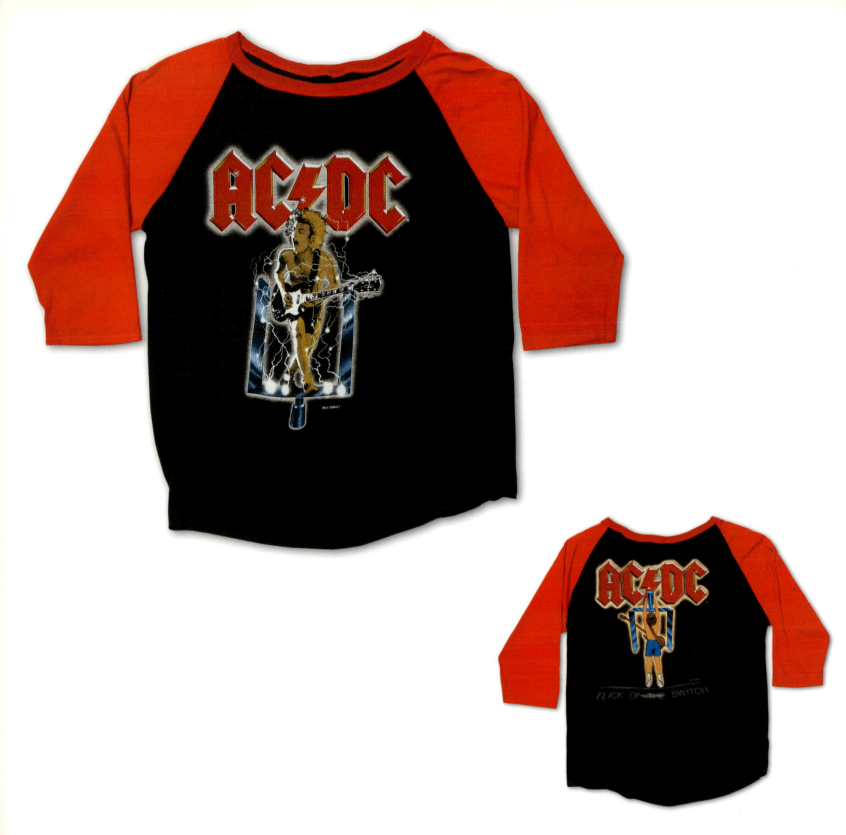

↑ *Flick of the Switch*, AC/DC, front and back, ca. 1989

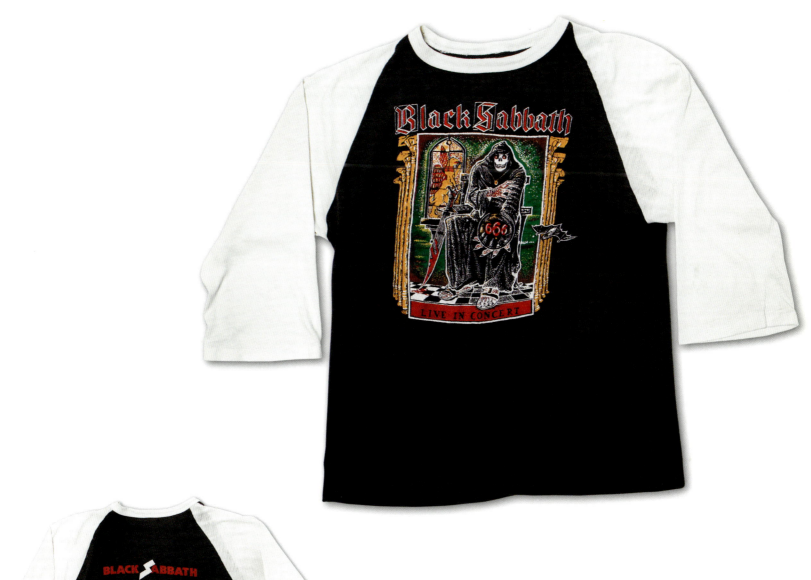
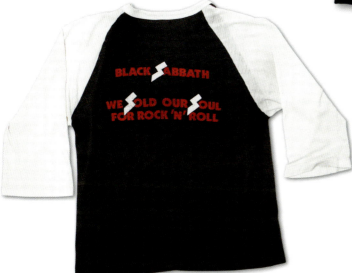

↑ *We Sold Our Soul for Rock 'n' Roll*, Black Sabbath, front and back, 1975
→ → AC/DC, 1992; Metallica, ca. 1993

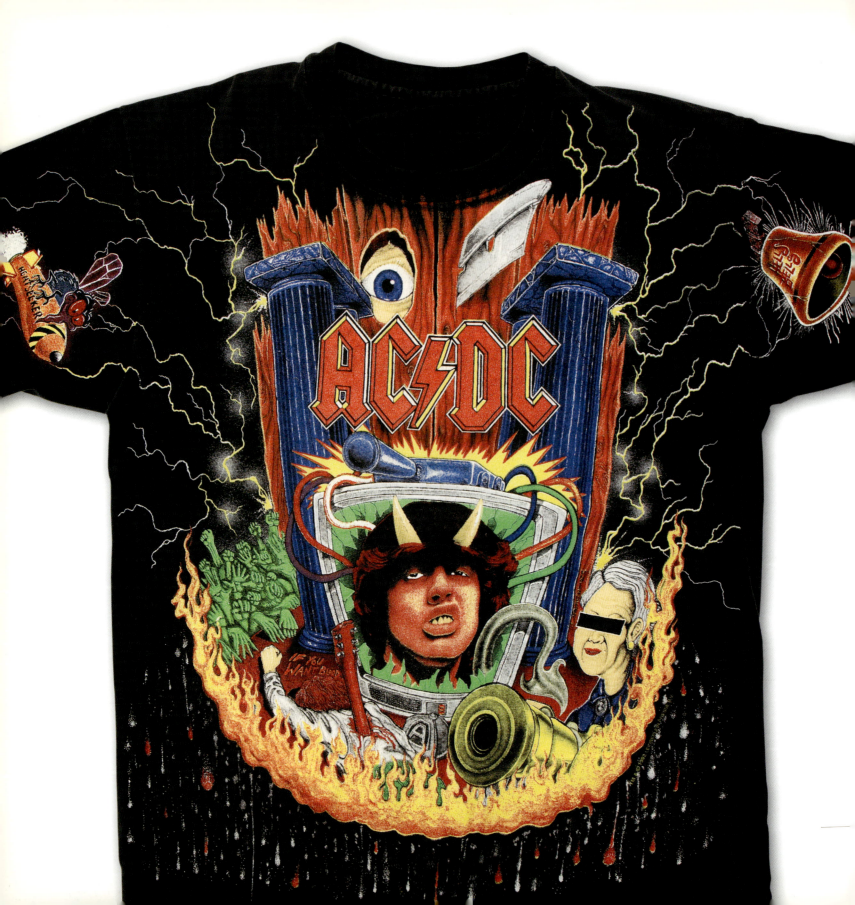

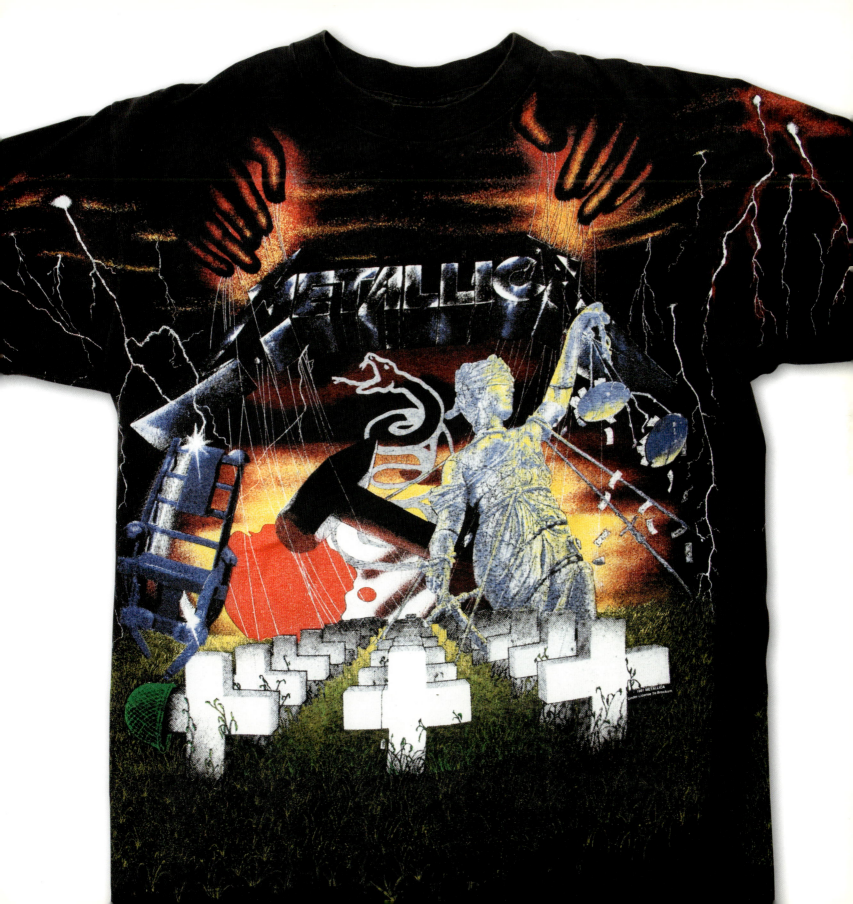

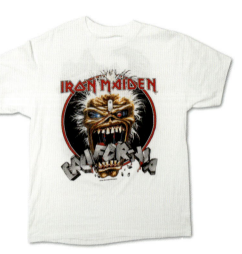
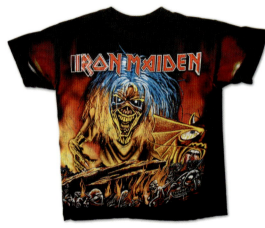
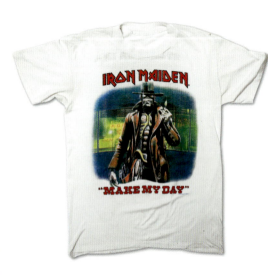
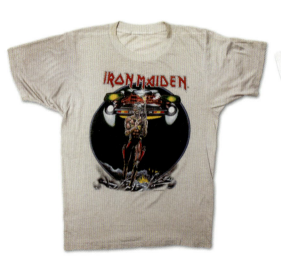

↑ Iron Maiden, various, 1979–1988

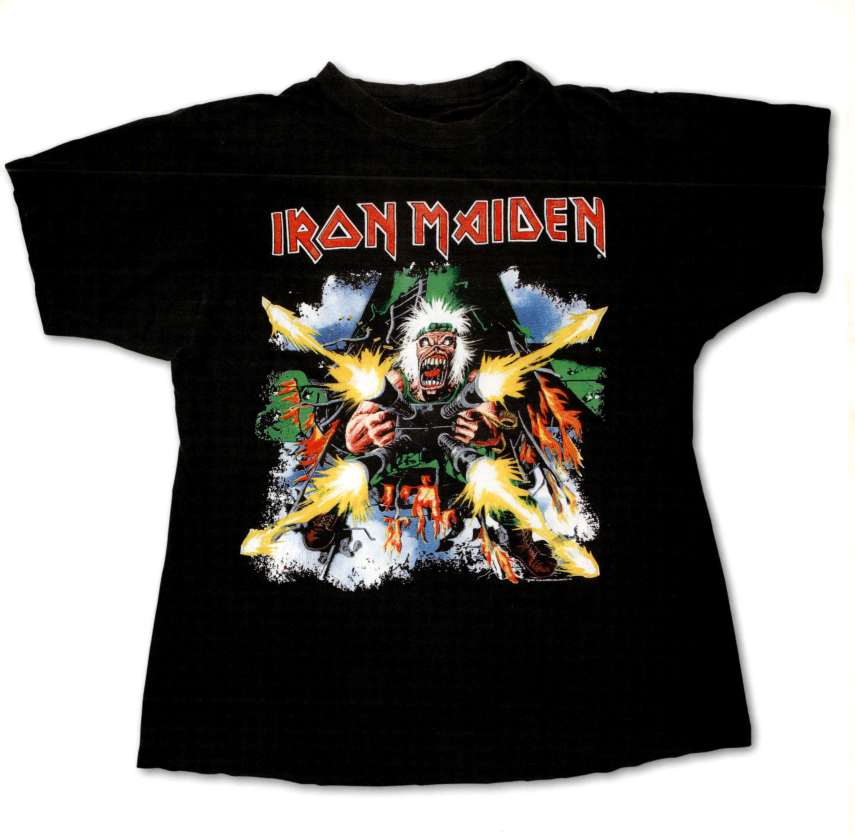

↑ Iron Maiden, ca. 1989

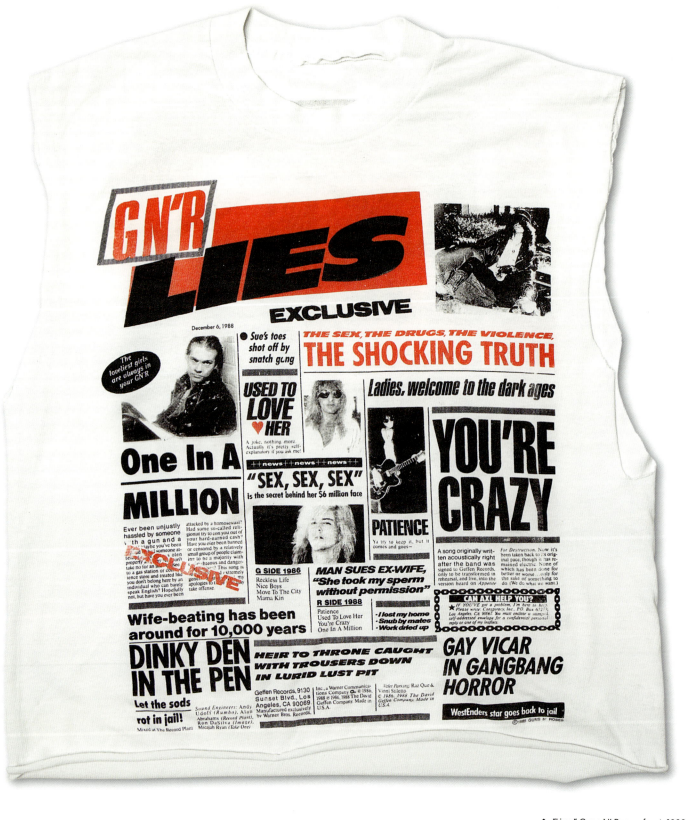

↑ "Lies," Guns N' Roses, front, 1988

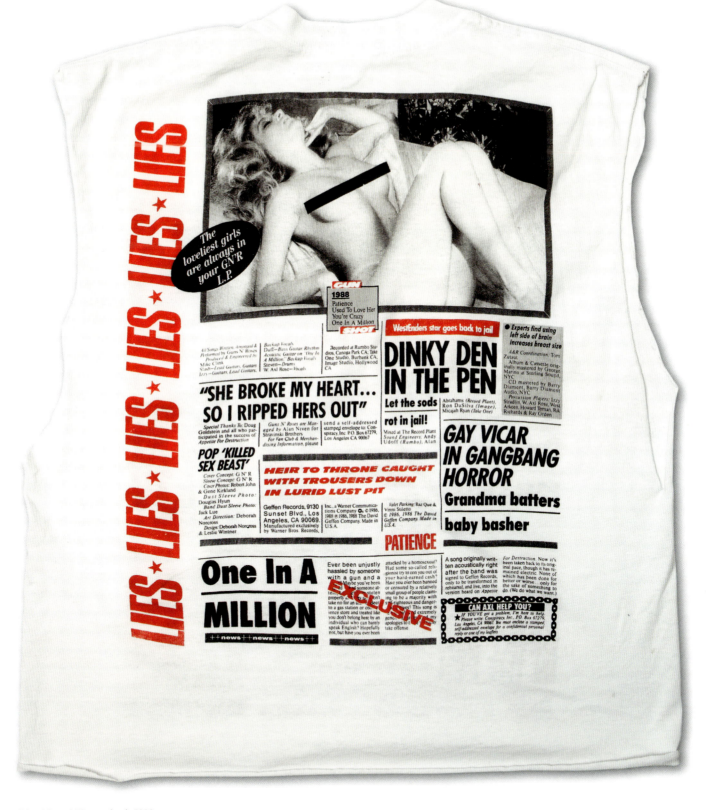

↑ "Lies," Guns N' Roses, back, 1988

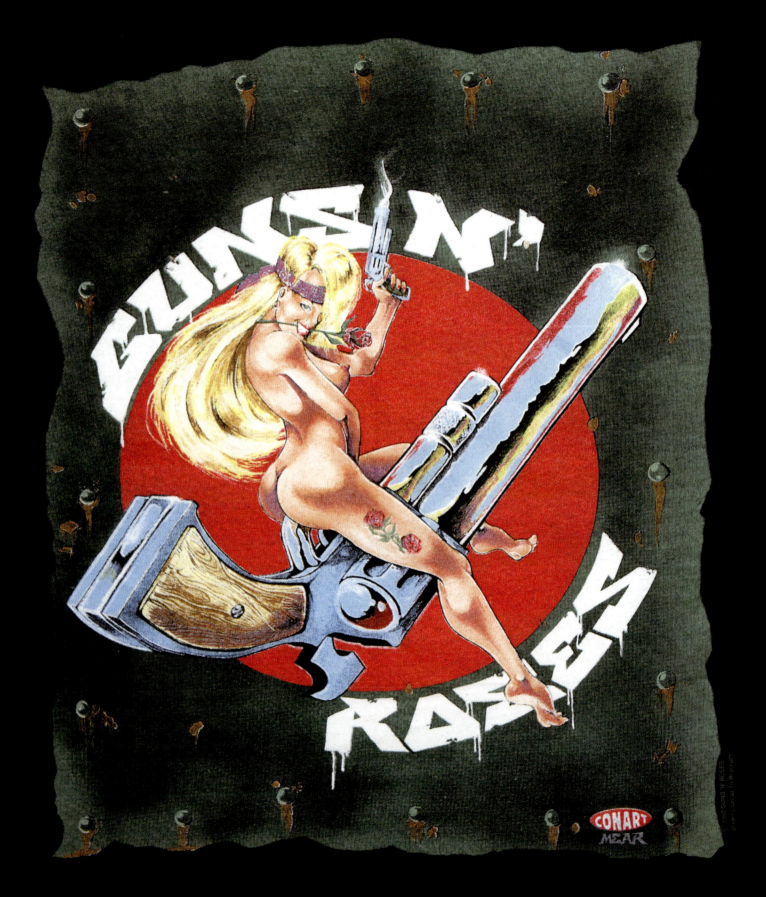

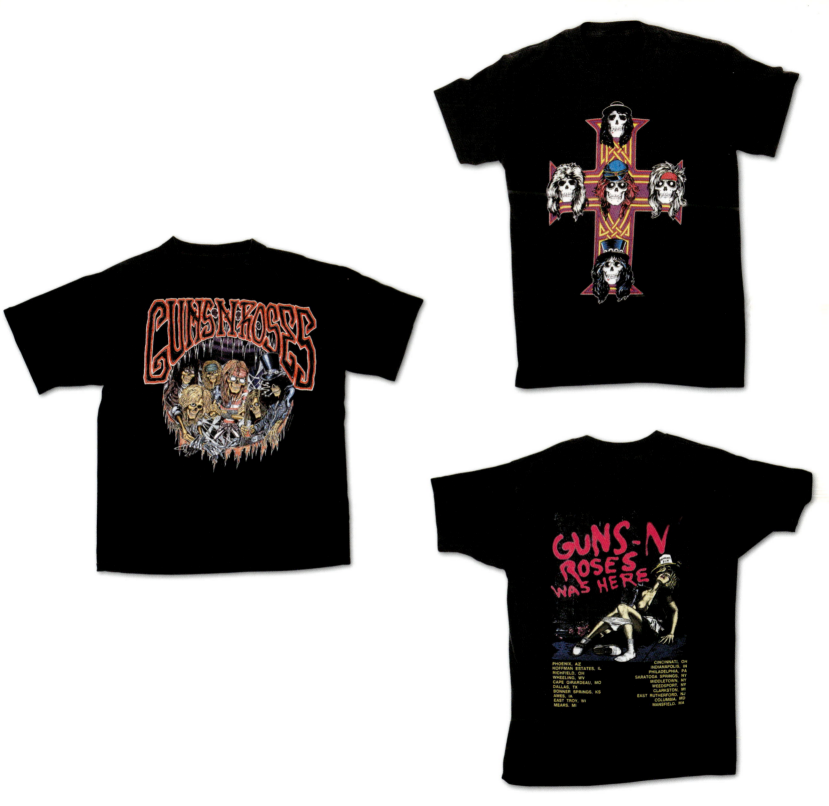

← Guns N' Roses, 1992
↑ Guns N' Roses, 1987; Guns N' Roses, ca. 1993; "Guns N' Roses Was Here" Tour, 1991

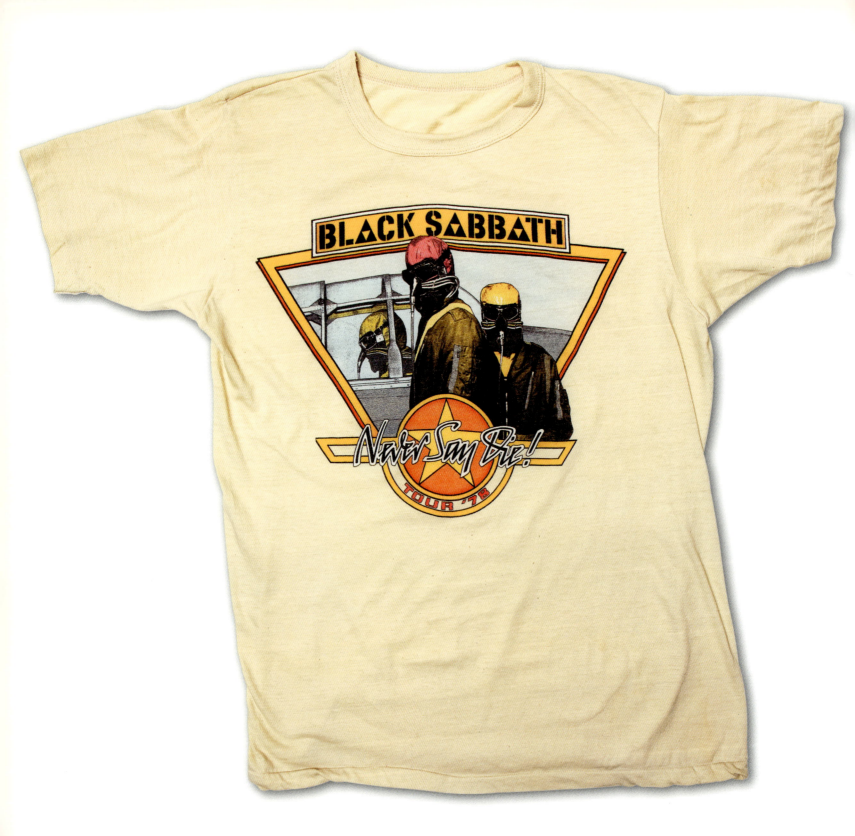

↑ "Never Say Die! Tour," Black Sabbath, 1978

↑ Jane's Addiction, 1990

↑ The Beach Boys, 1980

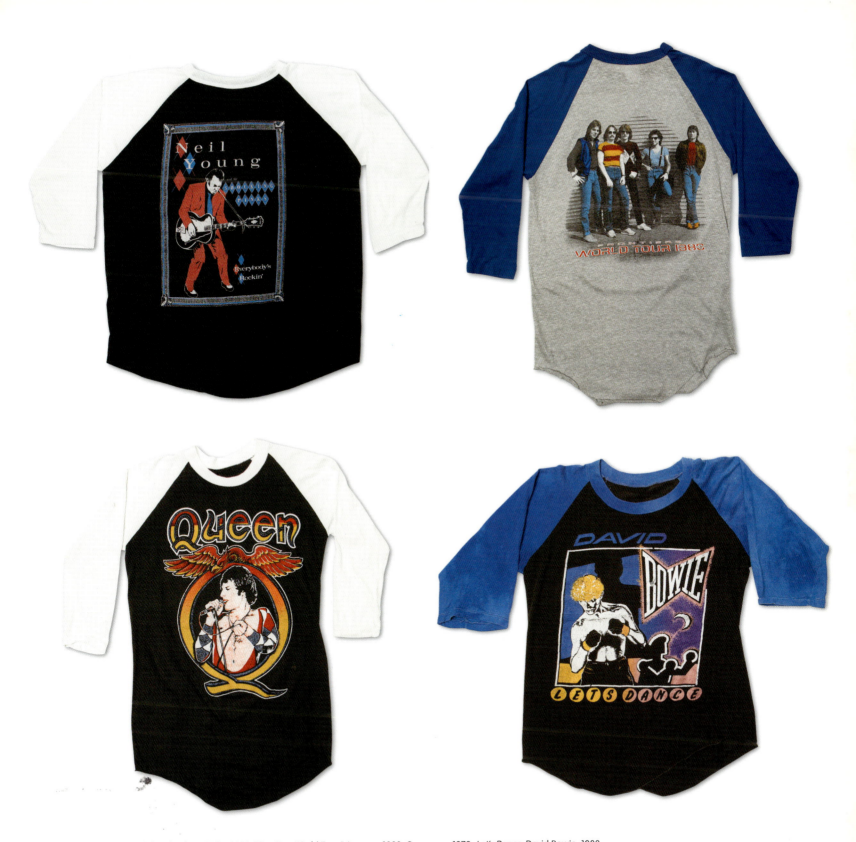

↑ Neil Young and the Shocking Pinks, 1983; "Frontiers World Tour," Journey, 1983; Queen, ca. 1979; *Let's Dance*, David Bowie, 1983

MUSIC 109

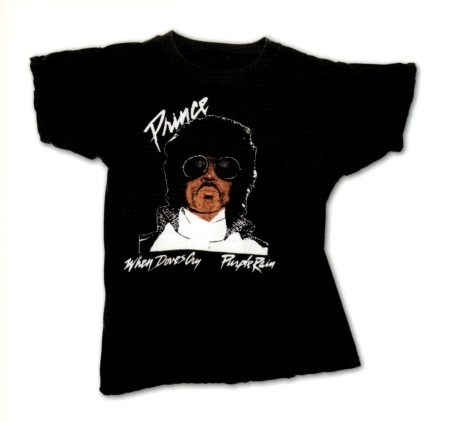
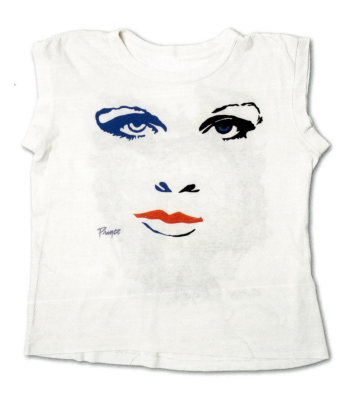
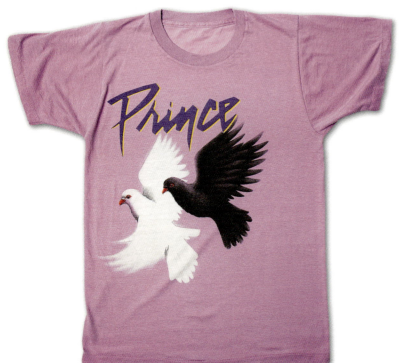
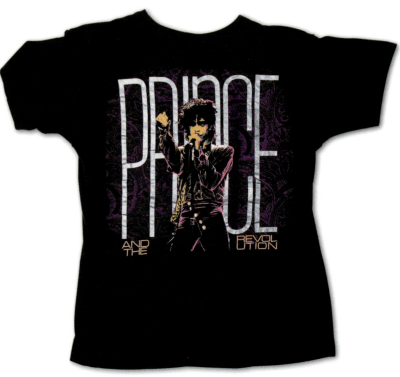

↑ *Purple Rain*, Prince, 1984; Prince, ca. 1983; Prince, 1989; Prince and the Revolution, ca. 1983

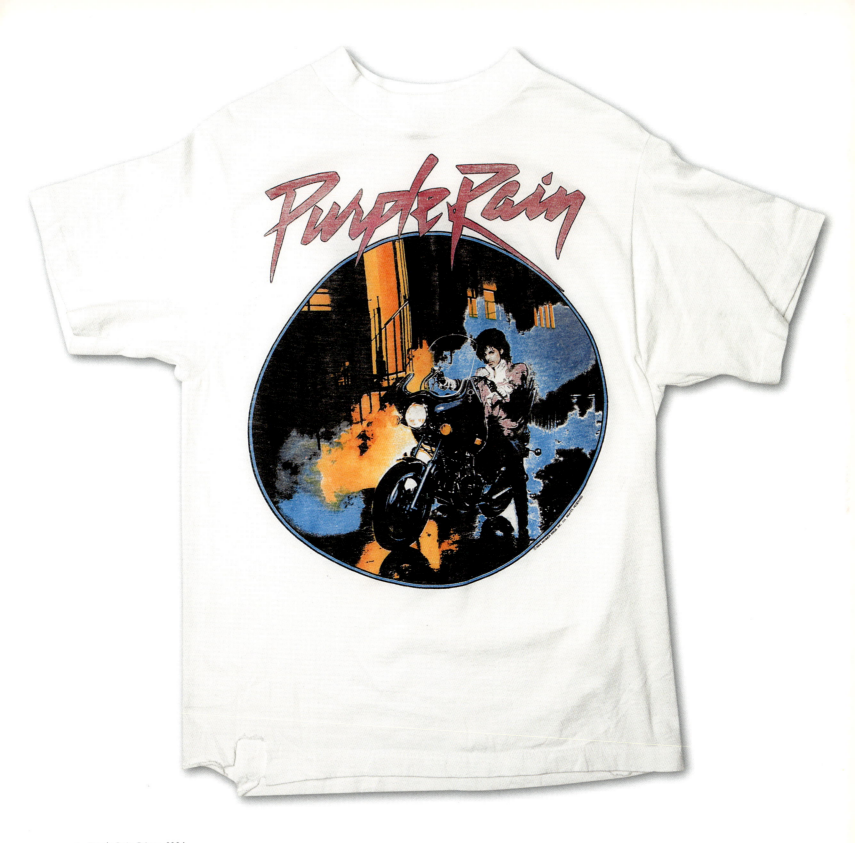

↑ *Purple Rain*, Prince, 1984

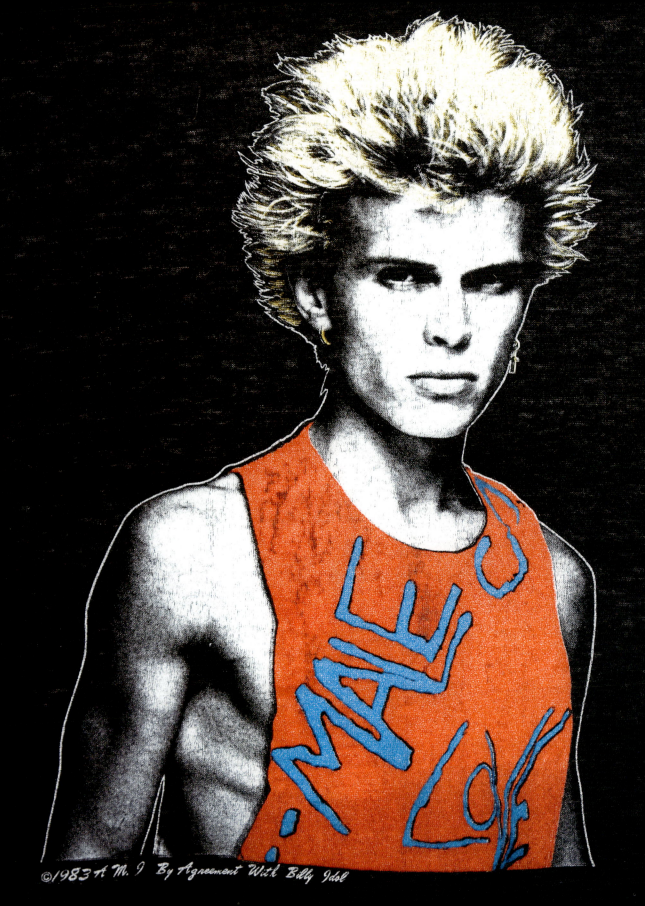

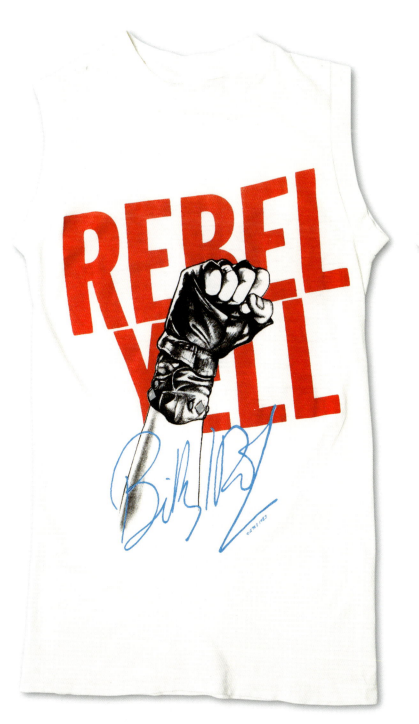
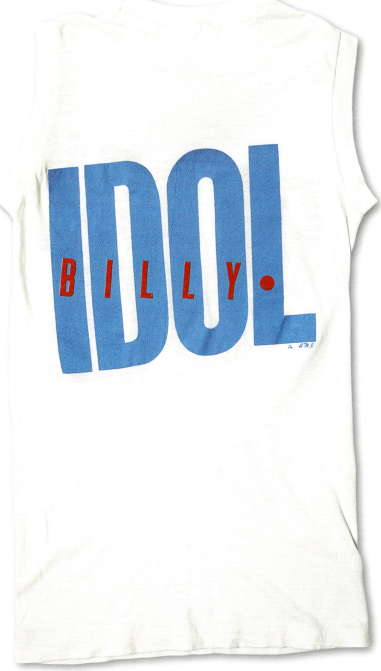

← Billy Idol, 1983
↑ "Rebel Yell," Billy Idol, front and back, 1983

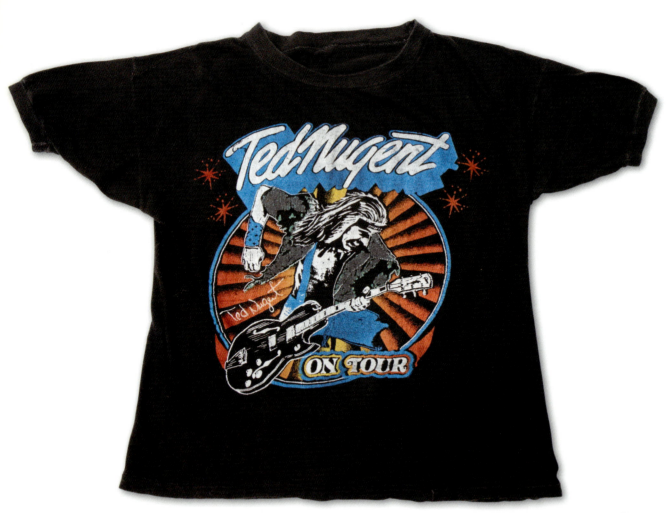
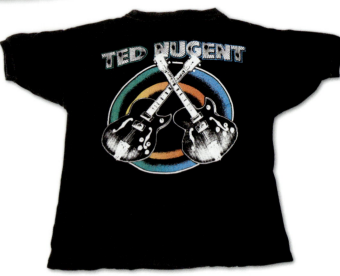

↑ "On Tour," Ted Nugent, front and back, ca. 1976

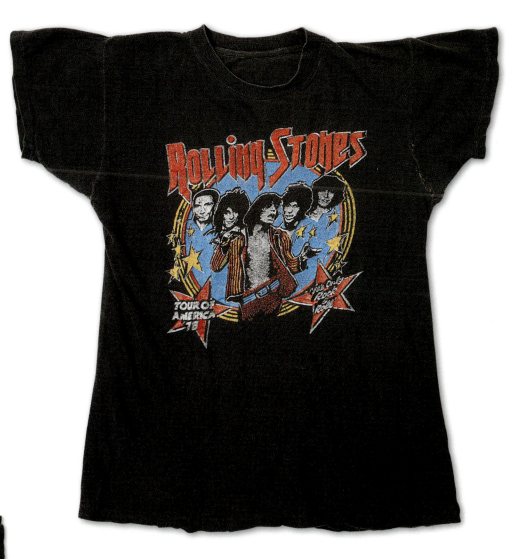
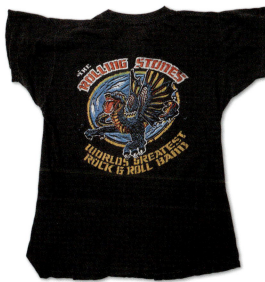

↑ "Tour of America," The Rolling Stones, front and back, 1978

MUSIC 115

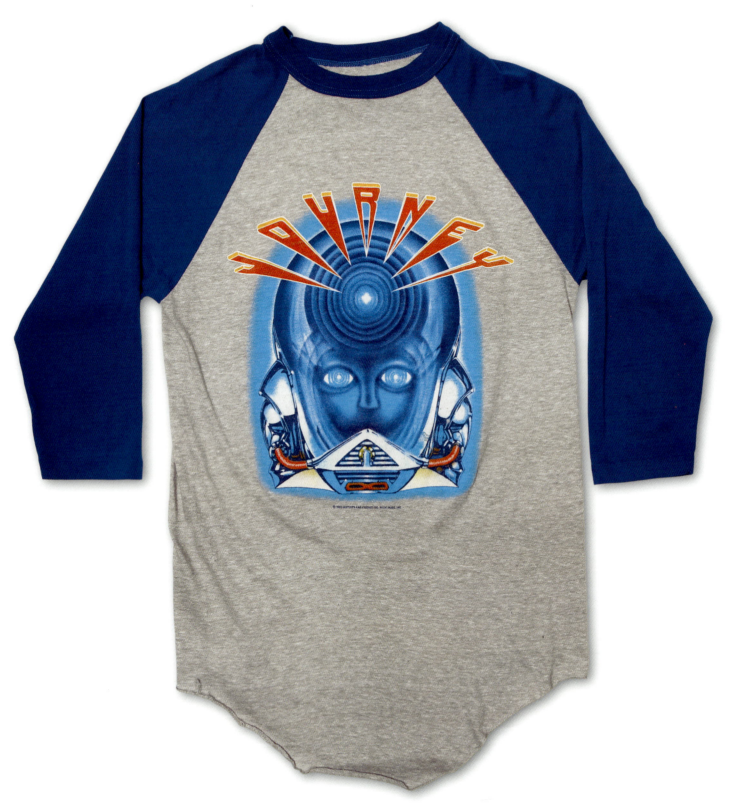

↑ "Frontiers World Tour," Journey, 1983

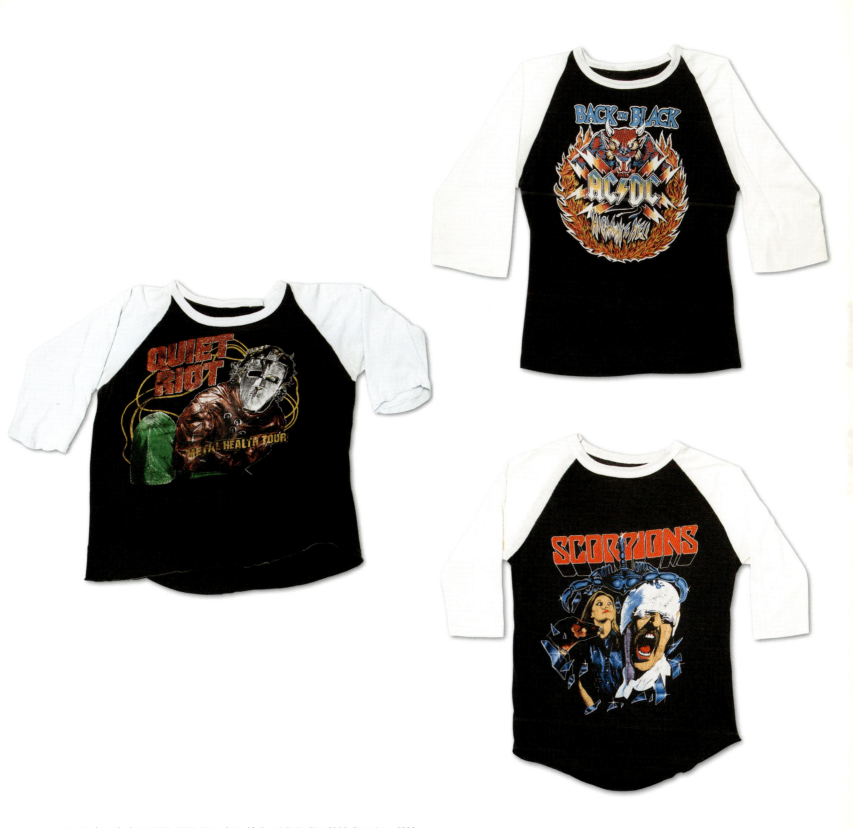

↑ "Back in Black," AC/DC, 1980; "Metal Health Tour," Quiet Riot, 1983; Scorpions, 1980

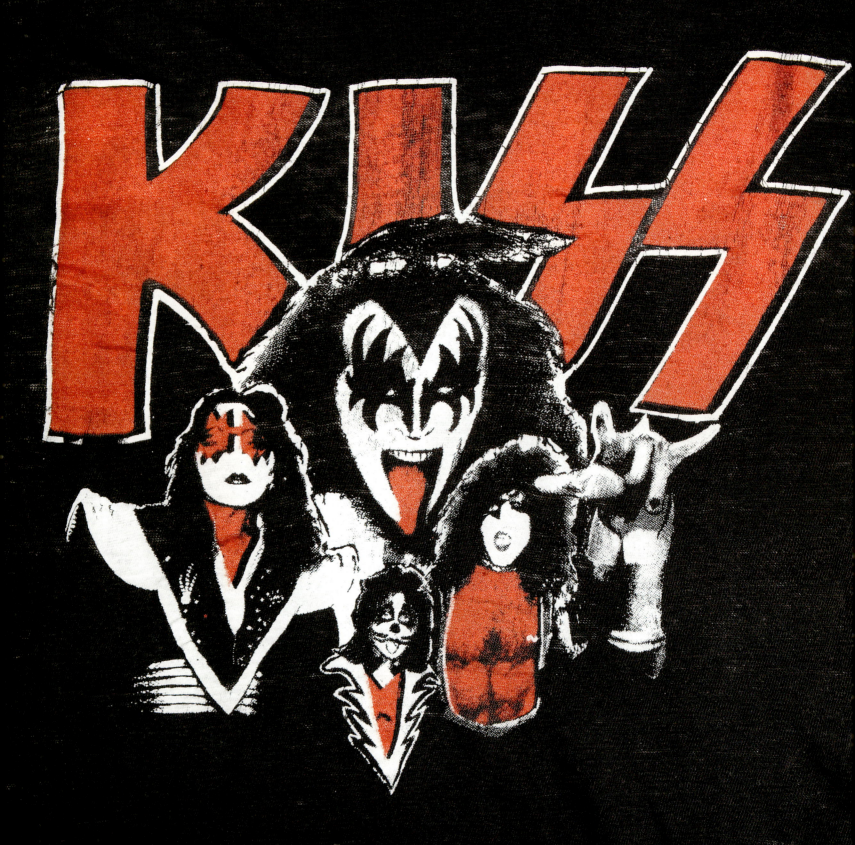

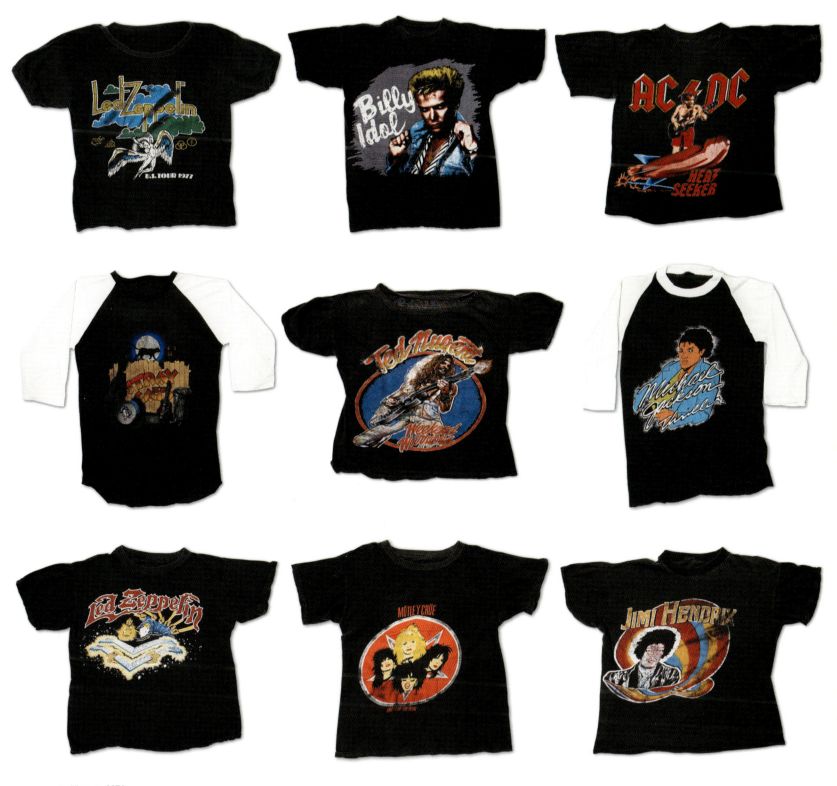

← Kiss, ca. 1979
↑ Bootlegs, various, 1973–1988

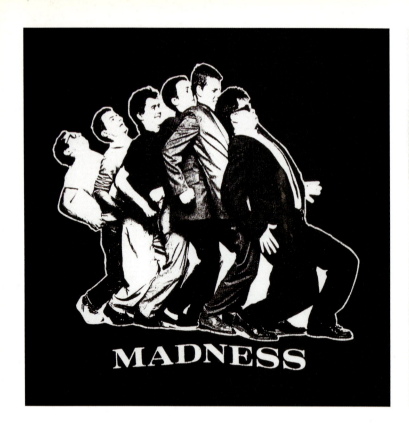 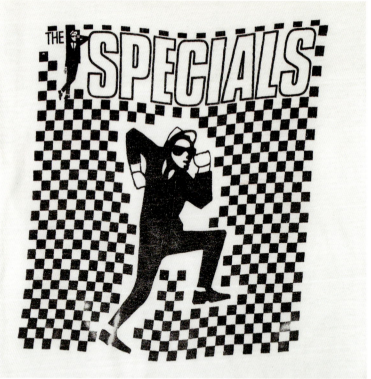 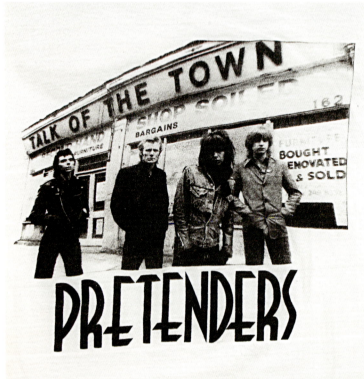 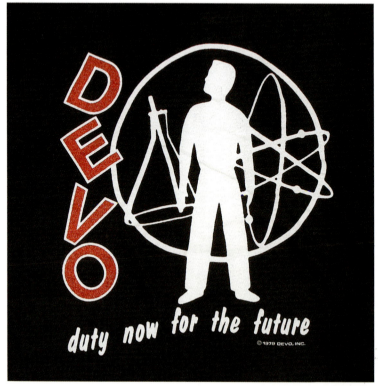

↑ Madness, 1976; The Specials, 1977; "Talk of the Town," The Pretenders, 1981; *Duty Now for the Future*, Devo, 1979
→ Motörhead, 1980s

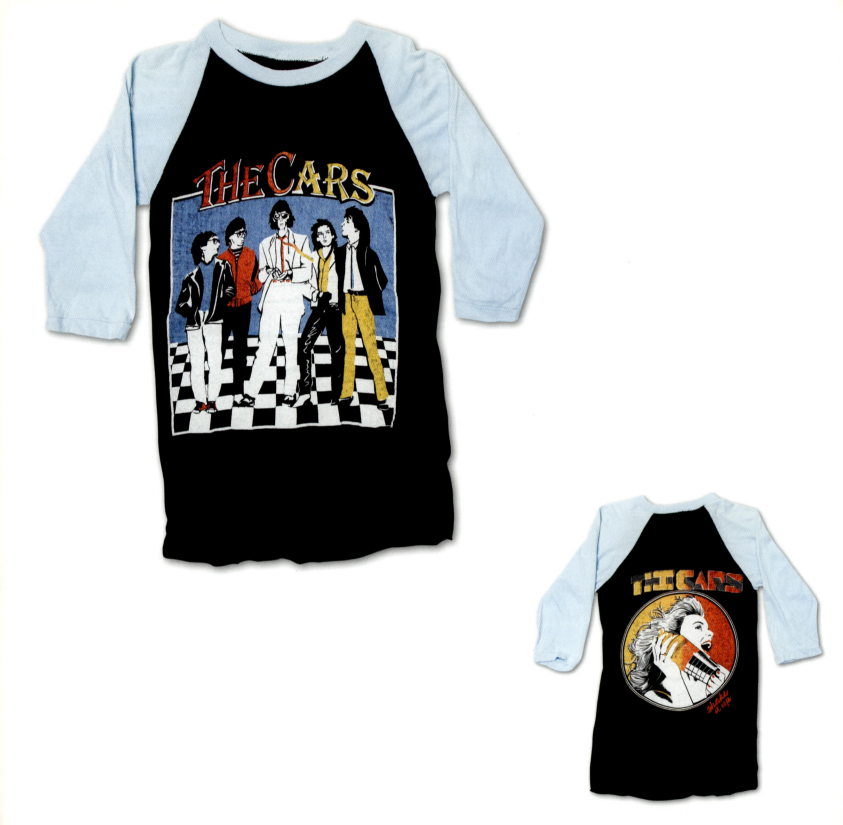

↑ *Shake It Up*, The Cars, front and back, 1981

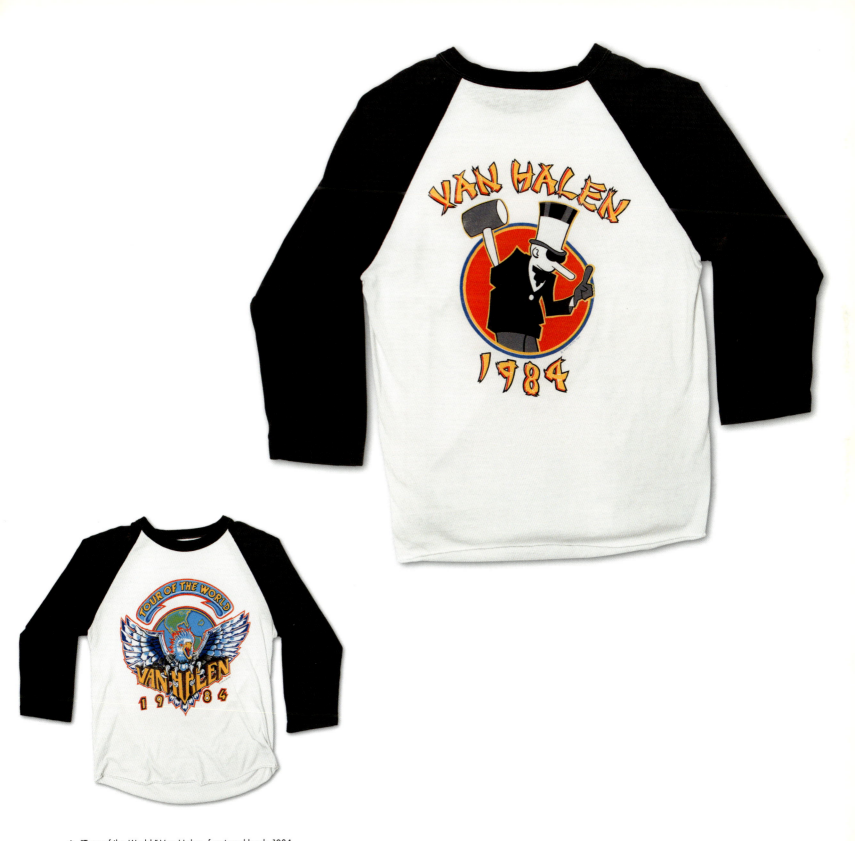

↑ "Tour of the World," Van Halen, front and back, 1984

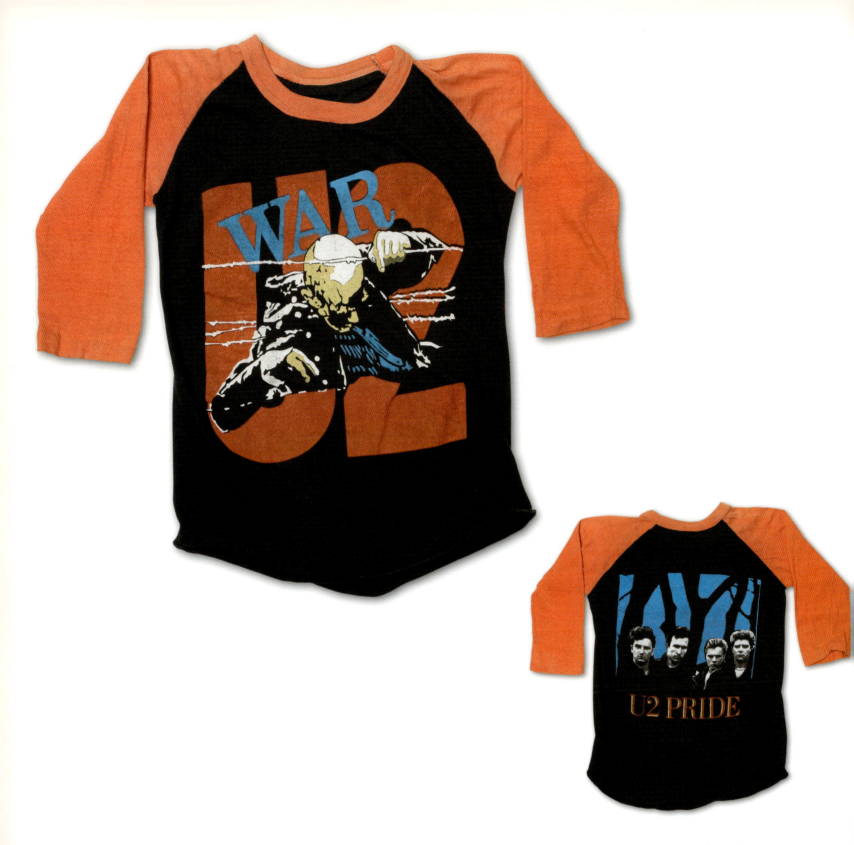

↑ *War*, U2, front and back, 1982

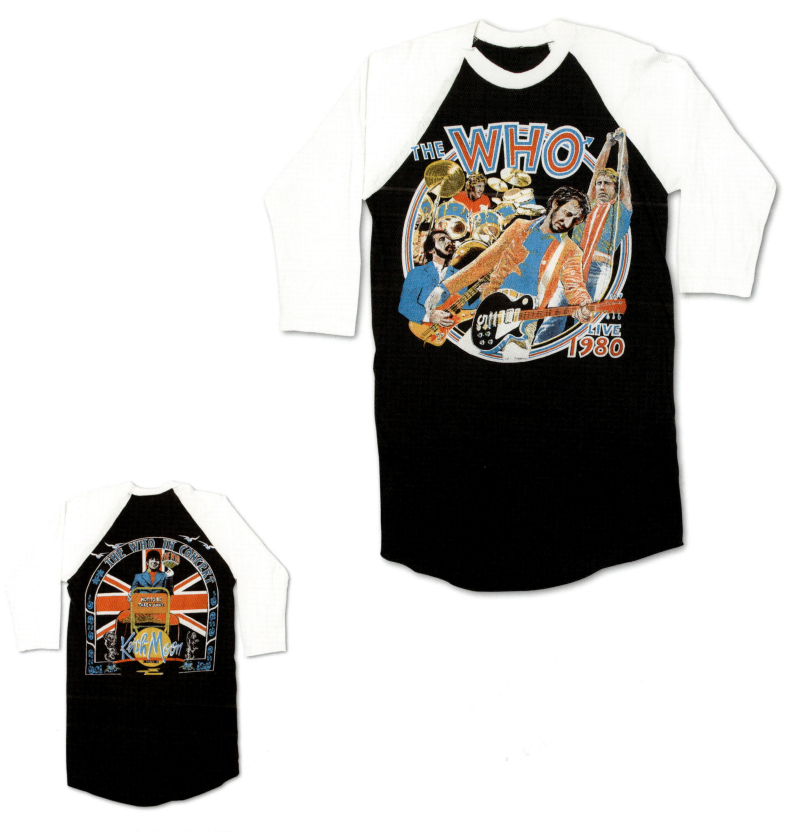

↑ "Keith Moon," The Who, front and back, 1980

↑ Bee Gees, ca. 1979; "Neil Diamond in Concert," ca. 1979; *Freeze Frame*, The J. Geils Band, 1981; "Paradise Theater World Tour," Styx, 1981

↑ The Cult, 1980

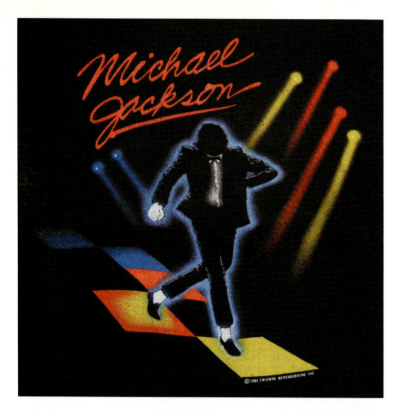
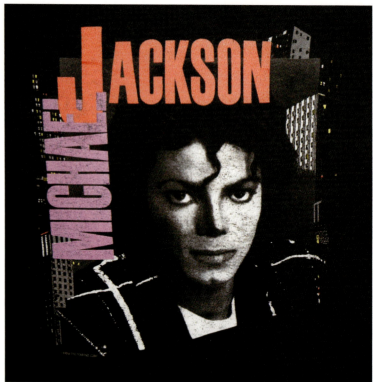
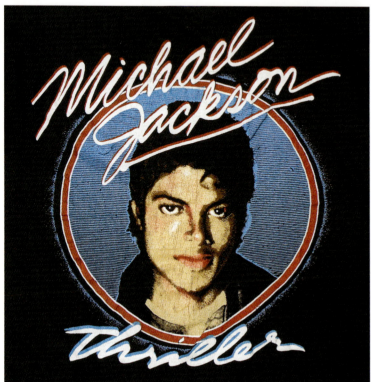
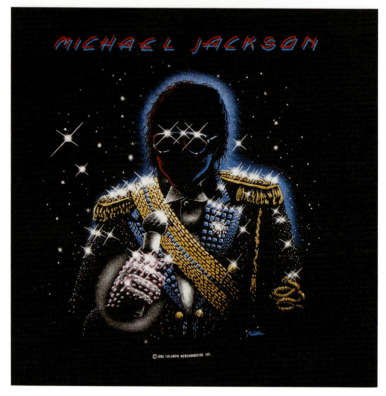

↑ Michael Jackson, 1984; Michael Jackson, 1987; "Thriller," Michael Jackson, 1983; Michael Jackson, 1984
→ Michael Jackson, 1984

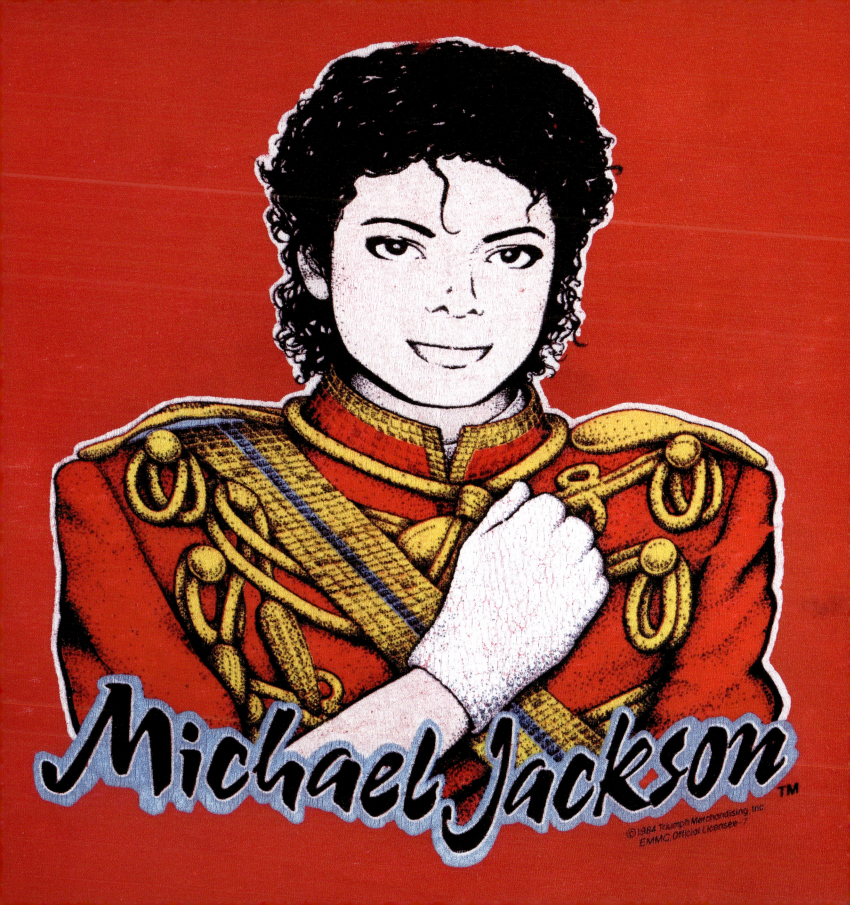

BEAT IT

©1984 Triumph Merchandising, Inc.
EMMC, Official Licensee

™

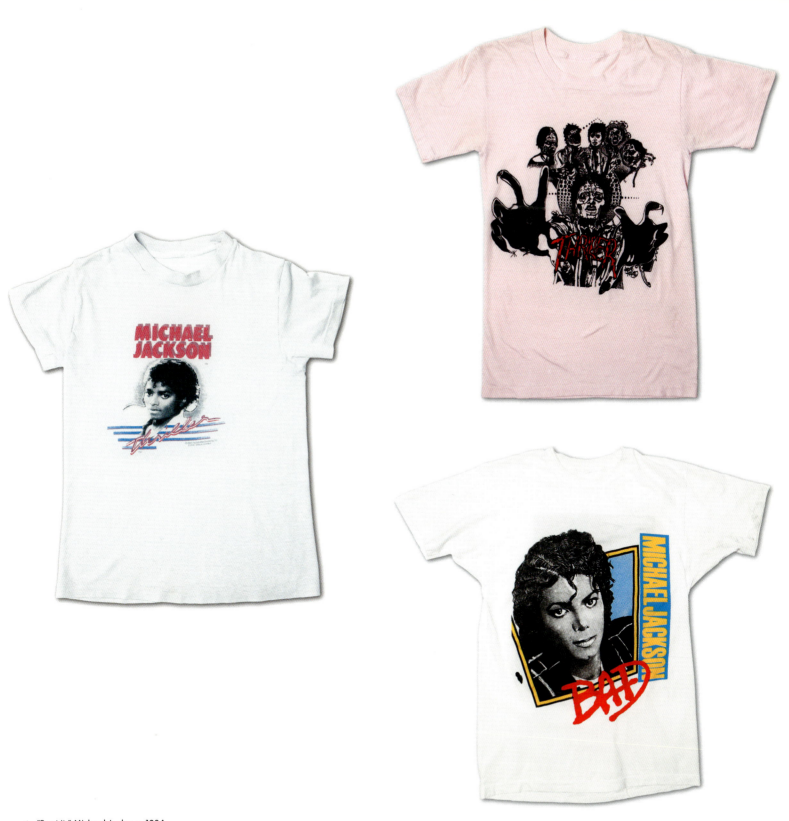

← "Beat It," Michael Jackson, 1984
↑ "Thriller," Michael Jackson, 1984; *Thriller*, Michael Jackson, 1984; *Bad*, Michael Jackson, 1987

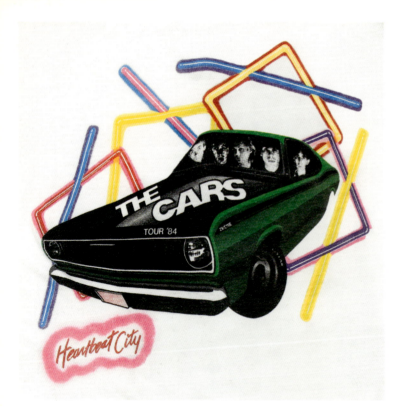
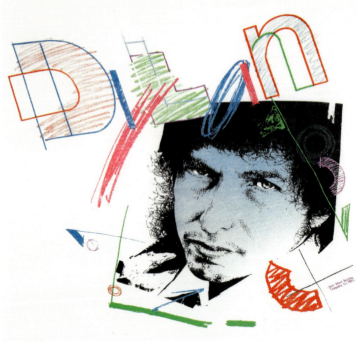
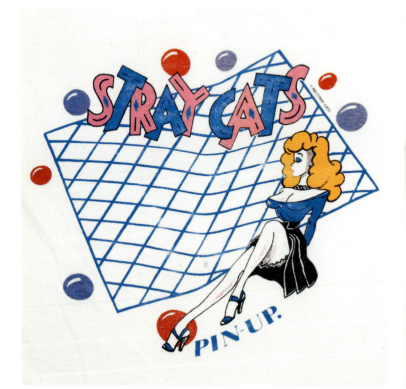
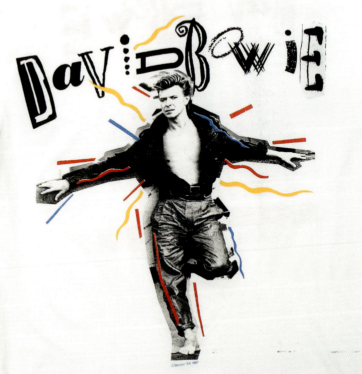

↑ "*Heartbreak City* Tour," The Cars, 1984; Bob Dylan, 1986; "Pin-Up," Stray Cats, 1983; David Bowie, 1987

→ *Knee Deep in the Hoopla*, Starship, 1985

STARSHIP

knee deep in the hoopla

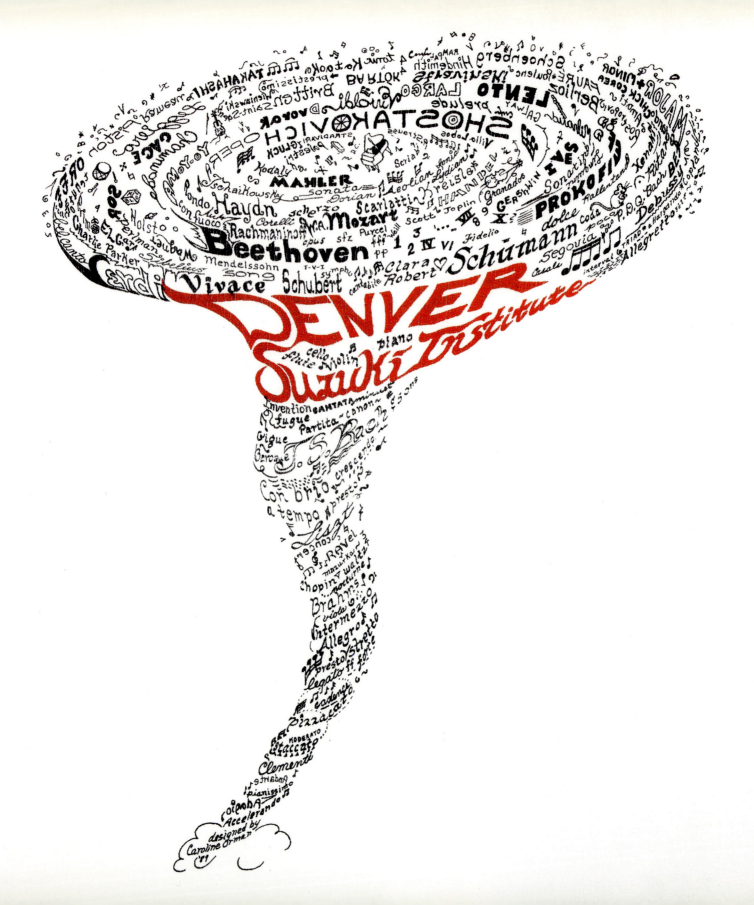

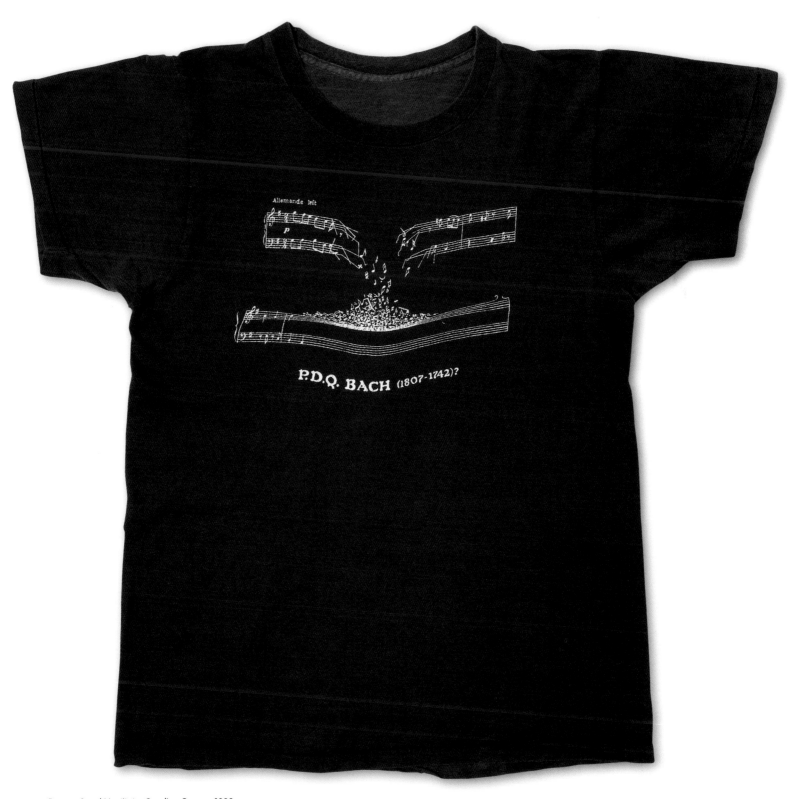

← Denver Suzuki Institute, Caroline Orman, 1989
↑ "P.D.Q. Bach," Peter Schickele, ca. 1983

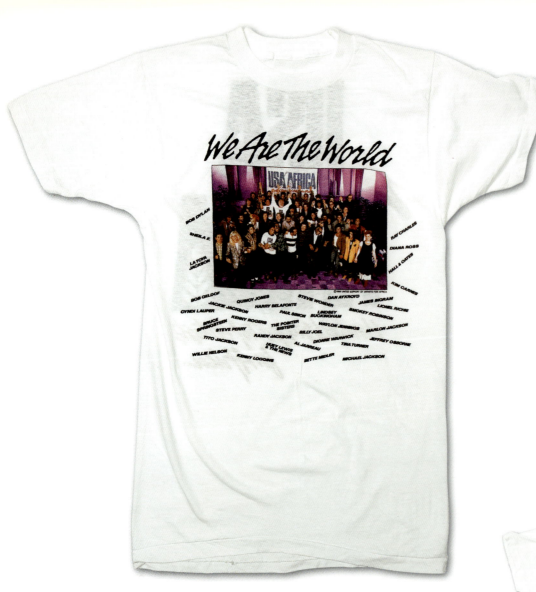
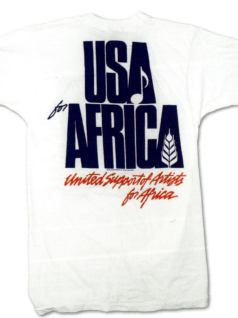

↑ "We Are the World," USA for Africa, front and back, 1985

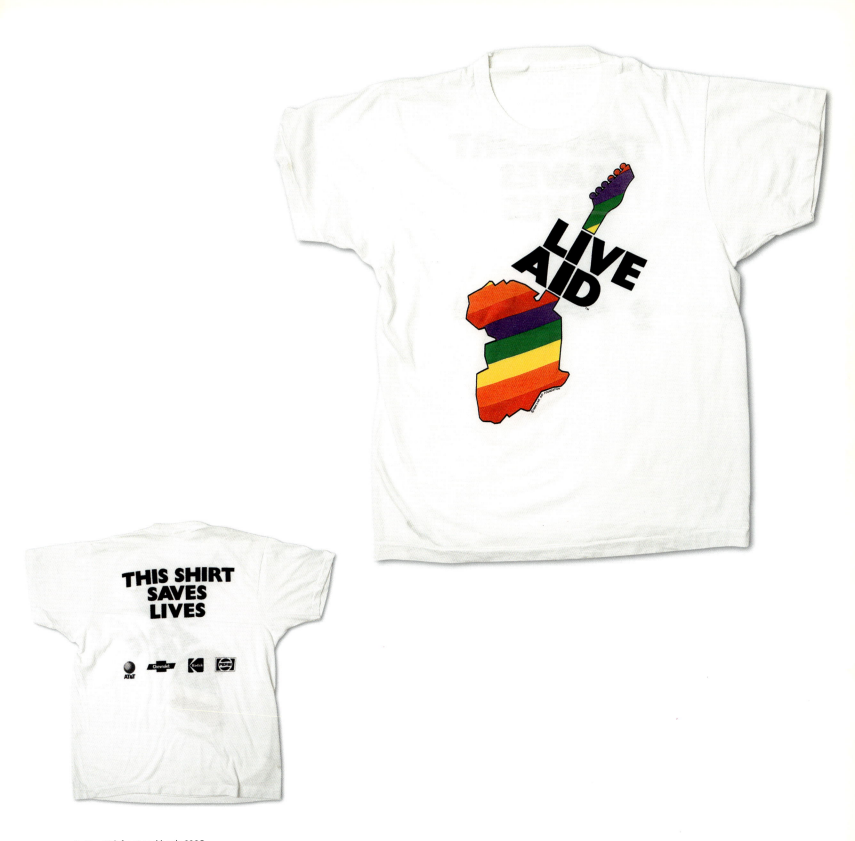

↑ Live Aid, front and back, 1985

MUSIC 137

↑ The Police, 1983

↑ Go-Go's, 1981

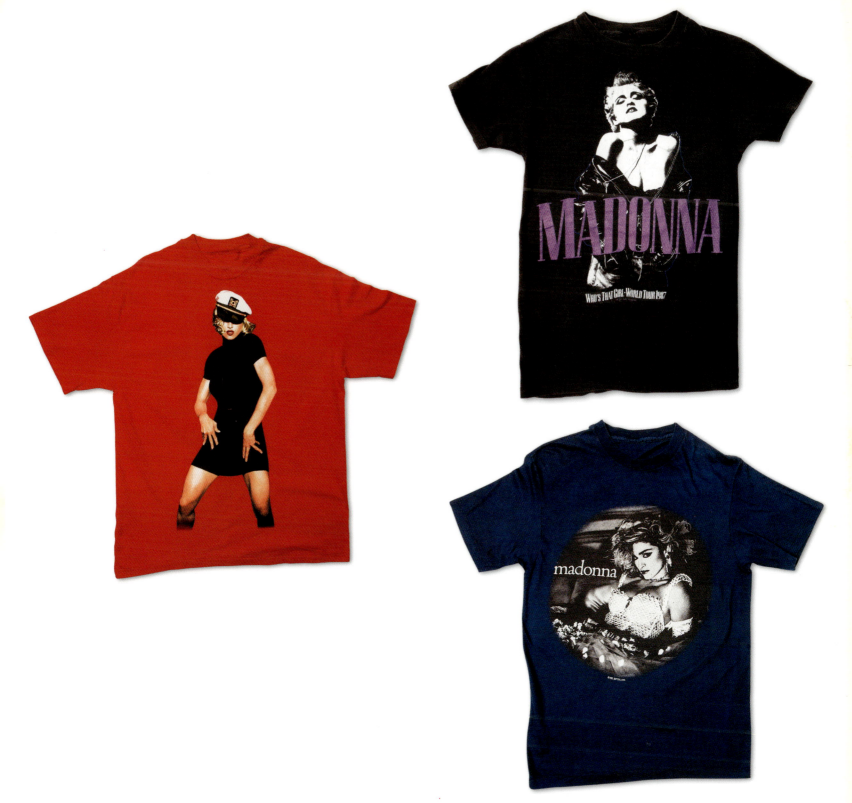

← *Who's That Girl*, Madonna, 1987
↑ Madonna, 1987; Madonna, ca. 1996; *Like a Virgin*, Madonna, 1985

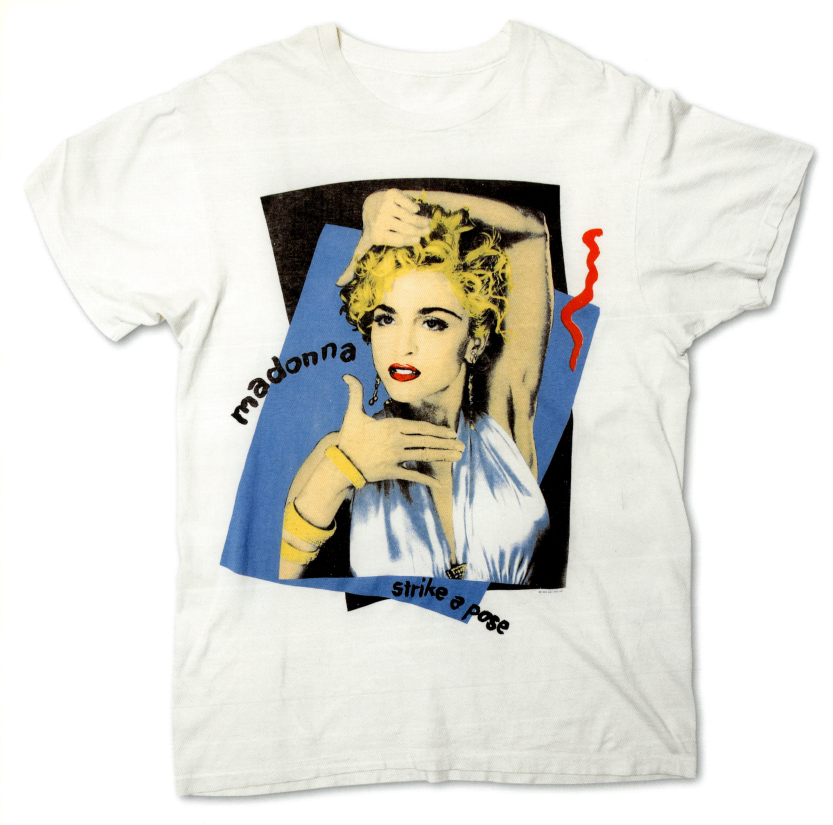

↑ Madonna, 1991

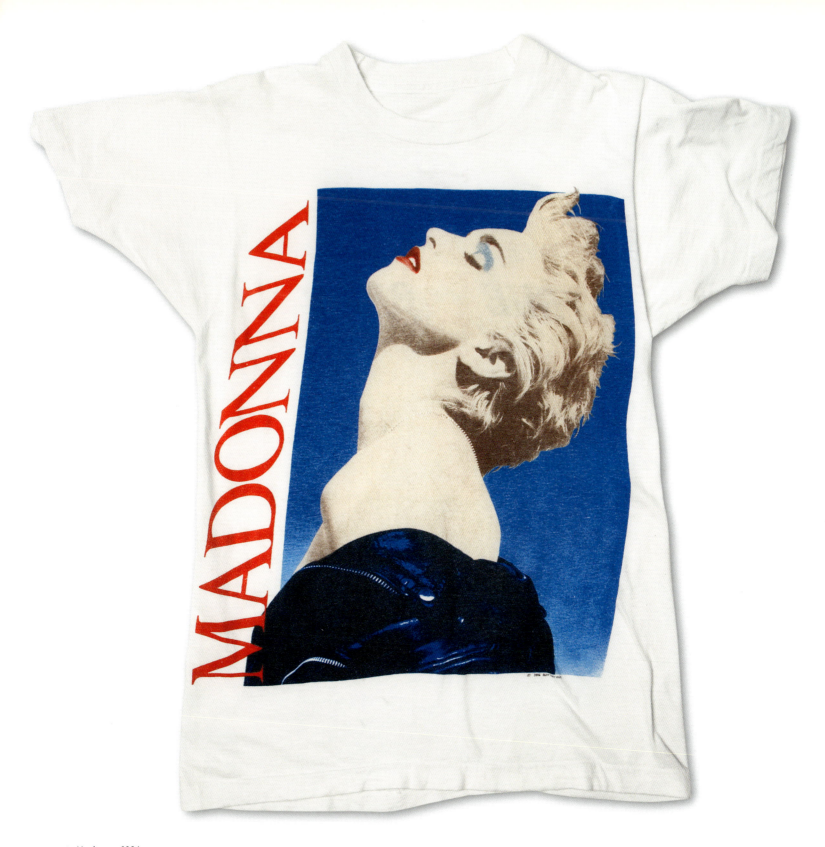

↑ Madonna, 1986

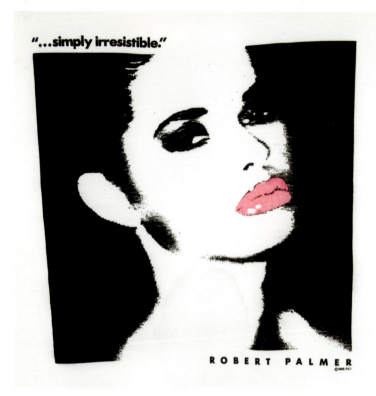
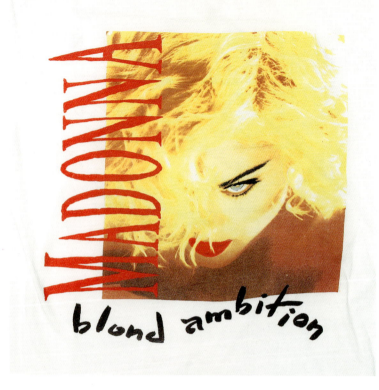
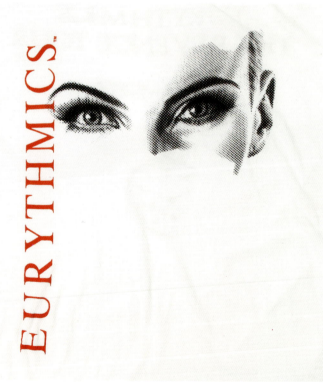
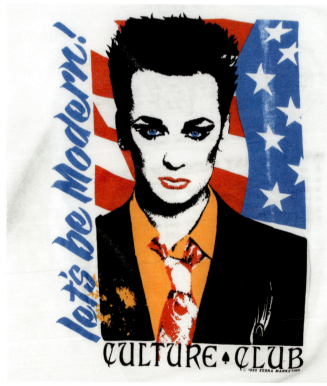

↑ "Simply Irresistible," Robert Palmer, 1988; "Blond Ambition" Tour, Madonna, 1990; Eurythmics, ca. 1986; "*Let's Be Modern!* Tour," Culture Club, 1985
→ Roxy Music, ca. 1983

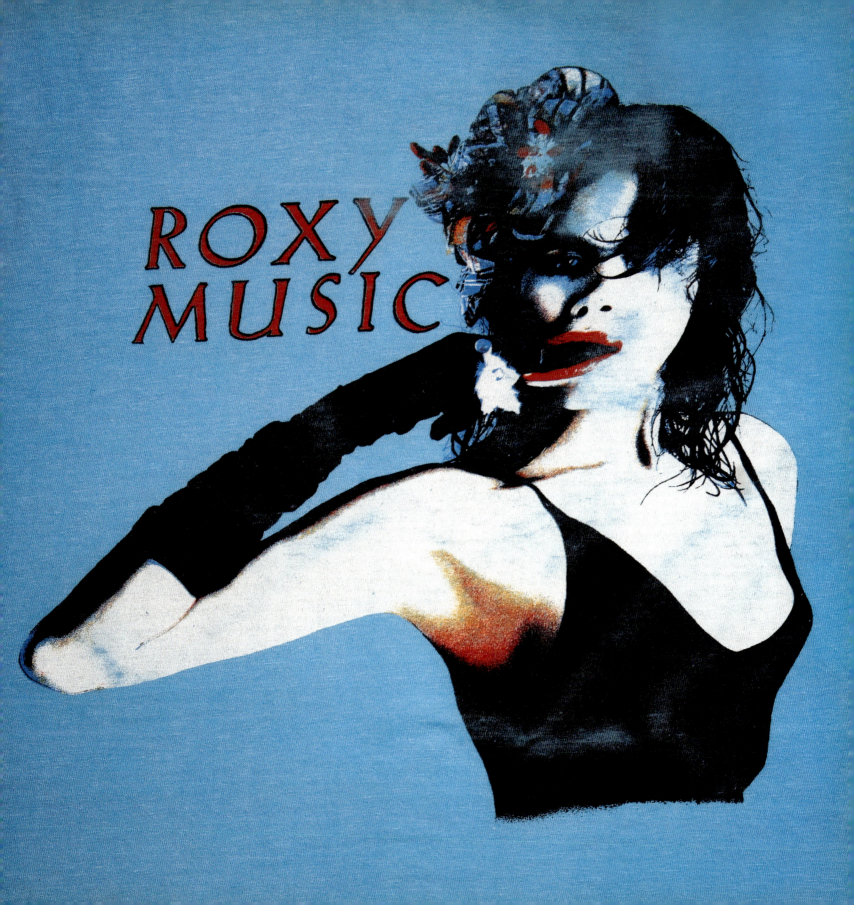

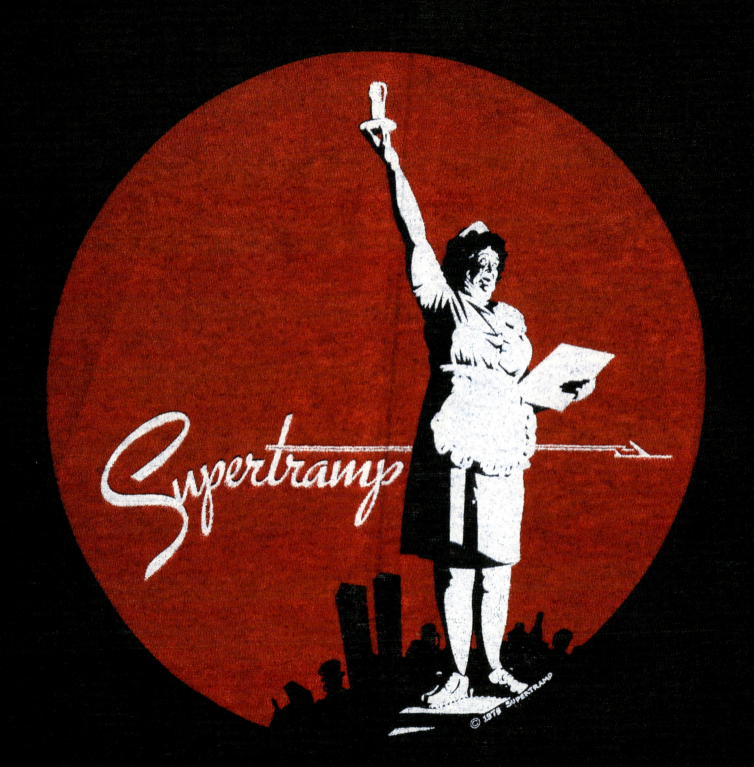

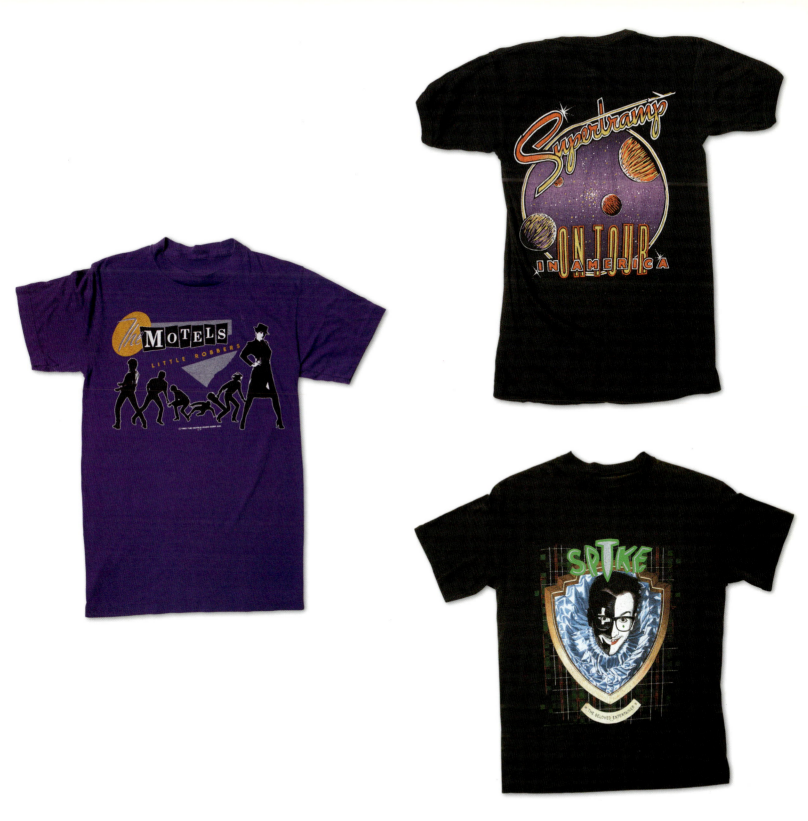

← *Breakfast in America*, Supertramp, 1979
↑ "On Tour in America," Supertramp, 1979; The Motels, 1983; *Spike*, Elvis Costello, 1989

↑ "The Fat Boys Are Back," front and back, 1985

148 MUSIC

↑ "Stop the B-52's Before It's Too Late Tour," front and back, 1980

↑ Rod Stewart, ca. 1983
←← *Radio*, L. L. Cool J, 1985

↑ Elvira, 1983

← Grand Funk Railroad, 1976
↑ David Lee Roth, 1986

↑ Frankie Goes to Hollywood, front, 1985; Triumph, 1986; Van Halen, 1986; "Tour '80," Genesis, 1980

↑ Adam and the Ants, 1981

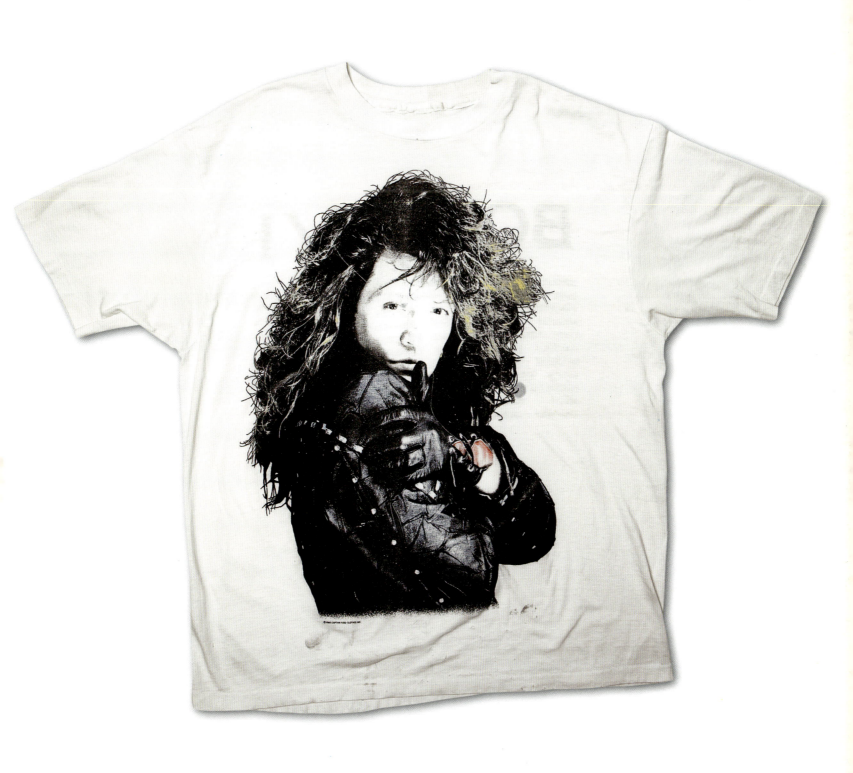

← *Rock in a Hard Place,* Aerosmith, 1982
↑ Bon Jovi, 1988

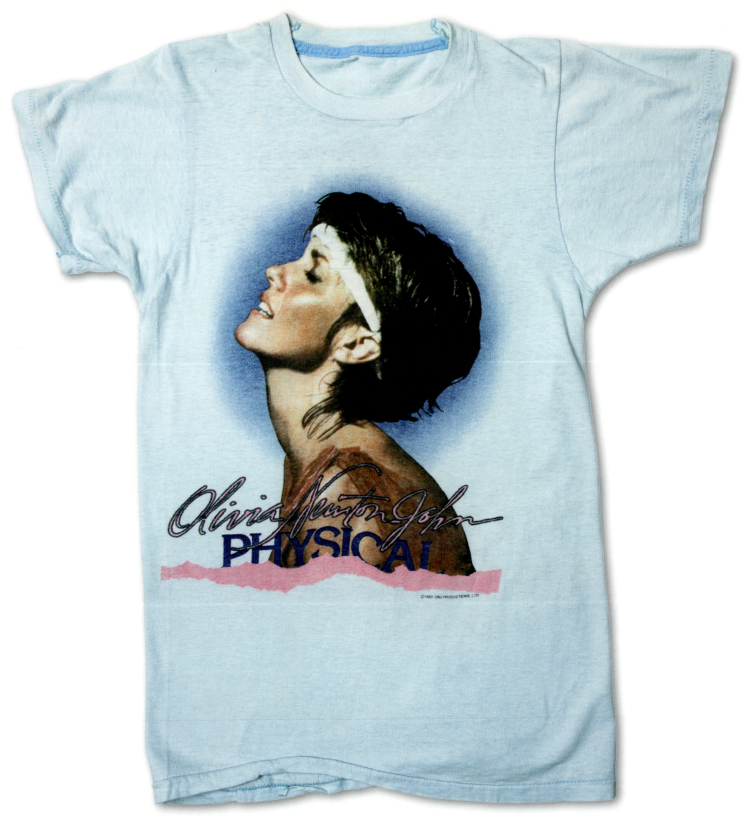

↑ *Physical*, Olivia Newton-John, 1982

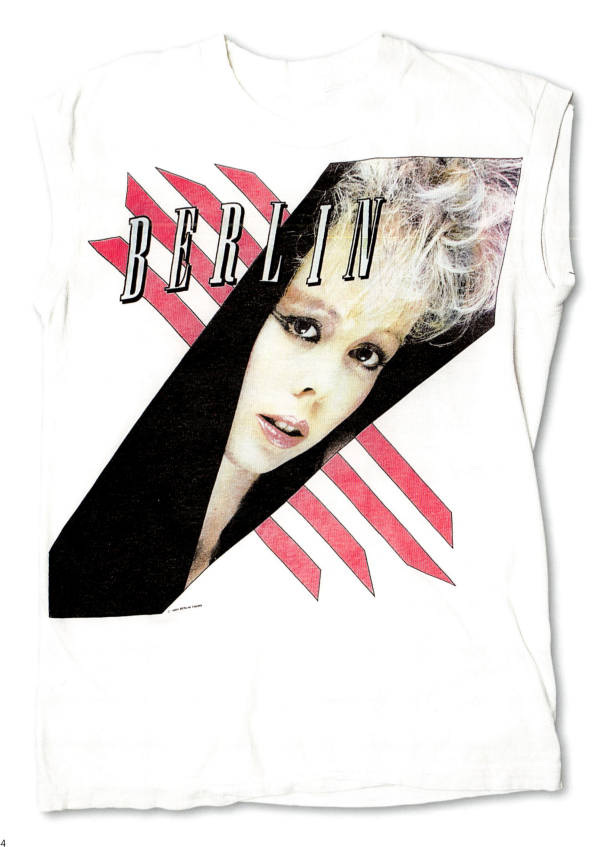

↑ Berlin, 1984

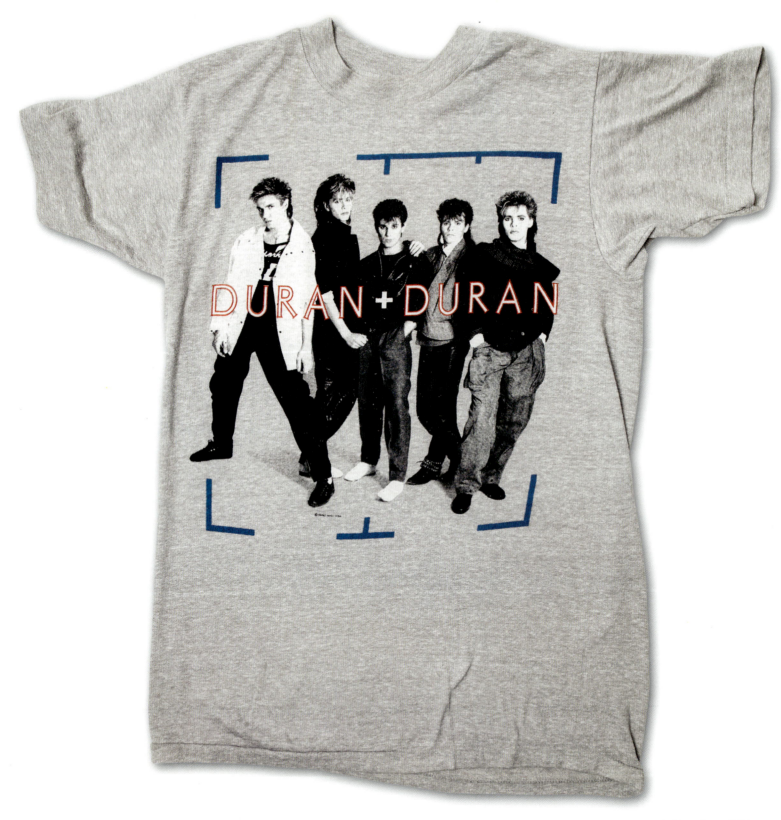

↑ Duran Duran, 1984

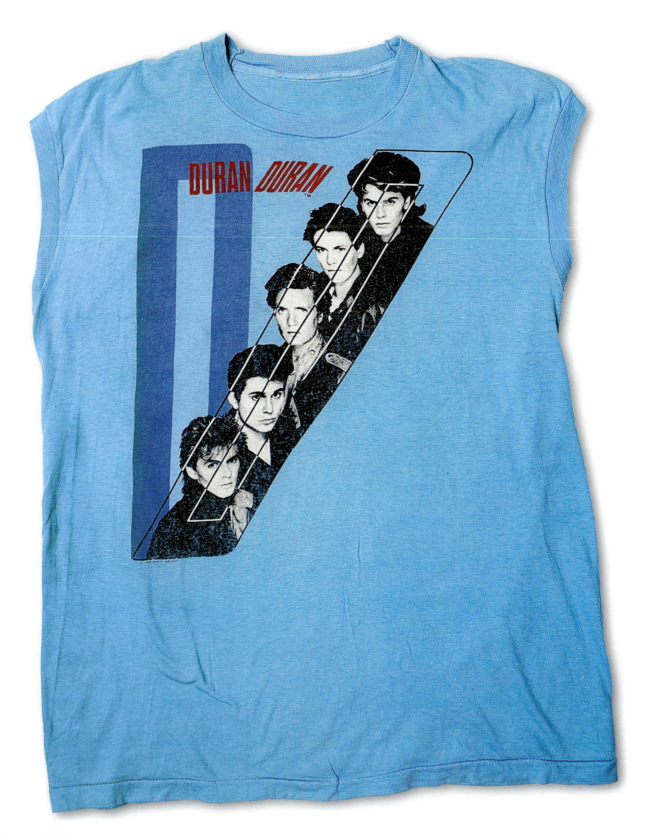
↑ Duran Duran, ca. 1983

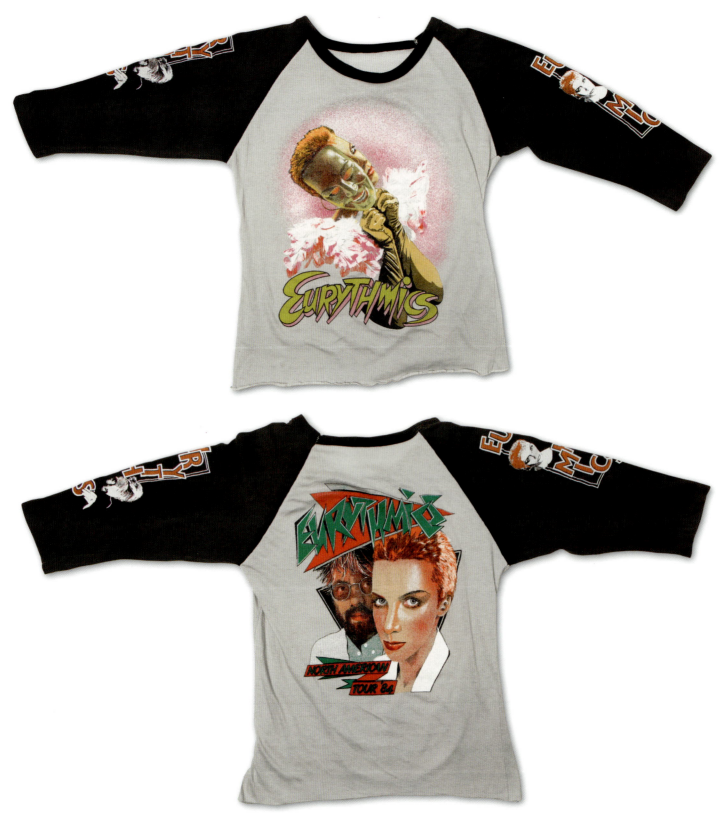

↑ Eurythmics Tour, front and back, 1984

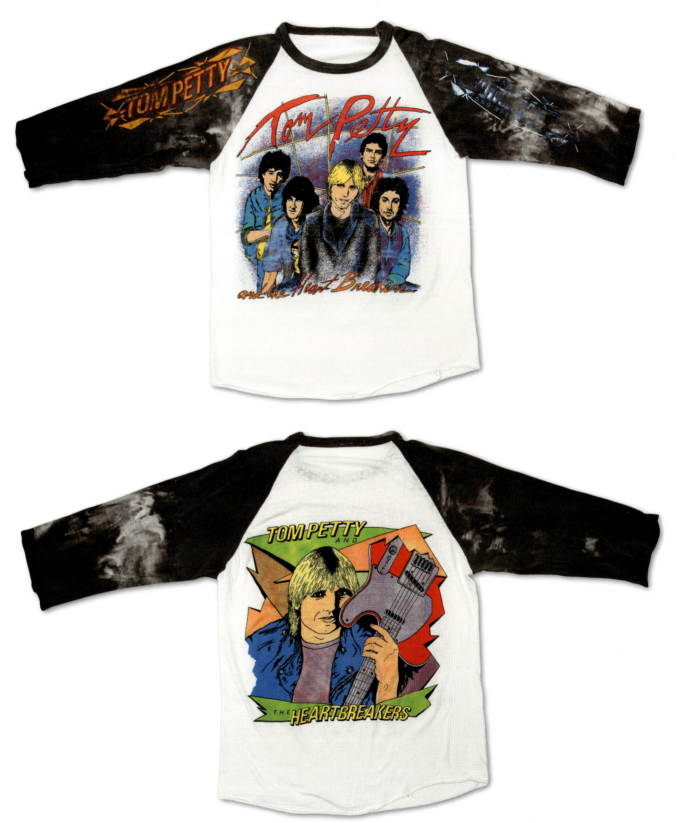

↑ Tom Petty and the Heartbreakers, front and back, ca. 1979

MUSIC 165

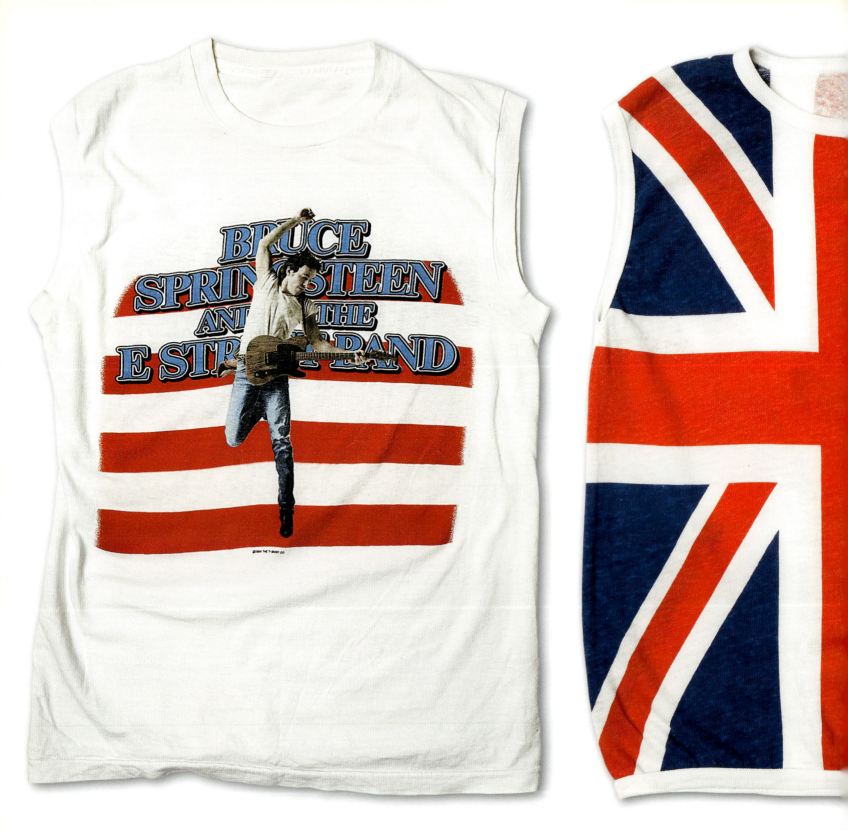

↖ *Born in the U.S.A.*, Bruce Springsteen, 1984

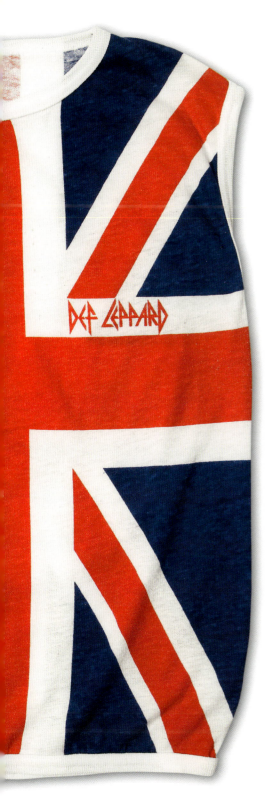
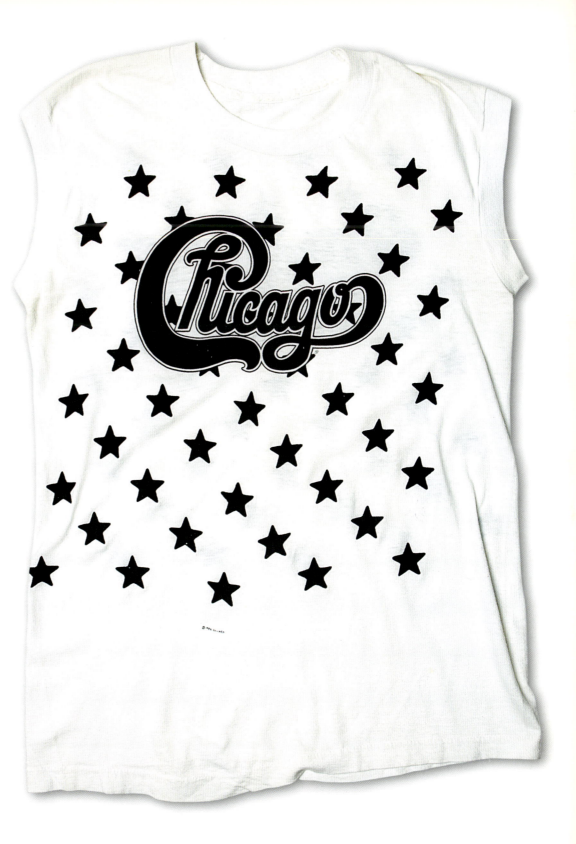

↑ Def Leppard, ca. 1983
↗ Chicago, 1984

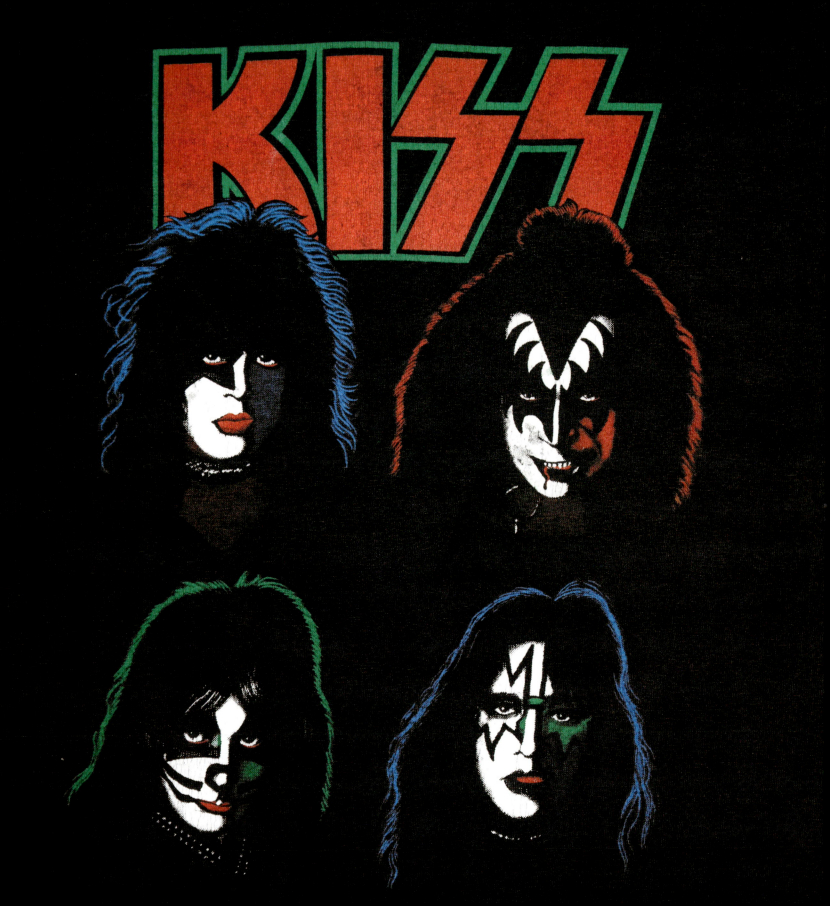

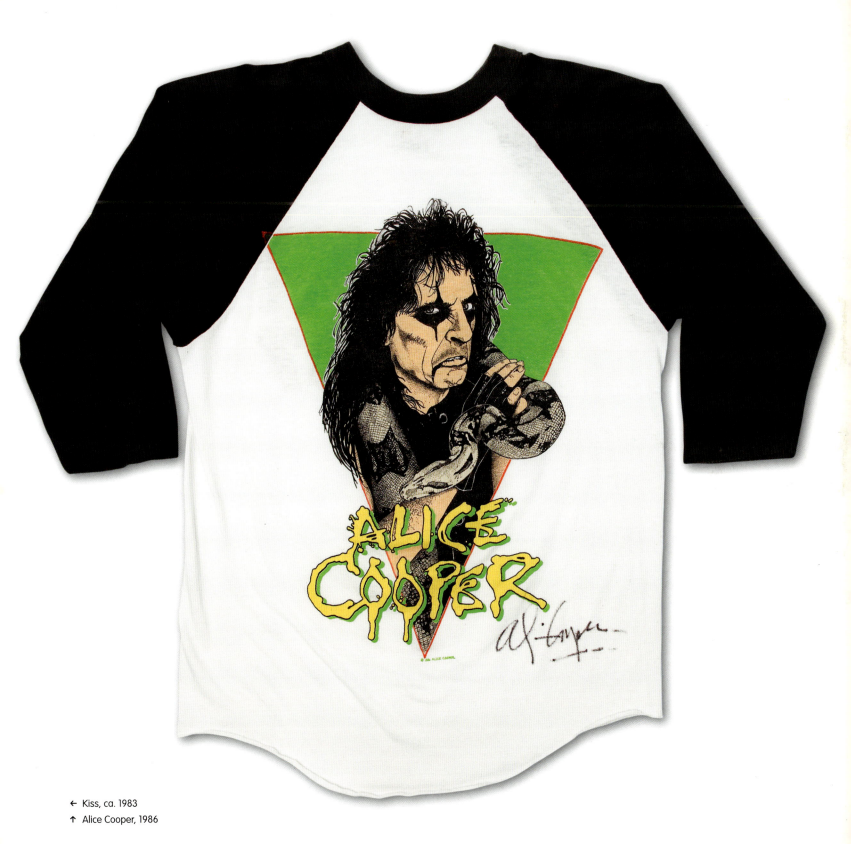

← Kiss, ca. 1983
↑ Alice Cooper, 1986

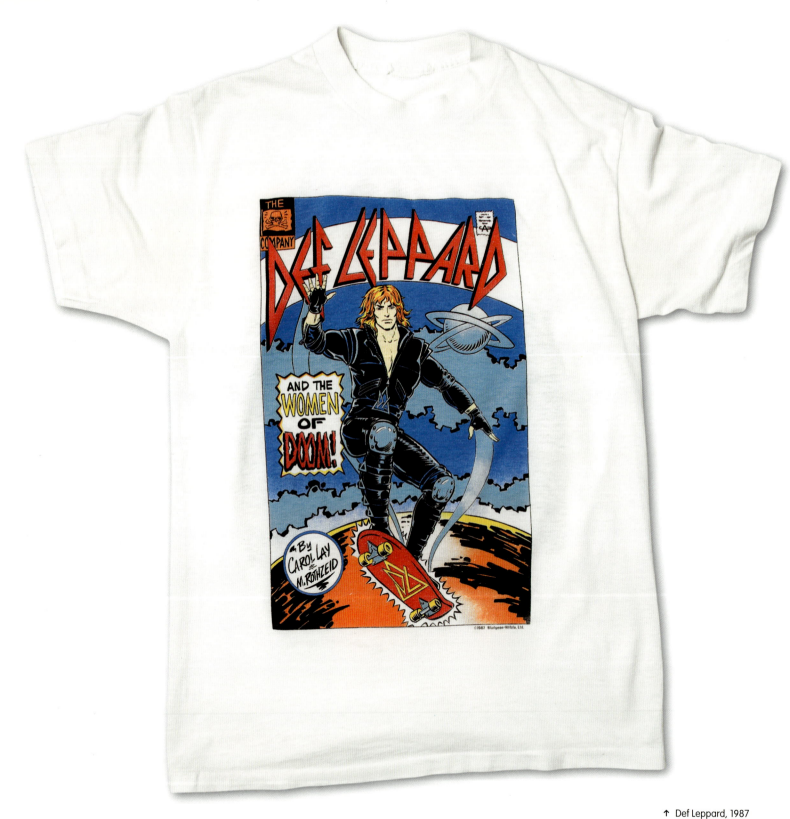

↑ Def Leppard, 1987
→ "I've Been Poisoned," Poison, ca. 1989

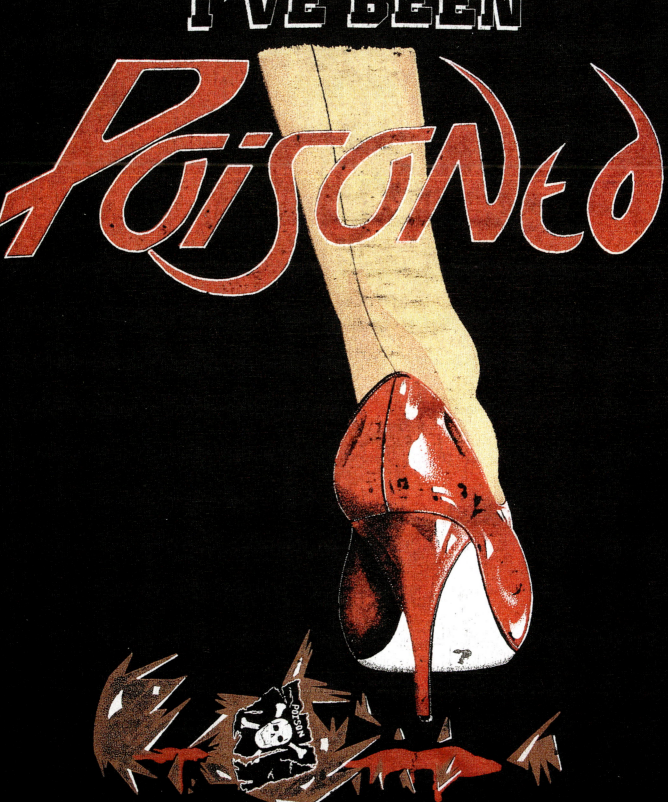

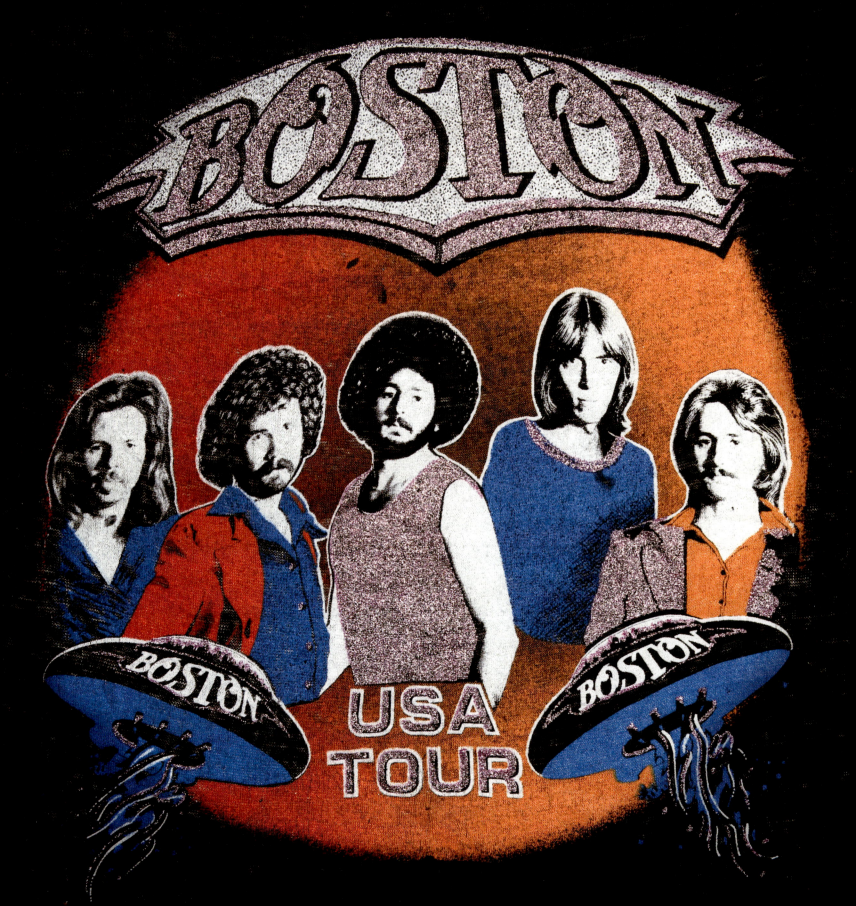

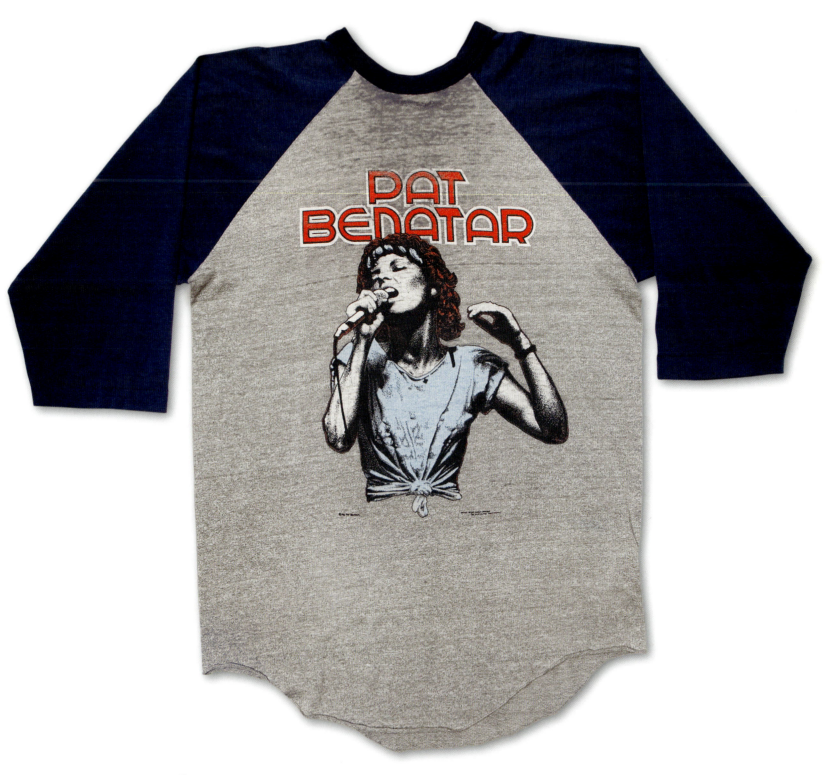

← "USA Tour," Boston, ca. 1979
↑ Pat Benatar, 1980

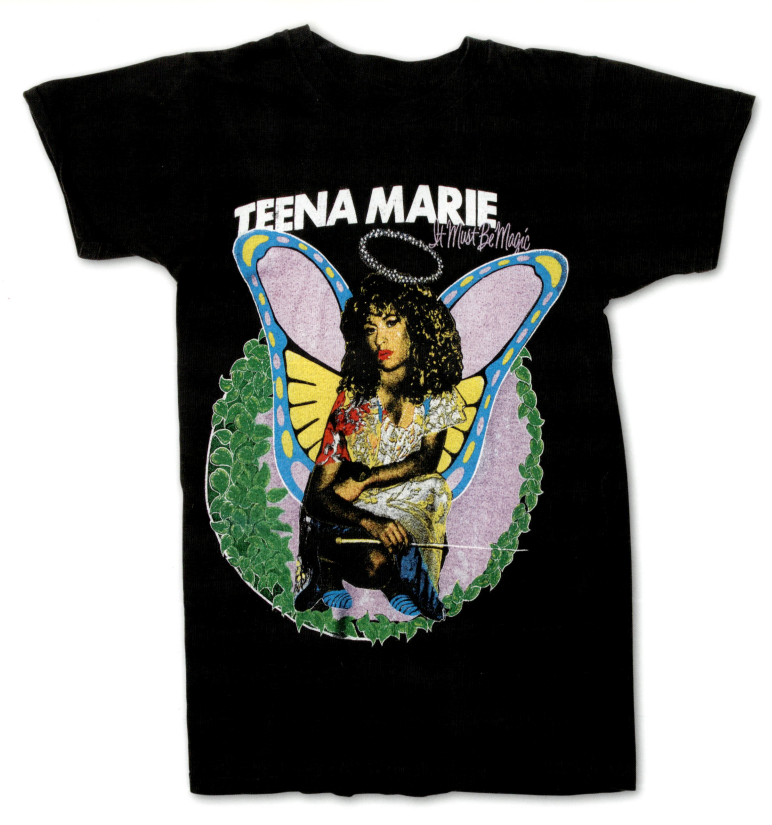

↑ "It Must Be Magic," Teena Marie, 1981

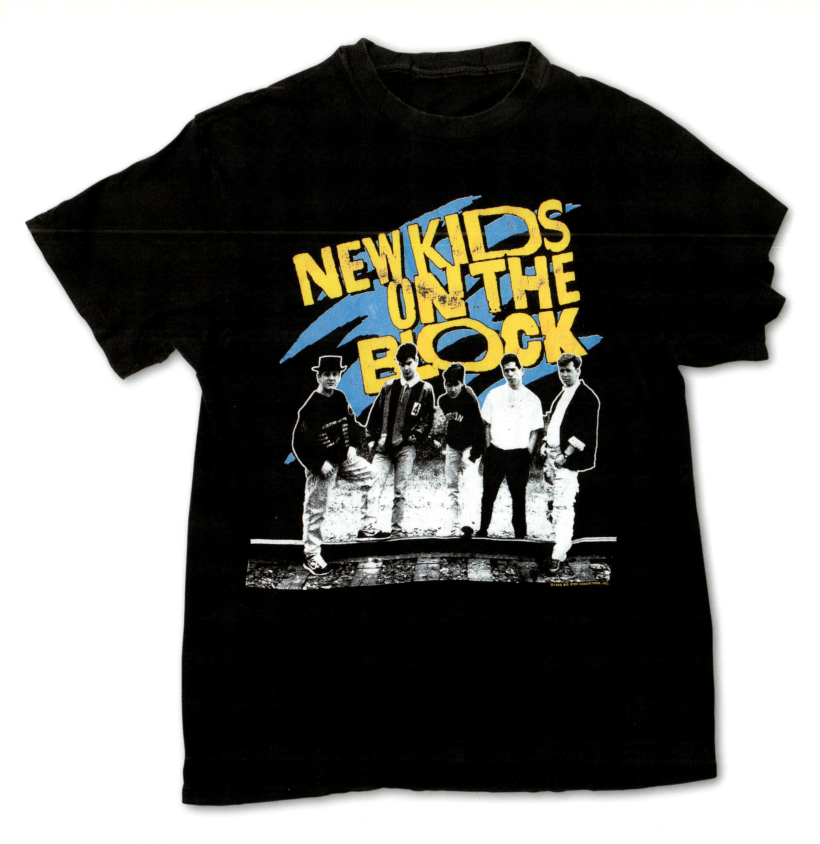

↑ New Kids on the Block, 1989

MUSIC 175

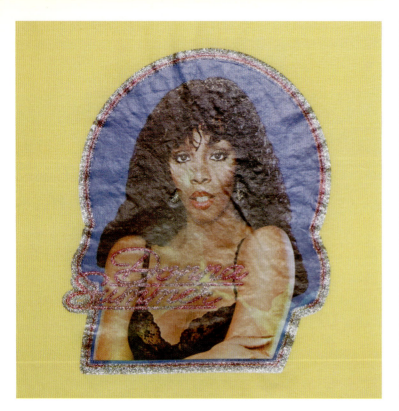
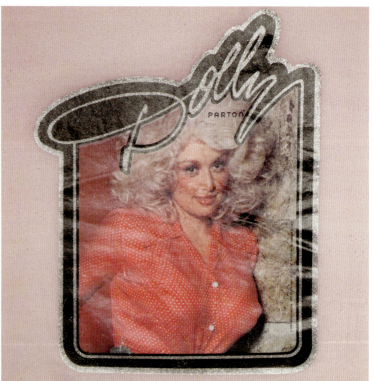
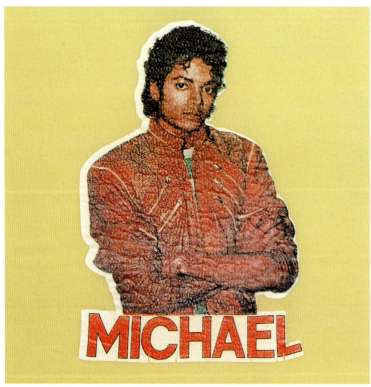
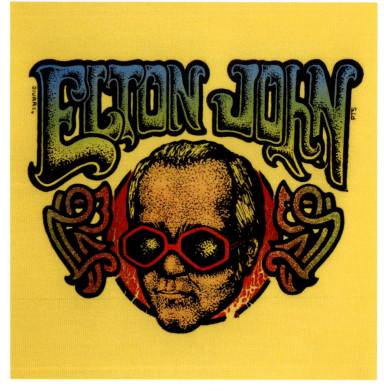

↑ Donna Summer, ca. 1976; Dolly Parton, ca. 1979; Michael Jackson, 1983; Elton John, ca. 1973
→ *Candy-O*, The Cars, 1979 →→ Nike, 1980s

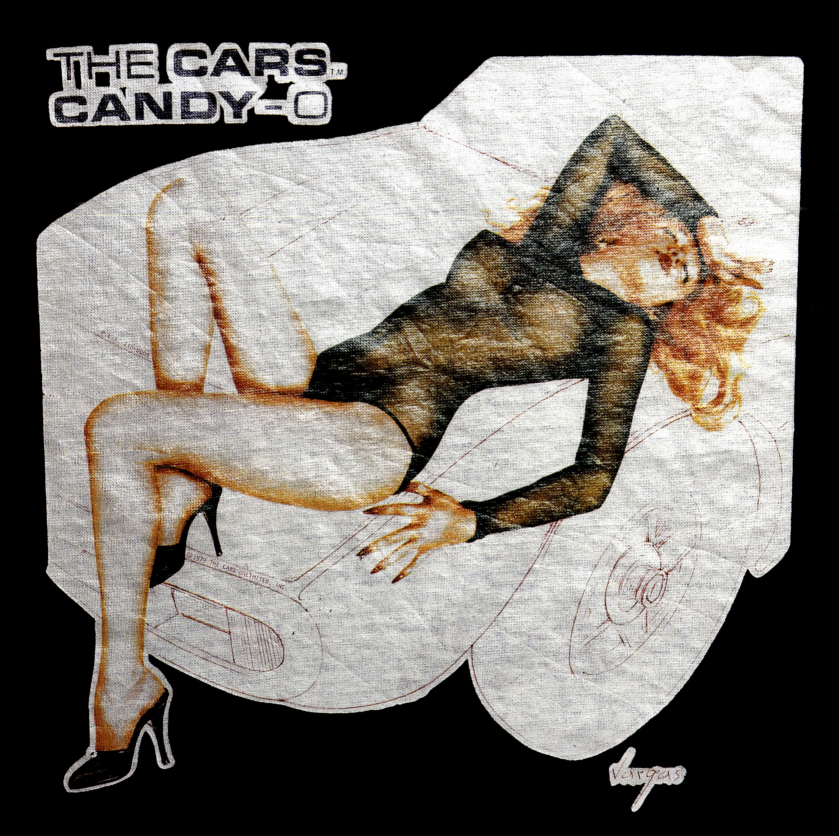

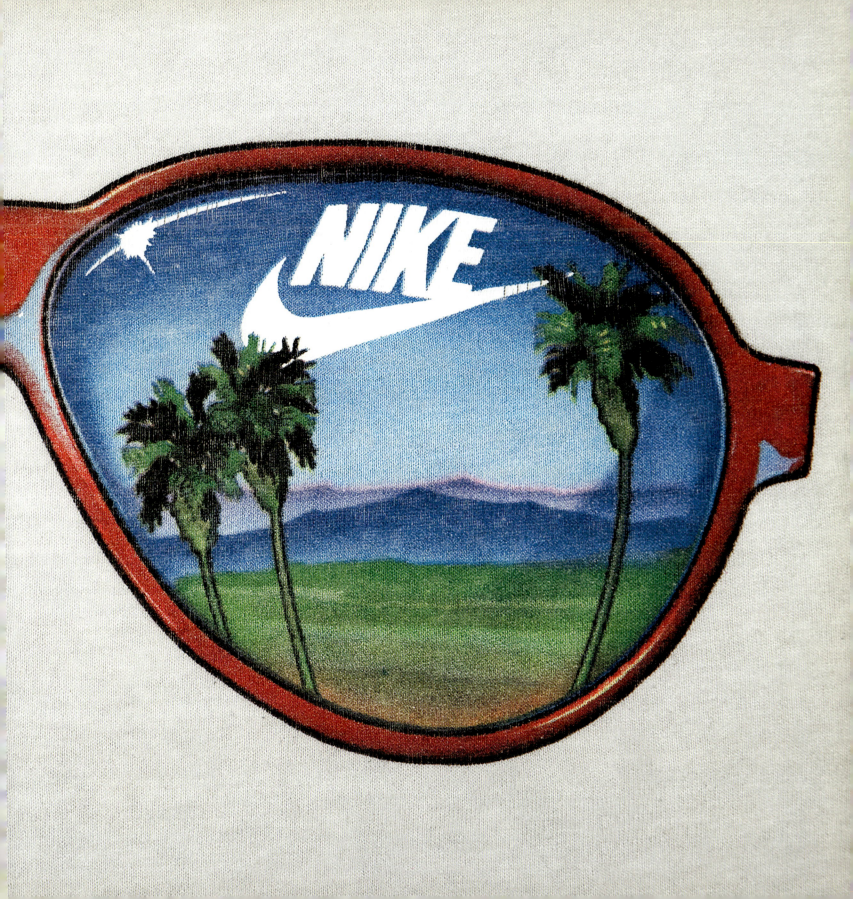

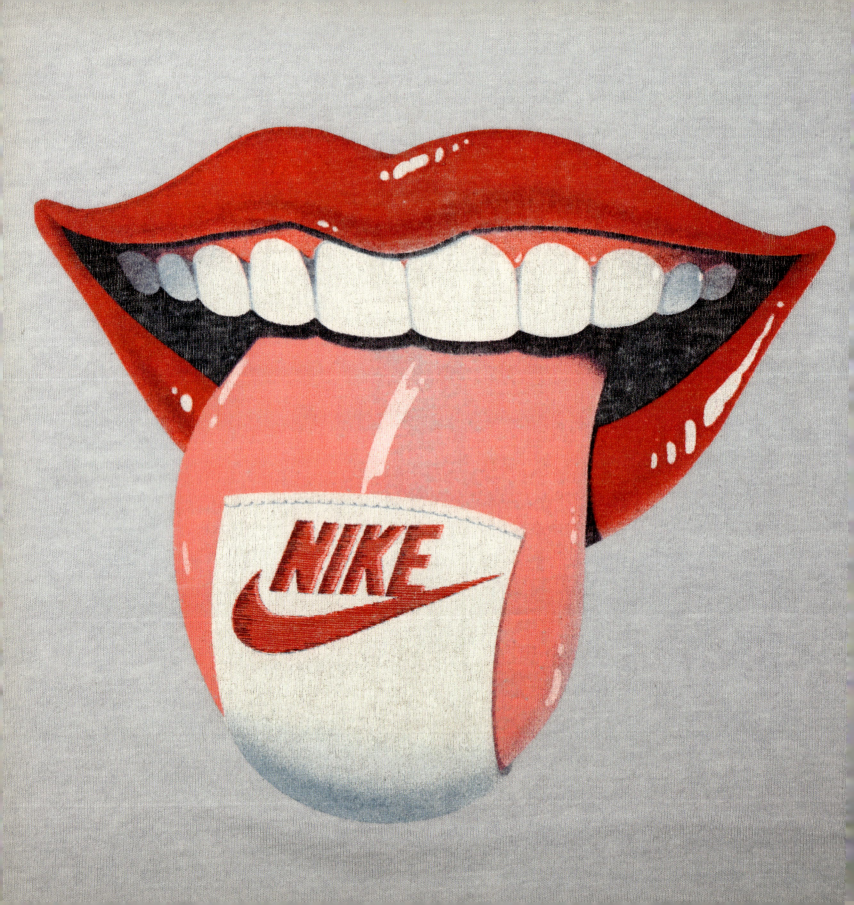

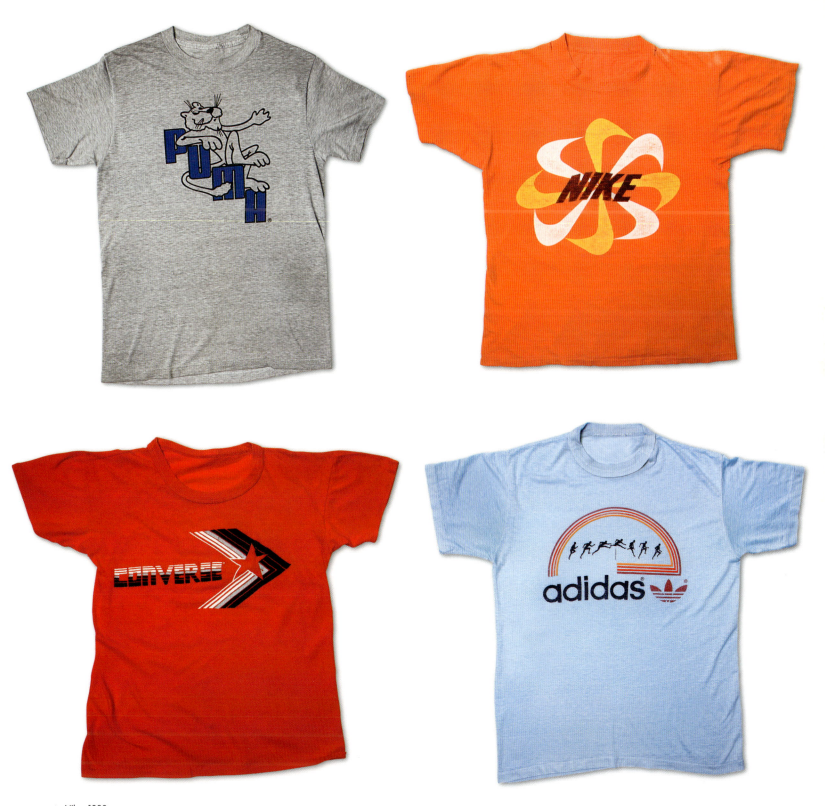

← Nike, 1980s
↑ Puma, ca. 1976; Nike, ca. 1979; Converse, 1980s; Adidas, 1980s

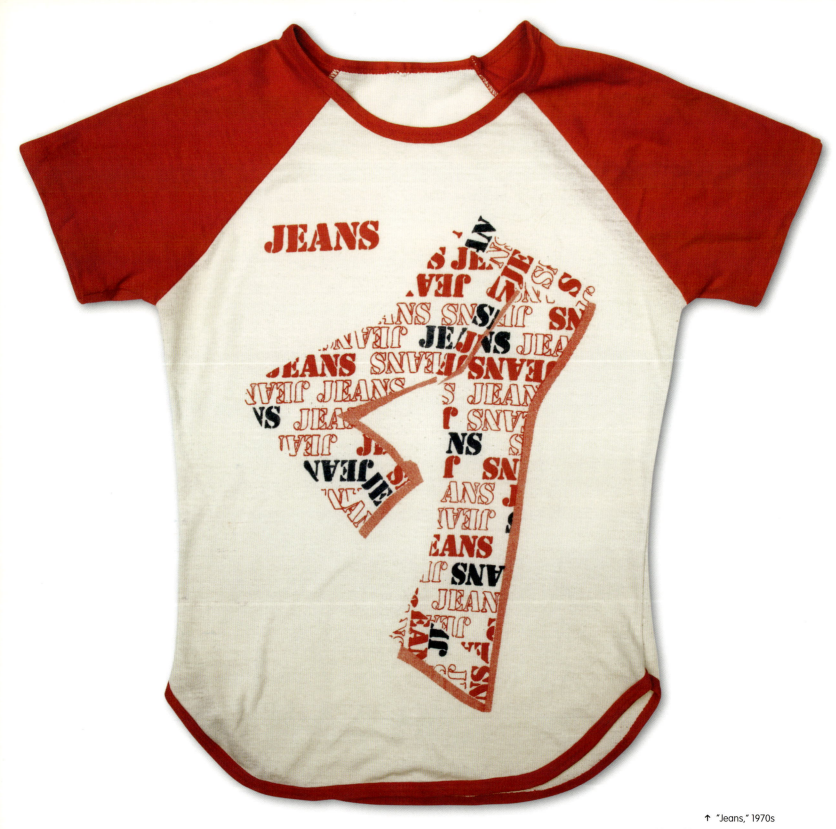

↑ "Jeans," 1970s
→ "Jeans Never Die," Lee, 1980s

↑ Keystone Cops, 1985

↑ Nurse, 1980

APPAREL 185

"Muscles," ca. 1979

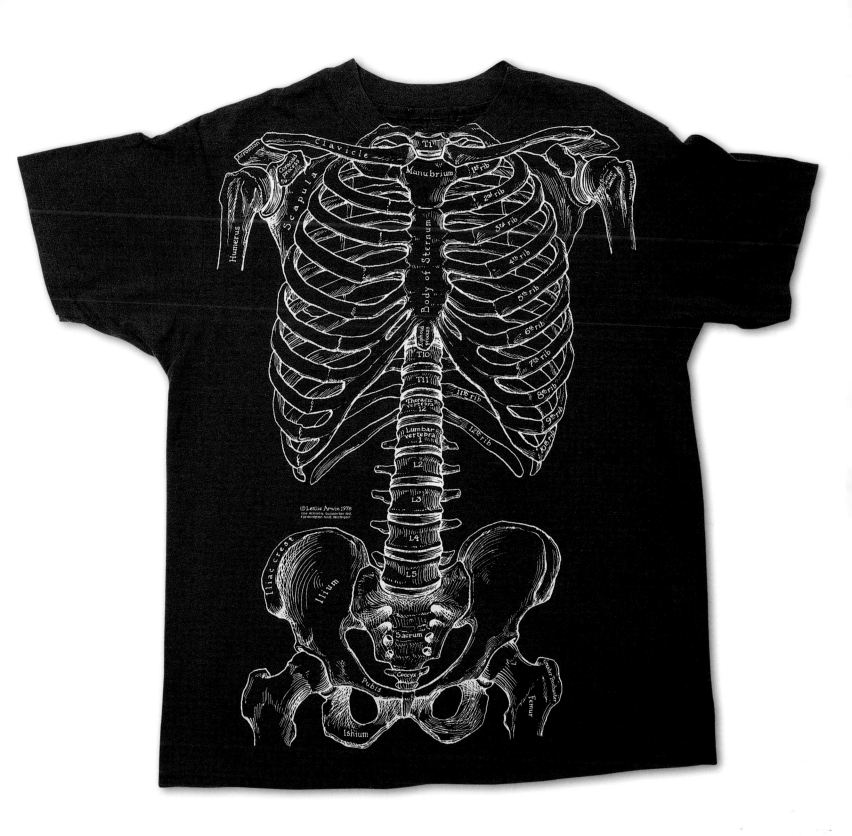

↑ Skeleton, Leslie Arwin, 1978

ANATOMY 187

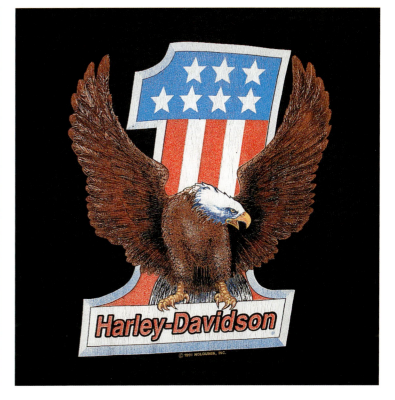

← "The Last Great American," Harley-Davidson, ca. 1989
↑ Harley-Davidson, ca. 1989; "Forged in Our Souls," Harley-Davidson, 1991; Harley-Davidson, Verne Holoubek, 1991; Harley-Davidson, ca. 1989

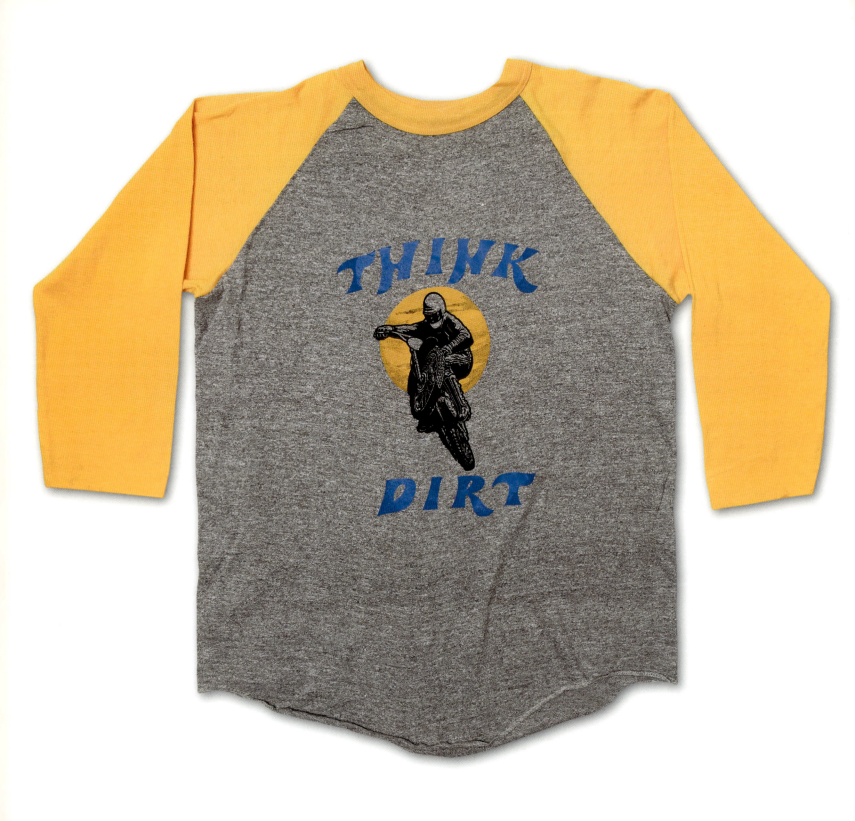

↑ "Think Dirt," ca. 1983

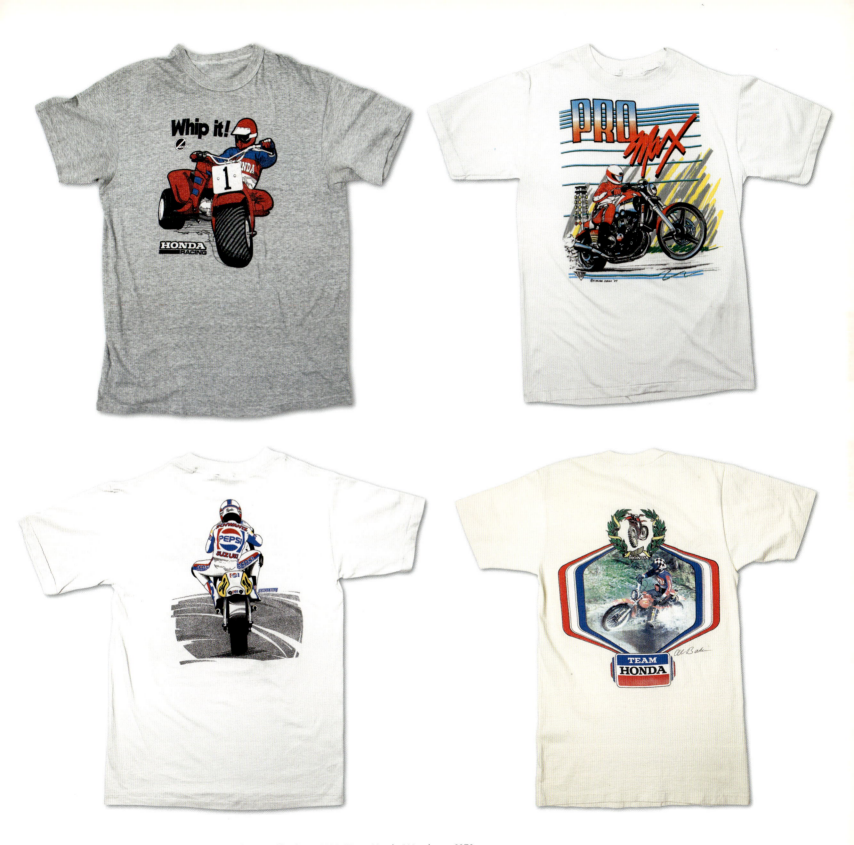

↑ "Whip It," Honda, ca. 1983; "Pro Max," front and back, ca. 1983; "Team Honda," Honda, ca. 1979

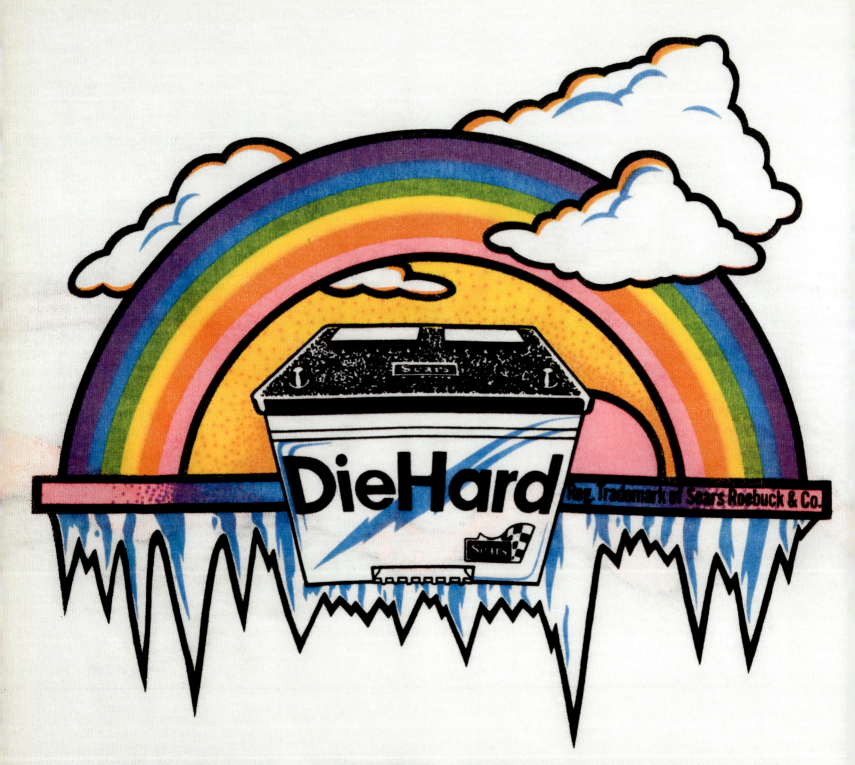

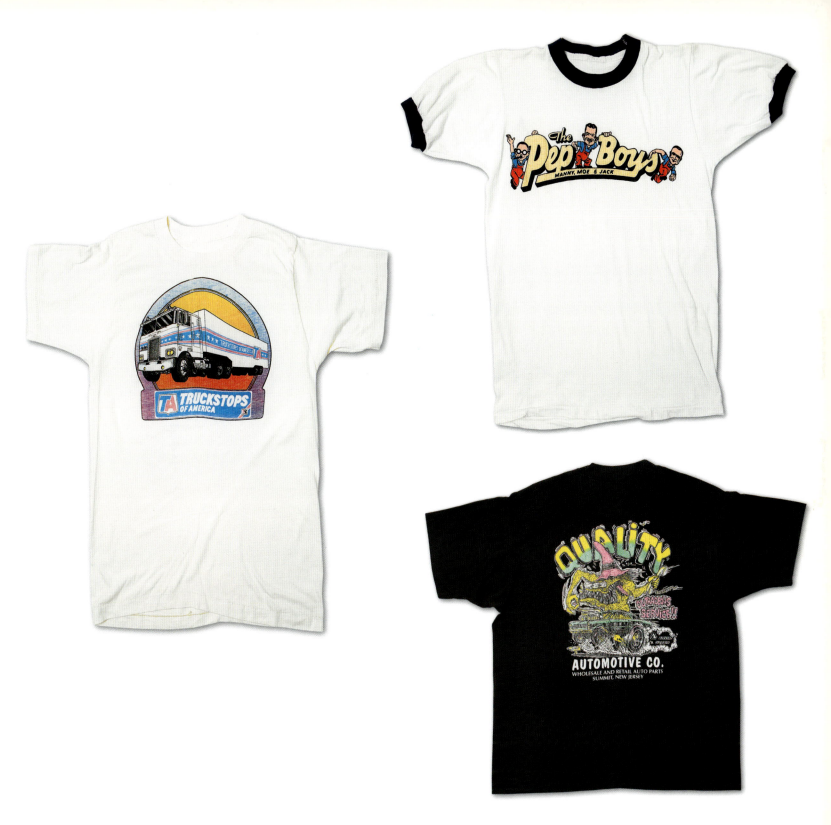

← "Wanna Start Something?" Sears DieHard batteries, ca. 1983
↑ The Pep Boys, ca. 1989; TravelCenters of America, ca. 1979; Quality Automotive Co., ca. 1983

AUTOMOTIVE 193

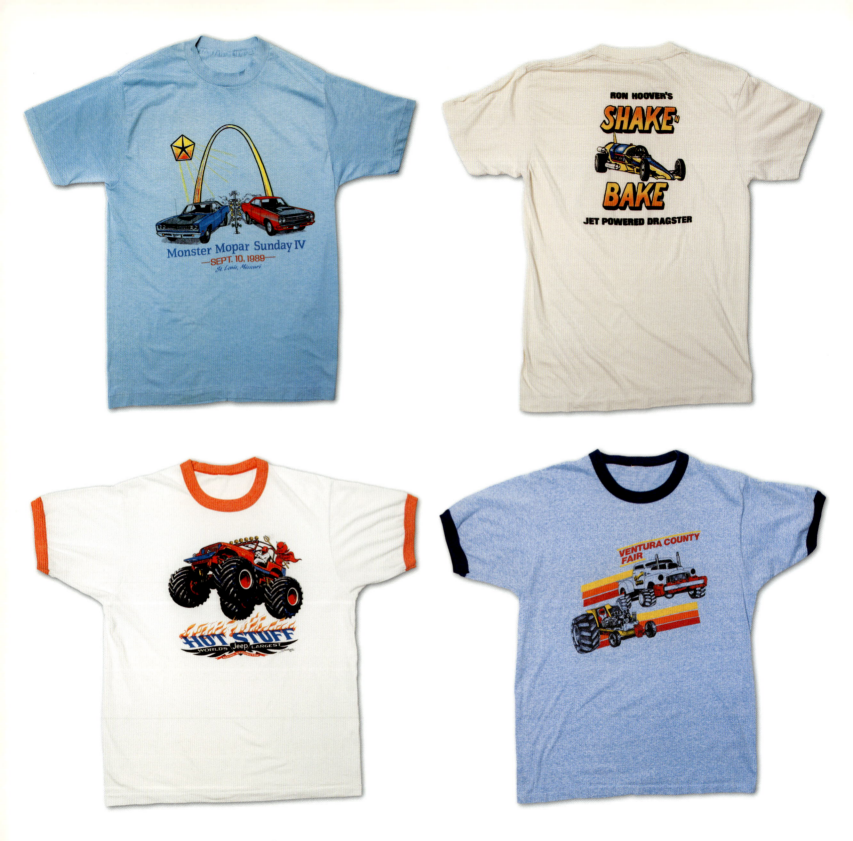

↑ "Monster Mopar Sunday IV," 1989; "Ron Hoover's Shake 'n' Bake," ca. 1983; "Hot Stuff," Jeep, 1987; Ventura County Fair, Ventura, California, ca. 1983

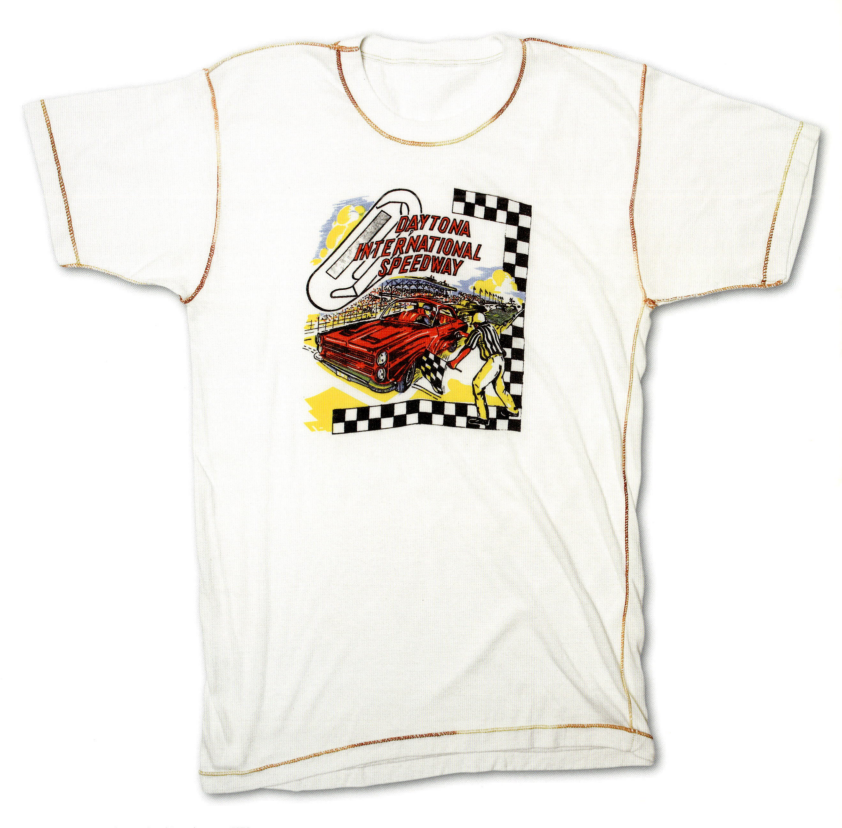

↑ Daytona International Speedway, ca. 1979

AUTOMOTIVE 195

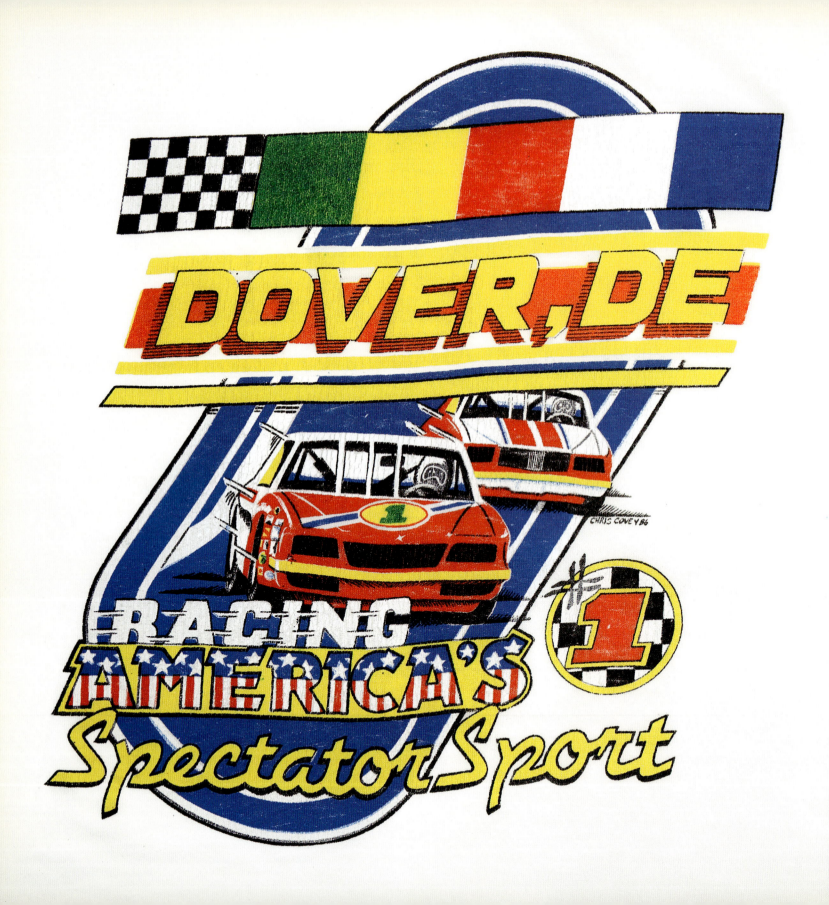

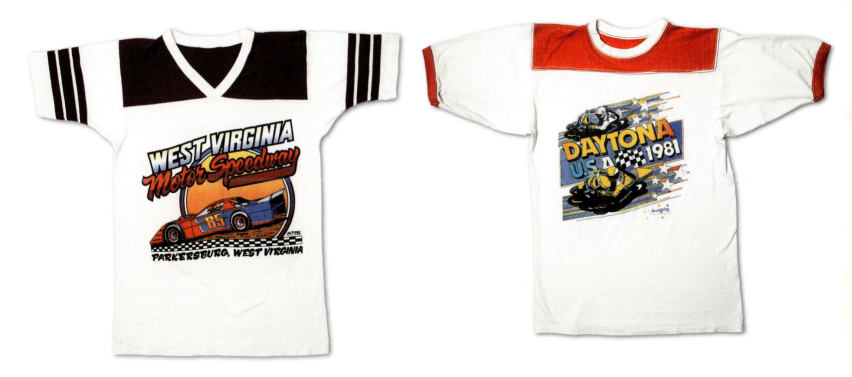
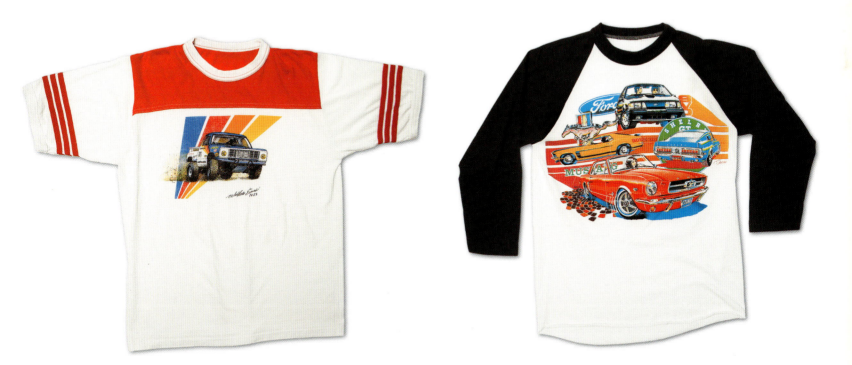

← "Racing," Dover, Delaware, 1986

↑ West Virginia Motor Speedway, 1985; Daytona International Speedway, 1981; Walker Evans, 1983; Ford, C. Smith, 1983

AUTOMOTIVE 197

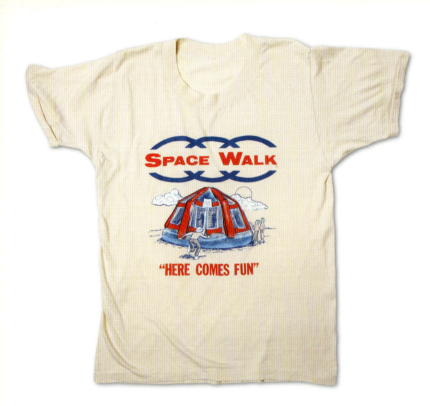
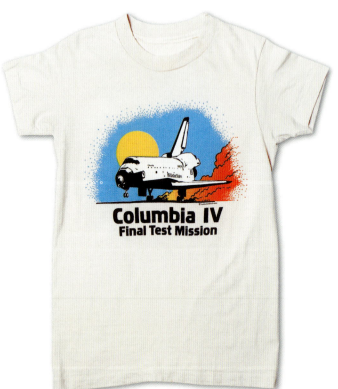
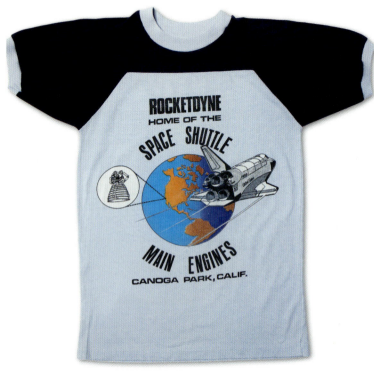

↑ "Space Walk," ca. 1983; "Home of the Space Shuttle Main Engines," Rocketdyne, 1980s; "Columbia IV," ca. 1986
→ Atlantis, NASA, 1980s

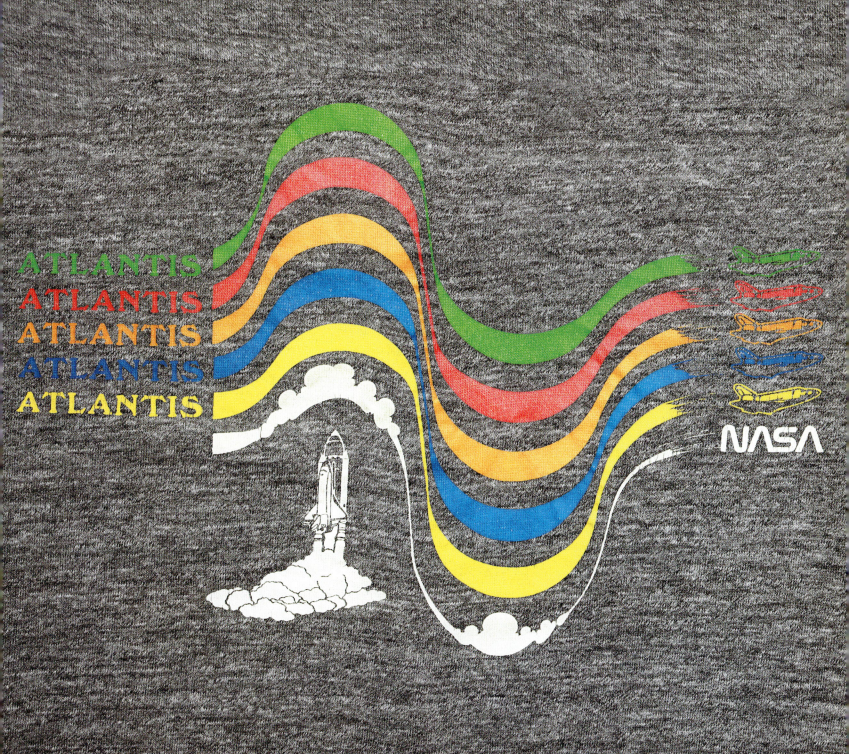

↑ "Shark Attax," front and back, 1980s

↑ Sea Gazelle Luxury Catamarans, front and back, 1982

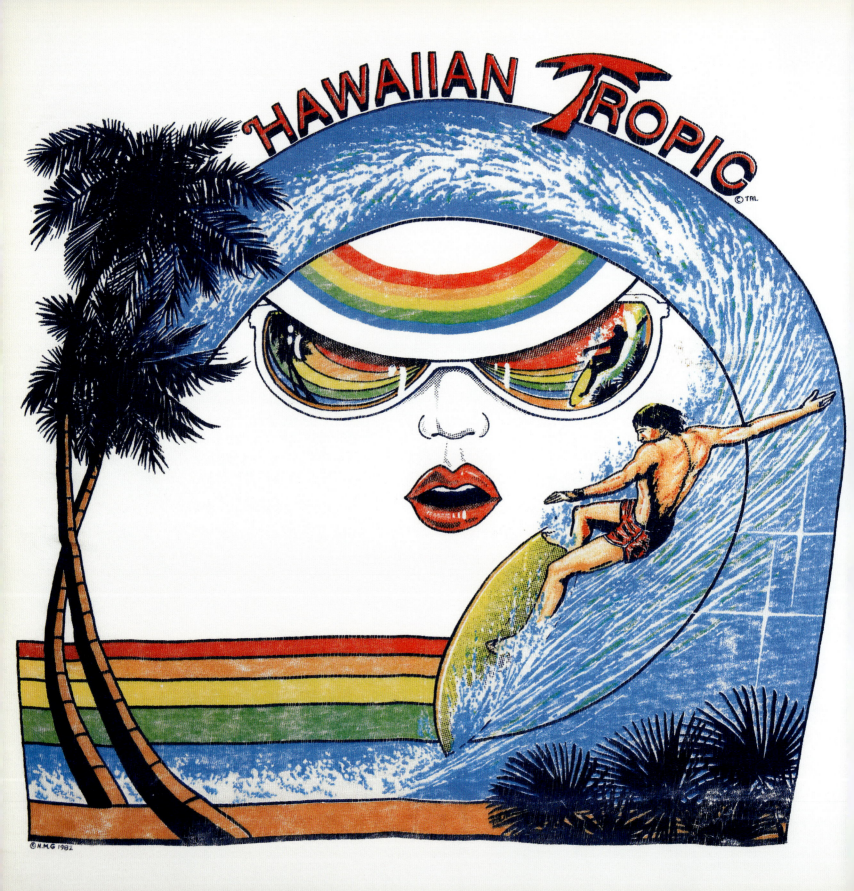

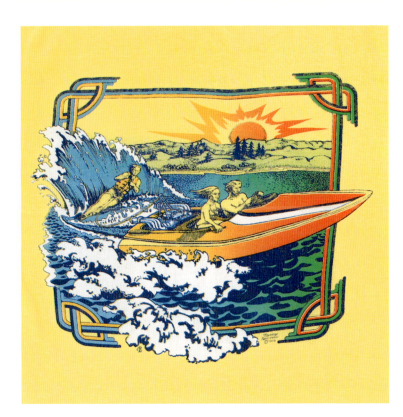
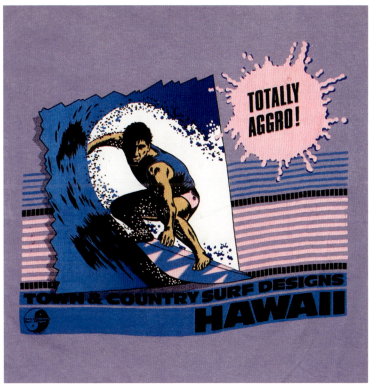
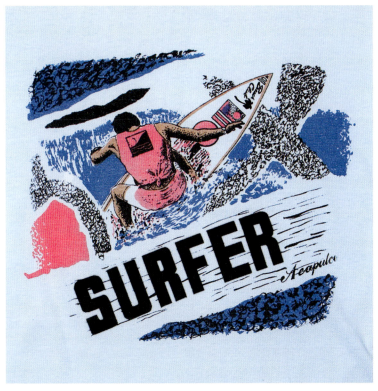
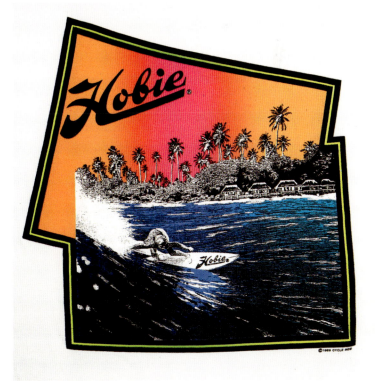

← Hawaiian Tropic, 1989

↑ Shoreline Sportswear, 1975; "Totally Aggro!," Hawaii, 1980s; "Surfer," 1990s; Hobie, 1989 →→ Ocean Pacific, ca. 1986

SURF & SUN 203

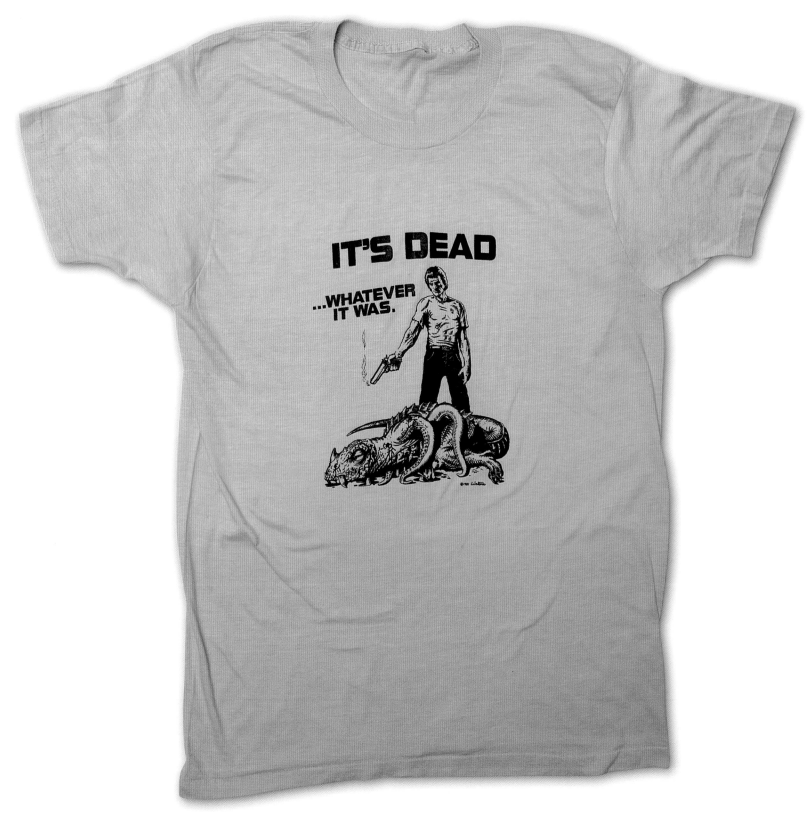

↑ "Whatever It Was," 1981

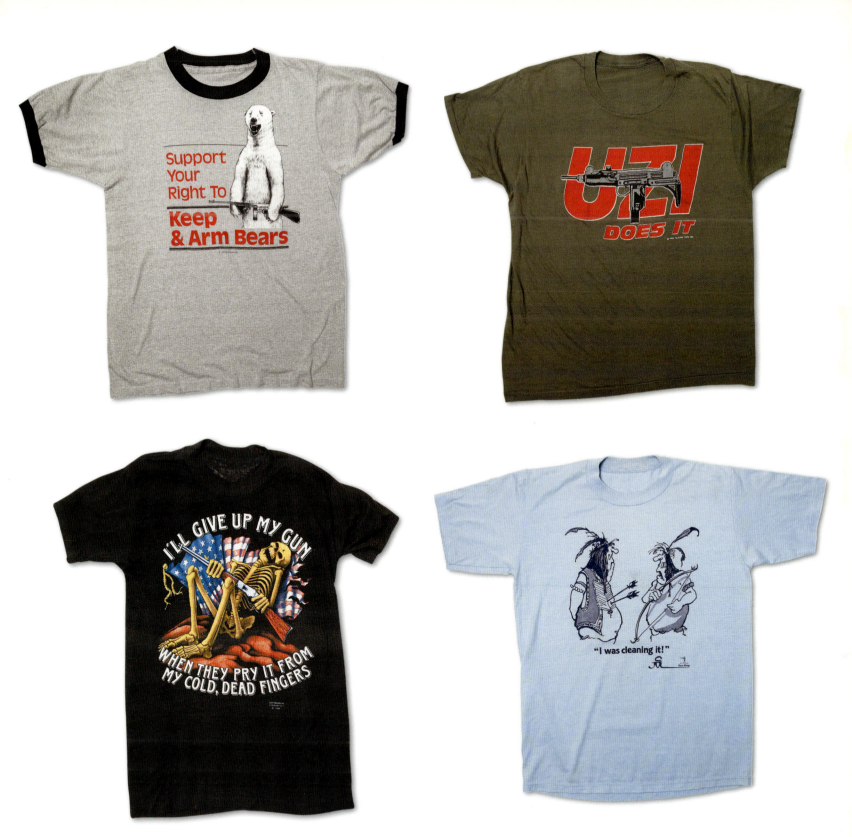

↑ "Keep & Arm Bears," 1984; "Uzi Does It," 1984; "I'll Give Up My Gun," 1980; "I Was Cleaning It," 1990s

↑ "Be All You Can Be," U.S. Army, 1990s

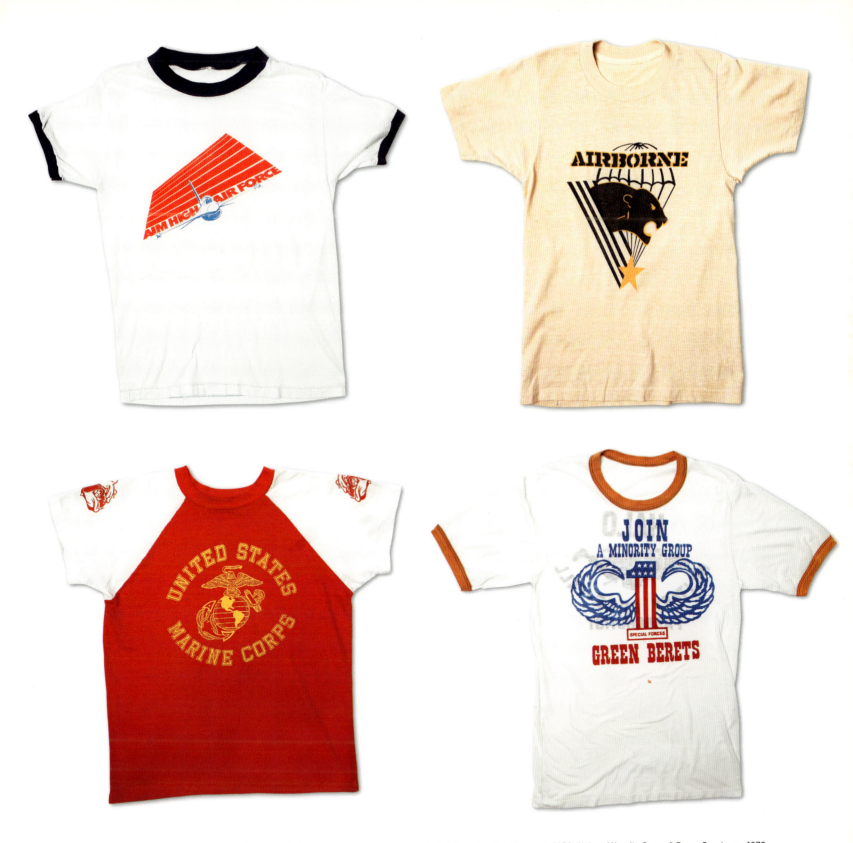

↑ "Aim High," U.S. Air Force, ca. 1989; "Airborne," U.S. Army Airborne Division, 1980s; United States Marine Corps, ca. 1979; "Join a Minority Group," Green Berets, ca. 1979

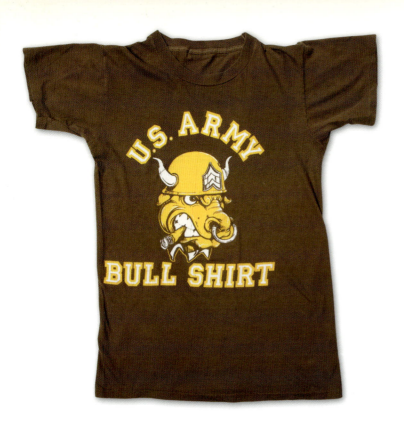
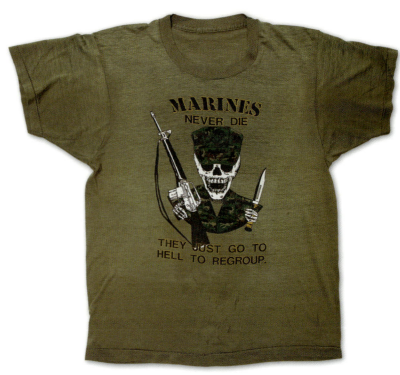
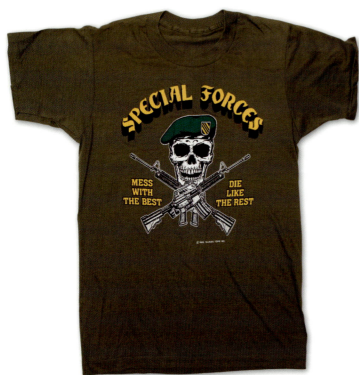
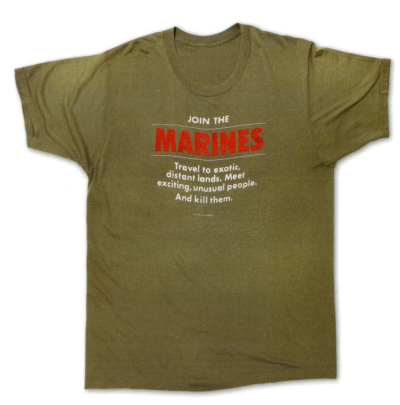

↑ "Bull Shirt," ca. 1983; "Marines Never Die," 1980s; "Mess with the Best," U.S. Army Special Forces, 1983; "Join the Marines," 1983
→ "Death from Within!," 1983

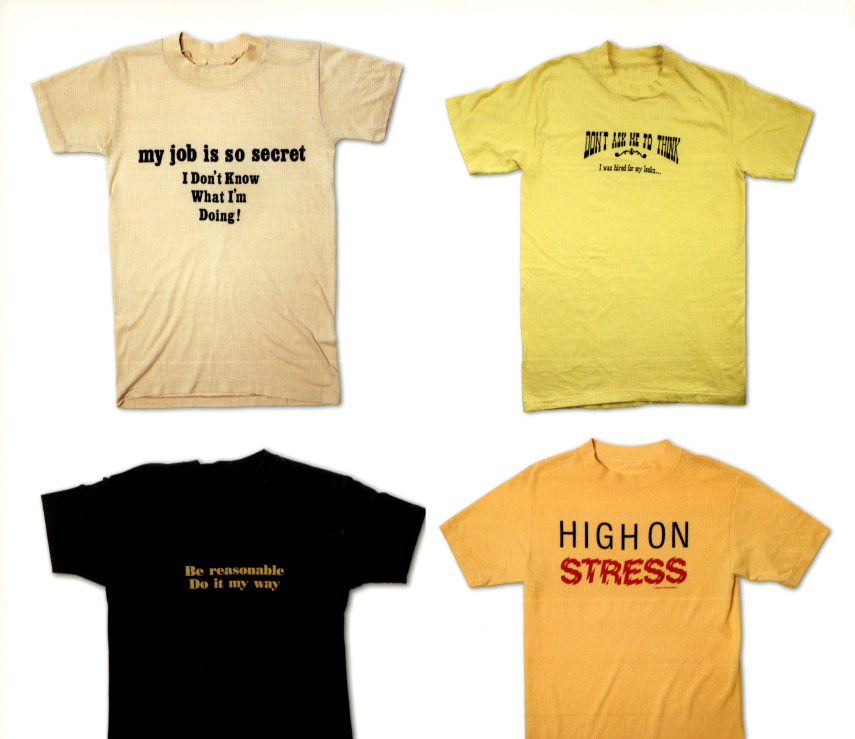

↑ "My Job Is So Secret," ca. 1983; "Don't Ask Me to Think," ca. 1979; "Do It My Way," 1980s; "High on Stress," ca. 1989

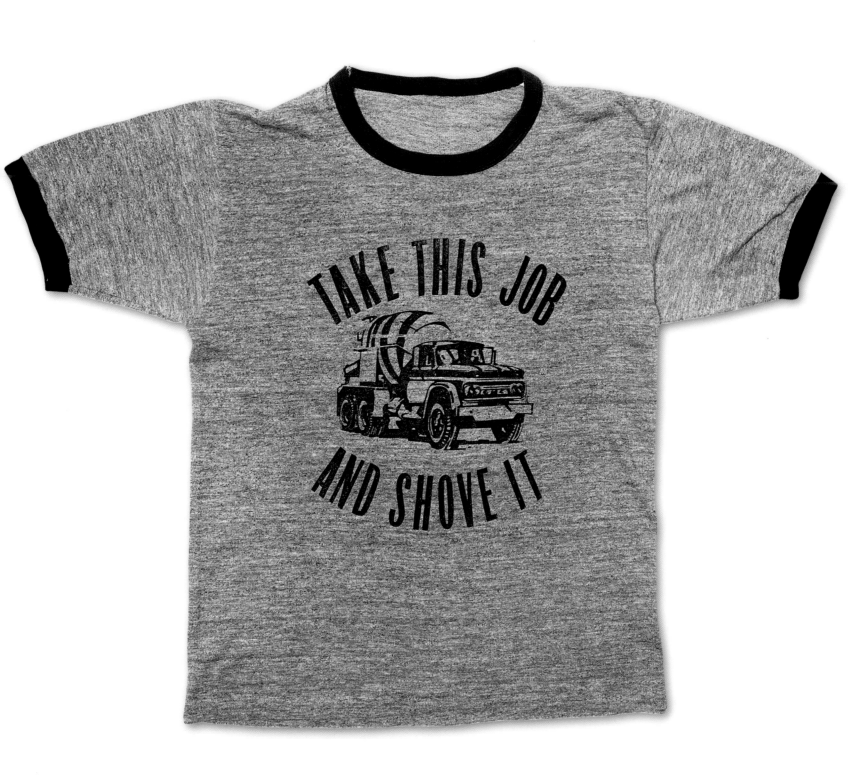

↑ "Take This Job and Shove It," Johnny Paycheck, 1977

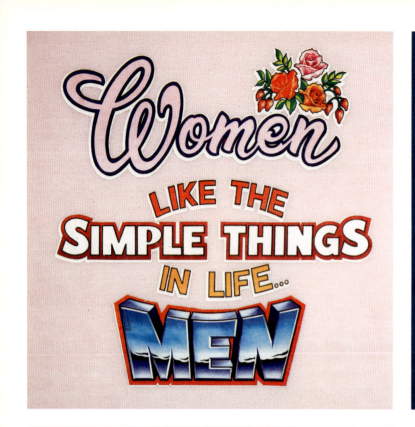

↑ "Women Like the Simple Things," ca. 1979; "My Next Wife," 1980s; "Wanted! Good Woman," 1980s; "One Woman," ca. 1983

→ "Cowgirl Wanted," 1980s

...good looking blue eyed male, S/D, 32 yrs old. Looking for nice looking, intelligent women. singles mom's ok. Please send photo & ph.

COWGIRL WANTED:

To rope and ride . . . with. Must look good in boots and tight jeans and be able to drink and two-step all night long. Should have a new pick-up and a good horse & saddle. Please send photo of horse.

MATURE 40 year old man, 6' tall, blue-eyed blonde seeks lasting relationship with good woman. No air heads please! Fun-loving, active, loves camping, motor-

When the going gets tough the tough go shopping.

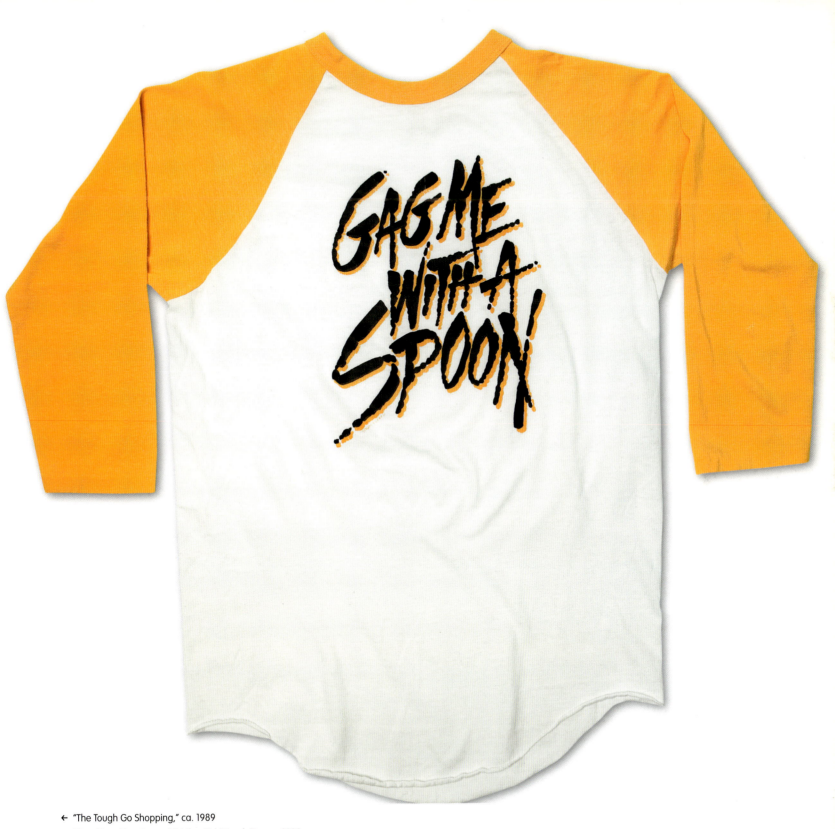

← "The Tough Go Shopping," ca. 1989
↑ "Gag Me with a Spoon," "Valley Girl," Frank Zappa, 1982

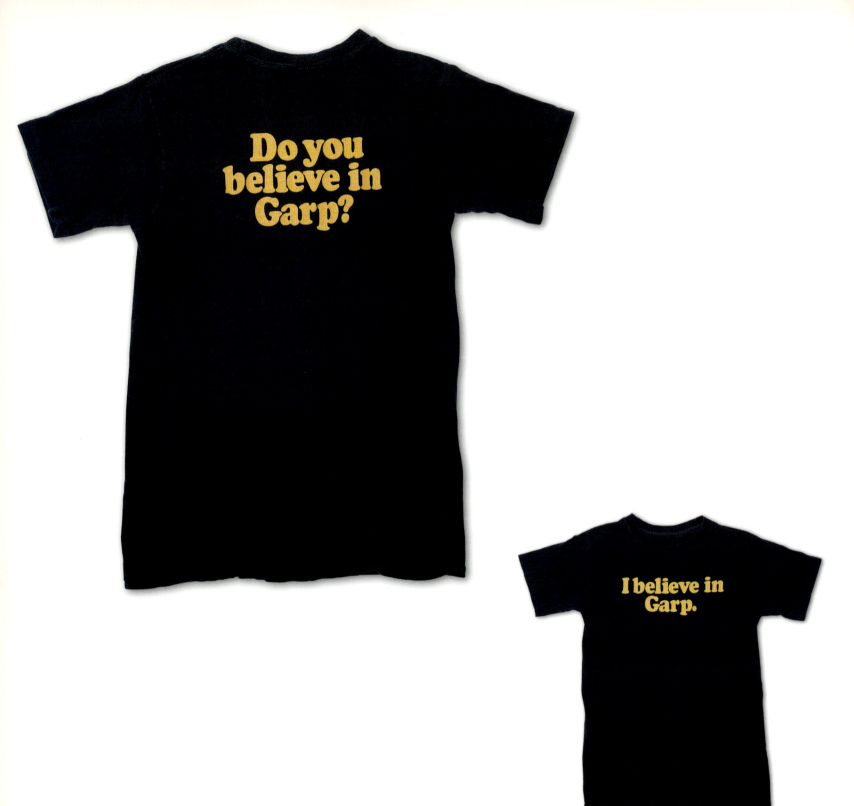

↑ "Do You Believe in Garp?," *The World According to Garp,* front and back, 1982

↑ "Never Wrong" front and back, ca. 1979

SLOGANS 219

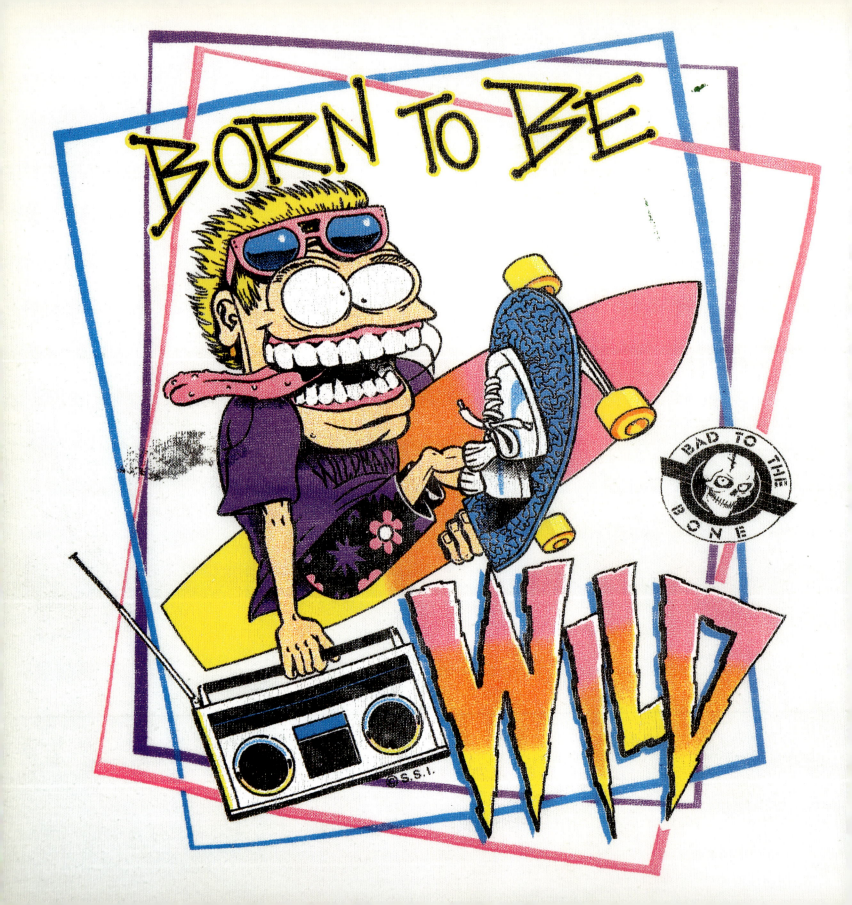

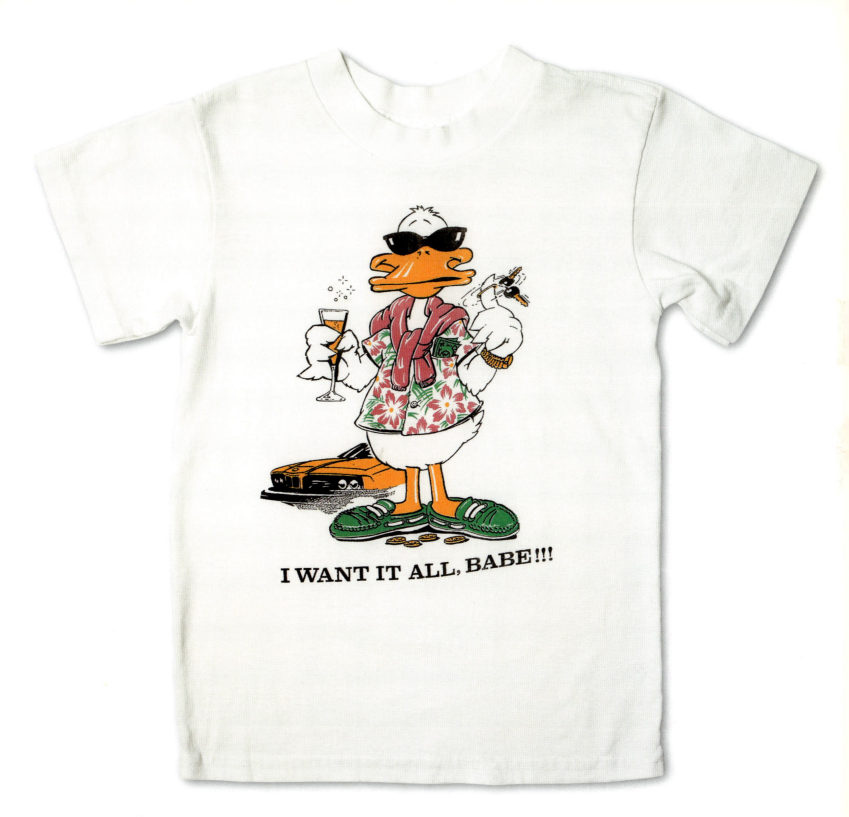

← "Born to Be Wild," ca. 1989
↑ "I Want It All, Babe!!!," ca. 1986

↑ "I Look Better with This T-Shirt Off," 1980s

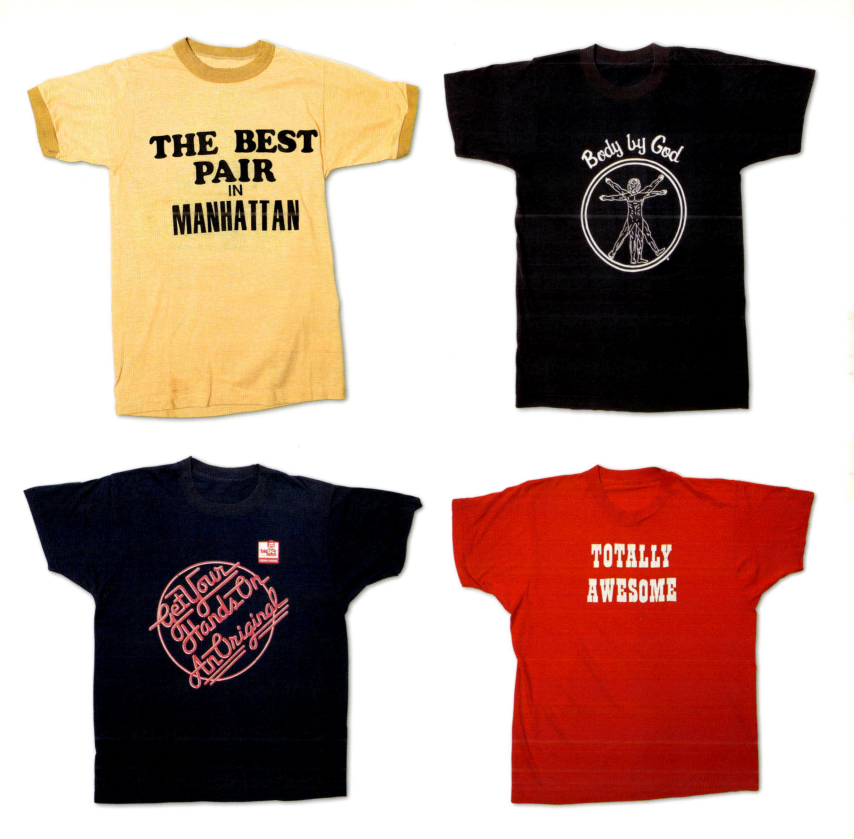

↑ "The Best Pair," ca. 1979; "Body By God," ca. 1983; "Get Your Hands on an Original," 1980s; "Totally Awesome," 1983

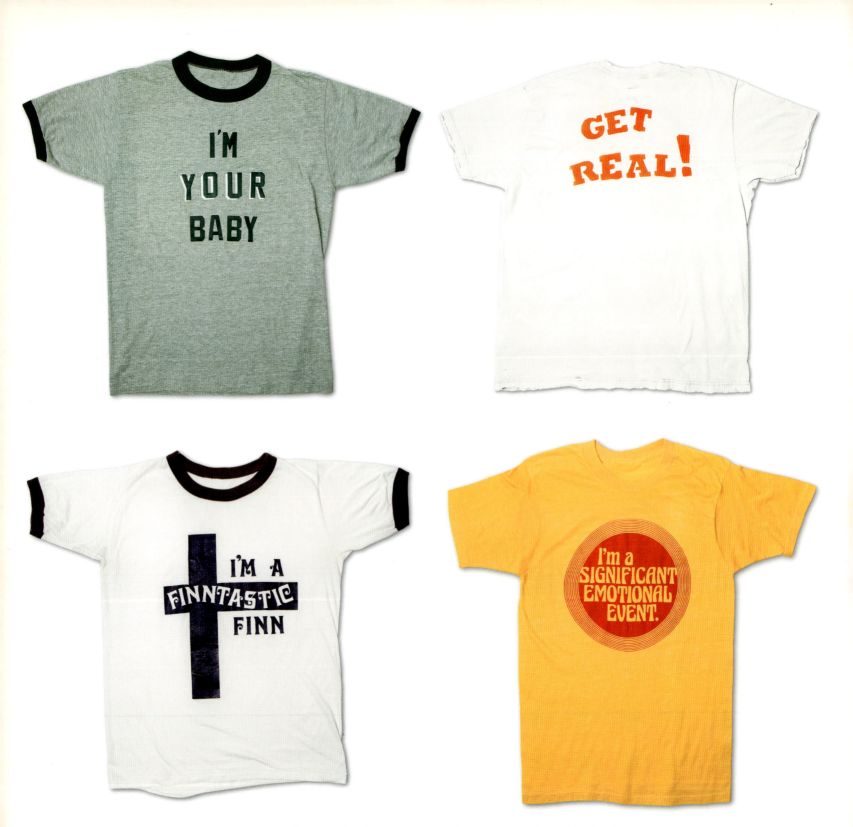

↑ "I'm Your Baby," ca. 1983; "Get Real," Tony Guetta, 1990; "Finntastic Finn," ca. 1983; "Significant Emotional Event," 1970s
→ "Assholes," 1980s

If I Had Any Friends,
I Wouldn't Be With These
Assholes

↑ "Are We Having Fun Yet?," Zippy the Pinhead, ca. 1989

↑ "Same Shit," 1980s

← "Fuck It," ca. 1983
↑ "Fuck Off," ca. 1983

↑ "High Explosives," 1980s

↑ "You Must Pay for Your Sins," 1980s; "Kill All the Lawyers," ca. 1983; "Dead People Are Cool," 1980s

↑ "You Have Mistaken Me," 1981; "Leave Me Alone," 1980s; "Go Bowling," ca. 1983; "I Know Karate," 1980s
→ "He's My Brother," ca. 1983

232 SLOGANS

NO...
HE'S MY
BROTHER

← "I'm with the Band," ca. 1976
↑ "Just Shirts," ca. 1976; "Keep on Streakin'," ca. 1979; "Expose Yourself," Grand Canyon, ca. 1979

SLOGANS 235

↑ "Try Anything," front and back, ca. 1979

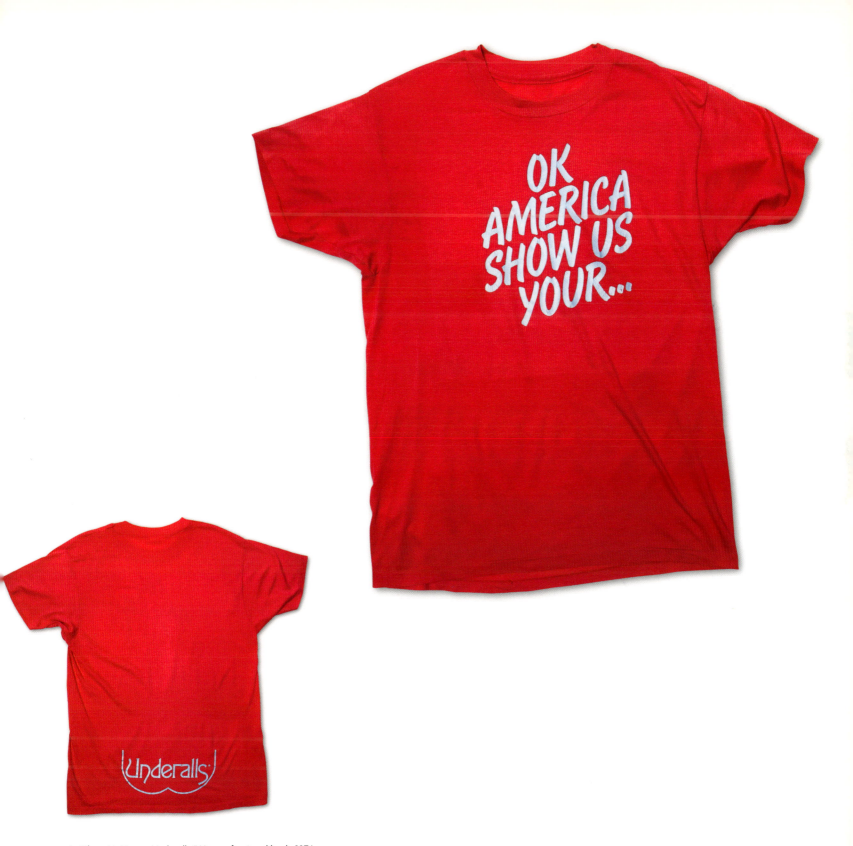

↑ "Show Us Your...Underalls," Hanes, front and back, 1976

"Uncle Sherman," 1976

UNCLE SHERMAN™ FAN CLUB

©1976
All Rights Reserved

↑ "Fire Extinguisher," 1980s

↑ "Moustache Rides," ca. 1979

↑ "Drum Corps Nuts," 1980s; "Dial 911," ca. 1983; "Bankers," ca. 1979; "Elevatormen," ca. 1983

↑ "Delivery People," 1980s

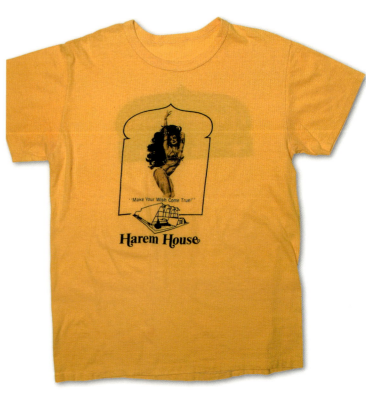

↑ "Sexually Gifted," 1980s; "Harem House," ca. 1983; "For a Good Time," Nevada, 1980
→ "Mustang Ranch Quality Control Supervisor," Mustang Ranch Brothel, ca. 1986

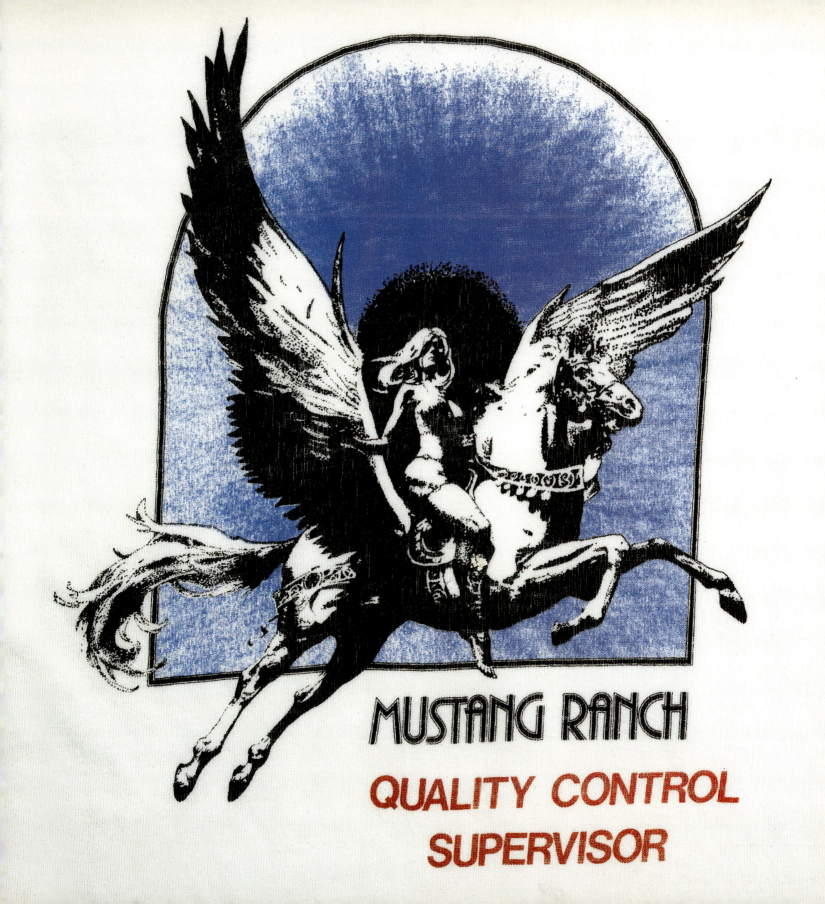

↑ "Twice the Trouble," ca. 1976

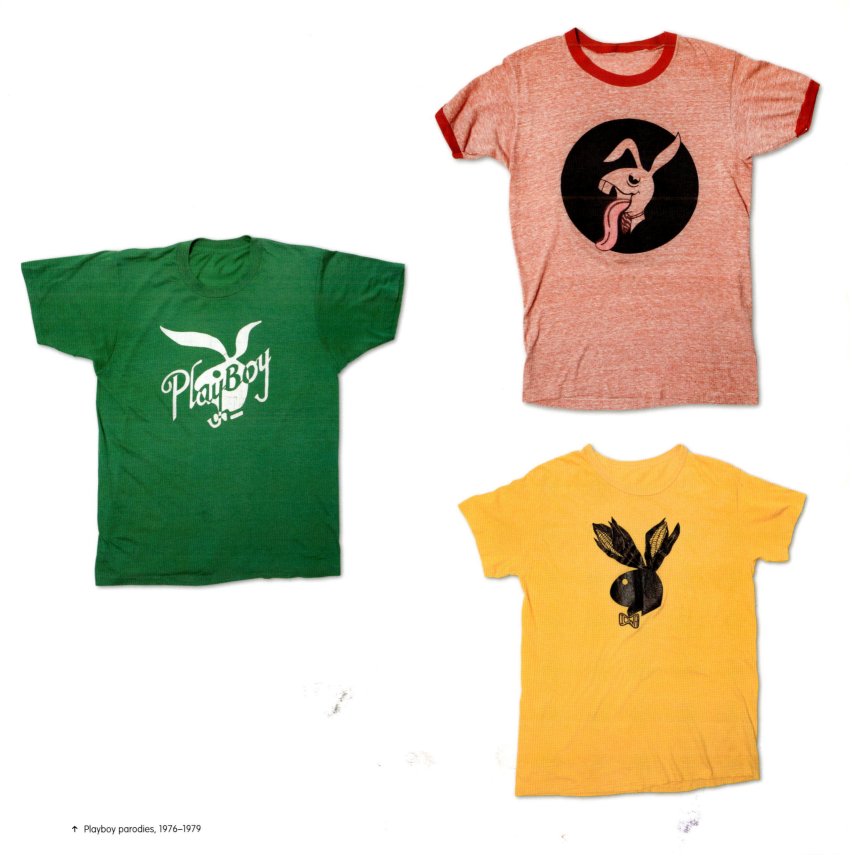

↑ Playboy parodies, 1976–1979

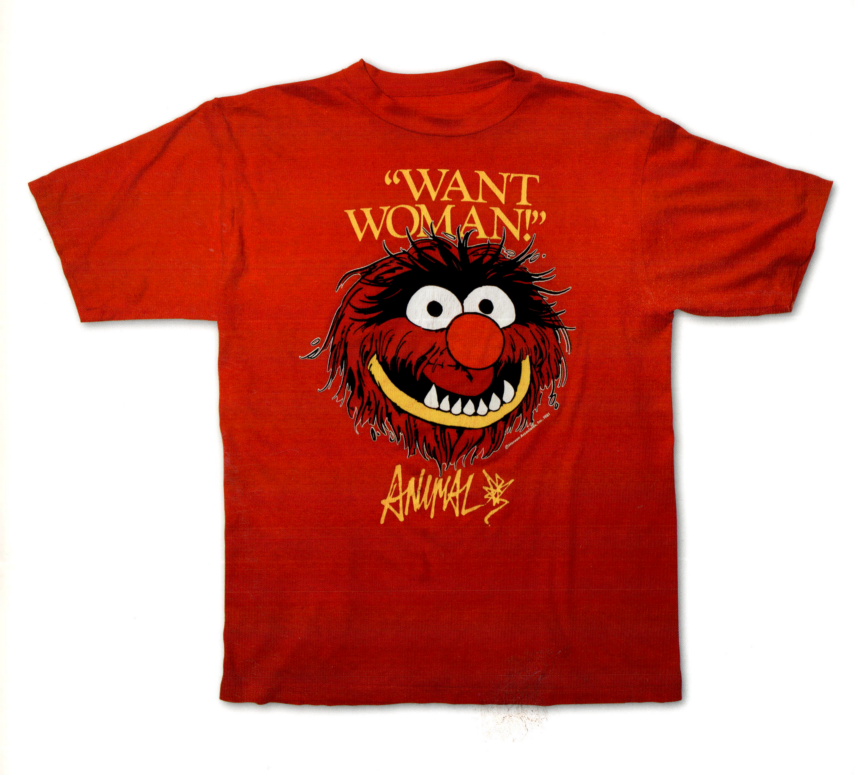

↑ "Want Woman!," Animal, *The Muppet Show,* 1981

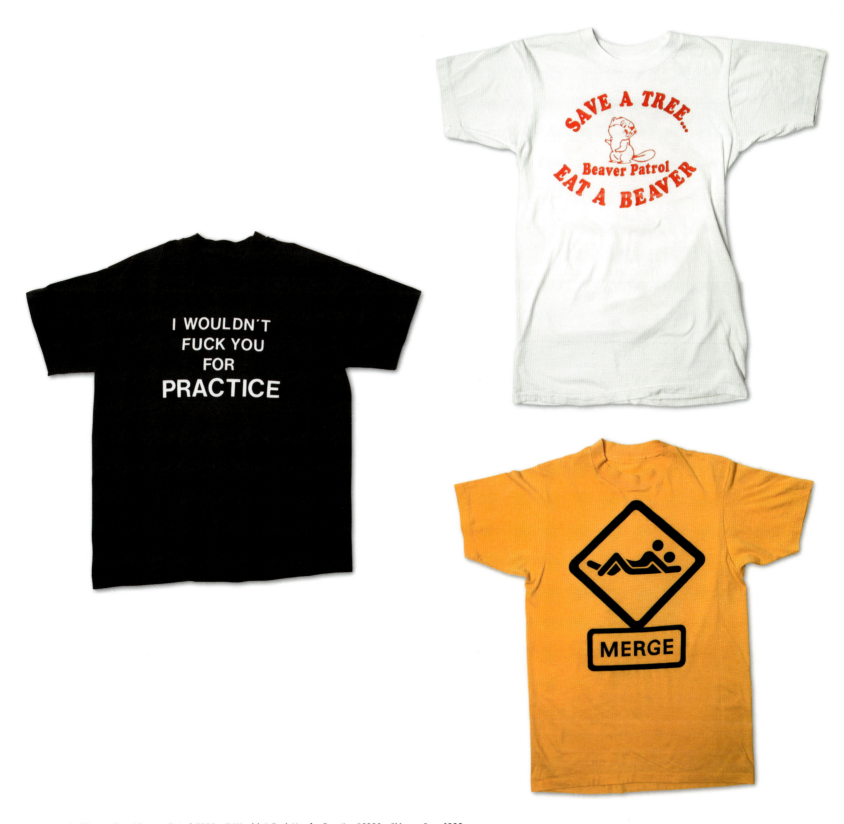

↑ "Save a Tree," Beaver Patrol, 1980s; "I Wouldn't Fuck You for Practice," 1980s; "Merge," ca. 1989

YOU TOUCHA
MY BODY
I SLAPPA
YOUR FACE!

ABSOLUT PERFECTION!

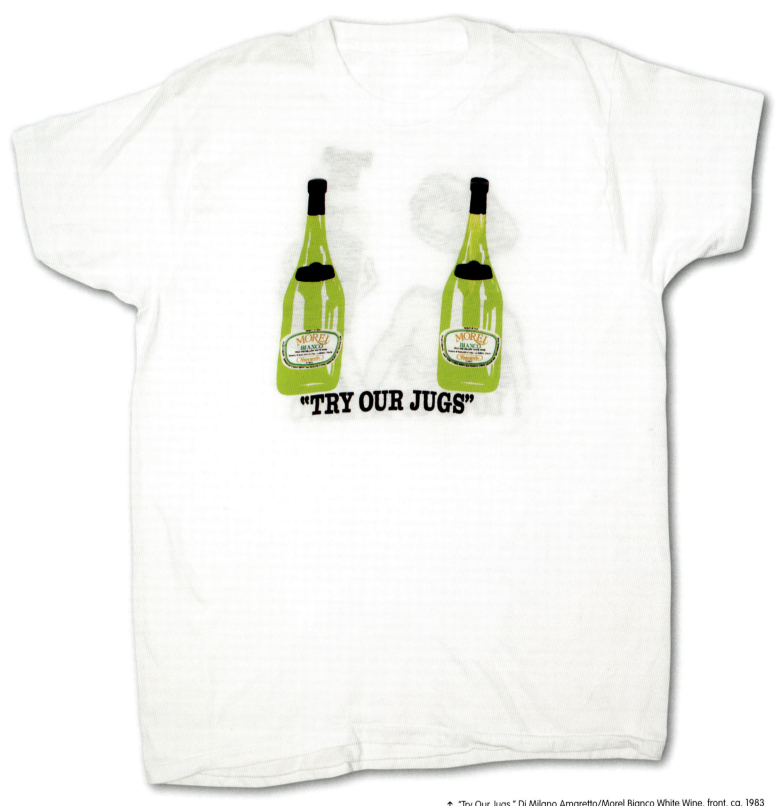

↑ "Try Our Jugs," Di Milano Amaretto/Morel Bianco White Wine, front, ca. 1983
→ "Absolut Perfection!", front 1980 →→ "I Slappa Your Face," ca. 1979; "Heaven," ca. 1989

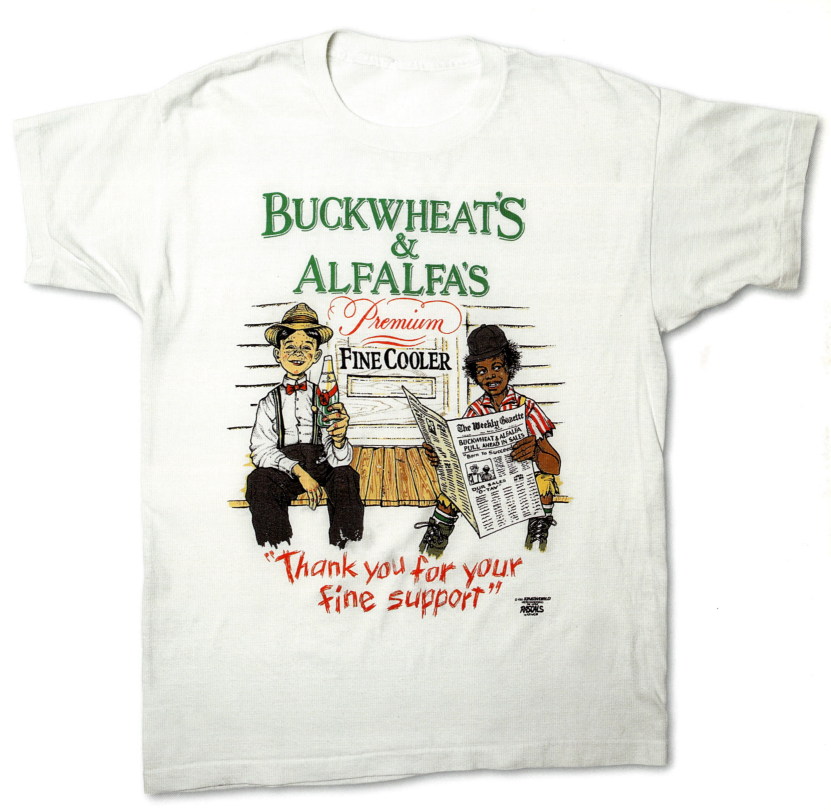

← "Buckwheat Extra," ca. 1989

↑ "Buckwheat's & Alfalfa's Premium Fine Cooler," ca. 1989

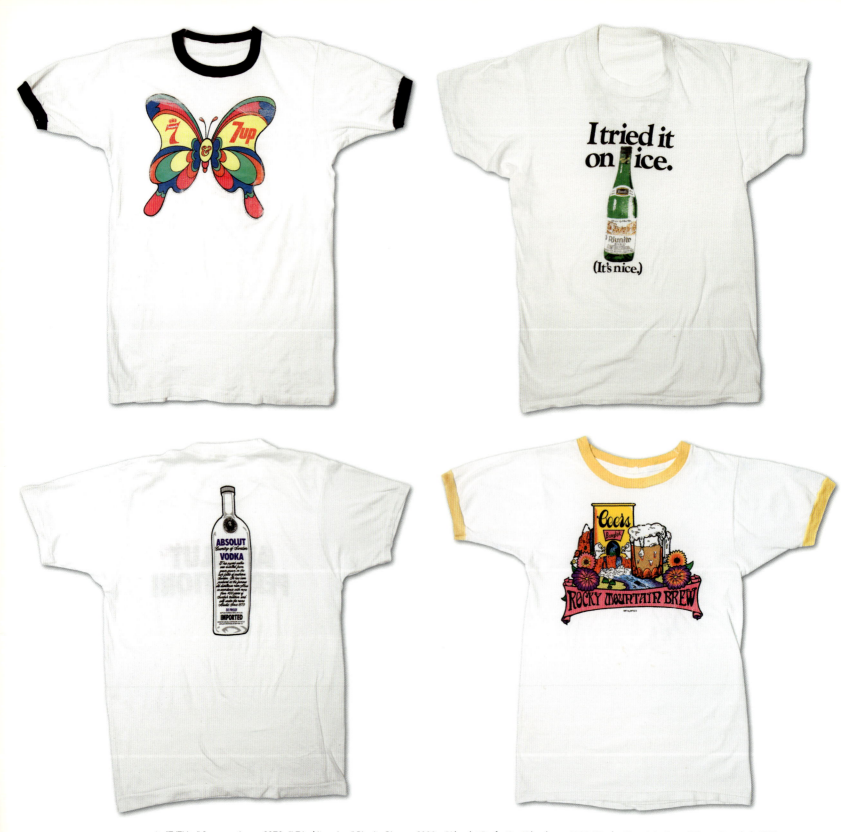

↑ "7/7Up," Seagram's, ca. 1979; "I Tried It on Ice," Riunite Bianco, 1980s; "Absolut Perfection!" back, ca. 1989; "Rocky Mountain Brew," Coors Bangkok, 1976

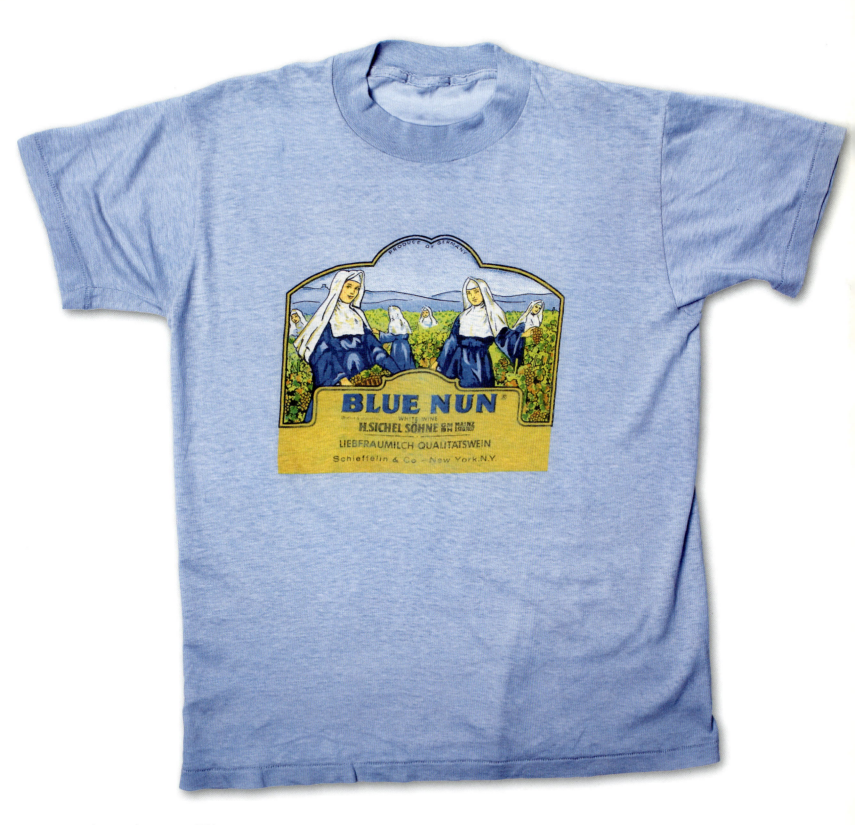

↑ "Blue Nun White Wine," ca. 1986

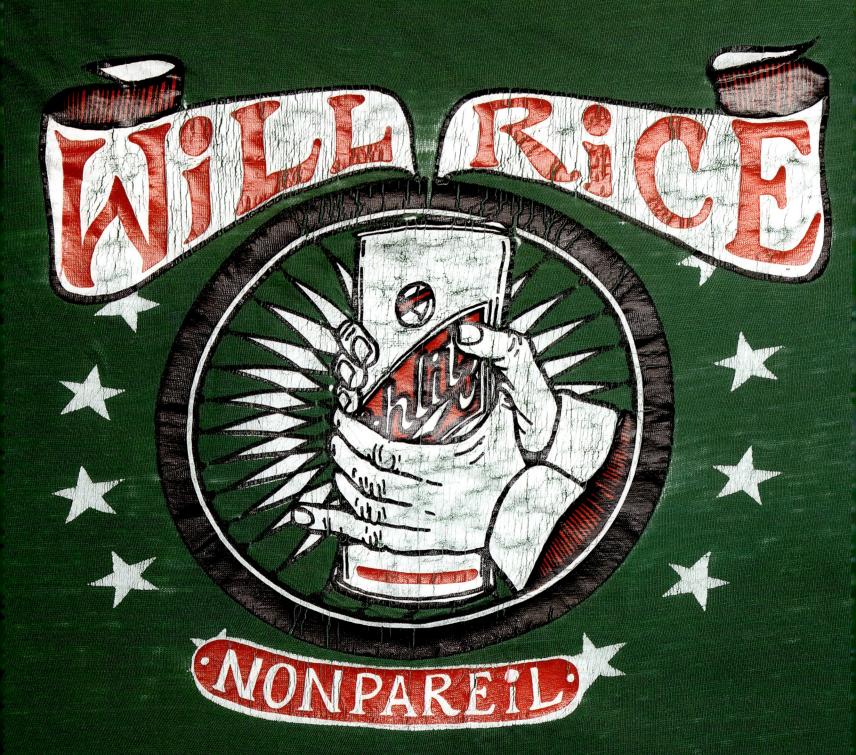

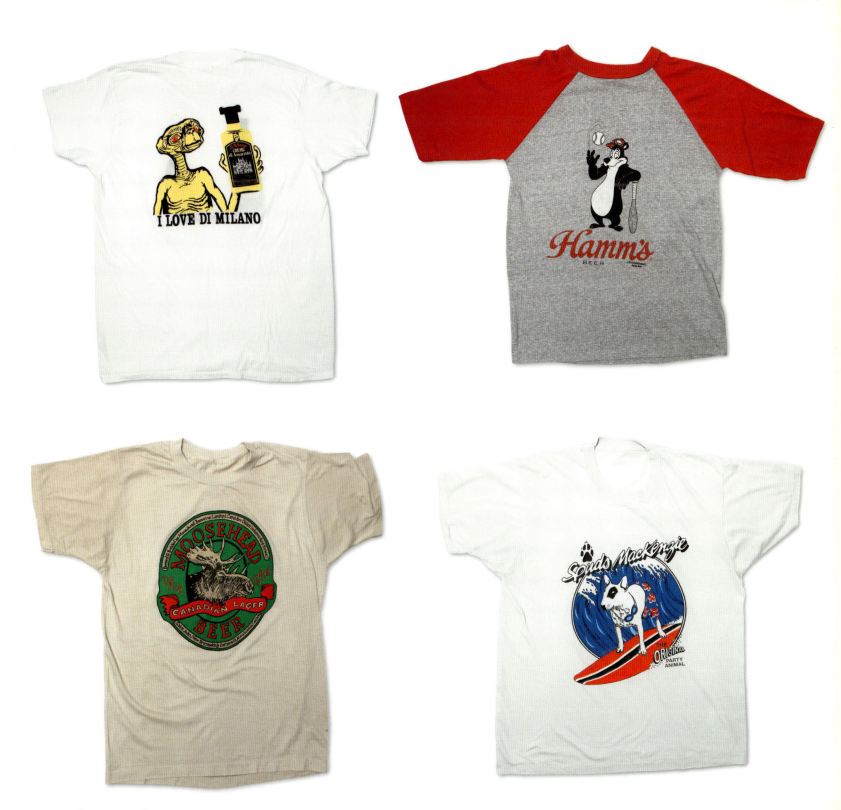

← Will Rice/Nonpareil, ca. 1983

↑ Di Milano Amaretto/Morel Bianco White Wine, back, ca. 1983; Hamm's Beer, 1978; Moosehead Beer, ca. 1989; Spuds MacKenzie, Budweiser, 1980s

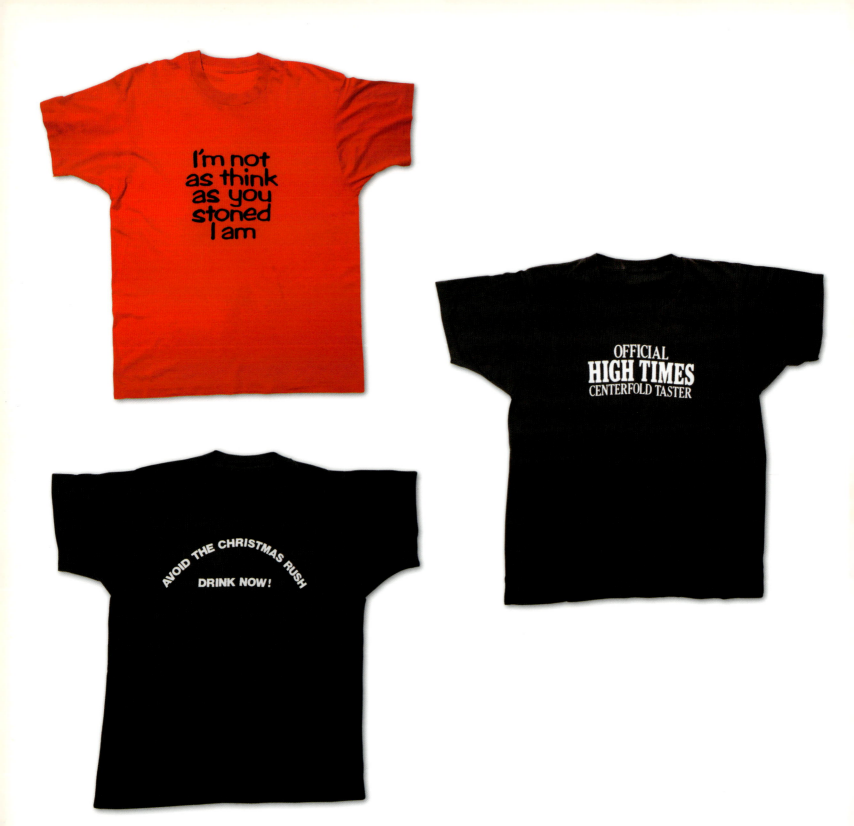

↑ "Stoned," 1980s; "Official *High Times* Centerfold Taster," ca. 1979; "Avoid the Christmas Rush," 1980s
→ "Drugs Are My Life," University of Wisconsin, 1980s

Drugs are my Life

UNIVERSITY OF WISCONSIN SCHOOL OF PHARMACY

↑ "Just Another Day in Paradise," Washington, 1984

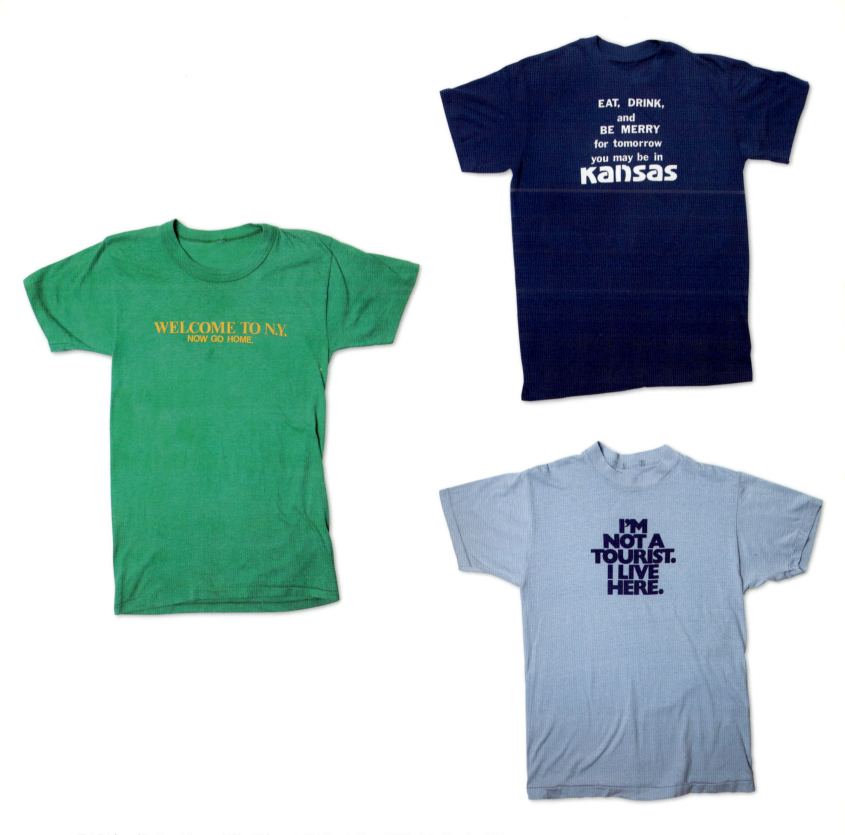

→ "Eat, Drink, and Be Merry," Kansas, 1980s; "Welcome to N.Y. Now Go Home," 1980s; "I Live Here," ca. 1989

TOURISM 263

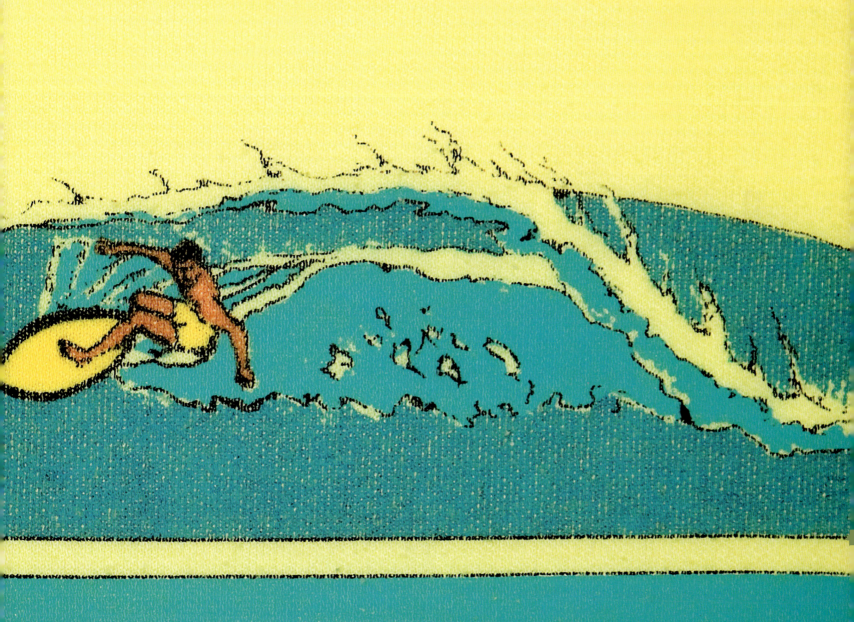

←← U.S. Virgin Islands, ca. 1983 ← "Circle C Ranch," Washington, ca. 1983
↑ Colorado, 1980s; Alaska, 1980s; Seattle, Washington, ca. 1983

TOURISM 267

↑ "N.Y.P.D. Homicide Squad," ca. 1989
→ "Liberty," New York, ca. 1976 →→ Hawaii, ca. 1983

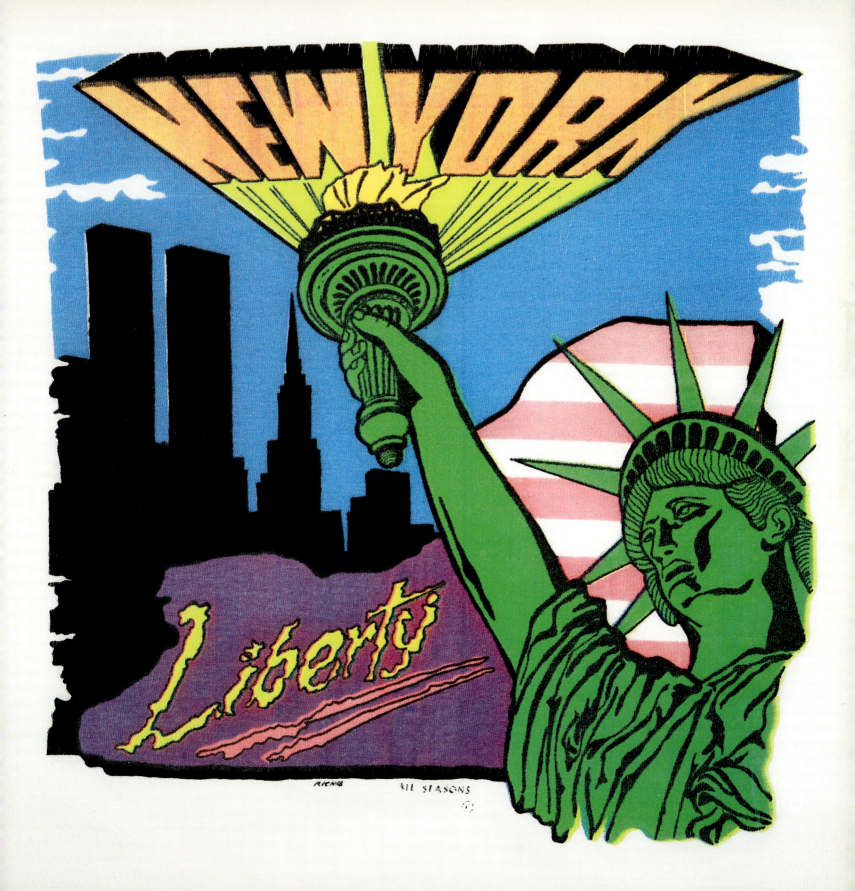

↑ California, 1982

↑ California, 1980s

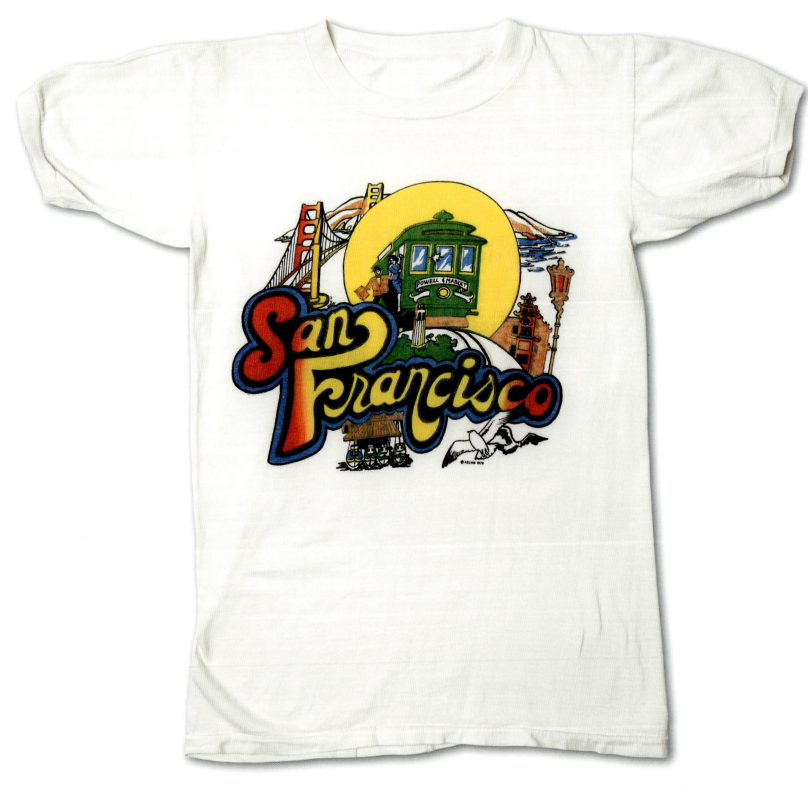

↑ San Francisco, 1976
→ "Andy Warhol," Jim Cherry, ca. 1979

WEEKENDS WERE MADE FOR

MINNESOTA

© 1987 Heartland Apparel, Inc.

← "Weekends Were Made for Minnesota," 1987
↑ "Minnesota State Bird," ca. 1983

TOURISM 277

↑ "White Sands, New Mexico," ca. 1983

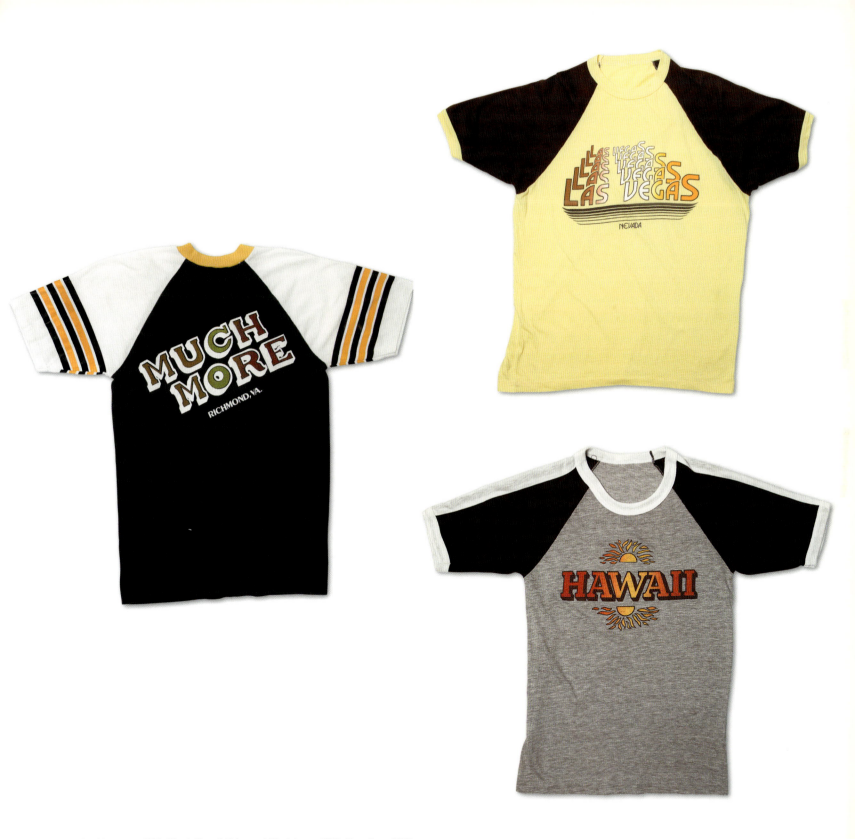

↑ Las Vegas, ca. 1983; "Much More," Richmond, Virginia, ca. 1979; Hawaii, ca. 1979

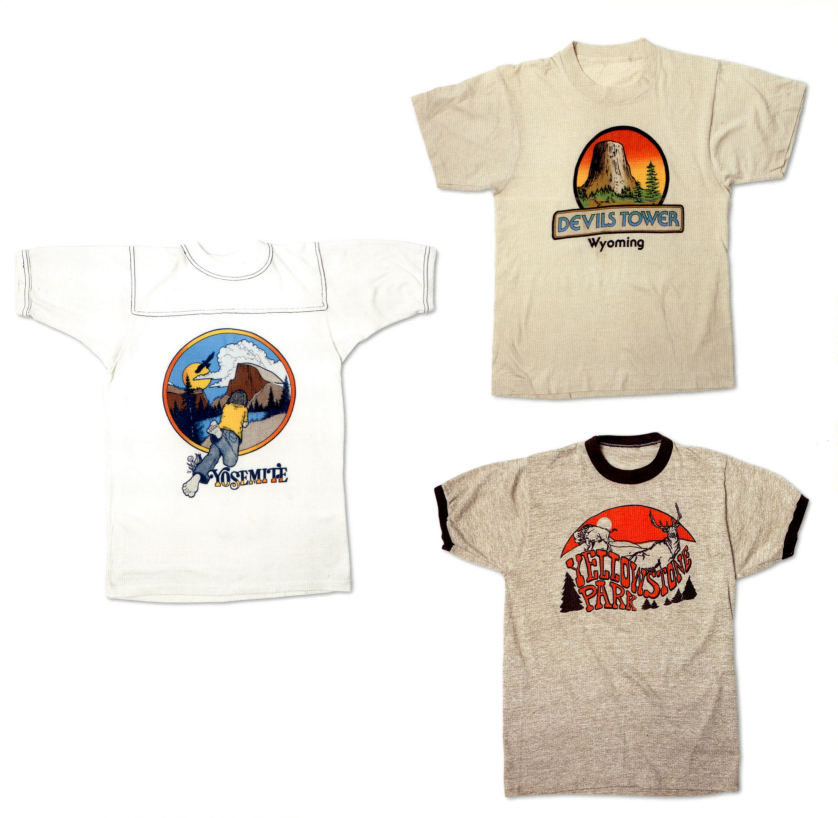

← "Happiness Is Yosemite," Yosemite National Park, 1981
↑ "Devils Tower, Wyoming," 1980s; Yosemite National Park, ca. 1979; Yellowstone National Park, ca. 1976

TOURISM 281

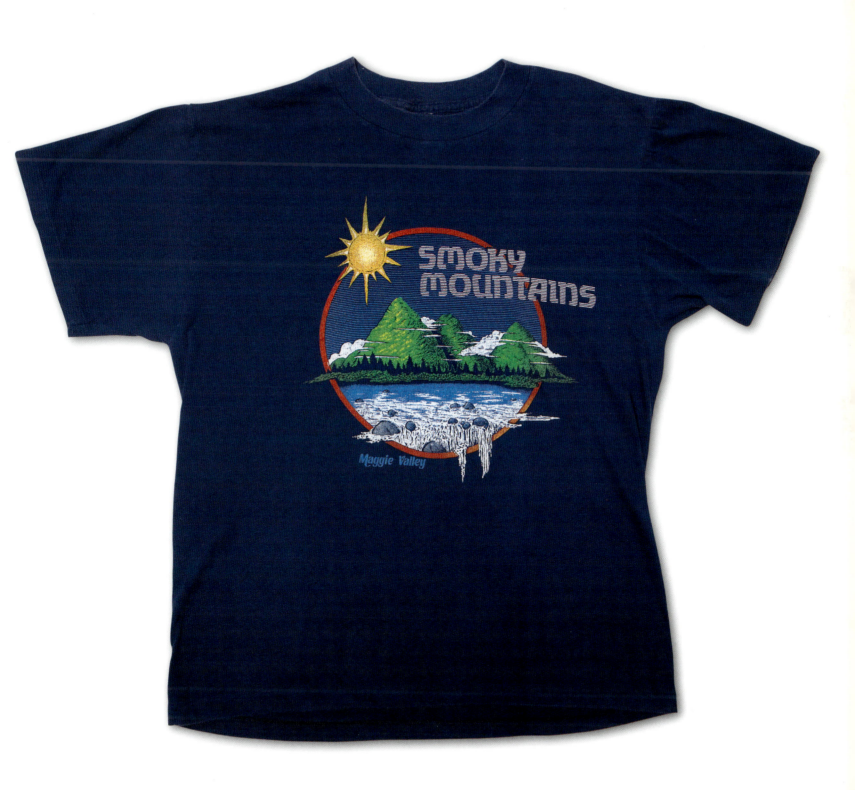

← Lake Tahoe, 1980s
↑ "Smoky Mountains," North Carolina, ca. 1983

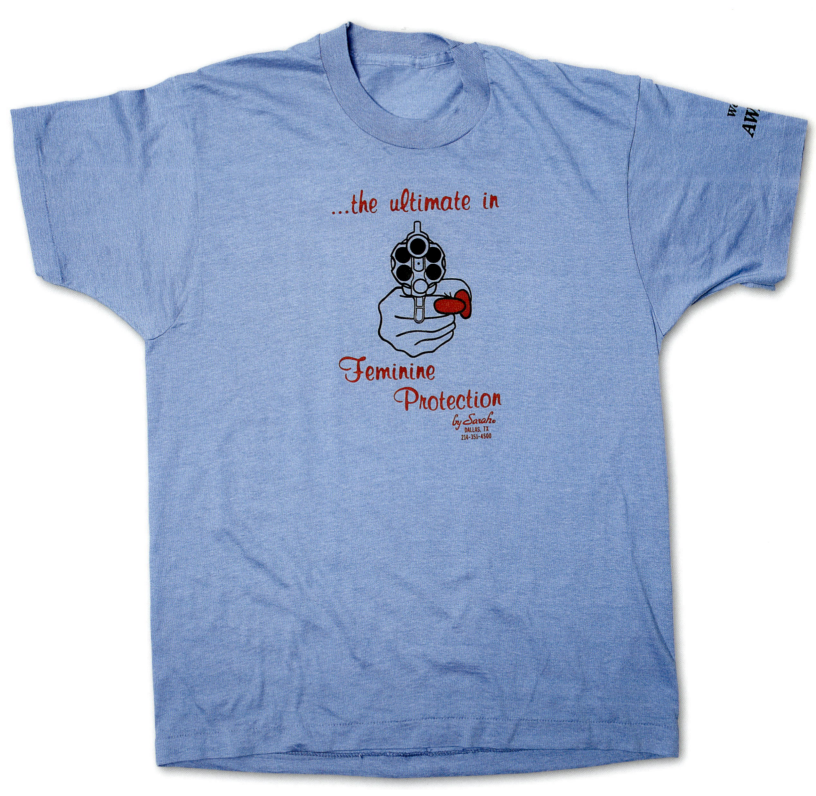

← "No Punks," ca. 1980s
↑ "Feminine Protection," ca. 1983

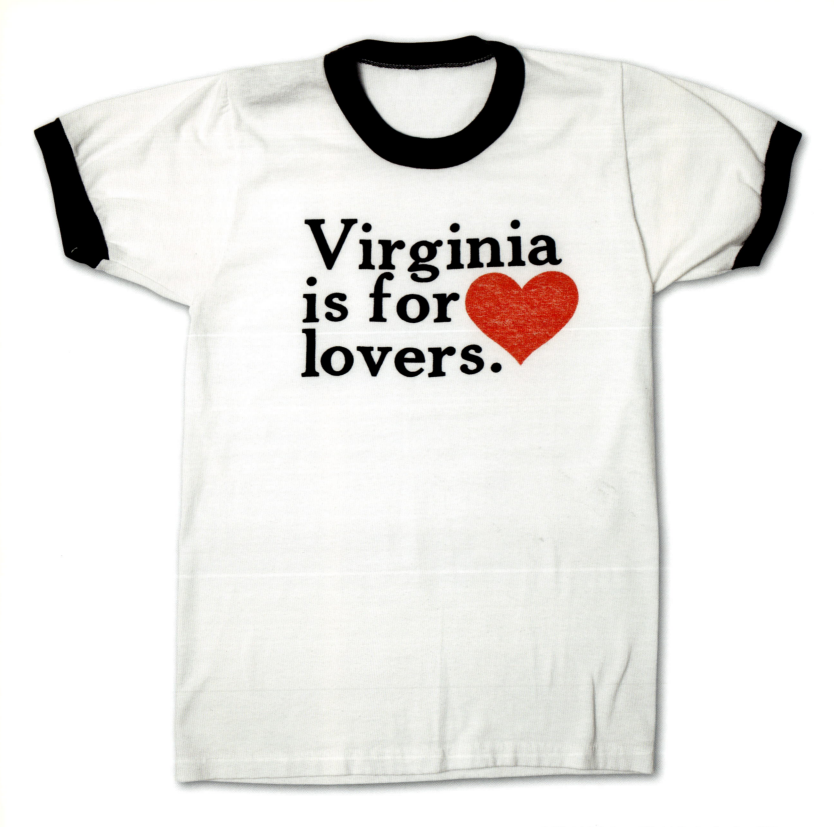

↑ "Virginia Is for Lovers," Virginia Tourism Board, ca. 1983

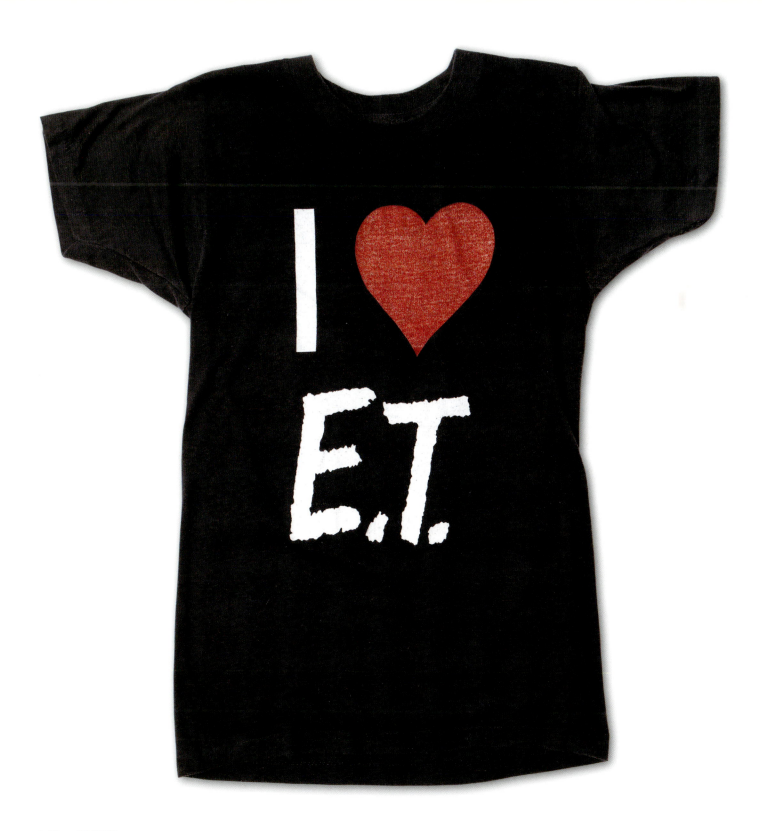

↑ "I Love E.T.," 1982

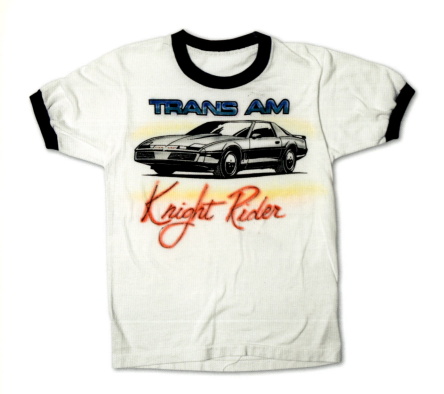

↑ "Trans Am," *Knight Rider*, 1982; "Trans Am," G.M. Van Nuys, California, ca. 1979; "Z/28 Camaro," Chevrolet, 1980s; *Knight Rider*, 1982
→ *Knight Rider*, 1980s

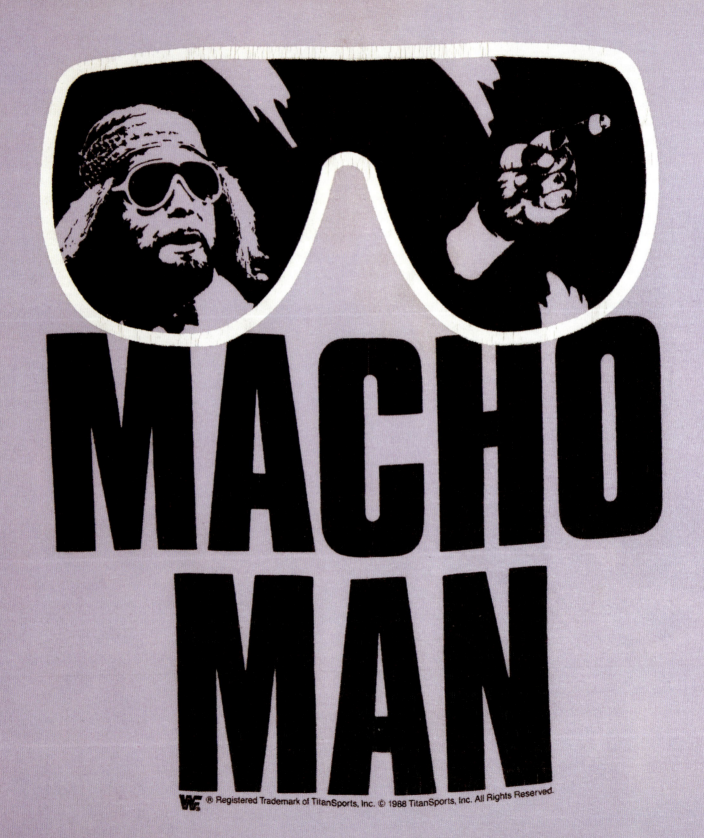

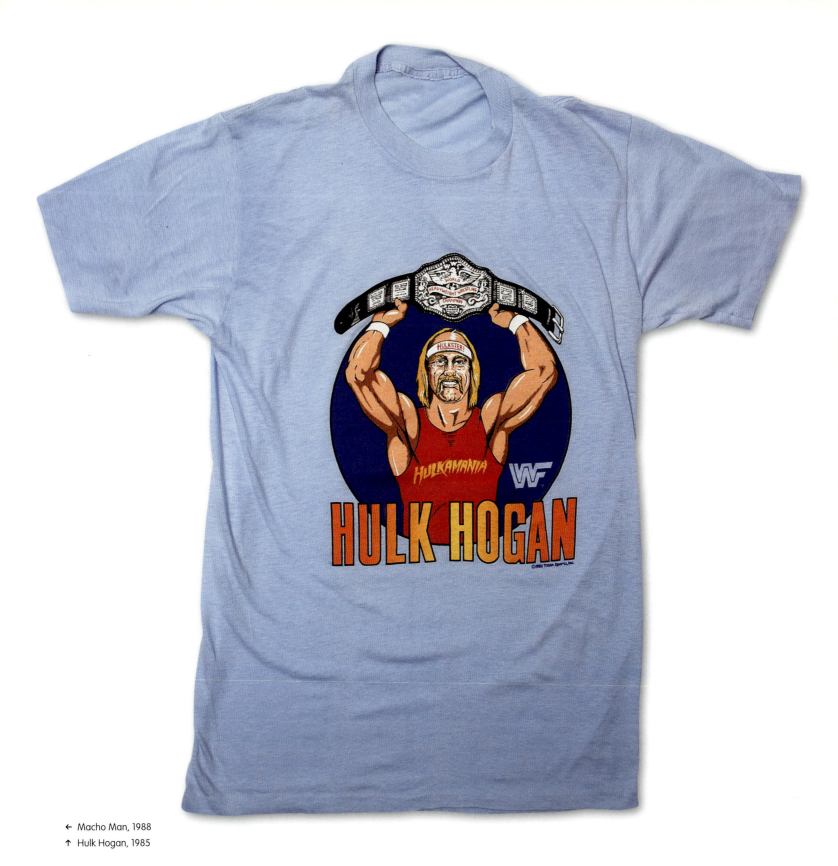

← Macho Man, 1988

↑ Hulk Hogan, 1985

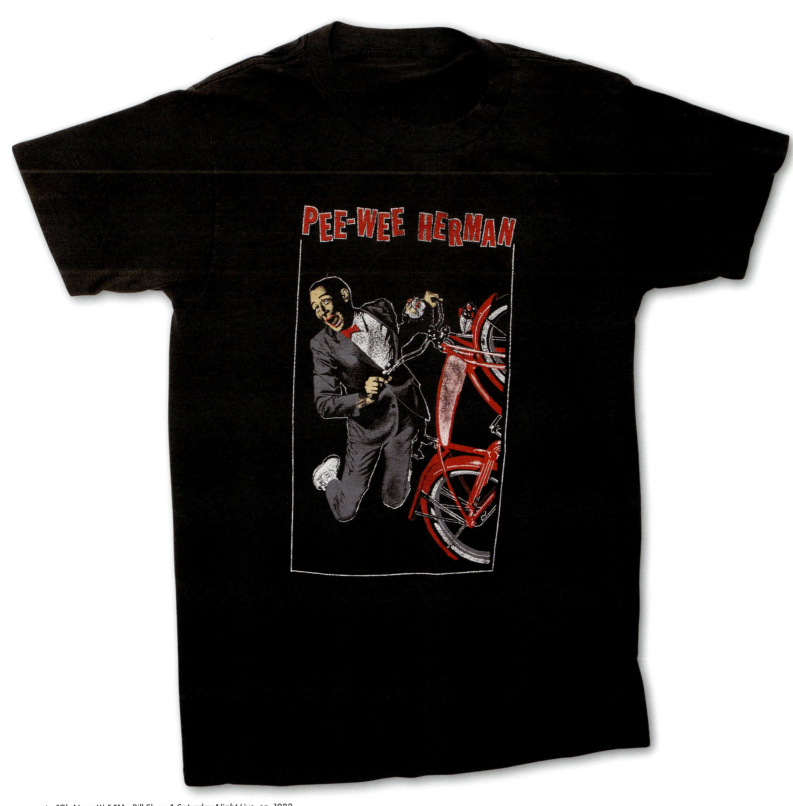

← "Oh Nooo!!!," "Mr. Bill Show," *Saturday Night Live*, ca. 1983

↑ Pee-Wee Herman, 1986

ENTERTAINMENT 293

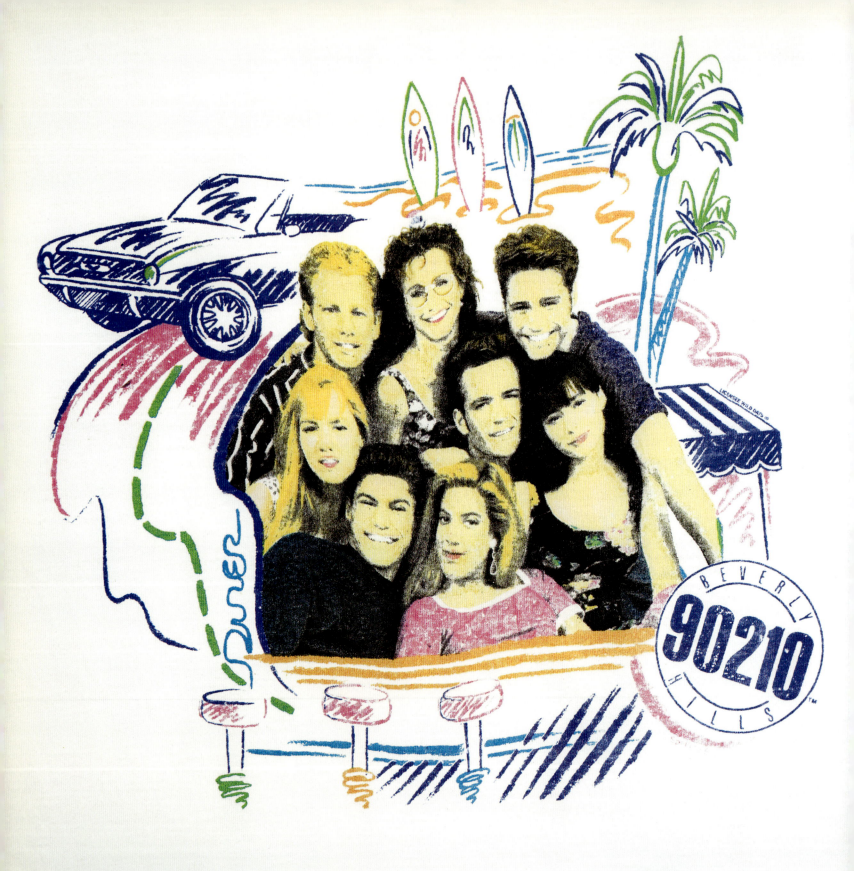

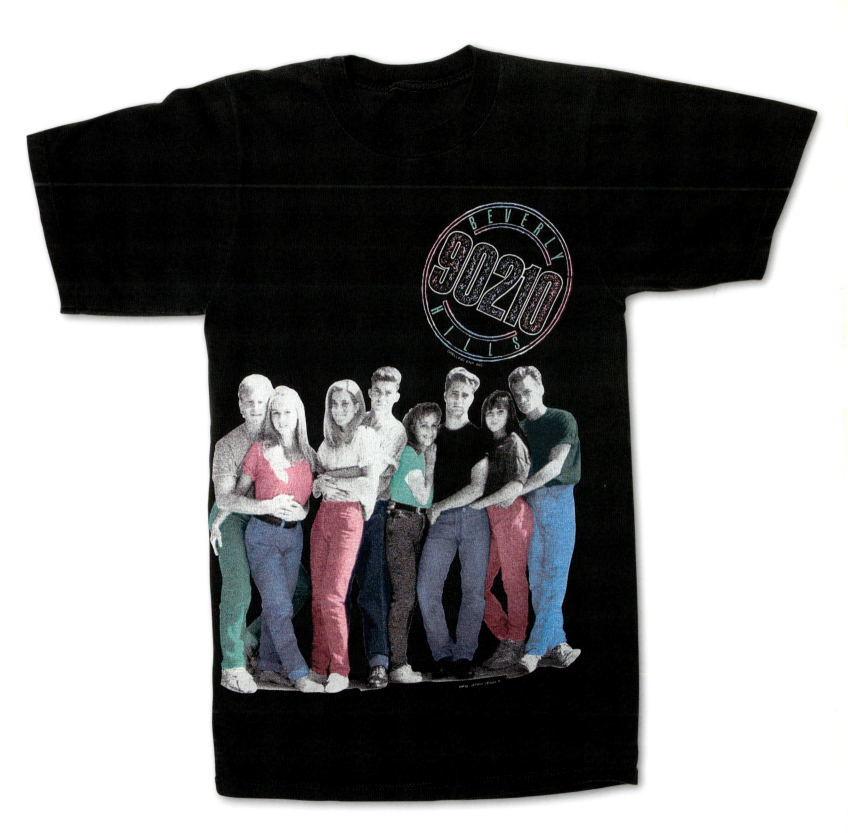

←↑ *Beverly Hills 90210,* 1990

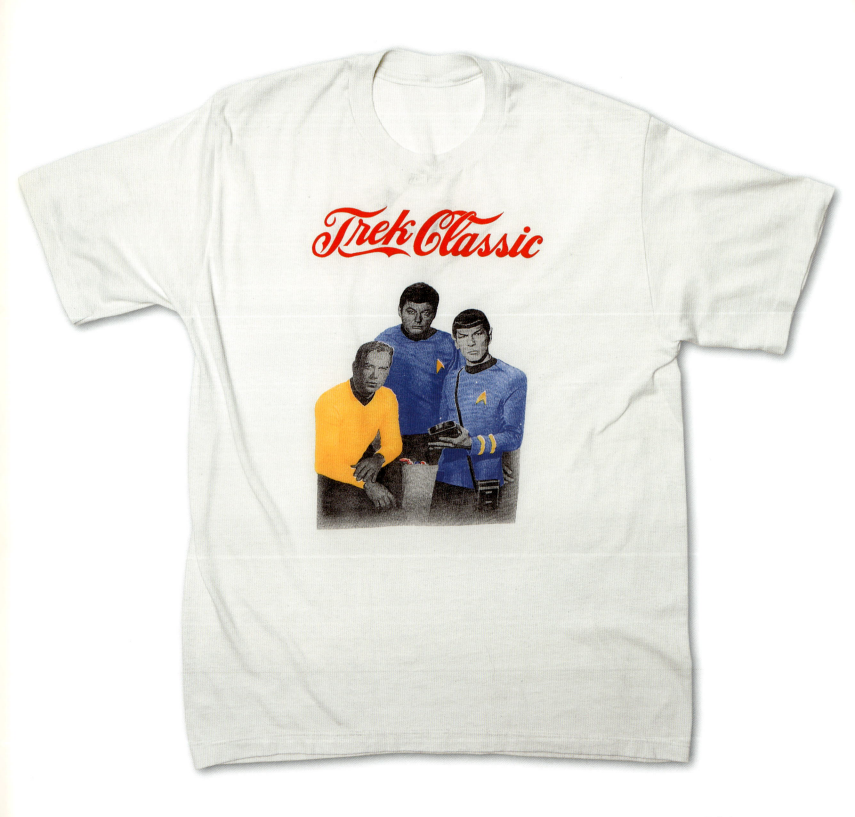

↑ "Trek Classic," 1980s

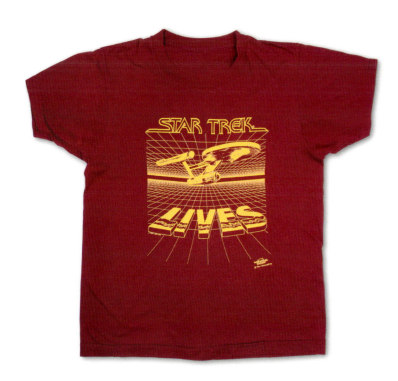

↑ *Star Trek V: The Final Frontier*, front, 1989; "Star Trek Lives," 1983; *Star Trek V: The Final Frontier*, back, 1989

↑ "KnoWhutImean?," Ernest, 1986; *Star Wars, Return of the Jedi*, 1983; "I Love Jerry's Kids," Jerry Lewis MDA Telethon, 1970s; "Aaaaay," *Happy Days*, ca. 1980

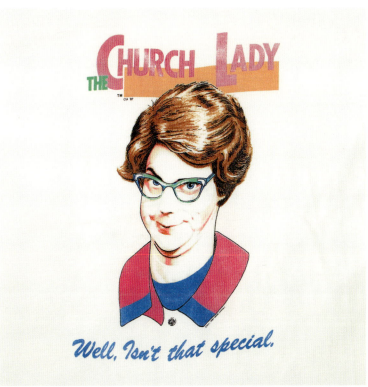
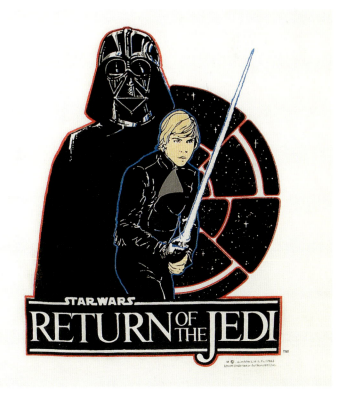

↑ *The New $100,000 Pyramid*, 1983; "Homey Don't Play That," *In Living Color*, ca. 1993; The Church Lady, *Saturday Night Live*, ca. 1986; *Star Wars: Return of the Jedi*, 1983

ENTERTAINMENT 299

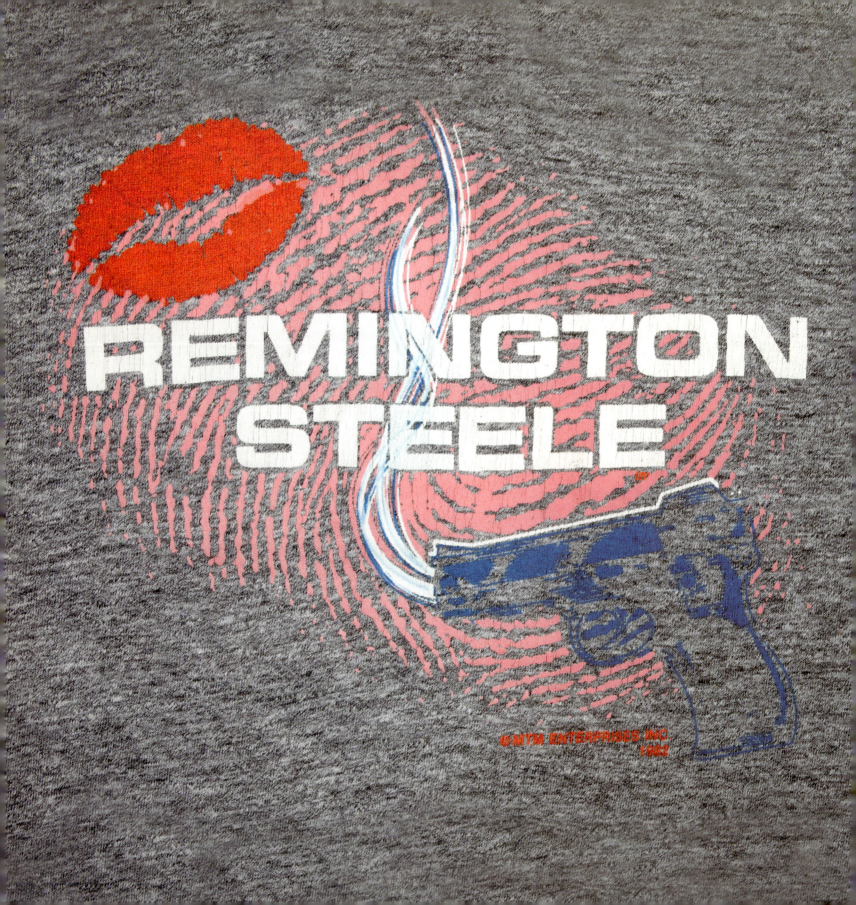

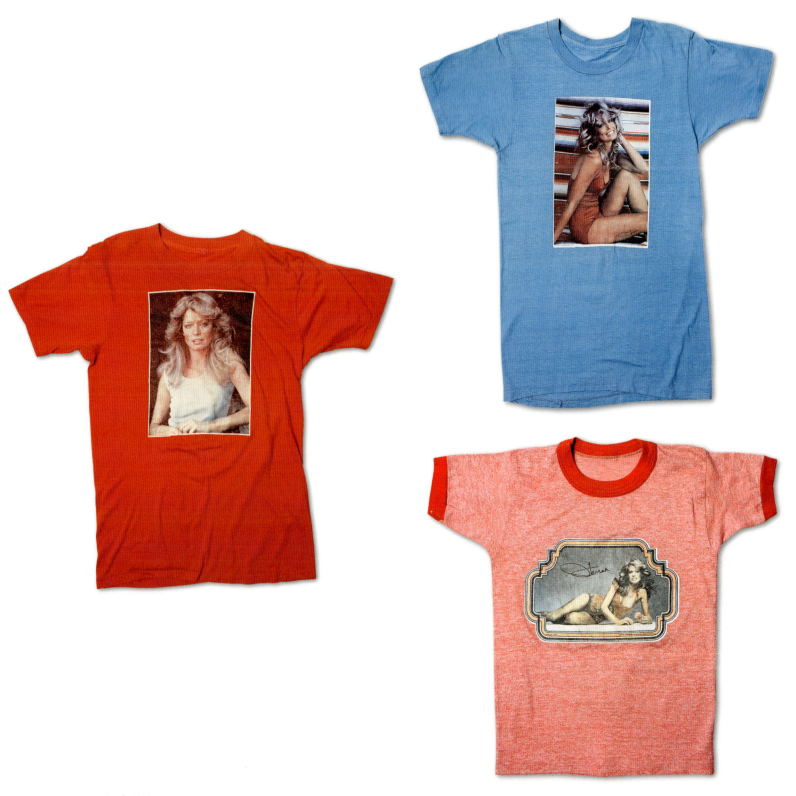

← *Remington Steele*, 1982
↑ Farrah Fawcett, 1976

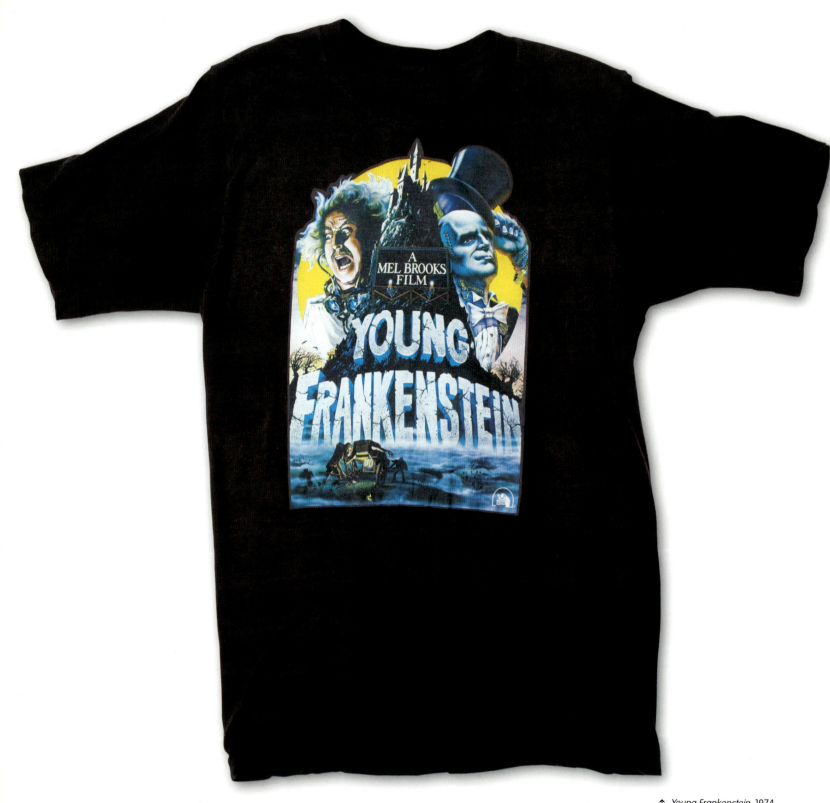

↑ Young Frankenstein, 1974
→ The Rocky Horror Picture Show, 1975

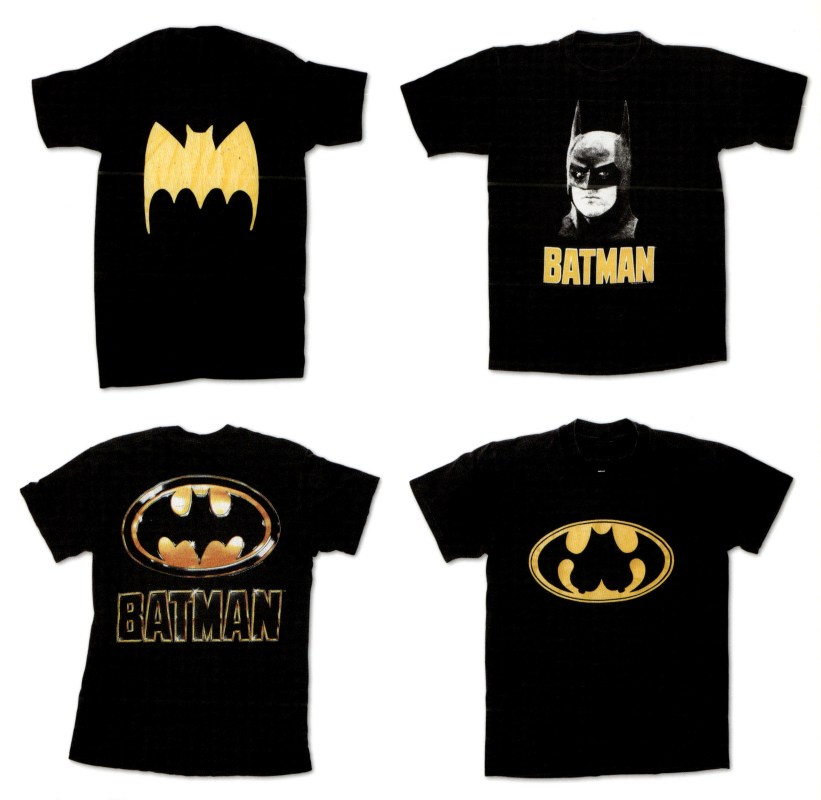

← Batman, ca. 1983
↑ Batgirl, ca. 1983; Batman, 1989; Batman, 1989; Batgirl parody, 1989

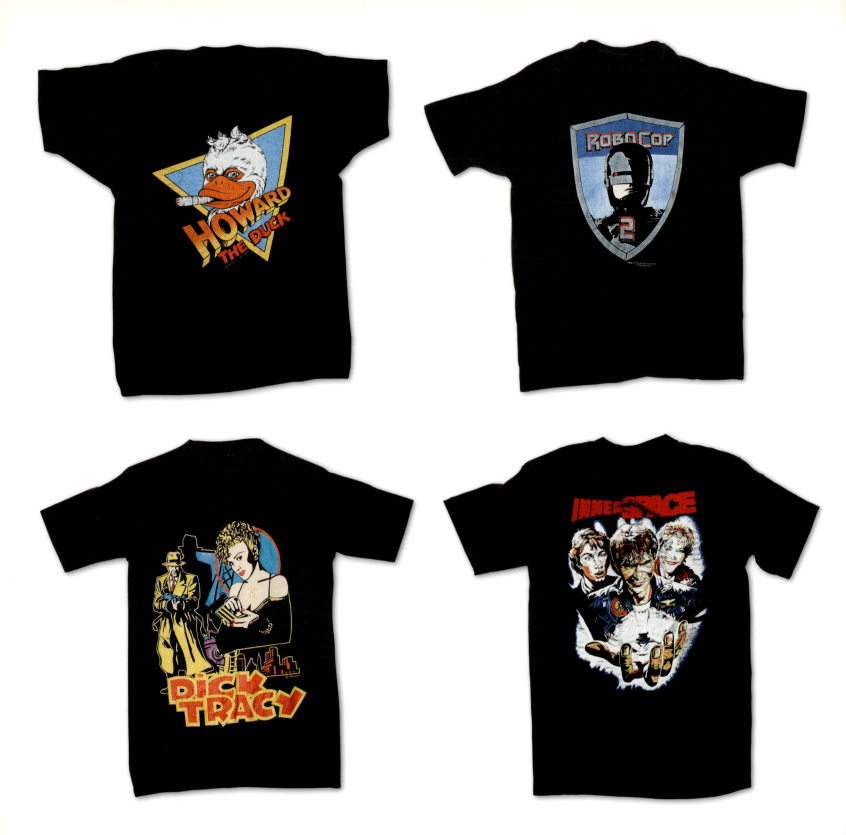

↑ *Howard the Duck*, 1986; *RoboCop 2*, 1990; *Dick Tracy*, 1990; *Inner Space*, 1987

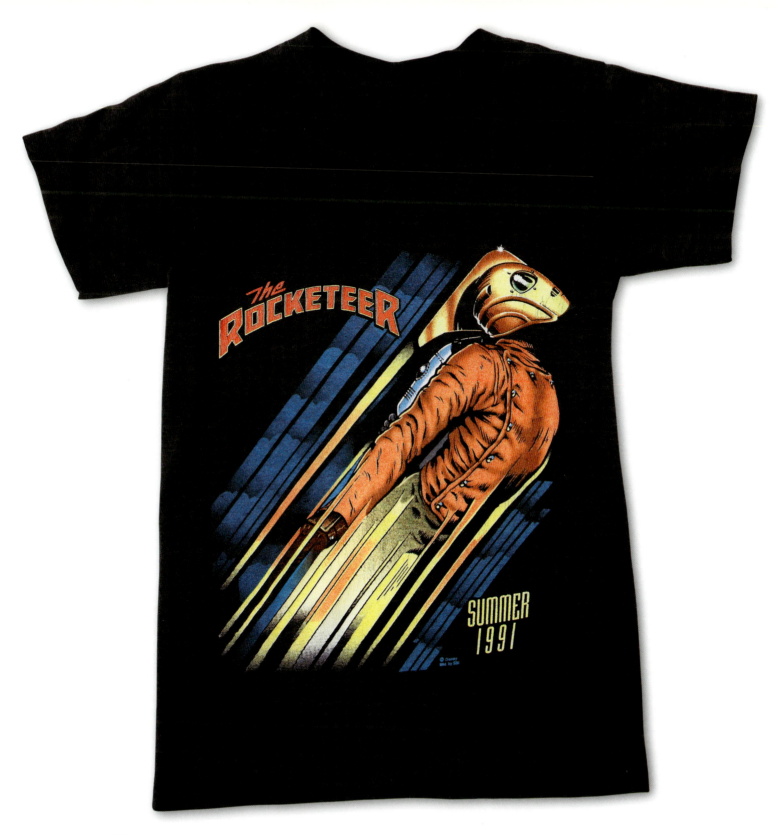

↑ *The Rocketeer*, 1991

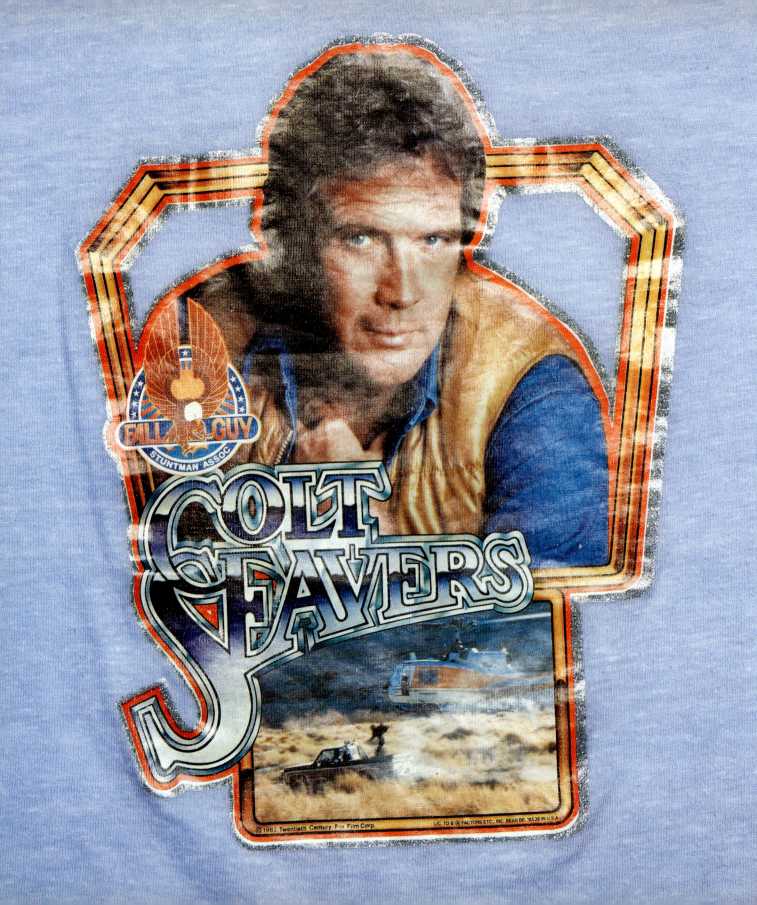

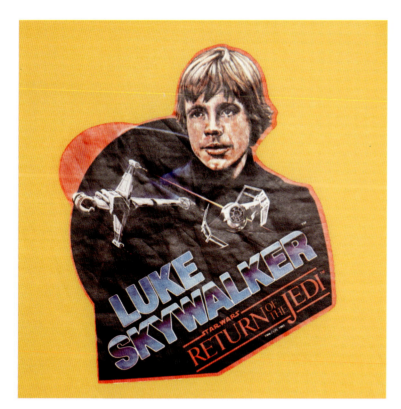
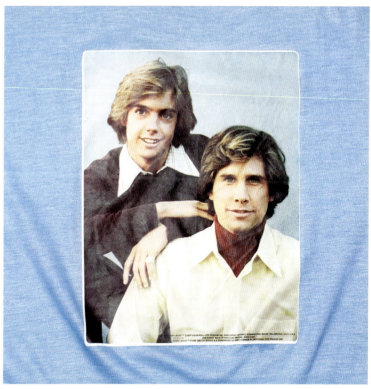
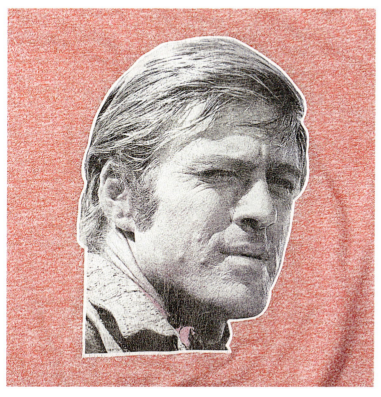
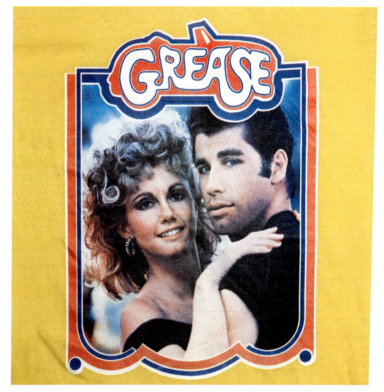

← "Colt Seavers," *The Fall Guy*, 1981
↑ "Luke Skywalker," *Star Wars: Return of the Jedi*, 1983; *The Hardy Boys*, 1977; Robert Redford, ca. 1976; *Grease*, 1978

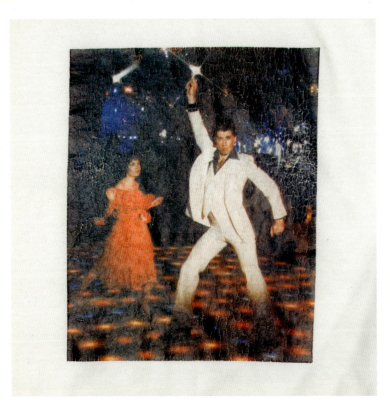
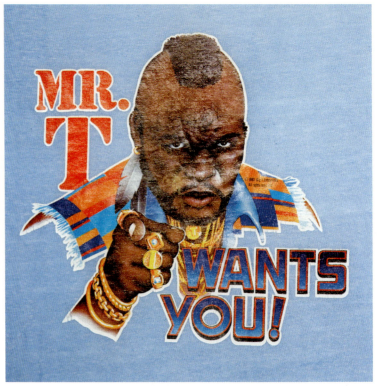
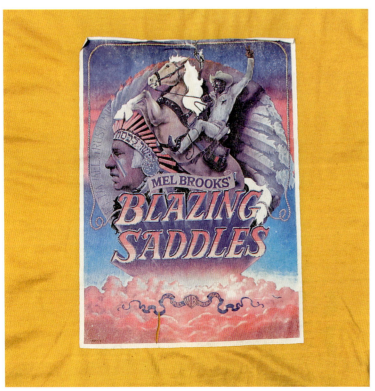
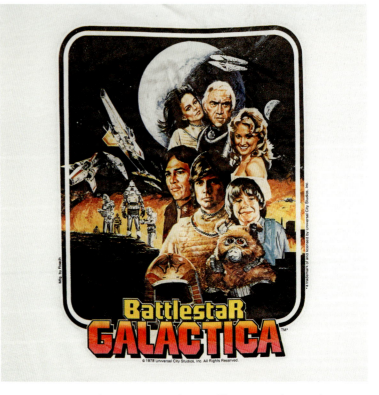

↑ *Saturday Night Fever*, 1977; "Mr. T Wants You," *The A-Team*, 1983; *Blazing Saddles*, 1974; *Battlestar Galactica*, 1978
→ *Captain Fantastic*, Elton John, 1975

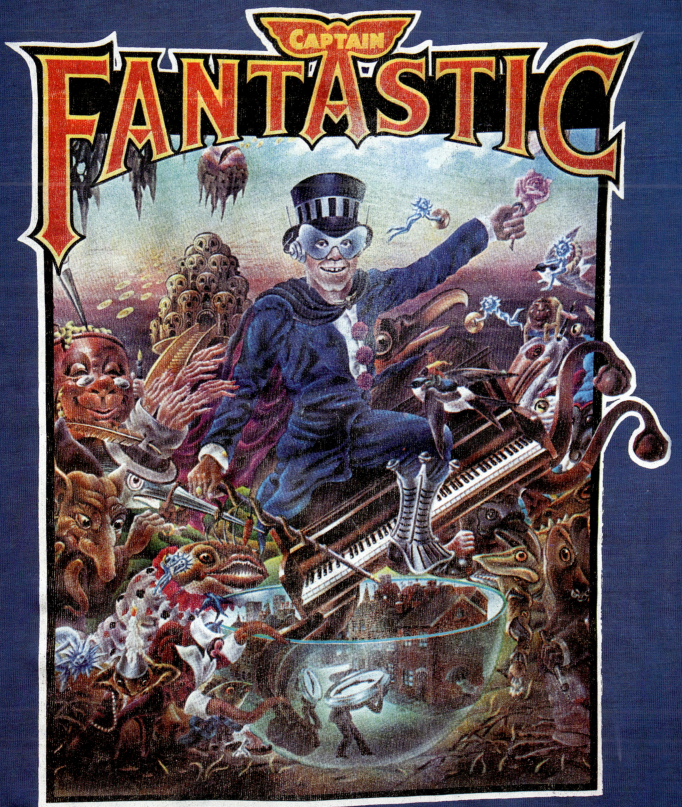

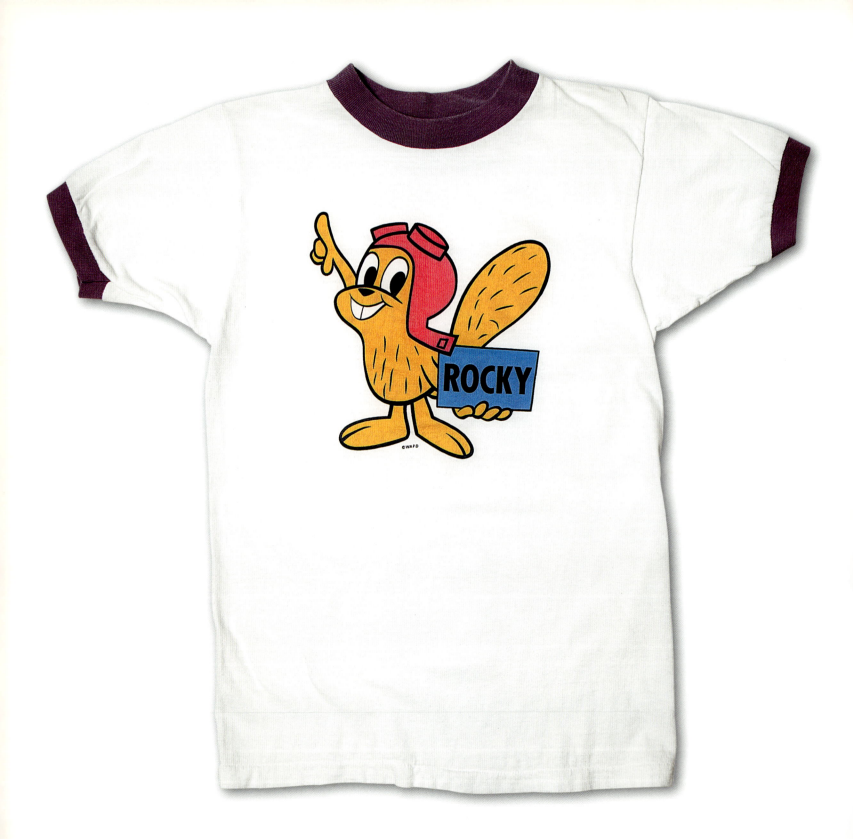

↑ "Rocky," *Rocky & Bullwinkle & Friends,* 1970s

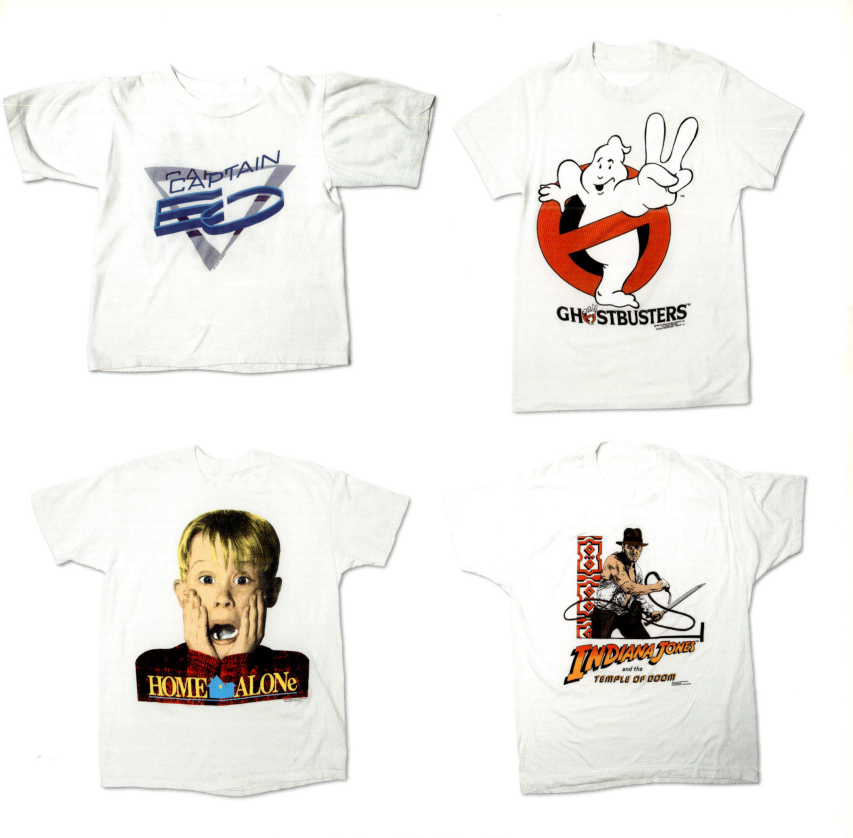

↑ *Captain EO*, 1986; *Ghostbusters II*, 1989; *Home Alone*, 1990; *Indiana Jones and the Temple of Doom*, 1984

↑ "Devo I," ca. 1976; *Gremlins*, 1984; *E.T., The Extra-Terrestrial*, 1983; *Munsters* parody, 1990

↑ Marx Brothers, ca. 1976; *Blues Brothers* soundtrack, Atlantic Records, 1980; *The Gong Show Movie*, 1980; *The Thing*, 1982

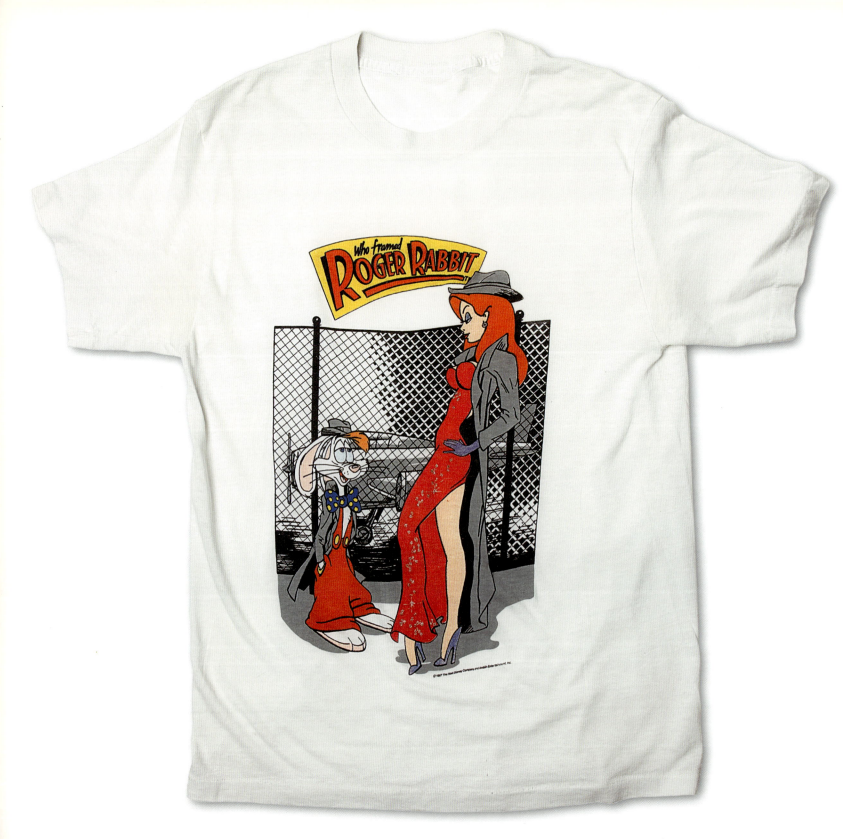

Who Framed Roger Rabbit, 1987

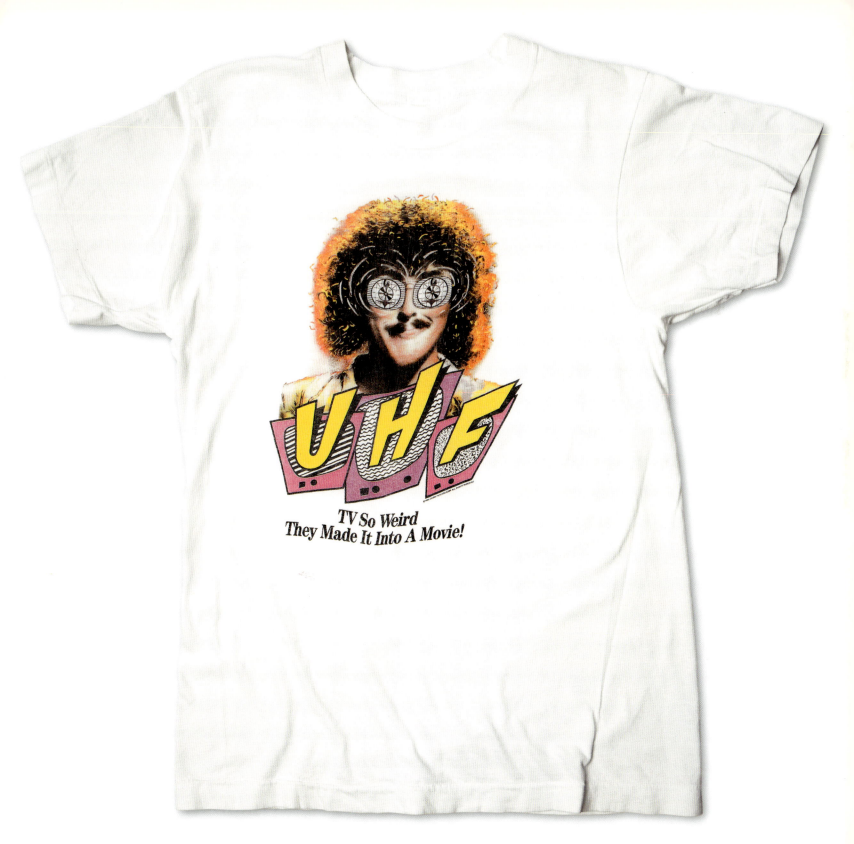

↑ UHF, 1989

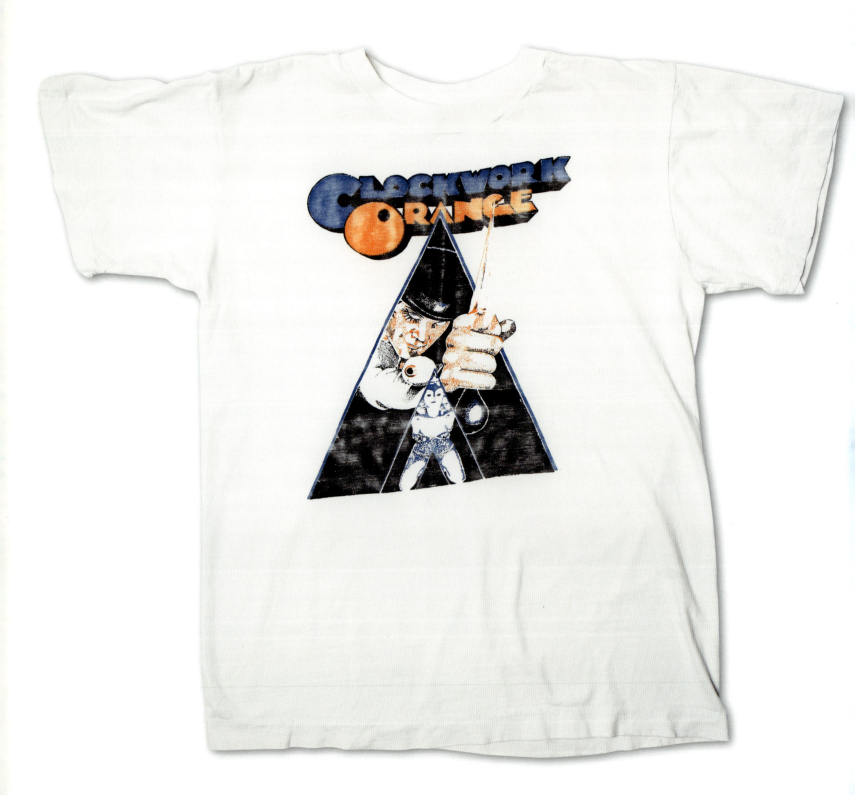

↑ *Clockwork Orange*, 1971
→ *For Your Eyes Only*, 1981

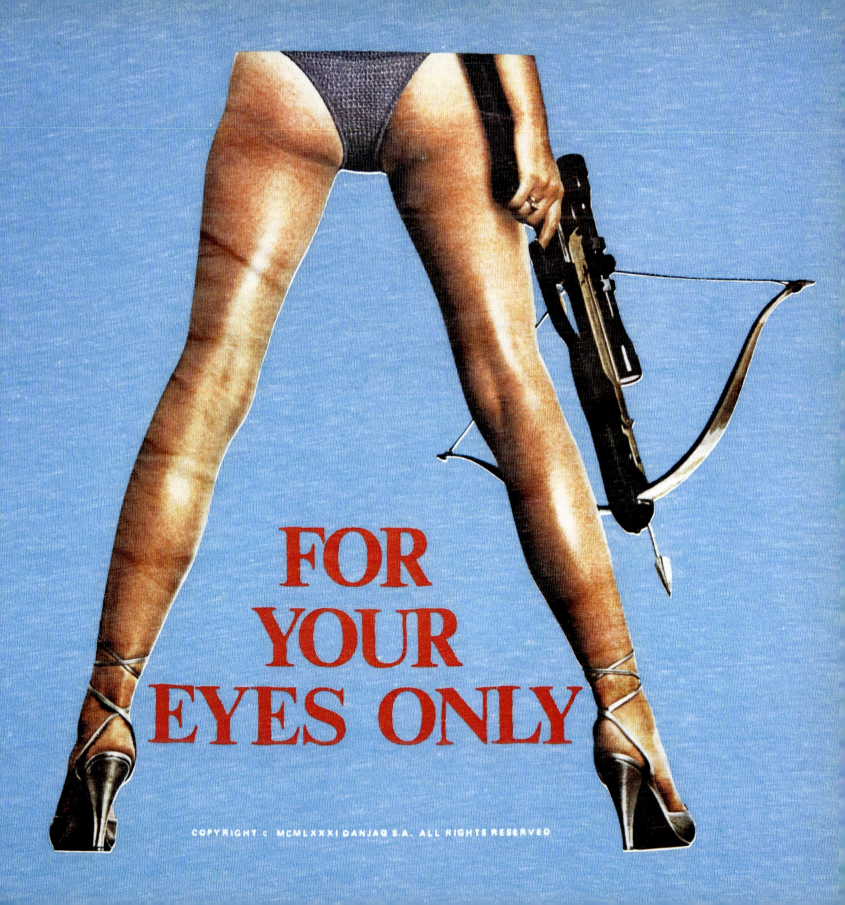

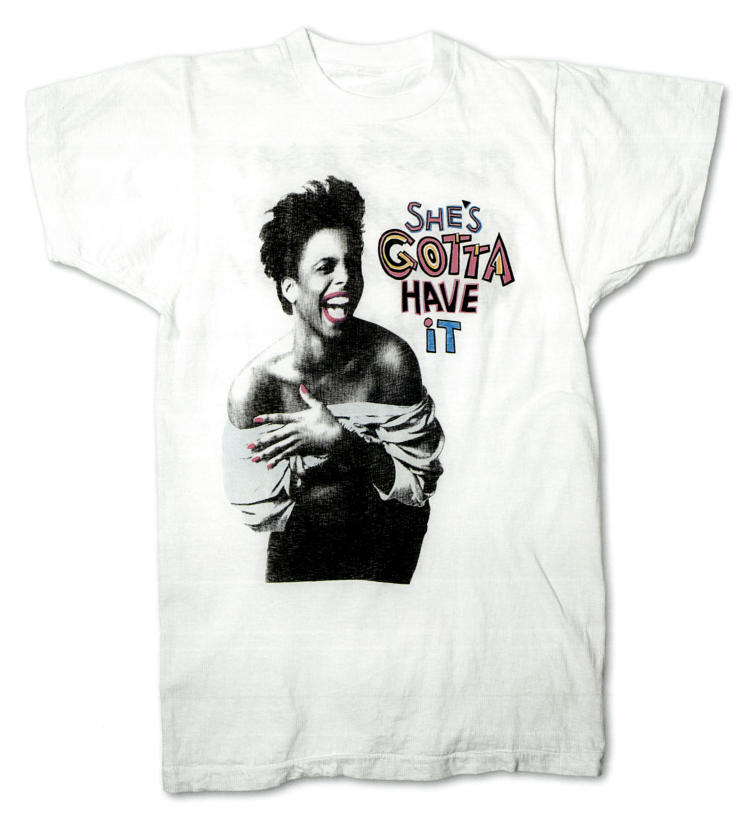

She's Gotta Have It, 1986

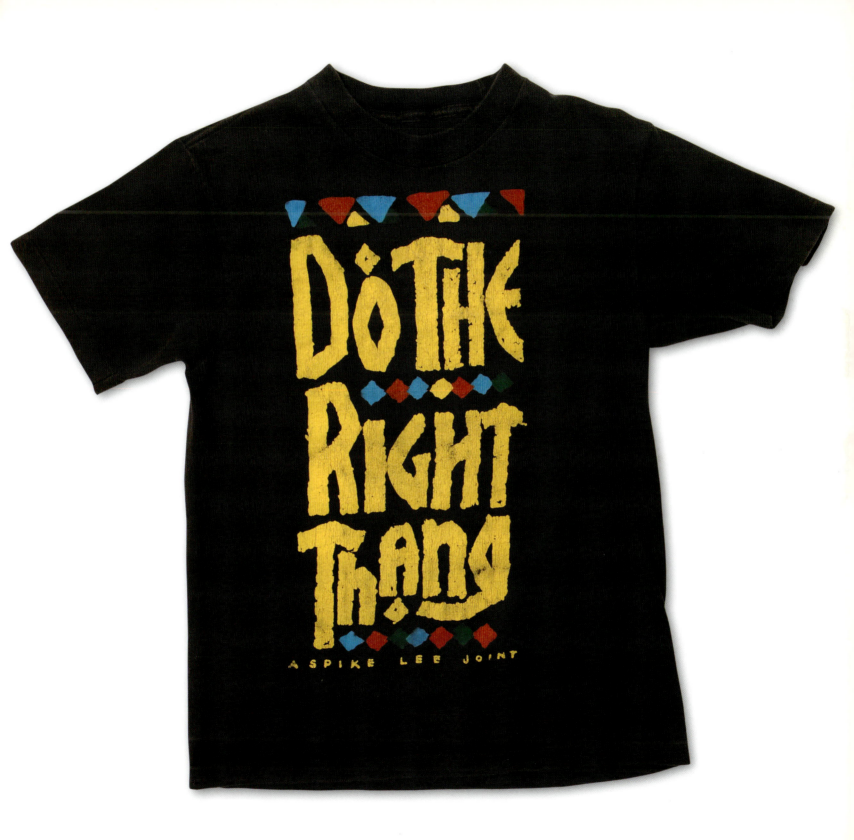

↑ "Do the Right Thang," 1989

ENTERTAINMENT 321

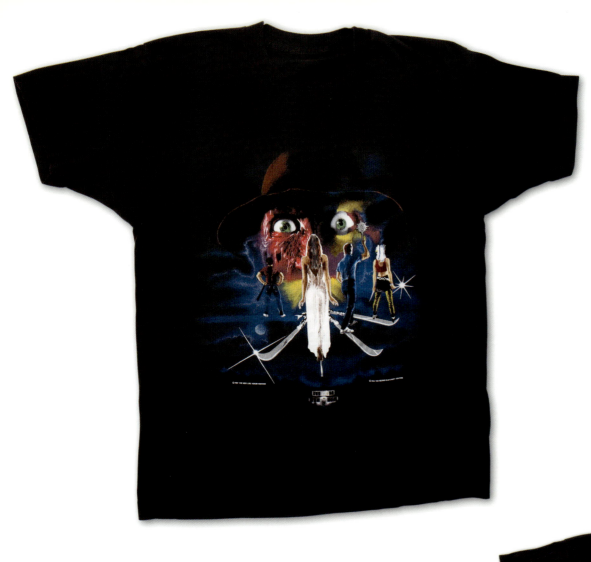

↑ *A Nightmare on Elm Street 3*, front and back, 1987

322 ENTERTAINMENT

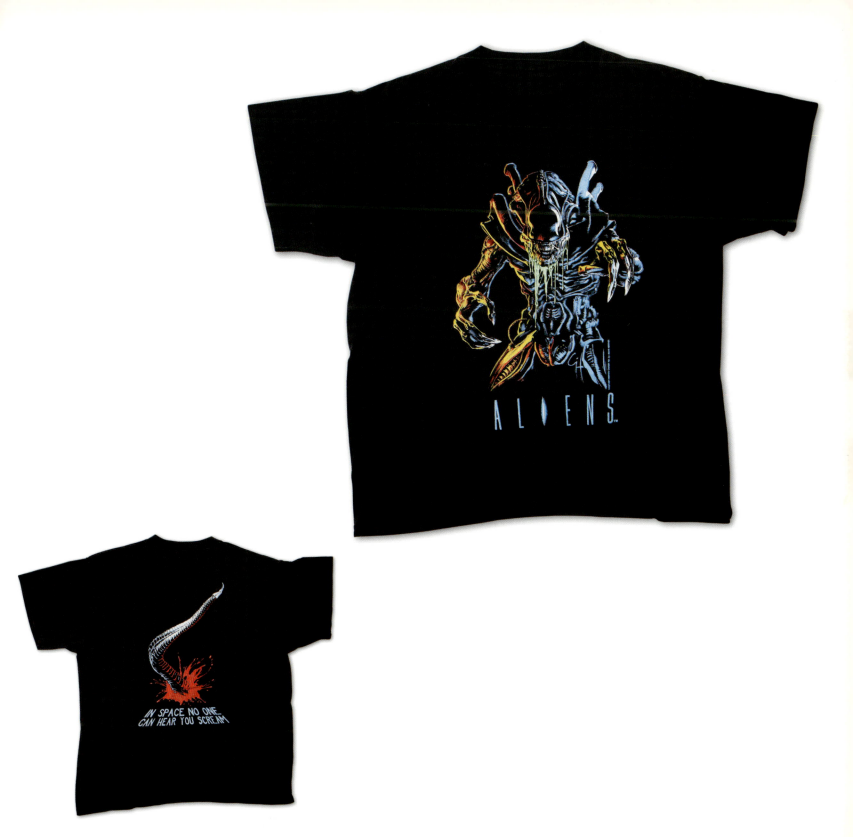

↑ Aliens, front and back, 1986

← "Freddy Krueger," *Nightmare on Elm Street*, 1984

↑ *Psycho II*, 1983; *Halloween 4*, 1988; "Michael Myers Lives!," *Halloween*, 1981; *Poltergeist*, 1982

ENTERTAINMENT 325

↑ "Born to Kill," *Full Metal Jacket*, 1987
→ *Rocky IV*, 1985

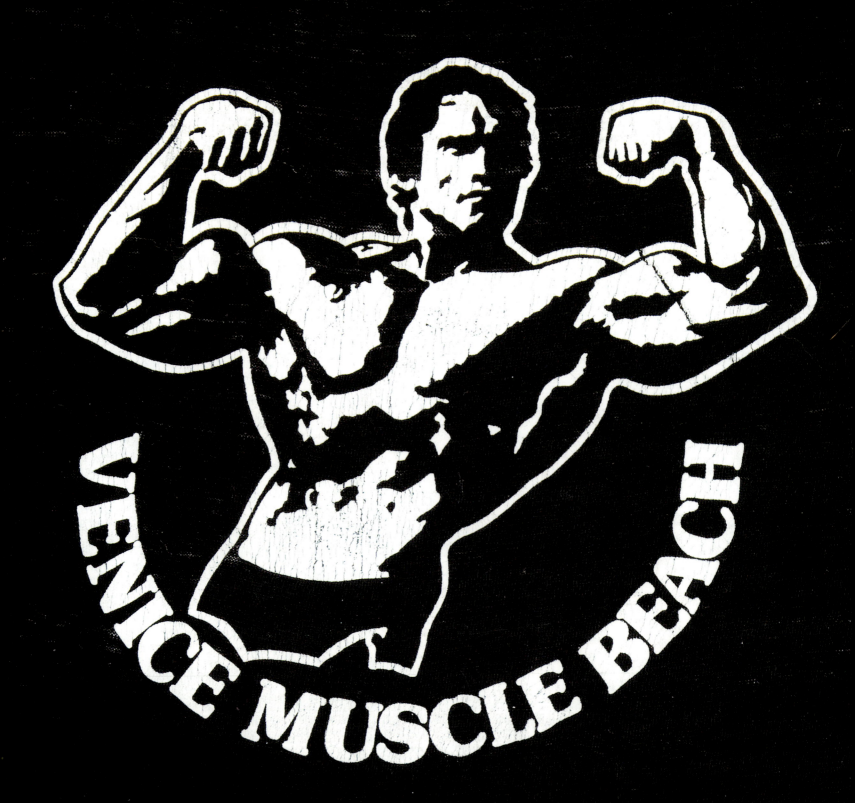

← "Venice Muscle Beach" Arnold Schwarzenegger, 1980s
↑ "I Am Back," *Terminator 2*, 1991

↑ "Buckle That Belt," 1980s

↑ "I've Got My MTV," 1985; The Pink Panther, Friz Freleng, 1987; "M.A.S.H. 4077th," 1982

↑ *The Karate Kid*, 1986
→ *Caddyshack*, 1980

Caddyshack

The comedy with...

© 1980 Orion Picture Co.
All Rights Reserved

← "*The Young and the Restless* Fanatic," 1976
↑ *Fatal Attraction*, 1987

ENTERTAINMENT 335

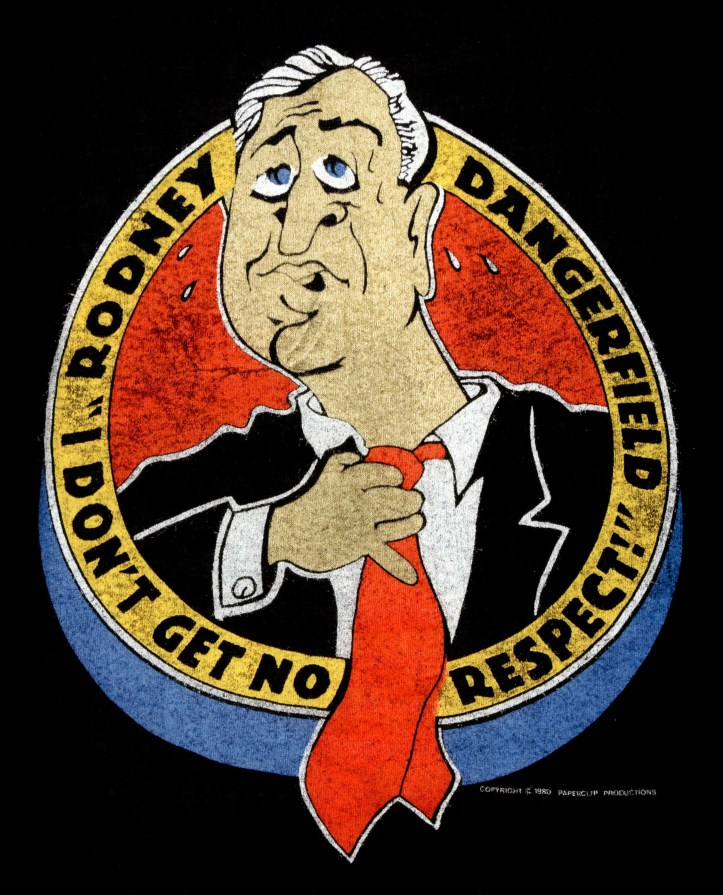

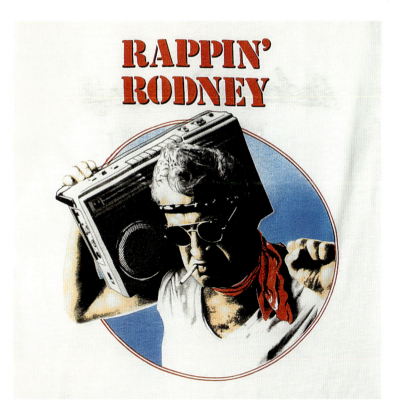
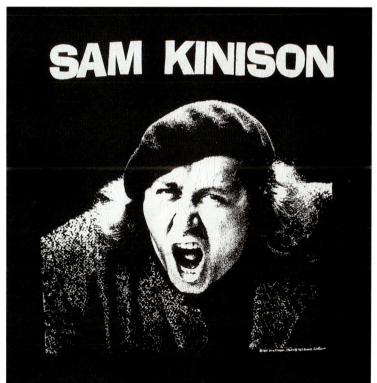
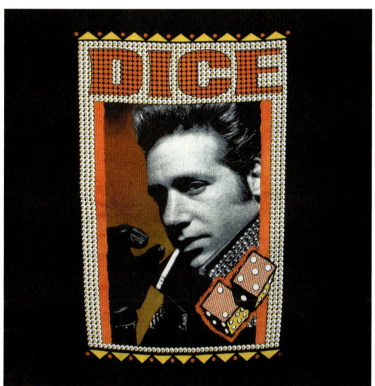

← "I Don't Get No Respect!," Rodney Dangerfield, 1980
↑ "Rappin' Rodney," Rodney Dangerfield, 1983; Sam Kinison, 1987; Andrew Dice Clay, 1991; Gallagher, 1981

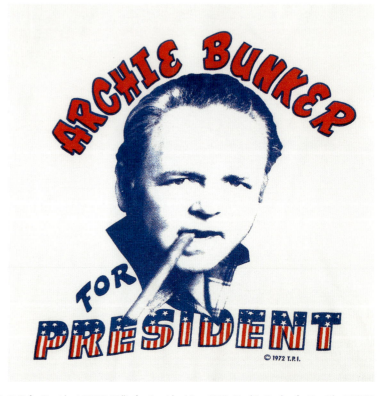

↑ Larry "Bud" Melman, 1982; "J. R. for President," 1980; "Ollie for President," ca. 1983; "Archie Bunker for President," 1972
→ "Alf for President," 1987

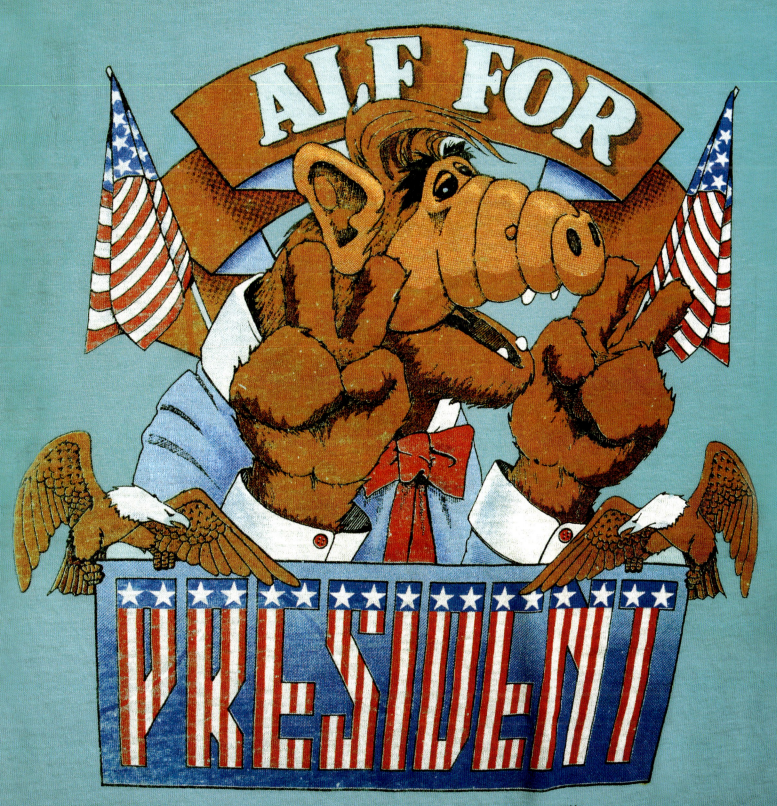

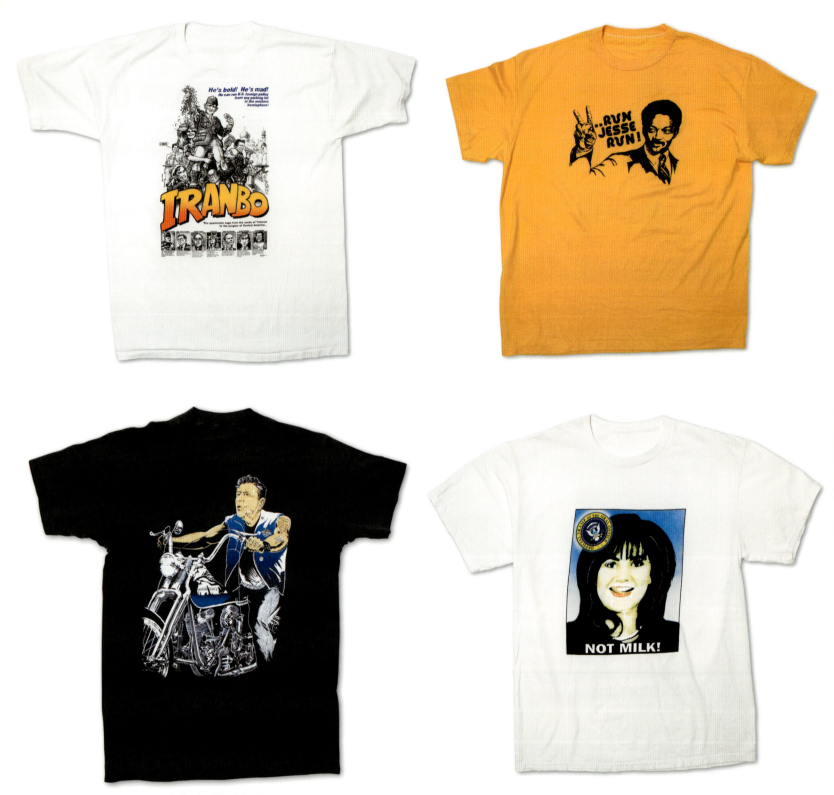

↑ "Iranbo," 1986; "…Run Jesse Run," Jesse Jackson presidential campaign, 1984; President Ronald Regan, 1980; "Not Milk!," Monica Lewinsky, 1993

→ "Rap Master Ronnie," President Ronald Regan, 1988

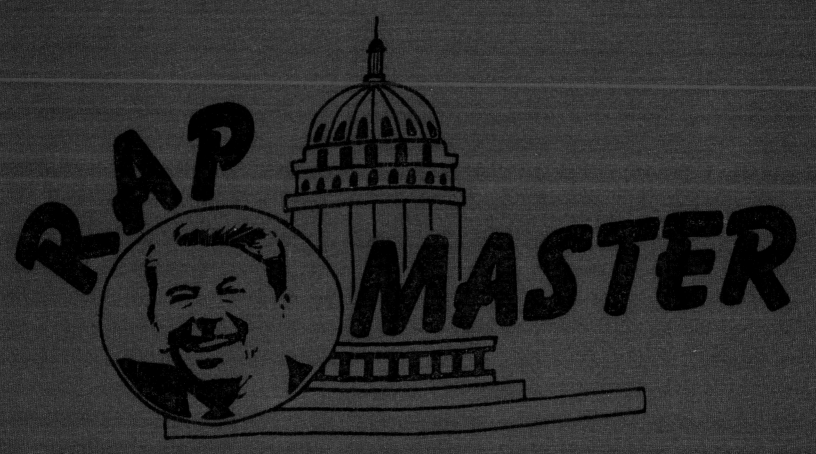

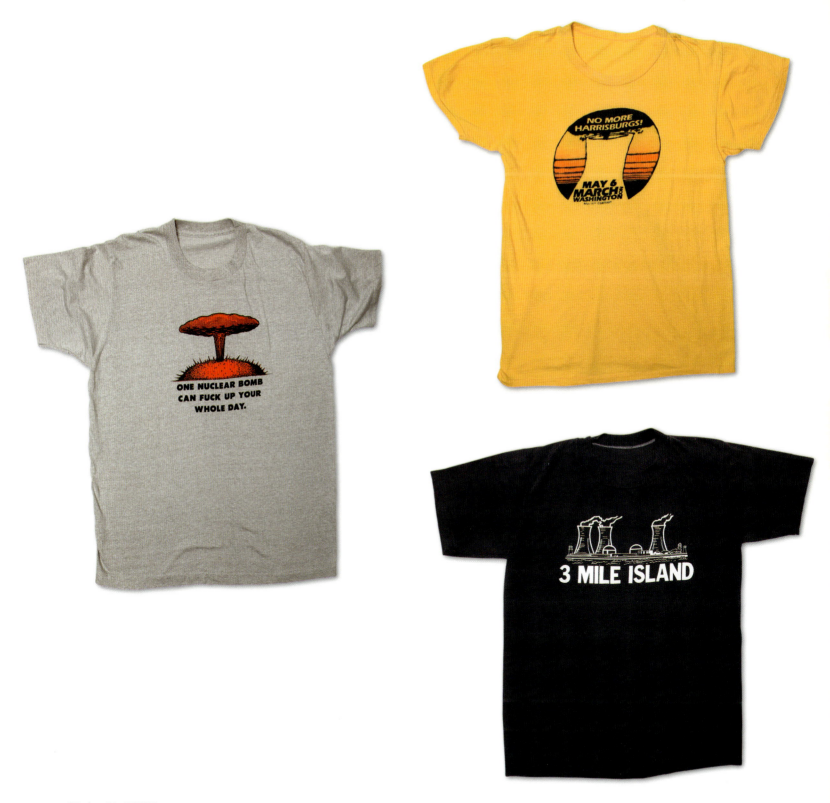

← "Nuclear War?!," 1980s
↑ "No More Harrisburgs!," Three Mile Island protest march, 1979; "One Nuclear Bomb," ca. 1983; "3 Mile Island," 1977

POLITICS & ACTIVISM 345

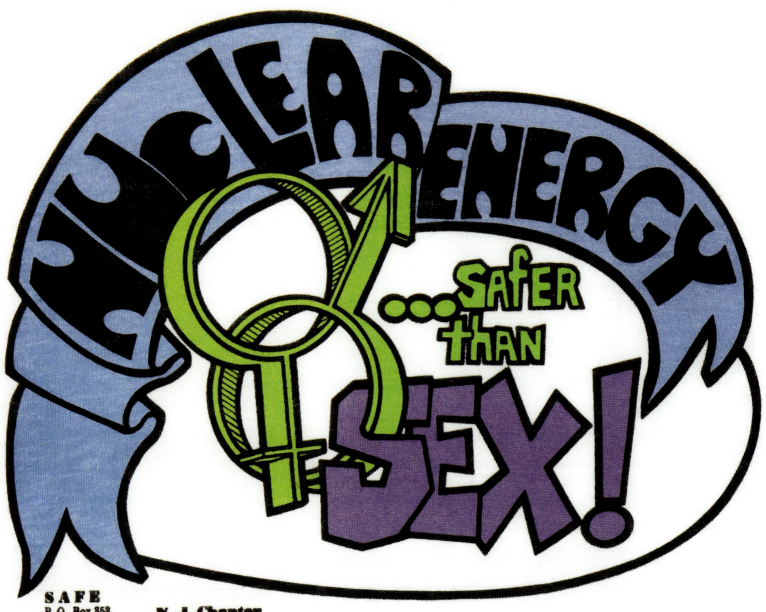

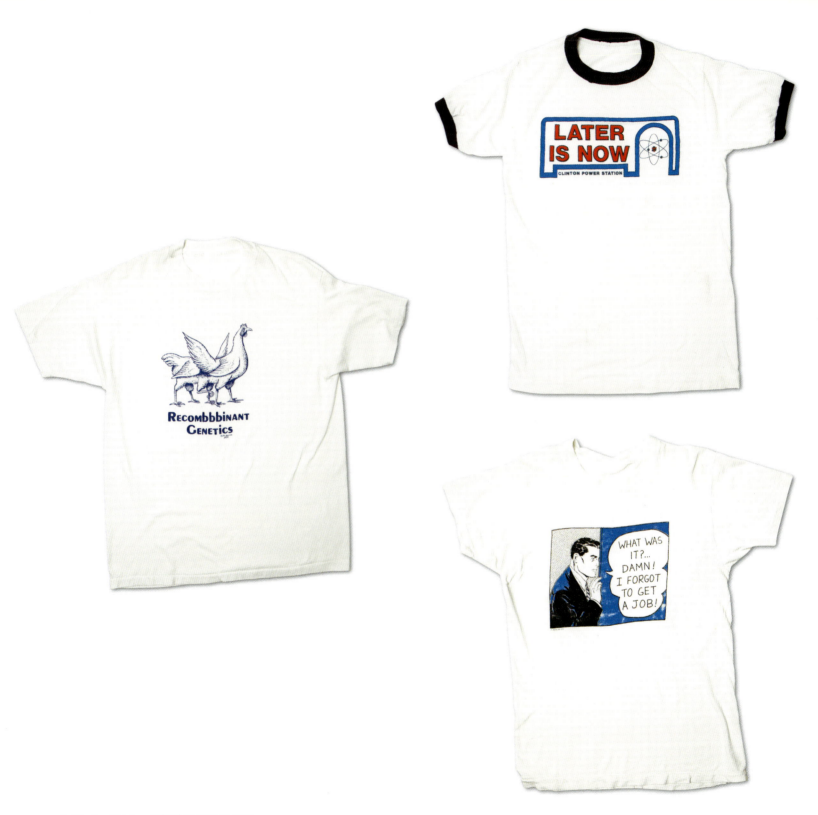

← "Nuclear Energy...Safer Than Sex," ca. 1979
↑ "Later Is Now," Clinton Power Station, ca. 1983; "Recombbbinant Genetics," J. C. Holden, 1979; "I Forgot to Get a Job," ca. 1989

POLITICS & ACTIVISM 347

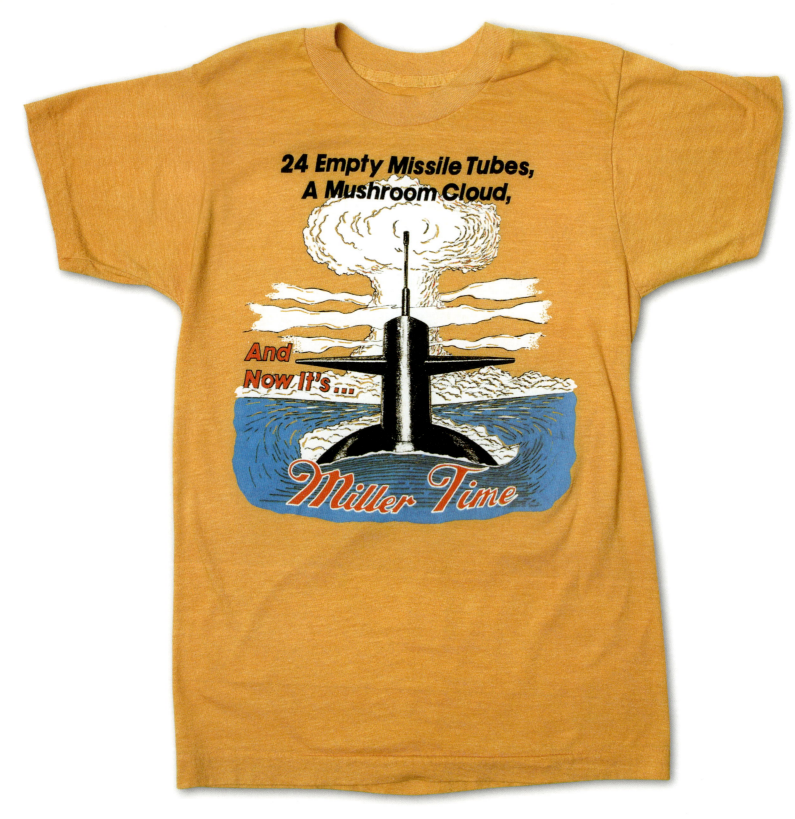

↑ Miller beer parody, ca. 1989

↑ Miller beer parody, ca. 1989

← "Texas National Forest," 1981
↑ "Save the Whales," Greenpeace, ca. 1979; "Ask Me About Clean Water," ca. 1979; Environmental Protection Agency, ca. 1983

POLITICS & ACTIVISM 351

↑ "Use Me Again," front and back, ca. 1983

↑ "Going Places," back and front, 1973

POLITICS & ACTIVISM 353

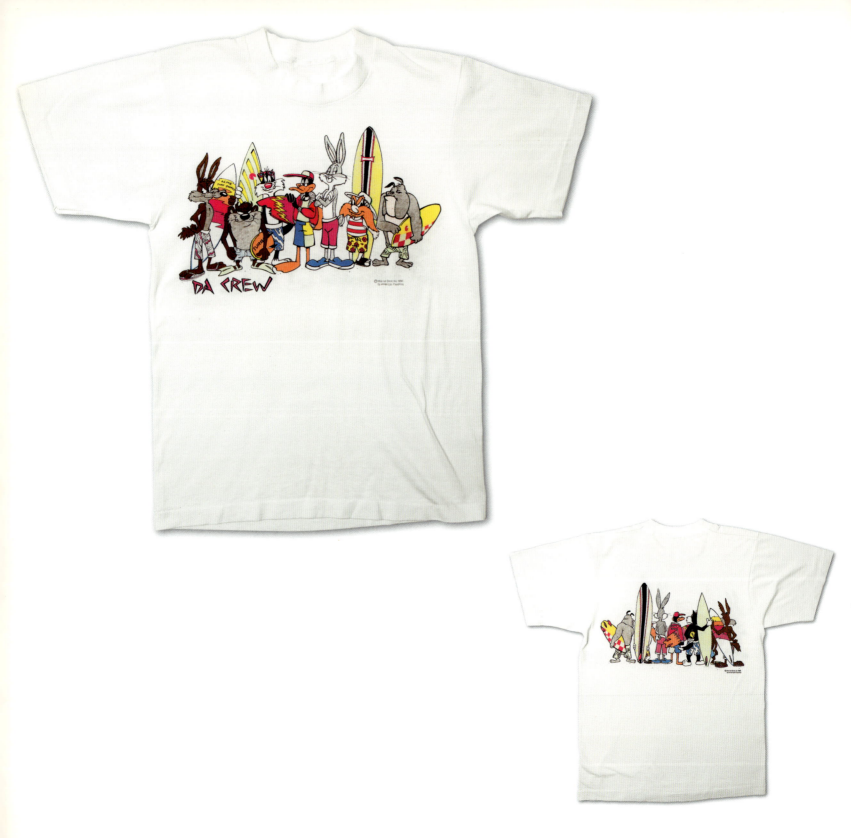

↑ "Da Crew," Warner Brothers, front and back, 1986

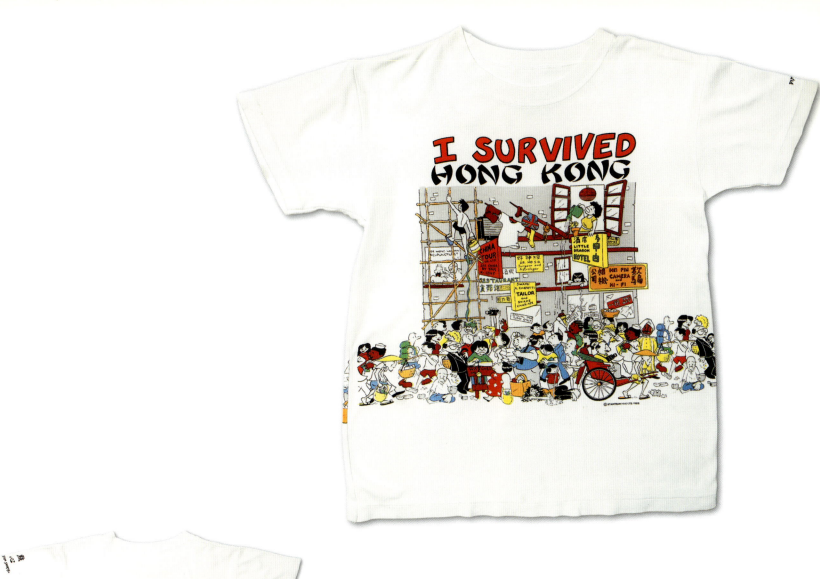

↑ "I Survived Hong Kong," front and back, 1985

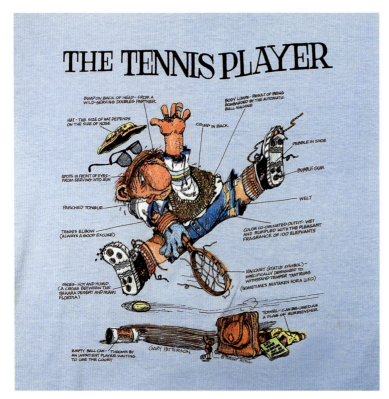
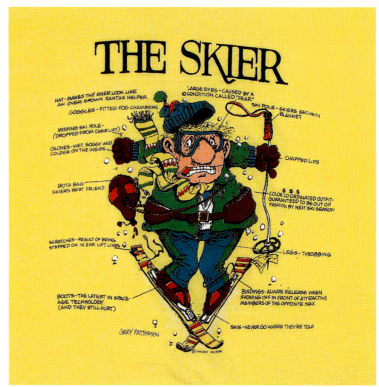
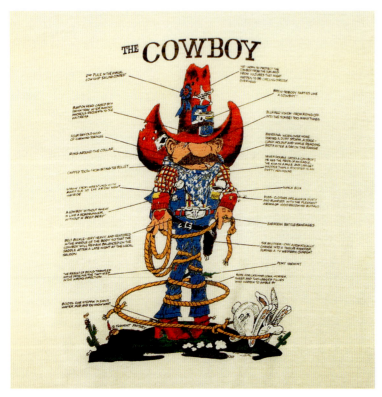
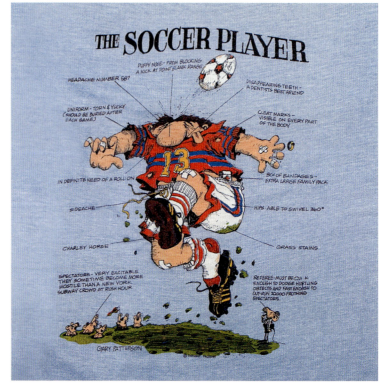

↑ "The Tennis Player," Gary Patterson, ca. 1989; "The Skier," Gary Patterson, ca. 1989; "The Cowboy," Gary Patterson, 1980s; "The Soccer Player," Gary Patterson, ca. 1989

→ "Weekend Warrior," Gary Patterson, ca. 1989

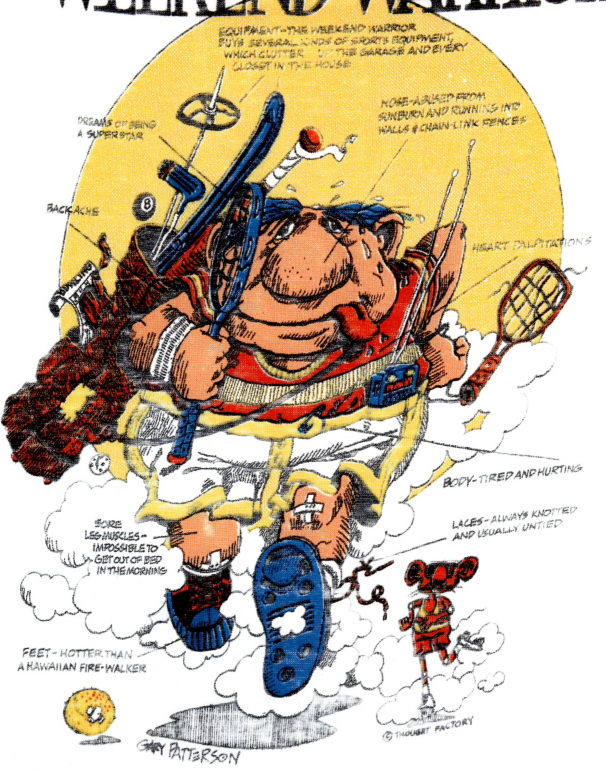

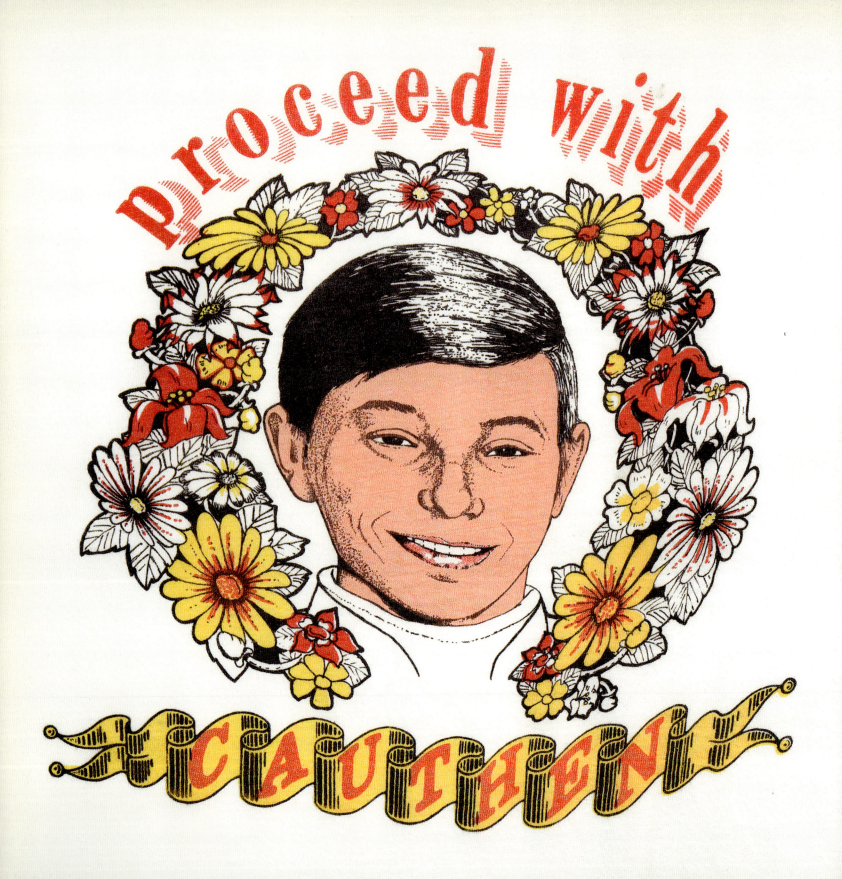

← "Proceed with Cauthen," Triple Crown winner Steve Cauthen, 1978
↑ Howdy Doody, 1950s

↑ Mr. Penguin, C. Coe, 1986; "Let's Party!," Hagar the Horrible, 1986; Bettie Boop, 1985; "Party Animal," Brutus, 1980s

↑ Porky Pig, "J-J-Just Do It," Nike/Warner Bros., 1993; "Sylvester," Looney Tunes, 1980; Yosemite Sam, "Make My Day," Looney Tunes, 1980; Gonzo, "Who Am I?" *The Muppet Show*, 1981

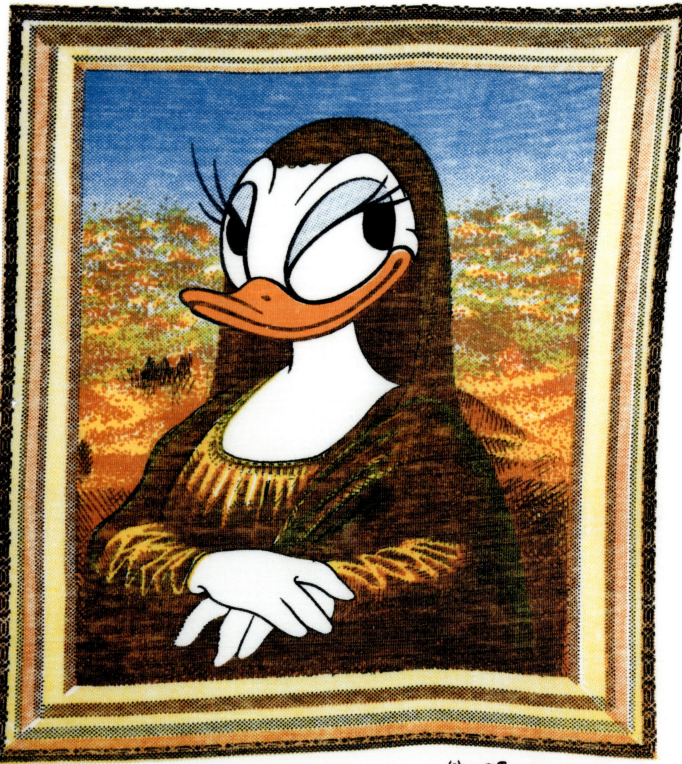

← Daisy Duck as the Mona Lisa, 1980s
↑ Minnie Mouse, front, ca. 1983

↑ Minnie Mouse, back, ca. 1983

↑ Chuck E. Cheese, 1981; "City Mouse," ca. 1979; "Macho Mouse," 1990s; "Mickey Rat," 1986

↑ "Kitty Wasters," Rick Tuthill, 1981; "I've Got a Drinking Problem," 1980s; "Couch Cows," ca. 1989; Cats, 1980s

↑ Garfield, "Everything Tastes Good on a Diet," Jim Davis, 1990s

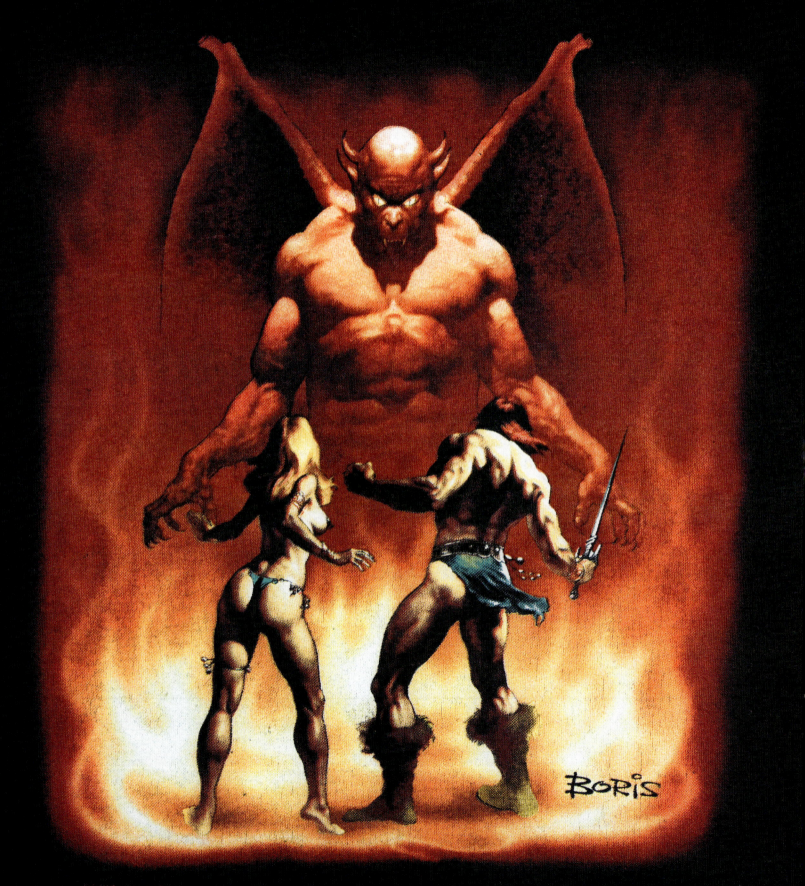

← ↑ Boris Vallejo, 1983–1986

← "Fashion Flash," Pat Nagel, 1980s
↑ "Wet Head," 1984

← "Member Doughboy Fan Club," Pillsbury Company, 1987
↑ Florida, 1980s; "Smile Mon," Jamaica, 1990s; "1-800-Eat-Shit," Florida, 1988; Troll "Dammit" doll, Thomas Dam, 1992

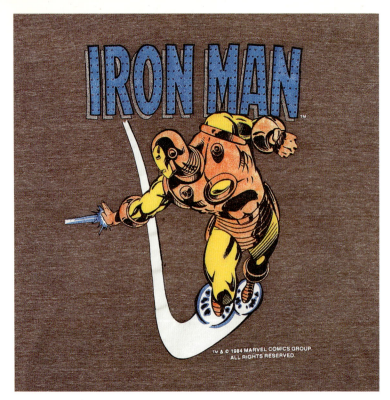
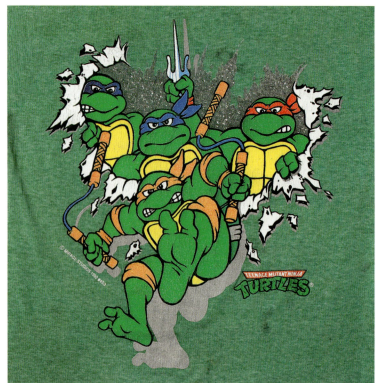
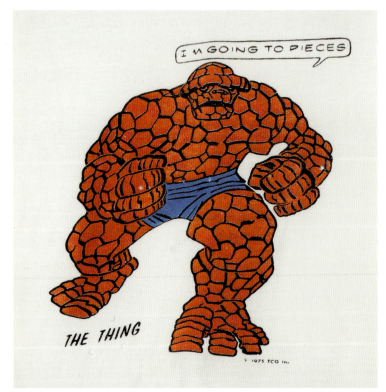
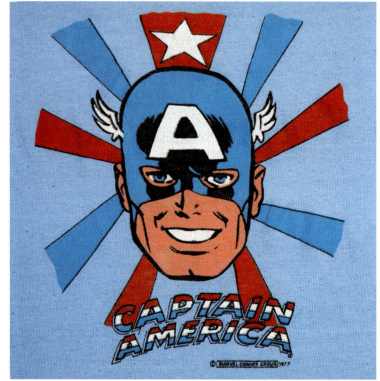

↑ Iron Man, 1984; Teenage Mutant Ninja Turtles, 1992; The Thing, 1975; Captain America, 1977
→ Smiley face, 1990s

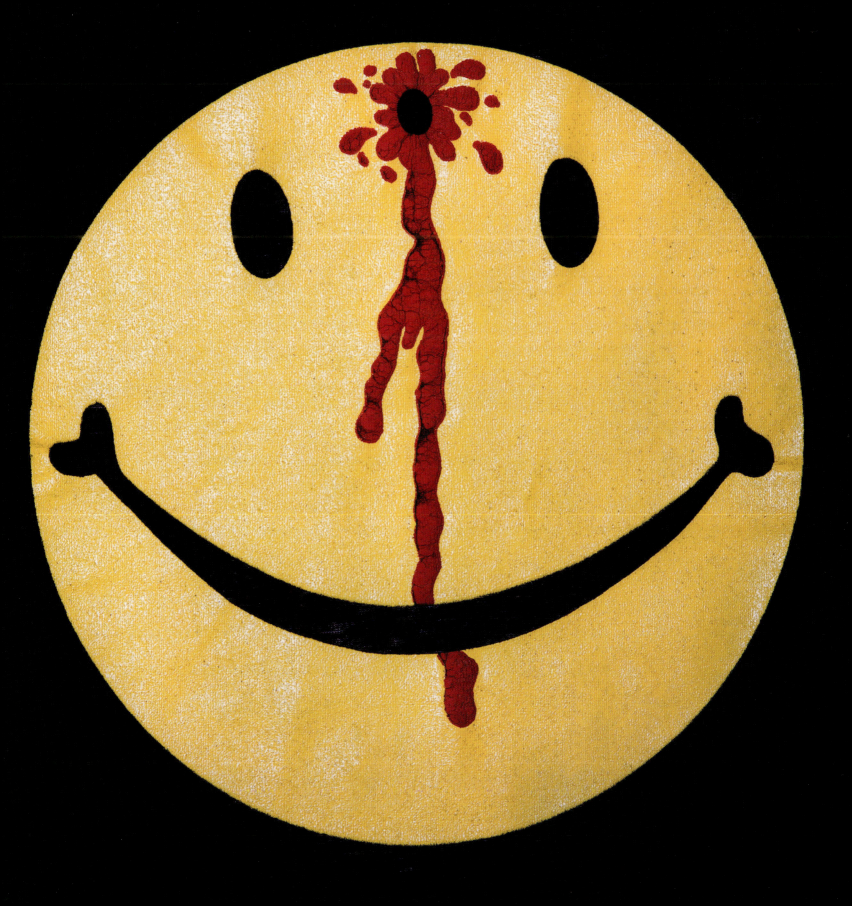

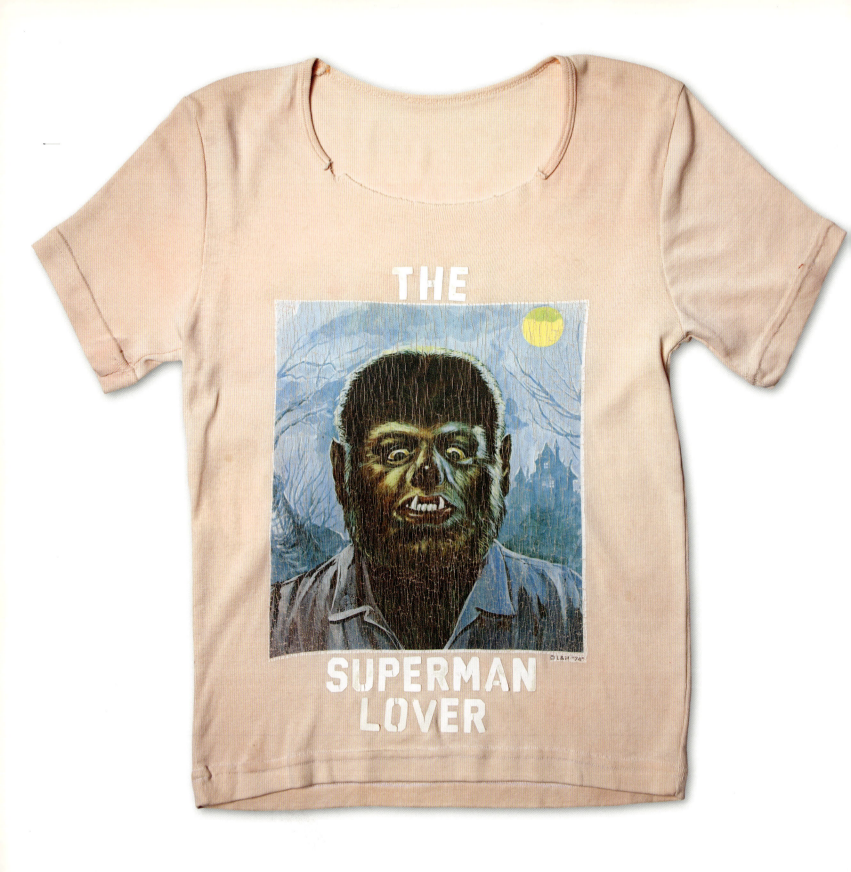

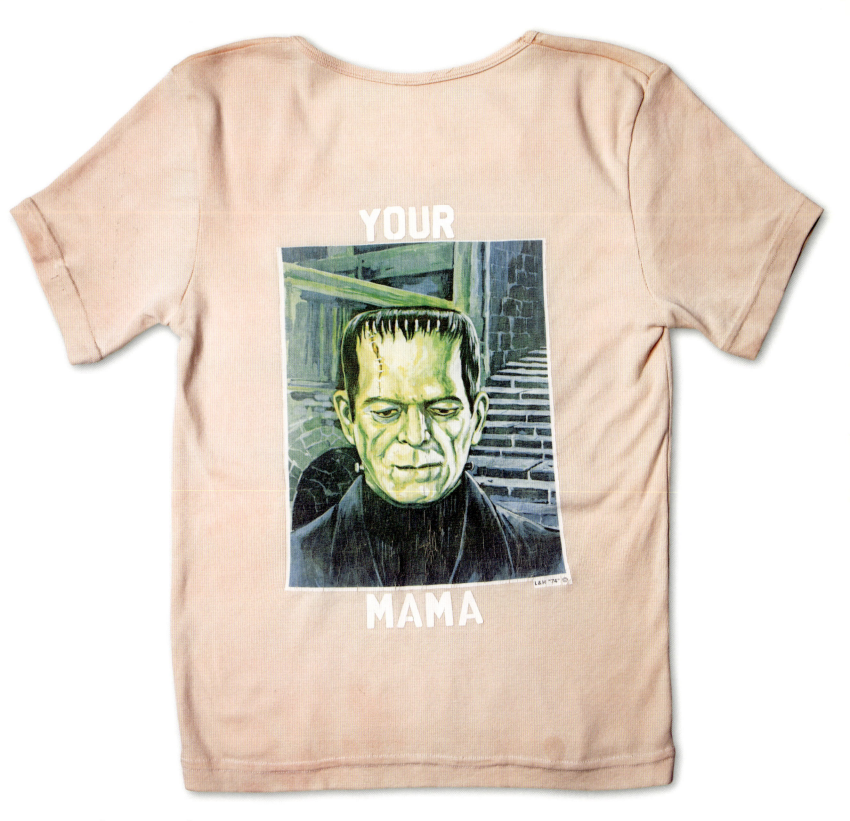

← ↑ "The Superman Lover," front; "Your Mama," back, 1974

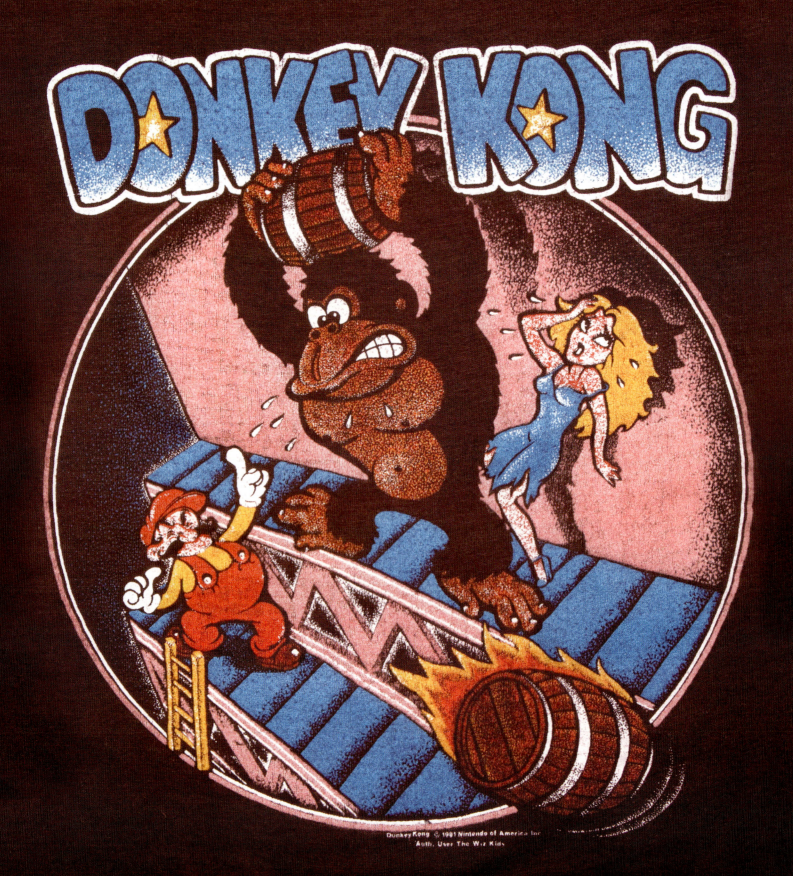

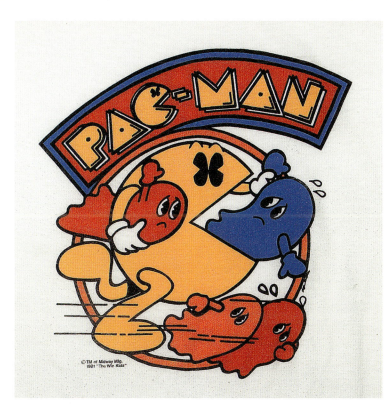
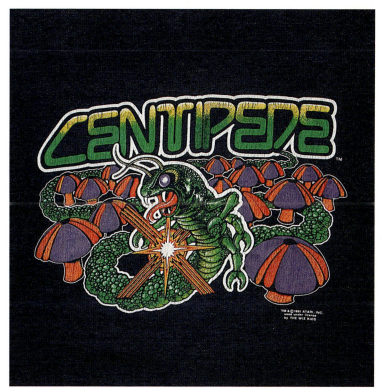
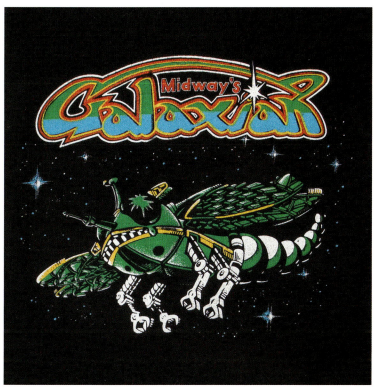
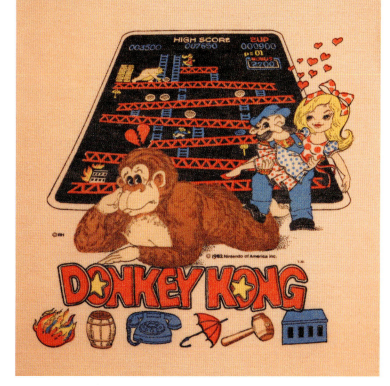

← "Donkey Kong," 1981
↑ "Pac-Man," 1981; "Centipede," 1981; "Galaxian," 1979; "Donkey Kong," 1982

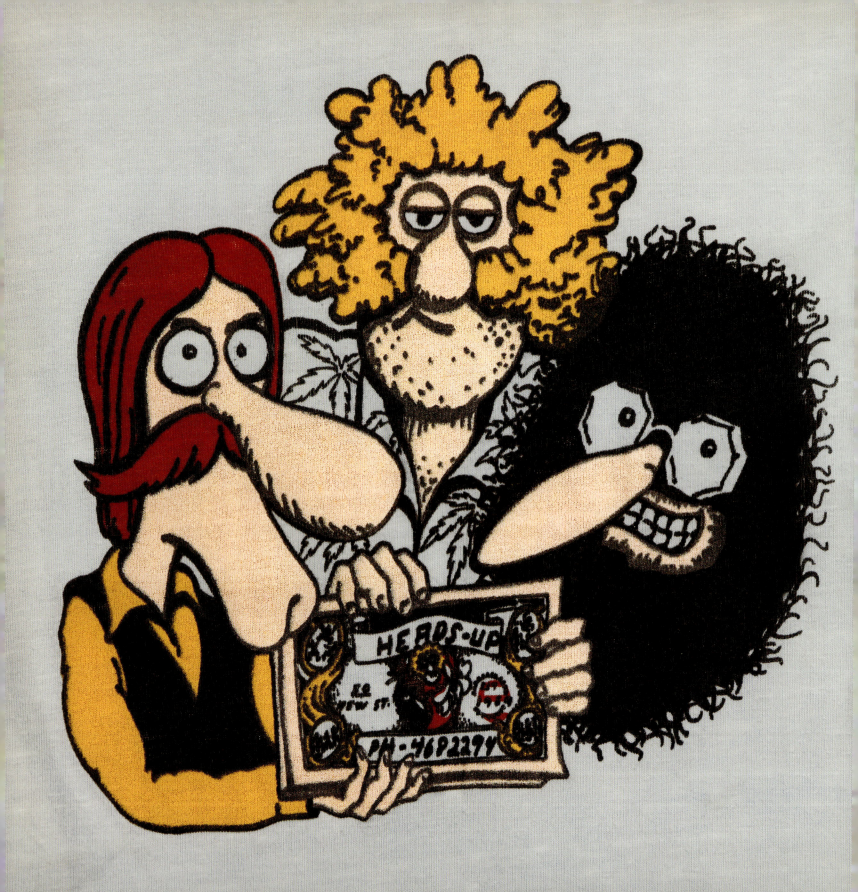

← "Freak Brothers," Gilbert Shelton, ca. 1973
↑ Zippy the Pinhead, Bill Griffith 1980s; Tony Guetta, 1990s; Lucien, Frank Margerin, 1979; *Europe '72*, Grateful Dead, Stanley Mouse, 1972

↑ "Where's the Real Waldo?," 1990
→ "Where's Waldo?," Martin Handford, 1987

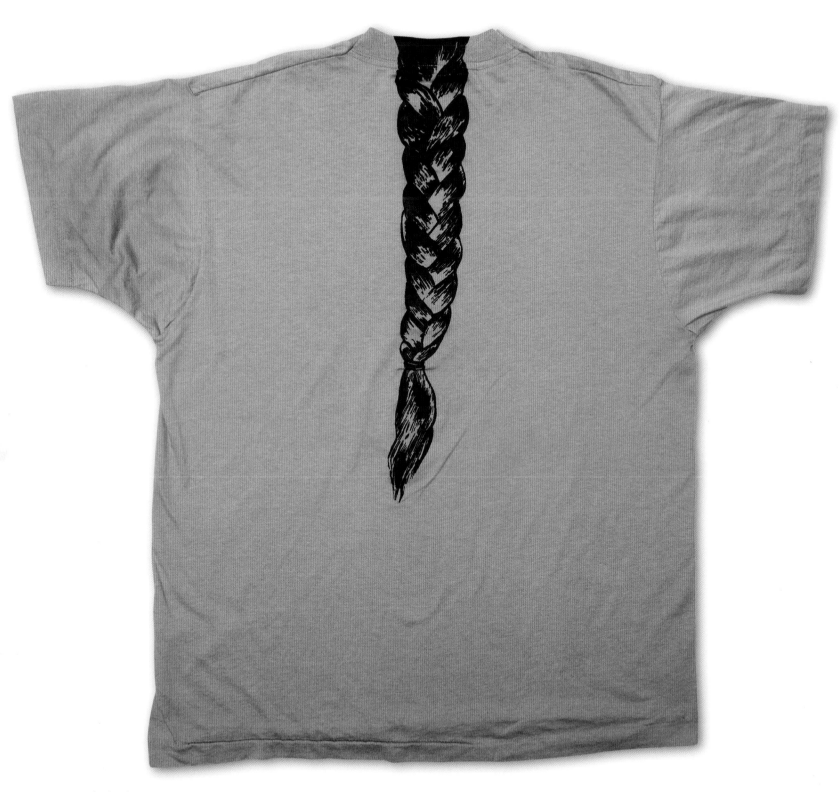

← Michael Jackson USA Tour, 1984
↑ Texas Tornados, 1991 →→ "A Hacker's Guide to Golfing Glory," Xerox, 1980s

The OFFICIAL T-SHIRT.

"upside-down golf instructions"

A Hacker's Guide to Golfing Glory

- Check your grip
- Hands parallel to club face
- Keep head behind ball
- Take away in one piece
- Left arm straight
- Make natural hip and shoulder turn
- Get club head high
- Weight on inside of right foot
- Start down-swing slowly
- Accelerate as you swing through the ball
- Finish high • Don't hurry
- Ball will not move till struck
- Think slow • Think effortless power
- Think about a lesson
- Regardless, it's more fun than work

So just read your chest and sock that sucker

XEROX

INDEX

A
Absolut 252, 256
AC/DC 95, 96, 98, 117, 119
Adam and the Ants 157
Adidas 22, 181
Aerosmith 158
Alaska 267
Albion College 53
Alf 339
Alfalfa 255
Aliens 323
Apple 74
Arizona State Univ. 15
Arwin, Leslie 187
A-Team, The 310
Athletic Supporter 32
Atlantic Records 315

B
B-52's, The 149
Bardot, Brigitte 12
Batgirl 304, 305
Battlestar Galactica 310
Bay to Breakers 51
Beach Boys, The 108
Bears (Chicago) 54
Bee Gees 126
Benatar, Pat 173
Berlin 161
Bettie Boop 360
Beverly Hills 90210 294, 295
Big Julie's Deli 70
Bill & Ted's Excellent Adventure 40
Bird, Larry 61
Black Sabbath 94, 97, 106
Blazing Saddles 310
Blue Nun 257
Blues Brothers 315
Bon Jovi 35, 159
Boston 172
Bowie, David 109, 132
Brandon, Marlon 13
Brutus 360
Buckwheat 254, 255
Budweiser 259
Bull Shirt 210
Bunker, Archie 338
Bush, George H. W. 341

C
Caddyshack 333
Caesar's Palace 62, 63
California 272, 273
California, USS 10
Callahan's Restaurant 70
Cape Cod 66
Captain America 374
Captain EO 313
Cars, The 122, 132, 177
Cauthen, Steve 358
Celtics (Boston) 61
Centipede 379
Cherry, Jim 275
Chevrolet 288
Chicago 66, 167
Chuck E. Cheese 365
Circle C Ranch 266
City Mouse 365
Clay, Andrew Dice 337
Clinton, Bill 341
Clinton Power Station 347
Clockwork Orange 318
Coca-Cola 64, 65
Coe, C. 360
Colorado 267
Columbia IV 198
Converse 181
Cooney, Gerry 62
Cooper, Alice 169
Coors 256
Coronado Half Marathon 51
Costello, Elvis 147
Crazy Eddie 72
Crumb, R. 18
Cult, The 127
Culture Club 144

D
Daisy Duck 362
Dam, Thomas 373
Dammit doll 373
Dangerfield, Rodney 336, 337
Davis, Jim 367
Daytona International Speedway 195, 197
Def Leppard 166–167, 170
Denver Suzuki Inst. 134
Devils Tower 281
Devo 120
Di Milano 253, 259
Diamond, Neil 126
Dick Tracy 306
Dodgers (Los Angeles) 47
Donkey Kong 378, 379
Doobie Brothers, The 22
Dover 196
Dr. Pepper 65
Drum Corps Nuts 242
Duran Duran 16, 162, 163
Dylan, Bob 132

E
E.T. 37, 287, 314
Elvira 153
Environmental Protection Agency 351
Estevez, Emilio 15
Eurythmics 144, 164
Evans, Walker 197
Ewing, J. R. 338

F
Fall Guy, The 308
Farm Aid 35
Fast Times at Ridgemont High 29
Fat Boys, The 148
Fatal Attraction 335
Fawcett, Farrah 301
Florida 373
For Your Eyes Only 319
Ford 197
49ers (San Francisco) 54
Foster Farms 70
Frankenstein 377
Frankie Goes to Hollywood 33, 156
Freleng, Friz 331
Full Metal Jacket 326

G
G.M. 288
Galaxian 379
Gallagher 337
Garfield 367
Genesis 156
Ghostbusters II 313
Giants (New York) 54
Glaser, Milton 4
Go-Go's 139
Gong Show Movie, The 315
Gonzo 361
Graceland 81
Grand Canyon 235
Grand Funk Railroad 154
Grateful Dead, The 84, 85, 87, 381
Grease 309
Green Berets 209
Greenpeace 351
Gremlins 314
Griffith, Bill 381
Guetta, Tony 224, 381

Guns N' Roses 102, 103, 104, 105

H
Hagar the Horrible 360
Halloween 325
Hamm's Beer 259
Handford, Martin 382, 383
Hanes 237
Happy Days 298
Hardy Boys, The 309
Harley-Davidson 188, 189
Harrison, George 86
Hawaii 67, 203, 270–271, 279
Hawaiian Tropic 202
Heaven 251
Hendrix, Jimi 119
Herman Goelitz Candy Co. 71
Herman, Pee-Wee 293
High Times 260
Hobie 203
Hogan, Hulk 290, 291
Holden, J. C. 347
Holmes, Larry 62
Holyfield, Evander 63
Home Alone 313
Honda 191
Hong Kong 355
Hoover, Ron 194
Hopkins Raspberry Smile Run 50
Howard the Duck 306
Howdy Doody 359
Howell, C. Thomas 15

I
Idol, Billy 112, 113, 119
In Living Color 299
Incredible Bulk, The 73
Indiana Jones 313
Inner Space 306
Iranbo 342
Iron Maiden 100, 101
Iron Man 374

J
J. Geils Band, The 126
Jackson, Jesse 342
Jackson, Michael 119, 128, 129, 130, 131, 176, 384
Jagger, Mick 20
Jamaica 373
Jane's Addiction 107
Jaws 30

Jeep 194
Jett, Joan 28
Jockey 13
John, Elton 176, 311
Journey 109, 116
Junglenuts 31

K
Kansas 263
Karate Kid, The 332
Keystone Cops 184
King, Don 26
Kinison, Sam 337
Kiss 24, 118, 168
Knight Rider 288, 289
Krueger, Freddy 324

L
Lake Tahoe 282
Lakers (Los Angeles) 60
Las Vegas 279
Laurel Hardware 73
Led Zeppelin 88, 119
Lee 183
Legal Seafoods 70
Lennon, John 23
Lewinsky, Monica 342
Lewis, Jerry 298
Live Aid 137
LL Cool J 150–151
Looney Tunes 361
Los Fabulous Art Maggots 340
Loverboy 37
Lucien 381

M
M.A.S.H. 331
Madonna 140, 141, 142, 143, 144
Maine 56
Margerin, Frank 381
Marie, Teena 174
Mark's Bros. Foundations 73
Marx Brothers 315
Maxell 74
Maxie's Hot Dogs 71
Melman, Larry "Bud" 338
Mercury News, The 51
Metallica 99
Mickey Mouse 8
Mickey Rat 365
Miller 348, 349
Minnesota 276, 277
Minnie Mouse 363, 364
Monday Night Football 58

INDEX 387

Monster Mopar	194	Orman, Caroline	134	*Rocketeer, The*	307
Moon, Keith	91, 125	*Outsiders, The*	15	*Rocky & Bullwinkle*	312
Moosehead Bear	259			*Rocky Horror Picture*	
Morel Bianco	253, 259	**P**		*Show, The*	303
Motels, The	147	Pac-Man	379	*Rocky*	312, 327
Mötley Crüe	119	Palmer, Robert	144	Rolling Stones	20, 78,
Motörhead	121	Parton, Dolly	176		79, 115
Mouse, Stanley	381	Patterson, Gary	356, 357	Roth, David Lee	155
Moustache Rides	241	Paycheck, Johnny	213	Roth, Ed	19
Mr. Bill	292	Penn, Sean	29	Roxy Music	145
Mr. Penguin	360	Pep Boys, The	193	Run Thru Hell Marathon	48
Mr. T	310	Perot, Ross	341	Rush	83
MTV	331	Pillsbury Company	372	Rushmore, Mt.	390
Munsingwear	9	Pink Floyd	92, 93		
Munsters, The	314	Pink Panther, The	331	**S**	
Muppet Show, The	248, 361	Pioneer	75	Sam's Wine Warehouse	49
Mustang Ranch	245	Playboy	247	*San Francisco Examiner*	51
Myers, Michael	325	Poison	171	San Francisco	17, 274
		Police, The	6, 7, 138	Santana	89
N		*Poltergeist*	325	*Saturday Night Fever*	310
N.Y.P.D. Homicide		Presley, Elvis	80, 81	*Saturday Night Live*	292, 299
Squad	268	Pretenders, The	120	Schickele, Peter	135
Nagel, Patrick	16, 370	Prince	110, 111	Schwarzenegger,	
NASA	199	Pro Max	191	Arnold	328
Neil Young and the		*Psycho II*	325	Scorpions	117
Shocking Pinks	109	Puma	181	Sea Gazelle Luxury	
Nevada	244	Purdue Univ.	57	Catamarans	201
New $100,000				Seagram's	256
Pyramid, The	299	**Q**		Sears	192
New Kids on the Block	175	Quality Automotive Co.	193	Seattle	267
New York	23, 263, 269	Queen	77, 109	Seavers, Colt	308
Newton-John, Olivia	160	Quiet Riot	117	Seger, Bob	83
Nightmare on Elm				7UP	256
Street, A	322, 324	**R**		Sex Pistols	27, 28
Nike	41, 178–179,	Rat Fink	19	Shark Attax	200
	180, 181, 361	Redford, Robert	309	*She's Gotta Have It*	320
North Carolina	283	Reese's Peanut Butter		Shelton, Gilbert	380
North, Oliver	338	Cups	71	Shoreline Sportswear	203
Nugent, Ted	114, 119	Reeves, Keanu	40	Skywalker, Luke	309
		Regan, Ronald	342, 343	Smith, C.	197
O		*Remington Steele*	300	Southeast Polk Physical	
Oakland Raiders	55	Rice, Will	258	Education	14
Ocean Pacific	204–205	Richmond	279	Specials, The	120
Ohio State Univ.	52	Riunite Bianco	256	Spiegelman, Art	69
Oklahoma	66	*RoboCop 2*	306	Springsteen, Bruce	166
Olympics	44, 45, 51	Rocketdyne	198	Spuds MacKenzie	259

Star Trek	296, 297	**V**	
Star Wars	298, 299, 309	Val Surf Boardshop	38
Stewart, Rod	152	Vallejo, Boris	368, 369
Stray Cats	119, 132	*Valley Girl*	39, 217
Streetcar Named		Van Halen	123, 156
Desire, A	13	Venice Muscle Beach	328
Styx	126	Ventura County Fair	194
Summer, Donna	176	Virginia	286
Supertramp	146, 147		
Sylvester	361	**W**	
		Waldo	382, 383
T		Wallace Armer	73
Teenage Mutant		Warhol, Andy	275
Ninja Turtles	374	Warner Bros.	354, 361
Terminator 2	329	Washington	262, 266
Texas Tornados	385	"We Are the World"	36, 136
Texas	350	West Virginia Motor	
Thing, The	315	Speedway	197
Thing, The	374	White Sands	278
3 Mile Island	345	*Who Framed Roger*	
Three Stooges	74	*Rabbit*	316
Tom Petty and the		Who, The	90, 91, 125
Heartbreakers	83, 165	Winter, Alex	40
Trans Am	288	Wolfman	376
TravelCenters of		*World According to*	
America	193	*Garp, The*	218
Triumph	156		
T-Shirtery, The	25	**X**	
Tuthill, Rick	366	Xerox	74, 386
Tyson, Mike	63		
		Y	
U		Yankees (New York)	46
U.S. Armed Forces	208,	Yes	82
	209, 210	Yosemite National Park	
U.S. Virgin Islands	264–265		280, 281
U2	124	Yosemite Sam	361
UHF	317	*Young and the*	
Uncle Sherman	238, 239	*Restless, The*	334
Univ. of California,		*Young Frankenstein*	302
Los Angeles	53		
Univ. of Iowa	56	**Z**	
Univ. of Notre Dame	53, 56	Z/28 Camaro	288
Univ. of Washington	56	Zaire	26
Univ. of Wisconsin	261	Zappa, Frank	76, 217
USA for Africa	136	Zippy the Pinhead	226, 381
USDA	71	ZZ Top	83

I HAVE SURVIVED:

Nursery School☐, Kindergarten☐, Private School☐, Public School☐, Hebrew School☐, Parochial School☐, Summer Camp☐, Braces☐, Music Lessons☐, Marching Band☐, Intramural Sports☐, Intermural Sports☐, Gym☐, Early Acceptance☐, Parental Rejection☐, An Ethnic Mother☐, Brothers☐☐☐, Sisters☐☐☐☐, Only Childhood☐, ACT☐, SAT☐, APT☐, Orientation☐, Required English☐, Philosophy☐, History☐, Economics☐, Physics☐, Math☐, Chemistry☐, Foreign Language☐; Commuting☐, Off Campus Housing☐, Dorm Life☐, Roommates☐☐☐, Comparative Literature☐, Religion☐, Anatomy☐; Really Good Teachers☐☐☐, Really Bad Teachers☐☐☐, Aristotle☐, Kant☐, Pascal☐, Basic☐, Keynes☐, Plato☐, Faulkner☐, Chaucer☐, Shakespeare☐, Bach☐, Sophocles☐, Beethoven☐, Freud☐, Skinner☐, The Postal Service (U.S.)☐, The Postal Service (campus)☐, The Food Service (campus)☐, MCAT☐, DCAT☐, LSAT☐, GRE☐, Freshman☐, Sophomore☐, Junior☐, Senior☐ years

AND I SHALL PREVAIL!

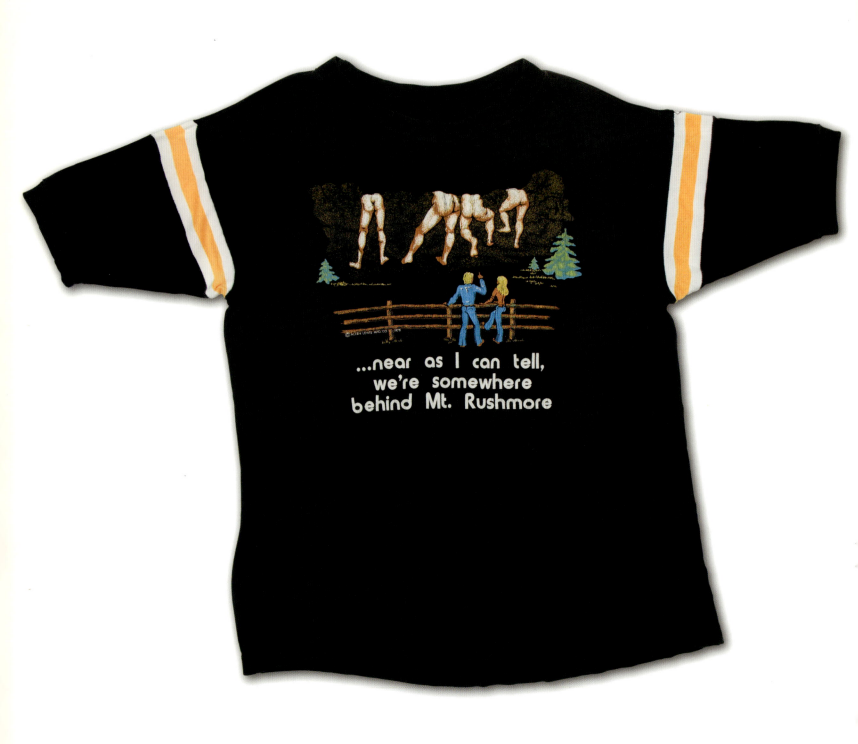

←← "I Have Survived," 1980s
↑ "Mt. Rushmore," ca. 1983 →→ "Your Ad Here," Lorsch Group, ca. 1976

"I have my brother Tony to thank for sharing his passion for classic tees with me; and of course I would like to say thank you to my wife for washing and folding all the T-shirts I bring home from work, and to my kids for always being excited every time I bring shirts home to them."
—Patrick Guetta, Los Angeles, 2010

About the authors:
Patrick & Marc Guetta's World of Vintage T-Shirts store on Melrose Avenue has been Hollywood's top source of vintage Ts for over a decade, catering to celebrities, tourists and Los Angeles' fashion obsessed. Patrick Guetta, worked with major movie studios in creating the licensed apparel company Too Cute!, is now launching his own characters called Junglenuts.

About the contributing author:
Alison A. Nieder has worked in fashion since 1985, in retail, apparel production, and as a fashion business journalist. She is executive editor of *California Apparel News*, a fashion trade publication covering the West Coast apparel and textile industries.

Die Autoren:
Patrick und Marc Guettas Boutique World of Vintage T-Shirts an der Melrose Avenue ist seit über einem Jahrzehnt Hollywoods wichtigste Quelle für Vintage T-Shirts und Anlaufstelle für die Stars, Touristen und Modeverrückten aus Los Angeles. Patrick Guetta hat in Zusammenarbeit mit den großen Filmstudios auch ein eigenes Modelabel gegründet: Too Cute!. Er bringt derzeit seine eigenen Comicfiguren, die Junglenuts, heraus.

Die Koautorin:
Alison A. Nieder arbeitet seit 1985 in der Modebranche, in Verkauf, Design und Herstellung von Kleidung und als Berichterstatterin aus der Modewirtschaft. Sie ist Herausgeberin von *California Apparel News*, einer Fachzeitschrift für Mode, die über die Modebranche und Textilindustrie an der amerikanischen Westküste berichtet.

Les auteurs :
Depuis plus d'une décennie, World of Vintage T-Shirts, la boutique de **Patrick et Marc Guetta** sur Melrose Avenue, est la principale source de t-shirts vintage où viennent s'approvisionner les célébrités, les touristes et les branchés de Los Angeles. Après avoir collaboré avec les grands studios de cinéma pour créer la marque Too Cute !, Patrick Guetta a récemment lancé ses propres personnages de bande dessinée, les Junglenuts.

A également collaboré à cet ouvrage :
Alison A. Nieder travaille dans la mode depuis 1985, dans la vente au détail, la production et en tant que journaliste. Elle dirige *California Apparel News*, une revue professionnelle spécialisée dans l'habillement et l'industrie textile de la côte Ouest.

All images are from the collection of Marc and Patrick Guetta, **www.vintageshirt.com**, unless otherwise noted. Any omissions for copy or credit are unintentional and appropriate credit will be given in future editions if such copyright holders contact the publisher. Photo credits: © Bob Gruen/www.bobgruen.com: 23, 28. © Corbis. All Rights Reserved: 12. © Harvey L. Silver/Corbis. All Rights Reserved: 24. Jim Heimann Collection: 9, 10 above and below, 11, 13 above, 25 right, 35, 37 right, 38 right. © Hulton Archive/Getty Images: 20. © Neil Leifer 2010: 26 © Orion Pictures Corp. 40. © Universal Pictures: 29, below. © Warner Bros. Pictures: 13 below, 15 below.

Foreword © 2010 Patrick Guetta
Introduction © 2010 Alison A. Nieder

The publisher gratefully acknowledges the following individuals in the creation of this volume: Teena Apeles, Francesco Belvedere, Mia Chamasmany, Craig B. Gaines, Nicole Greene, Ryann McQuilton, and Vanessa Pesaran.

To stay informed about upcoming TASCHEN titles, please request our magazine at www.taschen.com/magazine or write to TASCHEN, Hohenzollernring 53, D-50672 Cologne, Germany, contact@taschen.com, Fax: +49-221-254919. We will be happy to send you a free copy of our magazine which is filled with information about all of our books.

© 2010 TASCHEN GmbH
Hohenzollernring 53
D-50672 Köln
Germany
www.taschen.com

Art direction: Josh Baker, Los Angeles
Production and photography: Jennifer Patrick, Los Angeles
Editorial coordination: Nina Wiener, Los Angeles;
 Kathrin Murr, Cologne
Design: Katie Stahnke and Marco Zivny, Los Angeles
German translation: Anke Caroline Burger, Berlin
French translation: Philippe Safavi, Paris

Printed in China
ISBN 978-3-8365-2072-0